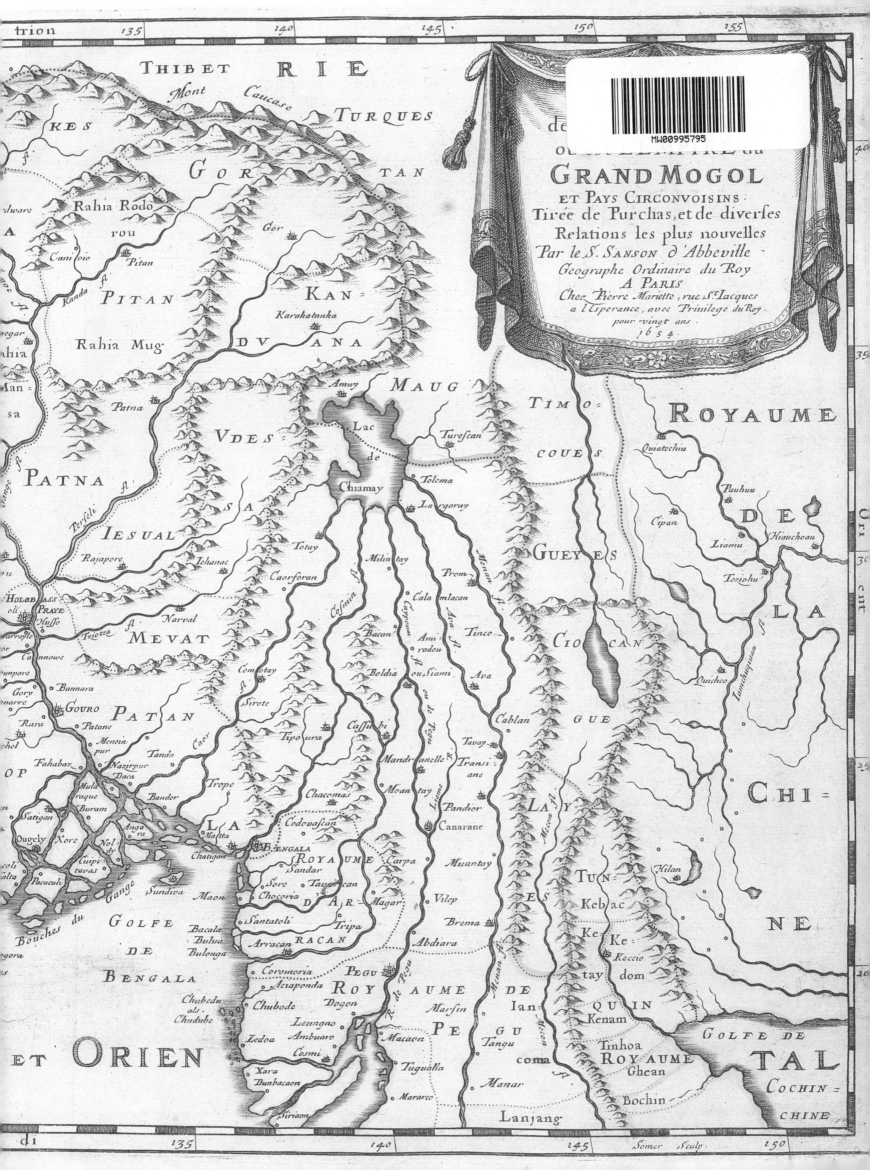

BRAHMAPUTRA

Shambhala Publications, Inc.
Horticultural Hall
300 Massachusetts Avenue
Boston, Massachusetts 02115
http://www.shambhala.com

Copyright © 1998 Editions Olizane, Geneva
English edition copyright © 1998 Local Colour Limited, Hong Kong
Photography and text copyright © 1998 Tiziana and Gianni Baldizzone

9 8 7 6 5 4 3 2 1

First Edition

Printed in Spain

⊛ This edition is printed on acid-free paper that meets the
American National Standards Institute Z39.48 Standard

Distributed in the United States by Random House, Inc., and in Canada by Random House of Canada Ltd

Translation: David Kennard in association with First Edition Translations Limited
Design: Vitamine / Editions Olizane, Geneva

Library of Congress Cataloging-in-Publication Data
Baldizzone, Tiziana.
[Brahmapoutra. English]
Tales from the river Brahmaputra by Tiziana and Gianni Baldizzone.
p. cm.
ISBN 1-57062-401-1 (hardcover)
1. Tales–Brahmaputra River Valley. 2. Tales–Bangladesh–Brahmaputra River Valley. 3. Tales–China–Tibet–Brahmaputra River Valley.
4. Buddhism–Customs and practices. 5. Hinduism–Customs and practices. 6. Islam–Customs and practices. 7. Brahmaputra River
Valley–Social life and customs. 8. Bramaputra River–Description and travel. I. Baldizzone, Gianni. II. Title.
GR305.5.B3B3513 1998
[DS485.B6967]
398.2'0954-dc21 98-23050
CIP

TIZIANA AND GIANNI BALDIZZONE

TALES FROM
THE RIVER

BRAHMAPUTRA
TIBET · INDIA · BANGLADESH

SHAMBHALA

BOSTON

1998

INTRODUCTION

TSANGPO, BRAHMAPUTRA, JAMUNA. Three names, but a single river. Tibet, India, Bangladesh. Three countries, but a single river. Buddhism, Hinduism, Islam. Three faiths, but a single river. A mythological source, hidden among the ice sheets of one of the most sacred regions in the world. With a course of almost three thousand kilometres, it crosses some of the most inhospitable regions on Earth. A disquieting question mark for 19th century geographers: were the Tsangpo of Tibet and the Brahmaputra of India the same or two different rivers? In the absence of geographical facts, ancient maps traced the course of the Brahmaputra in a very fanciful way, based on legends and stories collected by travellers.

A 'Great River,' which is the meaning of its Tibetan name. A mysterious river, full of history. A river with many stories to tell.

Stories about the men who came to search for, and discover, this river. About armies who crossed it. About pilgrims who purified themselves in its waters. About the gods who quarrelled on its banks. About savage tribes and tea pioneers. About the otters that fish in its water and the tigers of Bengal. About the ashes of the dead, carried along by the Ganges, and then deposited by it into the Ocean.

The mystery of Brahmaputra has captured our imaginations ever since we first traced its course on an old map that dates back to 1654: its source was shown as a large lake to the north of Burma. The adventures of Pundit, the 'James Bond of geography,' sent out by the Survey of India in the 19th century to discover more about it, contributed to our increasing fascination with this river.

We had already encountered the Great River in our earlier trips to India and Tibet, but we had never come close enough to get to know it properly. There was scant information, especially in such regions as the huge gorges carved out by the Tsangpo before it crosses the border into India, which even today remain some of the least explored areas of the world.

In short, the call of the Great River was irresistible.

Taking the explorers of the past as our guides, we set off on our search: from its source to its mouth, from its birth to its old age.

We ascended to its mythological sources in Tibet, where the river is a child. We followed its growth along the fertile

valley of central Tibet, where it witnessed the descent of the first kings from heaven and the dawn of Tibetan civilization. Between the towering peaks of the Kongpo where, full of vigour and sheer force, it falls precipitously from a height of over three thousand metres to one hundred metres, without forming the legendary waterfall which the explorers of the early 20th century spent years searching for but never found.

Then on to the valleys south of the Himalayas, through the tribes of the Abor and the thousands of Hindus on pilgrimage, to its mythological sources in India; until, in the plains of Assam, where it assumes the name Brahmaputra as it passes through the tea plantations. We negotiated its waters in Bangladesh, where it flows under the name Jamuna until, tired and heavy-laden with water, it opens out into the Ocean like the petals of an enormous lotus, the Padma.

We have followed its life course and met the people who live on its banks.

And finally to its mouth, the meeting place and melting pot for the religions and cultures of the three countries through which the river passes.

It was a long and arduous journey. Many times we were on the point of giving up the whole venture. It seemed that our project was under some strange curse. It seemed that the genie of the Great River was rebelling against our intrusion. There were continual ups and downs. At times the Brahmaputra prevented us from reaching it, at other times it allowed us to approach its most remote corners. There were times when we lost it, and times when we were overwhelmed by its sheer presence.

Over the years the Brahmaputra has become an inseparable friend. With this river we have shared a whole range of emotions and it is to the river itself that we now dedicate this book.

In these pages you will find the stories it has shared with us: about the people of the past who came to explore it; and about the people of the present who live close to it.

TIB

MOUNT KAILASH

TAMCHOK
KHAMBAB

HIMA

Agra •

Kathmandu •

Benares

GANGES

INDIA

ET

GYALA
PELRI

Lhasa Tsedang

Xigatsé YARLUNG TSANGPO TSANGPO NAMCHE
BARWA DIHONG

DIBONG PARASURAM-
KUND

LOHIT

Sadiya

LAYA

BRAHMAPUTRA ASSAM

BURMA

Guwahati

JAMUNA BAN

MEGHNA

Dacca GLADESH

Chandpur

Calcutta

SUNDERBANS

BAY OF BENGAL

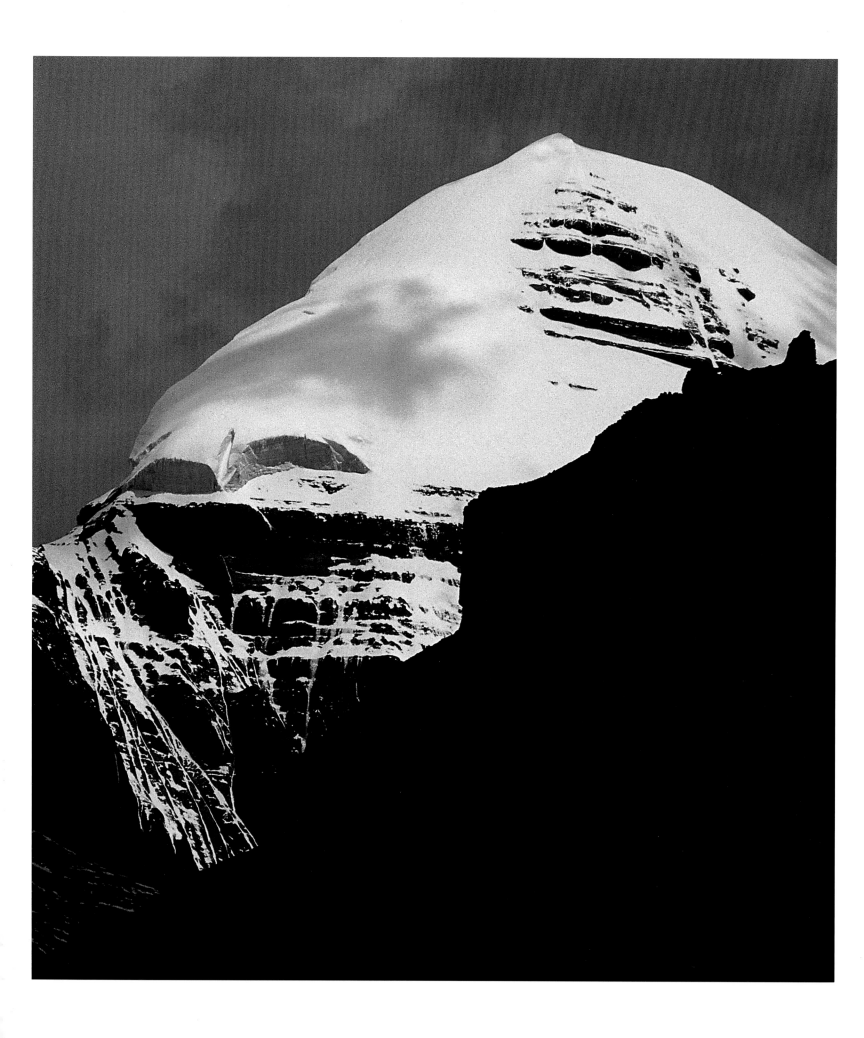

BIRTH

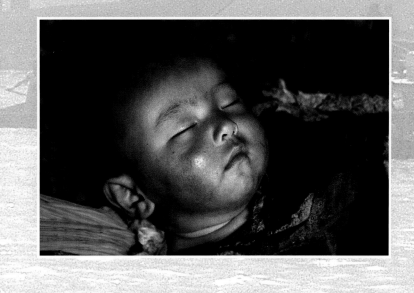

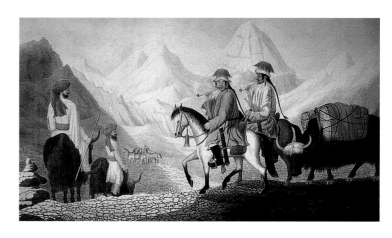

Hearsey and Moorcroft on the road to Lake Manasarovar
(H. Y. Hearsey, July 1812, India Office Library, London)

TAMCHOK KHAMBAB

TAMCHOK-KHAMBAB: 'The river that gushes from the mouth of the horse.' Its sands are emeralds and its water makes anyone who drinks it as strong as a horse. This is the mythological source of the Brahmaputra, the river which flows to the east.

In Tibetan mythology a stream rises from Tisé, the sacred mountain identified with Kailash, and casts its waters into the Mapham Tso lake, the Manasarovar.

The four cardinal points of this lake are watched over by mysterious caves that conceal the four divine animals: an elephant, a lion, a peacock and a horse. From their mouths flow, in different directions, the four major rivers of the Indian subcontinent.

To the north flows the Senge-Khambab (the Indus), the river gushing from the mouth of the lion, with its sand like diamonds and its water which gives the courage of the lion to those who drink it; to the west flows the Lanchen-Khambab (the Sutlej), from the mouth of the elephant, with its golden sands and water which imparts the strength of the elephant; to the south flows the Mapchu Khambab (the Karnali, a tributary of the Ganges), the river gushing from the mouth of the peacock, with its silver sand

and water which imparts the grace of the peacock to those who drink it.

Surprisingly the same myth about the sources of the rivers occurs in the mythologies of Hinduism, Jainism and in Bon, the original religion of Tibet.

In the *Puranas*, the four great rivers which irrigate the subcontinent all have their source in a verdant region around the mythical Mount Meru, a holy mountain, and the pistil of the lotus flower that symbolizes the world.

According to legend, the Ganges was born from the big toe on Vishnu's left foot and washes away all sins, after having washed the moon, and reaches the peak of Mount Meru, described in the *Puranas* as a mountain of extraordinary height which towers up at the heart of the universe, surrounded by seven continents and seven oceans.

From the four faces of Meru, the first of gold, the second of crystal, the third of ruby and the fourth of lapis lazuli, the Ganges descends and purifies the Earth, dividing into the four rivers that serve to carry life blood to the Indian subcontinent from the four cardinal points.

The mythical and ideal world Meru, rising from the waters that gave birth to the world and which the followers of as many as four different religions have identified as the Olympus of their gods,

*Mount Kailash (photograph: Capt. Rawling
1903/1905; Royal Geographical Society London)*

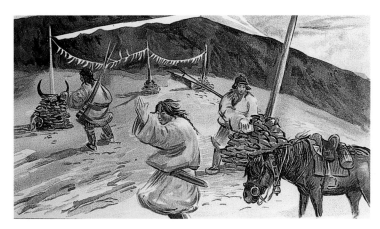

*Prayers on Maylum Là (drawing: by A. H. Savage Landor,
from* In the Forbidden Land*)*

finds its earthly manifestation in Mount Kailash: the holy mountain, venerated from the end of the earlier period until the advent of Buddhism, whose physical and orographical contours present remarkable similarities to the paradise of Meru as described by the ancient witnesses.

Kailash, or the Crystal, dominates the plains to the north of the Himalayas. At its feet lie the two sacred lakes of Manasarovar and Raksas Tal, close to which the major rivers of the subcontinent have their origin.

The search for the mythological source of the Brahmaputra, which in Tibet is known as the Tsangpo, or the Great River, led us one cold evening at the end of summer to the sacred regions of Mount Kailash and Lake Manasarovar.

Tarchen, a cluster of buildings beneath the southern face of Kailash, and the traditional point of departure for walking round the mountain (*khora*), was seething with pilgrims from as many as four religions.

Among them were Hindus, for whom Kailash is the throne of Shiva, the place where he sits in meditation with his consort Parvati, daughter of the Himalayas, among rows of celestial nymphs (*apsaras*) and the divinities of the air (*gandharvas*); and Jainists, who venerate the mountain as Ashtapada, the place where their first prophet, the legendary Saviour Tirthankara Rishabha achieved Nirvana.

At one time, *sadhus*, yogis and pilgrims from India faced a long journey on foot, fraught with dangers, across the Himalayan passes, sustained by the belief and hope of reaching the Shiva's throne and of bathing in the sacred lakes. Fear of death did not put them off, because of the comfort they drew from the knowledge that their bodies would be buried in the most holy waters in the world.

Now that roads and means of communication have made access easier, Indian pilgrims face another hardly less daunting danger in the form of Indian and Chinese bureaucracy.

In Tarchen, among the Indians who had arrived, in organized groups, an official from the Bank of Delhi was eager to tell us: 'Every year for five long years I have submitted a request to come to Kailash. It's not easy getting permission because there is an agreement between the Indian and Chinese governments that only a limited number of Indian citizens is permitted to make this pilgrimage and, because of the number of applications, the Indian Foreign Office picks the lucky names at random. At last this year, after such a long wait, I have managed to get here.' In Tarchen the group was entrusted to two Chinese guides who were to accompany them on the walk around the mountain. 'When we reached the Dirapuk Monastery,' he continued, 'at the base to the ascent to the summit of Drolma Lá, we were caught in a snowstorm, and the Chinese guides refused to let us continue. It was no use our

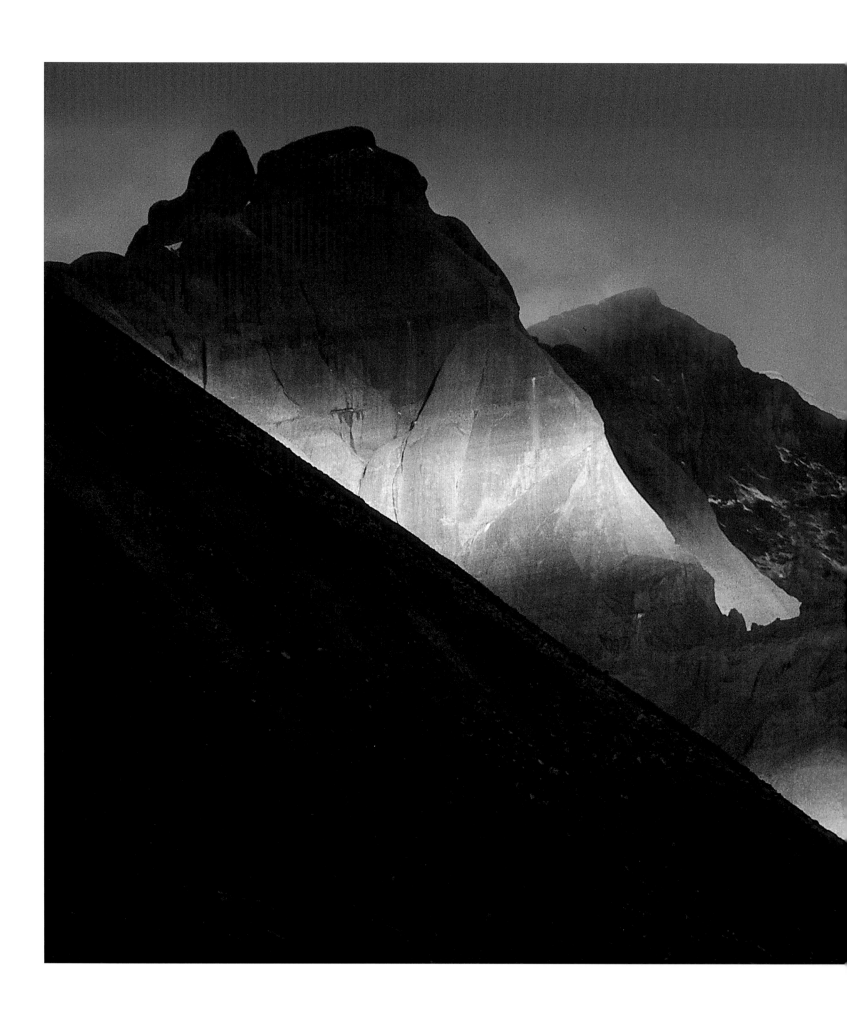

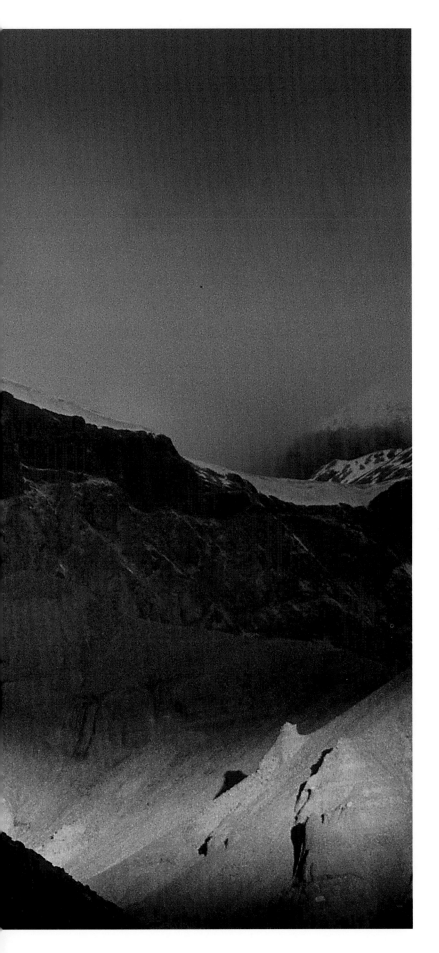

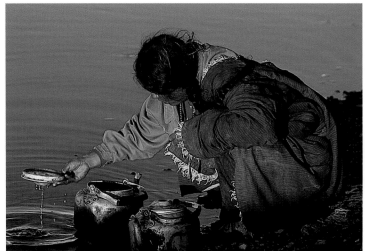

insisting, pleading or even threatening.' Not prepared to give in, the guides compelled them to return to Tarchen without completing their long awaited pilgrimage.

At one time, Buddhist pilgrims used to make the whole journey prostrating themselves on the ground at each step, with their arms extended forwards and their faces in the dust. Today they converge on Mount Kailash from all parts of Tibet, crammed into the backs of large trucks. For Buddhists, Kailash is Kang Rimpoche, the Snow Jewel. Its summit, from which echo the 'sounds of bells, cymbals and other musical instruments'[1] is the dwelling place of the Tantrist god, Demchog, symbol of the Supreme Beatitude and of his consort Dorje Phagmo.

For the Bonpo, the followers of the ancient Bon religion, most of whom come from the east of the country, western Tibet is Zang Zhung, the original land in which they predominated until the arrival of the Buddhists in the 7th century. At its centre is Kailash, Mount Tisé, where the legendary founder of Bon, Tonpa Shenrap, descended to Earth from paradise. Kailash is the inaccessible palace of their god Gekho. According to an account by Giuseppe Tucci, the Bonpo imagine the mountain 'as an enormous chorten of rock crystal – where various families of gods reside – with four gates: the Chinese Tiger, the Tortoise, the Red Bird and the Turkish Dragon, who are the guardians of the four cardinal points'.[2]

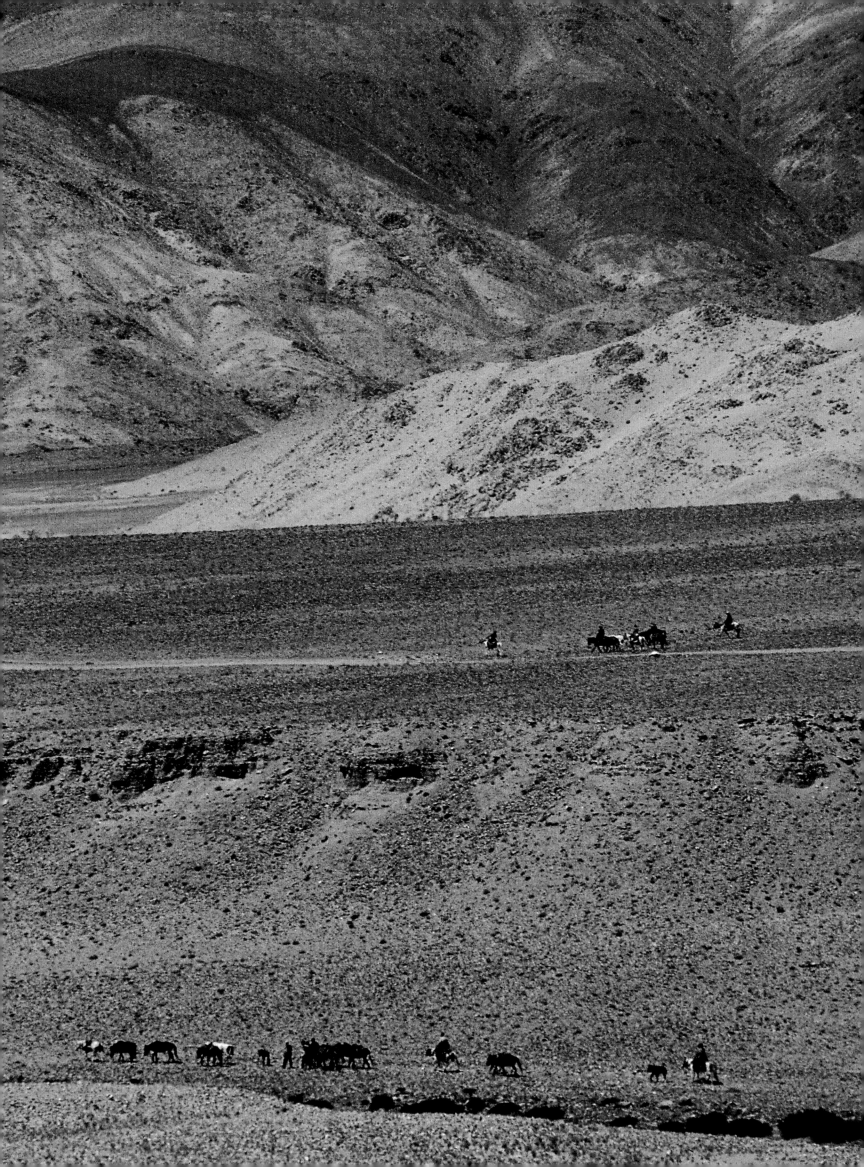

From Tarchen, at a height of 4,500 metres, the course of the *khora* ascends towards the west. You are hardly climbing, but the effect of the altitude is noticeable and breath tends to become suddenly in short supply.

'The higher you climb,' says a sadhu, 'the more you need to drink: water purifies the body and provides it with the oxygen the organism needs increasingly.' Before continuing the journey, take a glance towards the golden plains with the snowy outline of Gurla Mandhata and the Himalayas at the edge of the earth from which they sprang.

It is a landscape without boundaries, beyond time itself. Millions of years ago, the Tibetan plateau lay submerged by the waters of the Teti Sea, a huge lake from which, according to Tibetan tradition, the earth emerged only when Chenrezig, the Bodhisattva of Compassion, made an opening in the Himalayas through which the great river, the Brahmaputra, could flow. In the *Mahabharata*, the disappearance of the Teti Sea is attributed to Vishnu. According to the legend, on the northern shores of this sea lived a pair of gulls. Every year their eggs were destroyed by the advancing waters and they were never able to fledge their young. The gulls endeavoured to build their nest further and further away from the shore, but each time the sea took their eggs. In the end, out of compassion for the gulls' calls of grief, Vishnu drank the sea.

The water disappeared and left the way open for Mother Earth whose limbs, scattered in all directions as a result of the violence caused by the demon Hiramyankasha, gave birth to the Himalayas.

These legends are a mythological interpretation of the phenomenon of the shifting of the Indian subcontinent; a geological upheaval which resulted in the raising of the imposing Himalayan chain of mountains, and the progressive disappearance of the waters of the Teti Sea which were channelled southwards to form the river system which irrigates the Indian Subcontinent. The situation this has caused is quite unusual in orographical terms: four large rivers which water the subcontinent, the Indus, the Sutlej, the Karnali and the Brahmaputra, have their sources to the north of the watershed represented by the Himalayan chain, through which they have opened a way to reach the sea.

The Himalayas, forming a natural barrier in terms of access to the region, contributed to the age-long impenetrable mystery about the origin of the great rivers of Asia, and of the Brahmaputra in particular, the course of which was only fully discovered in the early part of the 20th century.

For centuries, the location of the sources and the courses of these great rivers was the goal of explorers, cartographers and geographers from the West.

The first maps offered widely diverging solutions, based either on legends and information found in the ancient texts or on the rare accounts of travellers who ventured into the Forbidden Land.

Towards the end of the 17th century Athanasius Kircher produced his map, drawing on the accounts of De Andrade and other Jesuit missionaries who, in that century, had crossed Tibet. In Kircher's map, in line with the legend contained in the *Puranas*, four rivers flowed from a great lake near a mountain from whose summit the Ganges descended.

In other 17th century maps a large lake was shown to the north of Burma. From this flowed four or more rivers, sometimes associated with the Brahmaputra, the Mekong, the Salween and the Irrawaddy.

It was only in 1782, in the first map of Hindustan compiled by Major James Rennell, General Surveyor of the East India Company, that the sources of the four rivers were not placed in a large lake and, for the first time, the Tsangpo of Tibet and the Brahmaputra of Assam were shown as a single waterway which flowed from Tibet and eventually had its mouth in the Bay of Bengal. The question of whether the Tsangpo and the Brahmaputra were one and the same, or two separate rivers continued to preoccupy the minds of explorers and geographers for another century.

The mysteries surrounding the sources of the great Asian rivers created from legends and fragmentary travellers' tales, as well as a fascination with the people who inhabited the lands north of the Himalayas, spurred many Westerners into crossing the mountains to western Tibet.

The dream of finding a people who, according to the yogis and the sadhus, followed religious practices similar to those of the ancient Christians, inspired the Jesuits to undertake an arduous journey, fraught with dangers, ready to risk their own lives in search of followers of the legendary kingdom of a priest known by the name John.

Among these, Father Ippolito Desideri became the first European to cross the sacred region of Kailash and Manasarovar and the sources of the Tsangpo, in the winter of 1715. He was the first to report that, from what he had heard, after crossing Tibet from east

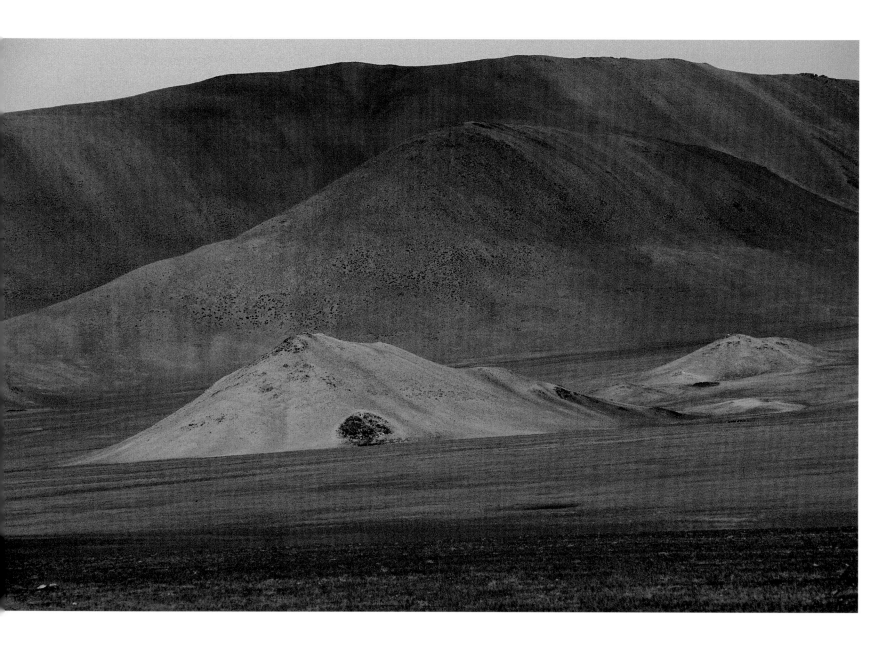

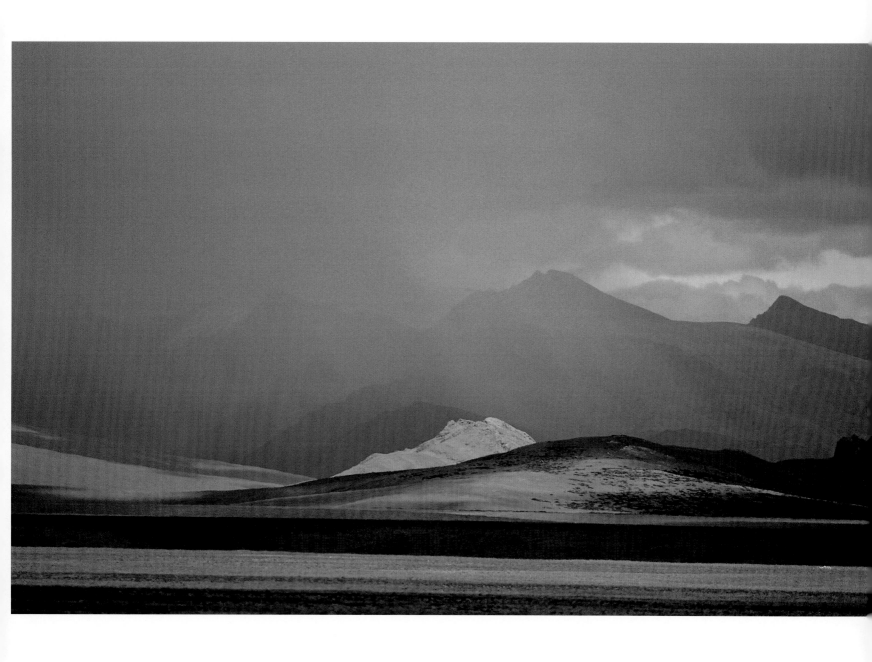

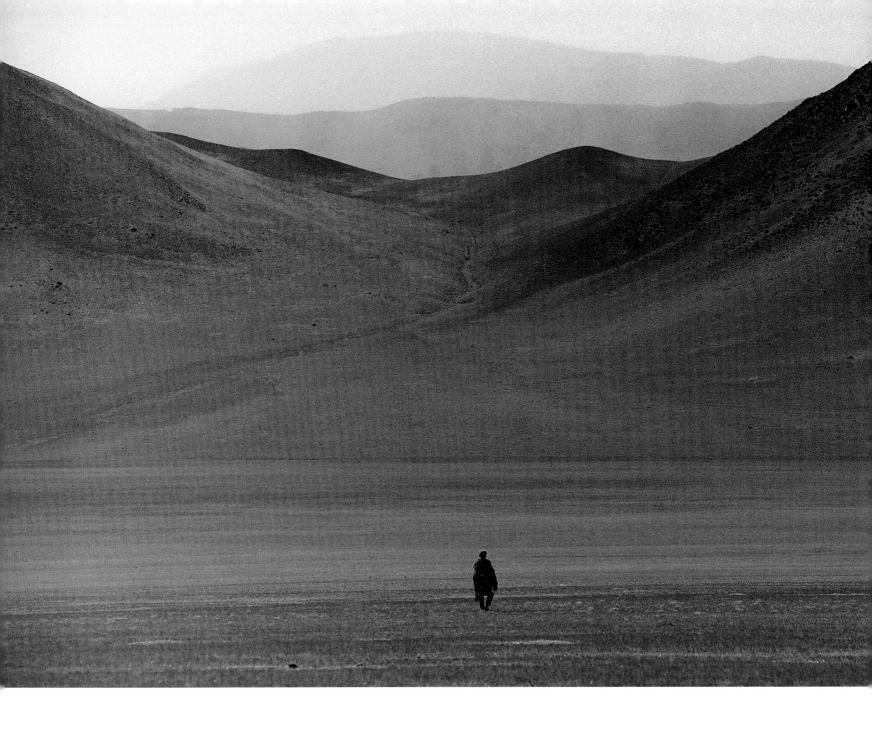

to west and having carved a way through the Himalayas, this great river continued across Assam until it joined up with another imposing river, the Ganges.

The road to western Tibet was a journey into the unknown that travellers of the time embarked on with scant resources and even less information; most of the time they were quite unprepared for the altitude, the long months of solitude and the harsh, unremitting natural environment which offered no relief apart from the sky above them. The advent of roads certainly removed many of the dangers that had once beset those attempting to journey across western Tibet.

Yet to reach the sacred region, pilgrims still face an interminable journey, crammed into the backs of Chinese trucks with limited provisions in the form of tsampa, dried meat and rock-hard cheese. They only stop when night descends. They spread out on the cold earth, wrapped in their chubas, or in the Western-style jackets which have now replaced traditional clothing, and go to sleep in the dark shadow of the truck, a reassuring presence in a natural world which, at night, seems hostile and alive with spirits.

In the solitude of the high plateau, among the deserts of sand and earth, chains of infinite peaks, insurmountable passes, and rivers of seething water, it is not surprising that men believe that each rock, each peak, each sheet of water conceals a spirit or a demon ready to ensnare any passer-by.

The unknown, and the danger and the mystery made this area in western Tibet even more fascinating, an area that, even on 19th century maps, appeared as a blank space and where the enigma of the sources of the four major rivers of India had yet to be solved.

From the beginning of the 19th century, western Tibet was the stage for a procession of explorers and adventurers.

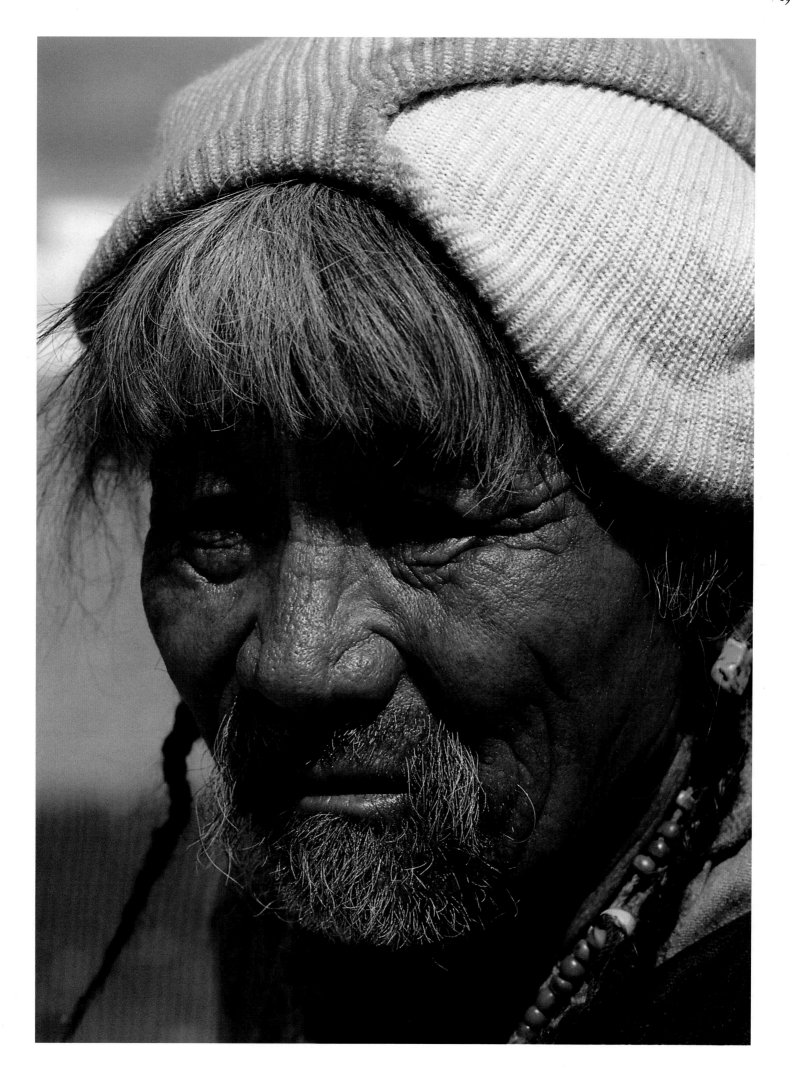

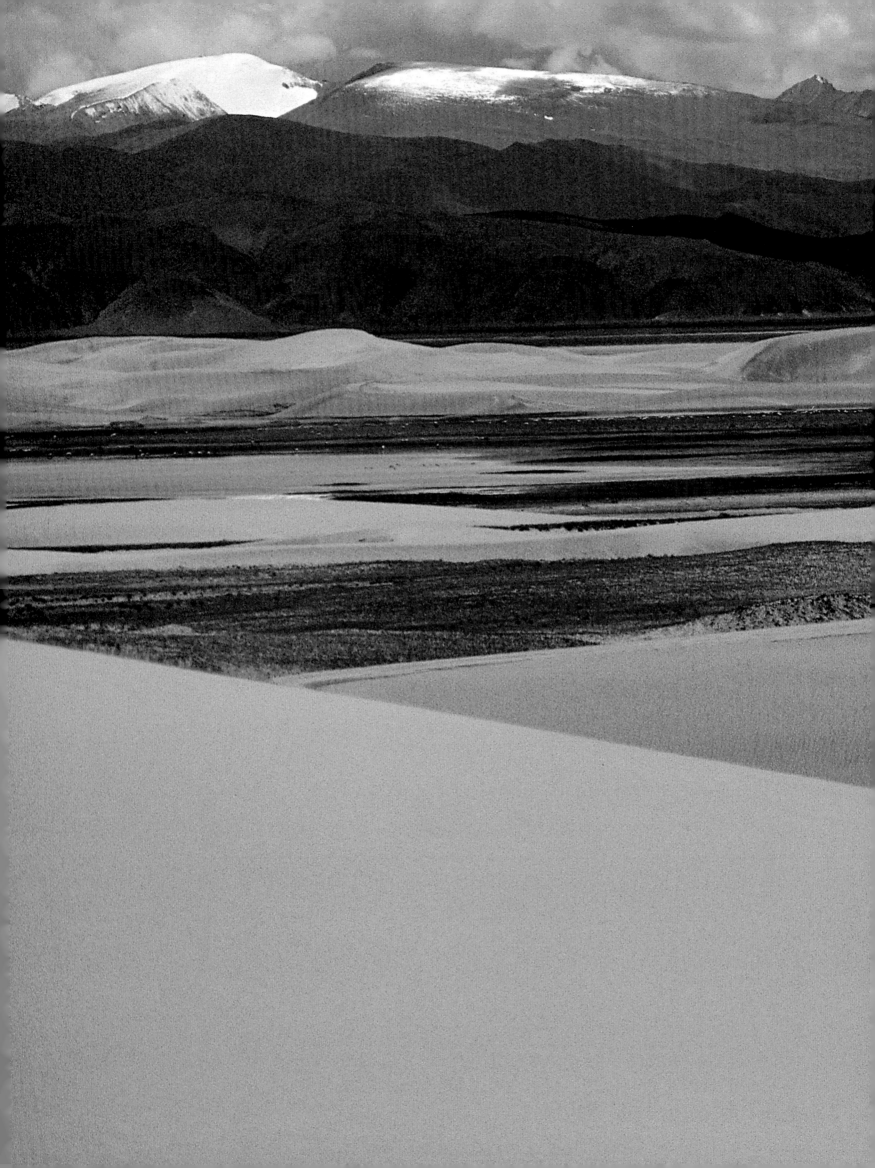

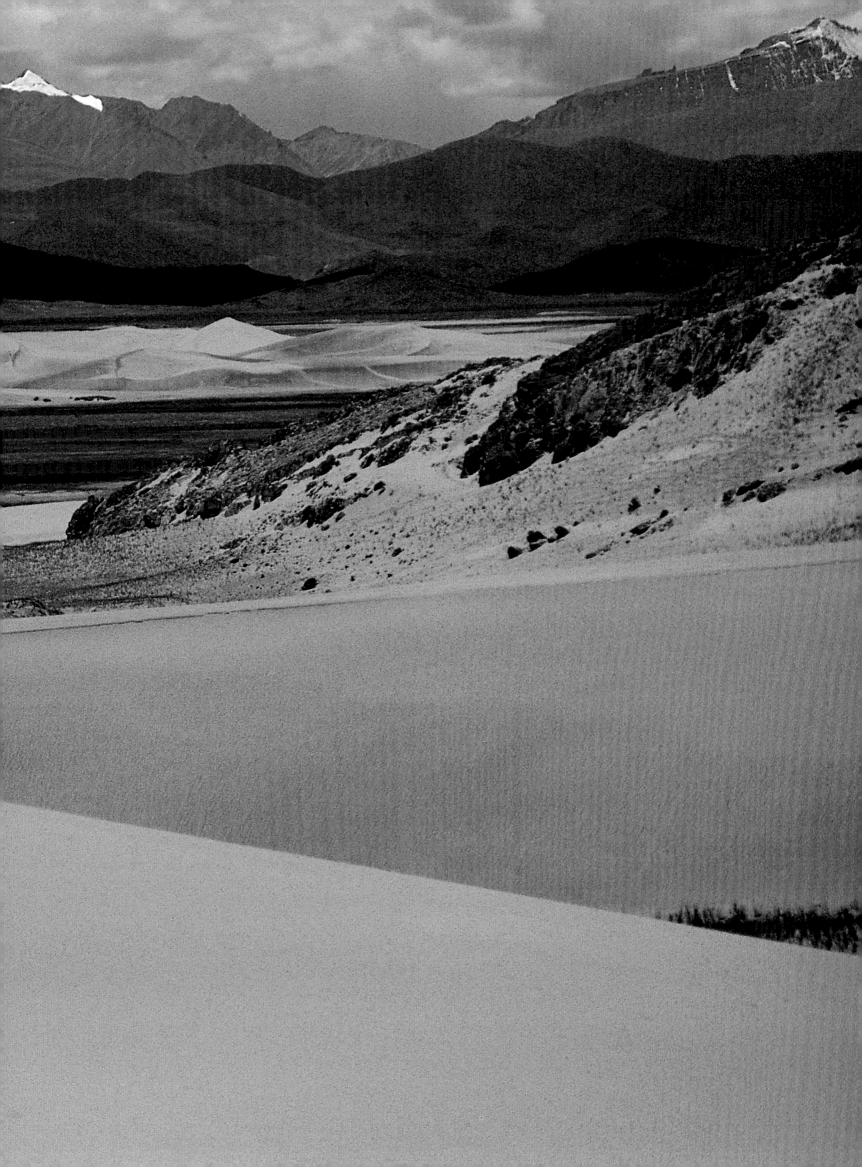

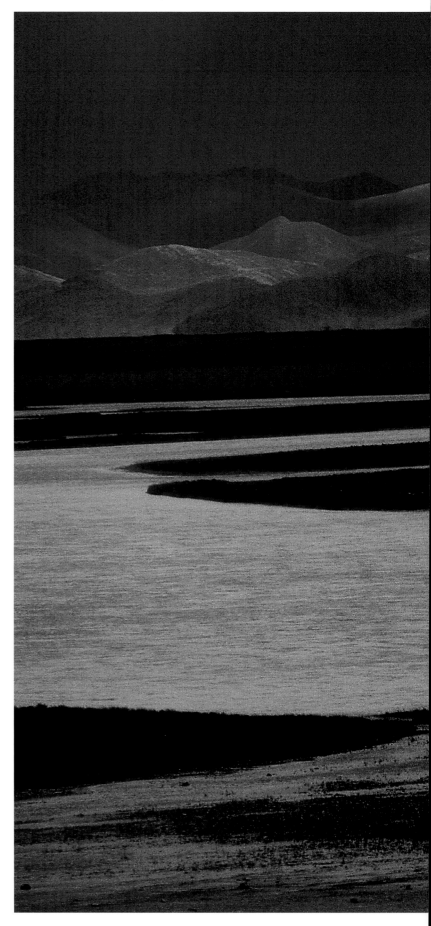

A century after Desideri, the English vet Moorcroft, together with Captain Hyder Jung Hearsey (a mercenary who had created a domain for himself on the border with Nepal) set off on the road for Tibet in search of the breed of goat that provides the precious wool for Cashmere shawls, of which he wanted to bring back some specimens in order to start a new trade. Pretending to be Hindu merchants, Moorcroft and Hearsey followed the Himalayan paths until they reached the plains in the region of Kailash and Lake Manasarovar.

With his field-glasses Moorcroft inspected the banks of the lake in a vain search for those rivers which mythology indicated flowed out of Manasarovar, the lake which was breathed out by Brahma, in whose waters, according to the legend, swam thousands of swans, and in which there flowered 'enormous lotus flowers on which the Buddha and the Bodhisattva would often come to sit in meditation.'[3] At the centre grew an enormous tree, a *jambu*, whose golden fruit was eaten by the inhabitants of the kingdom of Naga, located in the blue depths of the lake.

At that time, the tightest restrictions were imposed by the central government in Lhasa, preventing foreigners from entering Tibet for whatever reason. Fearing decapitation or being drowned in the waters of the Tsangpo, the local officials, the *dzongpon*, did everything they could to encourage those crossing their borders to

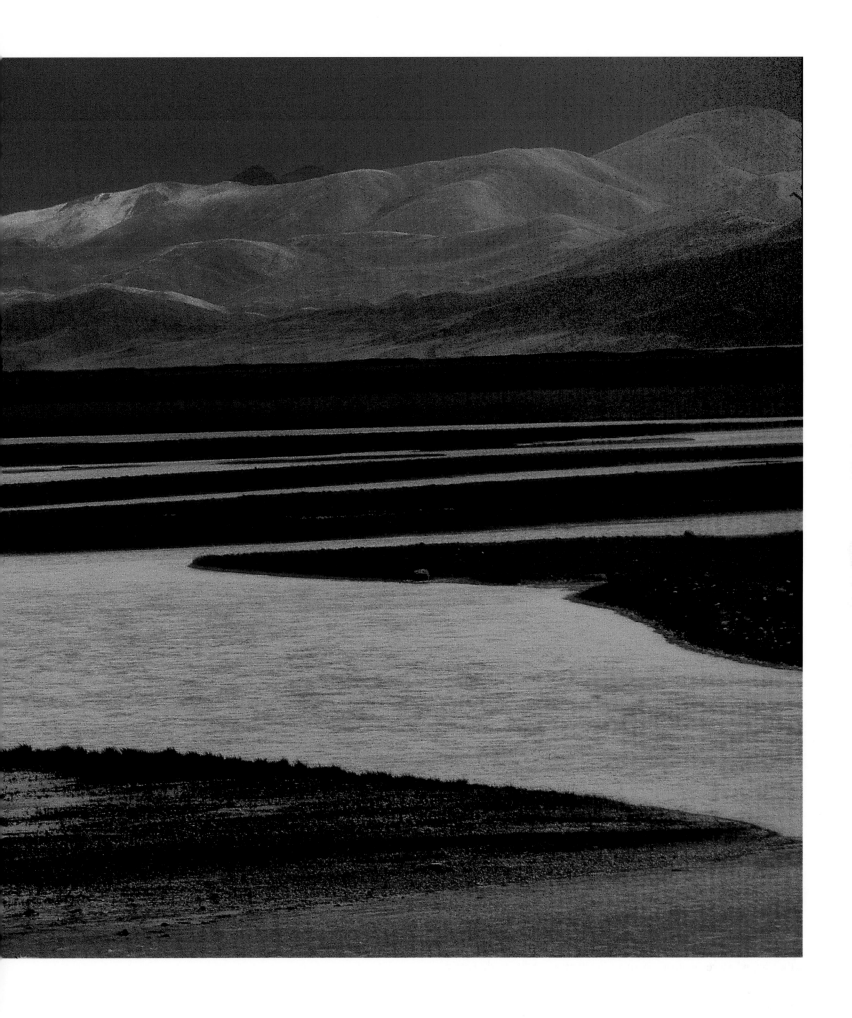

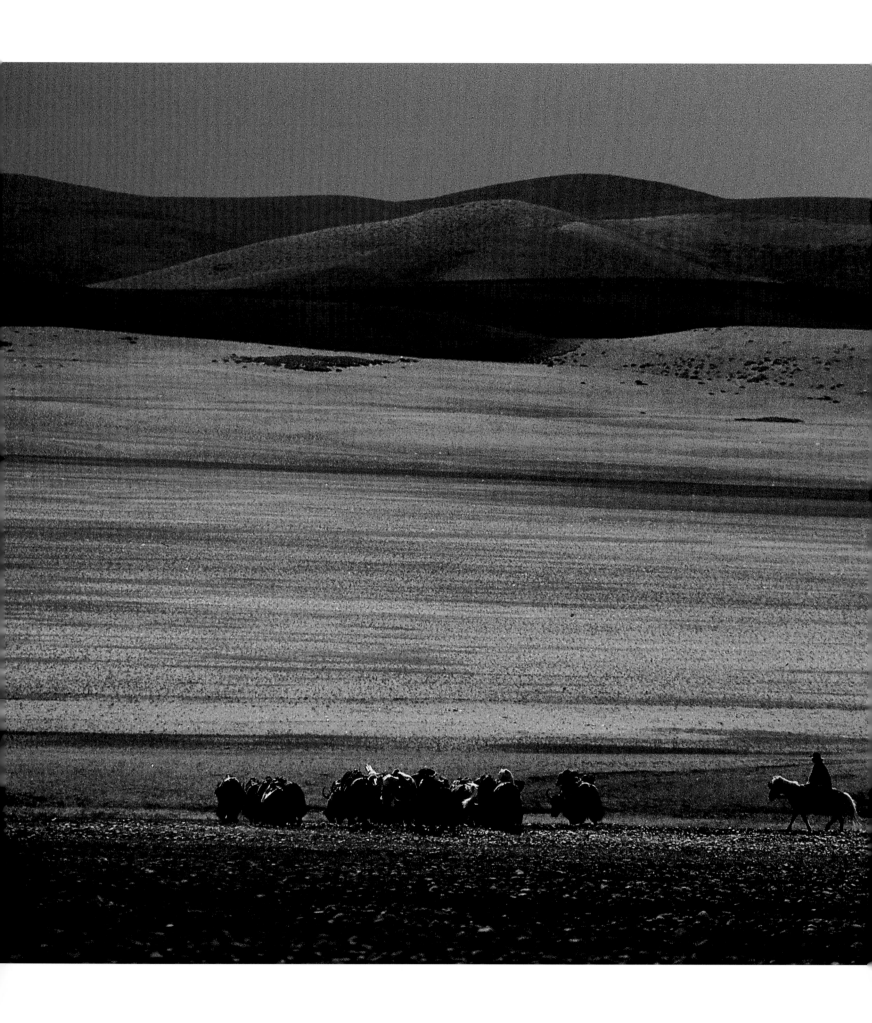

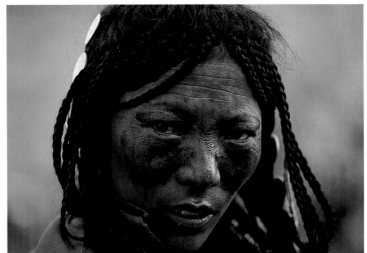

turn around and go back the way they had come. Determined not to give up, western explorers thwarted the *dzongpon* surveillance, resorting to every trick they could think of: disguising themselves, travelling at night, travelling by roads and tracks which were less well known.

It was one of these deviations off the beaten track, chosen purely by chance, that led the Englishman Edmund Smyth into the region where the sources of the Brahmaputra were located. A mountaineer and hunter, Smyth had made his way into western Tibet using paths to the east of the Gurla Mandhata, in his mission to secure the trophy of a *drong*, the large wild yak, a solitary, intrepid creature found at high altitudes far from human habitation. The curved horns of the animal were used by the Tibetans as containers for *chang* and *arak*.

Towards the end of the 19th century another young Englishman, A. Henry Savage Landor, arrived in the same region. This vain, arrogant young braggart had travelled to India for the precise purpose of conquering the Forbidden Land. The story he tells in his book, *In the Forbidden Land*, is full of episodes that betray the worst excesses of colonialism. He only needed to imagine that a Tibetan official was making fun of the English in order to throw himself upon him, take him 'by the scruff of the neck' and send him sprawling with his face in the dust. And when the poor victim

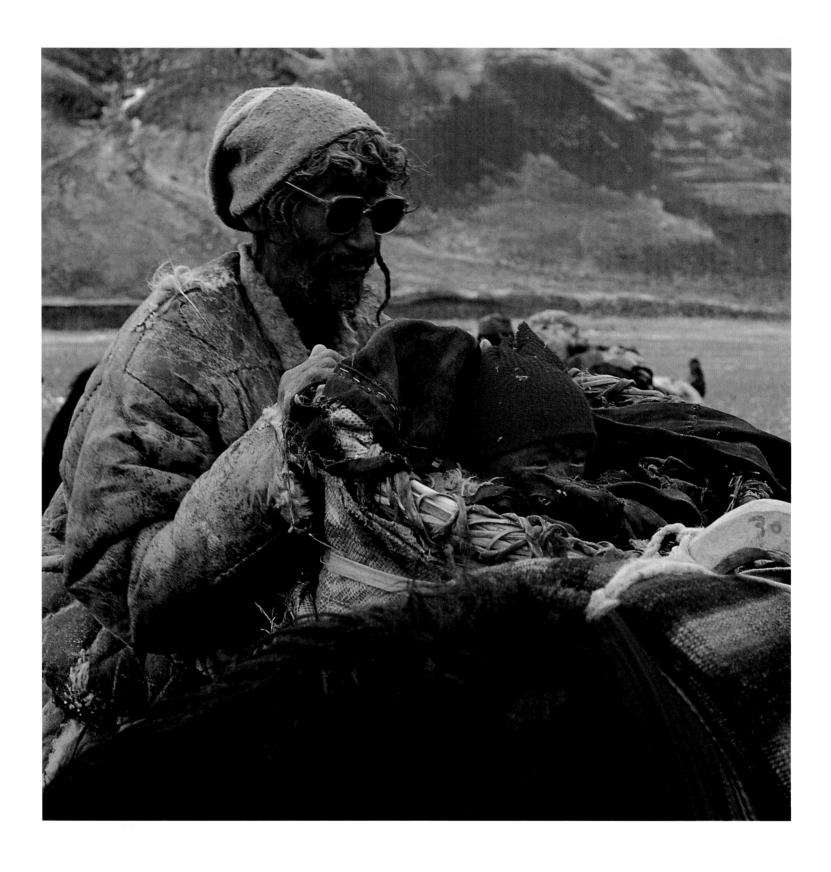

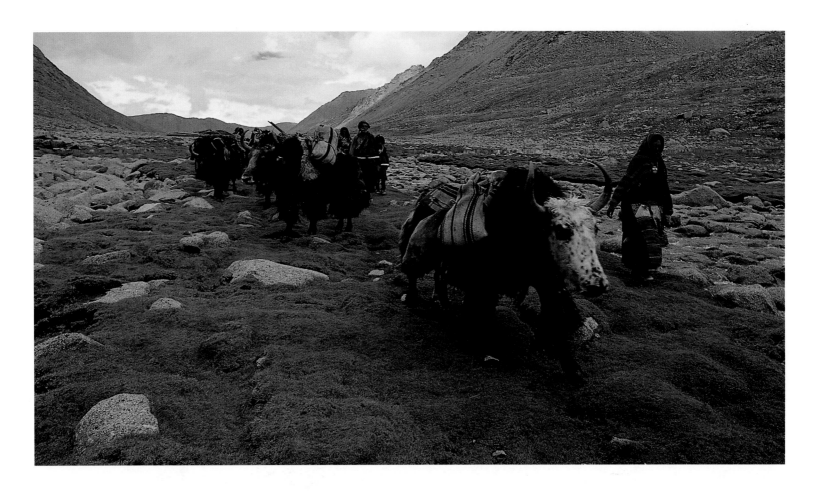

begged to be released, the writer boasts that he first got him to lick his boots clean. Savage Landor described the inhabitants of Tibet as barbarians and savages over whom he lost no opportunity to assert his superiority. Even the peace-loving *kiang*, the wild donkeys that grazed on the banks of the Brahmaputra, were in his eyes 'treacherous beasts, capable of accosting the traveller and knocking him to the ground unexpectedly by butting him in the stomach.'[4]

It is not surprising that, subjected to continual mistreatment, his porters eventually abandoned him, and that the Tibetans, once they had succeeded in getting their hands on him, gave him a taste of his own medicine and made him a scapegoat, before sending him back the way he had come, as they had done to many before him. Brought into the presence of the Pombo, he claimed he was subjected to every form of torture. They had made him ride a wild pony, seated on a wooden saddle with iron spikes that would dig into his back at the slightest movement. Tied by rope to a yak, and rendered immobile, he had been brought before a torture committee that he described as follows: 'in front of the Pombo's tent gathered the most abominable brutes I have ever seen. One of them, a huge, repellent figure, held in his hand a rough club of the type used for breaking bones; another held a bow and arrows; a third had an enormous sword; others exhibited miscellaneous

frightening instruments of torture. The crowd was baying for my blood and gathered round me in a semi-circle.'[5]

From his travels, the accounts of which are full of improbable stories about his rescuing yaks and porters who had fallen into the Brahmaputra, the explorer was able to produce a map, drawn in blood, in which he shows the sources of the Brahmaputra, which he modestly named Landor's source.

Savage Landor described it as 'a small stream, scarcely six inches wide, which descended between the rocks at the centre of the valley, and which was swallowed up by other streams produced by the melting snow from the mountains on both sides.'[6]

Standing in front of this little stream, which he claimed to be one of the sources of the Brahmaputra, Savage Landor confessed: 'I felt very proud to be the first European ever to have reached the sources, and it was certainly a pleasure to stand beside this sacred stream which, lower down, grew to an enormous width, but which here could be spanned by a man standing with his legs apart.'[7]

The real scientific discovery of the sources of the Tsangpo, in the region of the Chemayungdung glacier, not far from Manasarovar, is credited to the famous Swedish explorer Sven Hedin, who already had a number of arduous exploits in the steppes of Central Asia under his belt. Having penetrated Tibet from Ladakh, Sven Hedin had crossed the terrible expanses of the Changtang with the

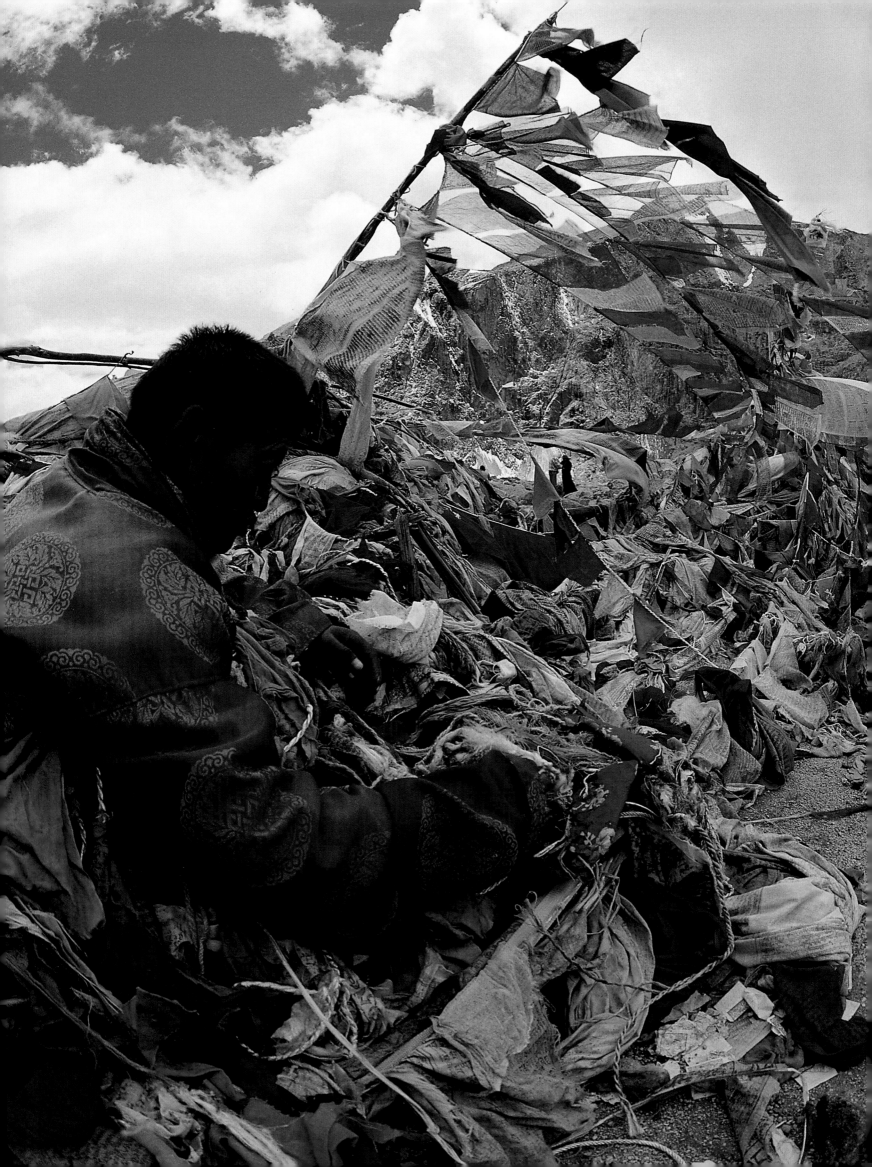

ambitious plan of reaching Lhasa and continuing along the great curve which the Brahmaputra traces before crossing the border into India. Stopped by a local *dzongpon*, he was forced to double back to Xigatsé, the city of the Panchen Lama.

From here, Hedin once again set off up the Tsangpo valley and, in the summer of 1907, ventured into the region of the sources. 'A world of giant peaks', he wrote, 'black rocks covered with snow, as sharp as wolf's teeth, between which nestled tongues of ice.'[8]

On 13 July of that same year, the Swedish explorer came to what he described as one of the 'most important discoveries made on earth.' 'It gives one a sense of pride,' he wrote in his *Transhimalaya*, 'to stand beside the origin of the three sources of the splendid river which pours out into the Ocean near Calcutta, the son of Brahma, that celebrated figure in the ancient history of India.'[9]

And even if subsequent geographical findings show that the Swede had indeed discovered one of the sources of the Tsangpo, though not the main one which issues from the Chemayungdung glacier, Hedin can still boast of having been 'the first white man to venture as far as the sources of the Brahmaputra and the Indus [discovered in the same year, 1907], 'the two famous rivers from time immemorial that embrace the Himalayas like the claws of a crab.'[10]

Sven Hedin was also the first Westerner to find his way to the area of the mythological source of the Brahmaputra and to negotiate the way of the *khora* around Mount Kailash, the track along which the pilgrims of four religions had prostrated themselves for centuries before the holy mountain.

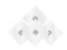

Along the Valley of Amitabha, the Buddha of Boundless Light, between high rock walls dominated by the snowy dome of Kang Rimpoche, we struggled on in the wake of the caravan of nomads to which we had attached ourselves. The head of the family was an old man with a wrinkled face shrivelled up by the sun. His name was Gochótar and he was very familiar with the path around the mountain because he had already walked it with his wife, a woman with a broad smile framed by two long plaits covered with turquoise.

Nestled in blankets, two babies made the journey in two large baskets hung on the flanks of a robust yak, soothed by the swaying movement of the animal. They were just a few months old, or a little older. The mothers could not say exactly when they had been born. Time in those parts does not have the importance attributed

to it by us in the West. What is regarded as important, however, is the number of times in one's life one is able to walk around the sacred mountain: once is enough to cancel out the sins of a lifetime; ten times cancels out all the sins of one's reincarnated lives; 108 times, the sacred number, guarantees that the pilgrim will reach Nirvana.

Dawn surprised us, submerged as we were in a heavy sleep. A short distance from our tent, dominated by the west face of the divine mountain, Gochótar and his family had lit a fire. They were warming their hands on the bowls full of steaming tea with salted butter.

A young lama who had come with his ancient mother from the distant Degé Monastery, in the Kham, was completing with devotion, while reciting a mantra, a *khora* around a rock on which it is believed the Buddha left his imprint (*shapje*).

When it was time to set off, and before leaving our camp, Gochótar threw a handful of *tsampa* on the hearth, a last offering to the god whom the nomads believe lives there. When the caravan had covered some distance, Gochótar turned to look at the smoke which the *tsampa* had caused. 'It is a good sign,' he informed us before we set out. 'If the *tsampa* does not produce smoke it is a bad omen and indicates we will have a bad camp next time we stop.'

The divine presence was all-pervasive in the valley. Even the animals seemed to be aware of it: some marmots, having left their burrows, had come out to forage and watched our movements with curiosity, quite unafraid of humans who, in this area where hunting has always been prohibited, do not represent any danger to them.

The Valley of the Gods, along the western slope of Mount Kailash, is sprinkled with evidence of the supernatural presence. Here a depression in a boulder is the imprint left by Padmasambhava; there a waterfall is the tail of the horse belonging to Gesar of

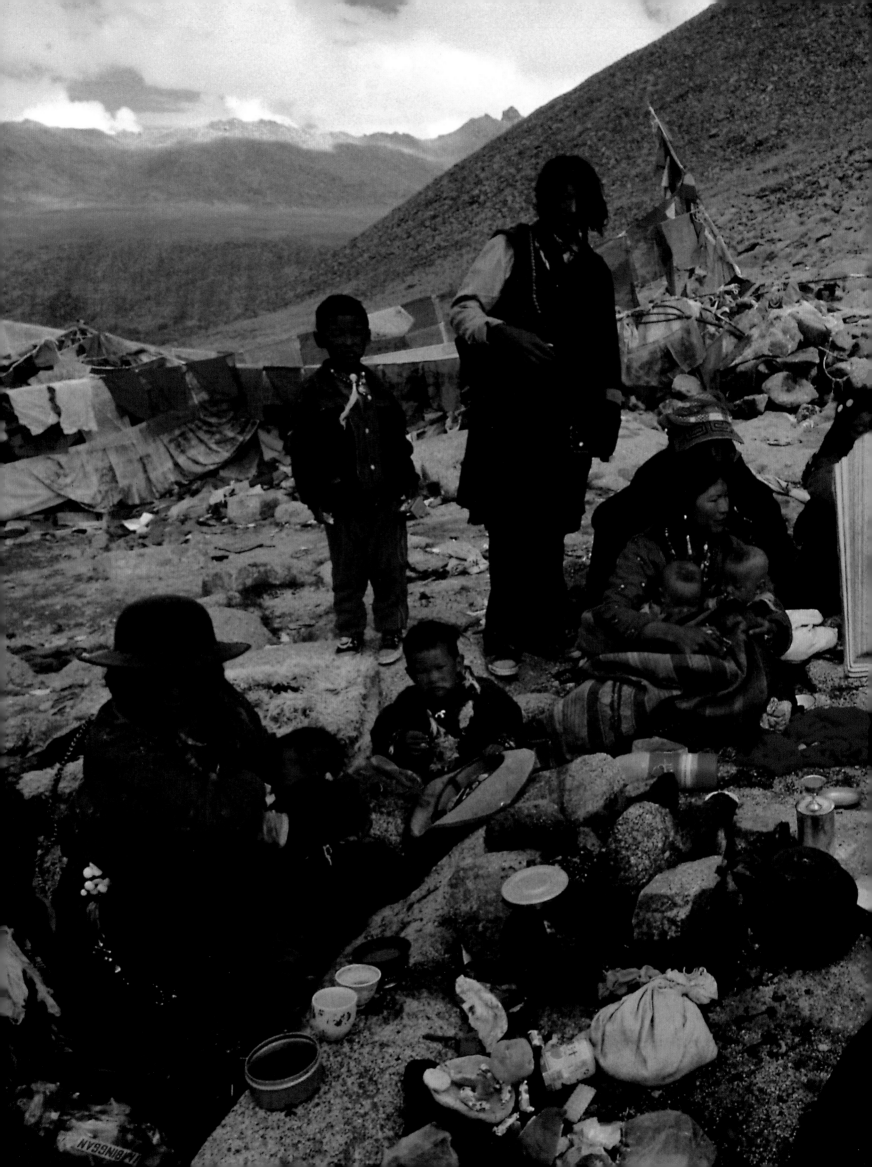

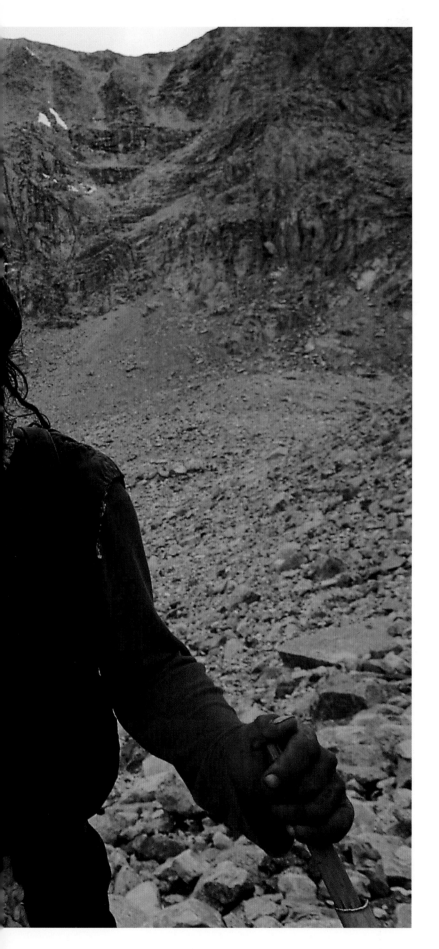

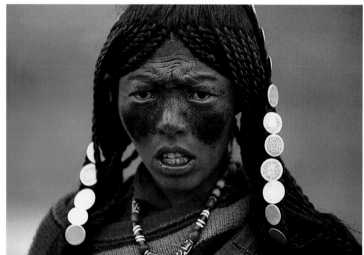

Ling, the legendary hero of the Tibetan's favourite epic; and over there a rock is the god Hanuman, prostrated before the throne of Shiva.

That evening we set up camp in a glade beneath the towering snowy peak of Mount Shiva. The northern face appeared incredibly close in the crystal clear atmosphere of its 5,000 metre height. Sharply defined against the dark blue of the night sky, the summit of Kang Rimpoché was visible – the Olympus which took on earthly form in order that men might approach the gods.

The distance separating us from the peak of Drolma Lá, 5,700 metres high, was not great, but the path ascended steeply between terraces of rock, with frozen patches. It was becoming more difficult to breathe; our stops were more frequent. In silence we walked one behind the other, following Rinchin Drolma, Gochótar's daughter, on whose back the head of little Pemba bobbed up and down. Urged on by the cries of the nomads, the beasts of burden struggled to keep their balance on the steep, narrow path, and the pilgrim babies were wisely transferred from the backs of the yaks to the greater safety of those of their mothers.

From the summit we could hear the happy, liberating cry 'La so, La so, La gyalo' of the Tibetan pilgrims who had reached the pass. A cry of triumph, but also a tribute to the gods who dwell in the mountains.

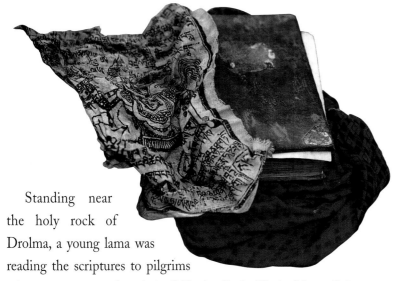

Standing near the holy rock of Drolma, a young lama was reading the scriptures to pilgrims who were resting after their difficult climb. He had been living there, in meditation, for a month, his only shelter a light cotton tent and the company of the *rlung-ta*, or the horses of the wind, the pieces of cloth in five colours which symbolize space, the clouds, fire, the earth and water. On these are printed mantras and the mythical 'horse of the wind,' carrying on its back the jewel that fulfils wishes and conveys the prayers printed on the cloth, by means of the wind.

Each pilgrim bowed down in front of the great rock of Drolma, the god who, according to legend, after guiding to the summit the first pilgrim, Godstankhapa, Master of Marpa, Master of Milarepa, and taking on the form of twenty-one wolves, dissolved among the snowy peaks without a trace.

After unsaddling the yaks, Gochótar and his family stopped to rest. They had lit a fire with a small bundle of straw and yak dung, a precious fuel at these altitudes where flora is rare.

The children passed round a felt hat full of little sweets in bits, while Rinchin Drolma served everyone with *tsampa* from a bag made of yak's wool.

It was a brief pause. A biting wind had sprung up and the clouds had obscured the summits. They did not seem menacing, but Gochótar was sure a storm was on its way and, saddling the yaks, he urged them onto the path that descends vertically to the Gauri Kund, the 'Lake of Compassion,' in whose icy green waters Buddhist, Hindu and Bon pilgrims purify themselves.

Though the temperature of the waters of Gauri Kund is polar even in summer, many pilgrims stop here: a few of the brave ones immerse themselves completely, indifferent to the biting coldness of the water; most limit themselves to bathing their hands and head.

'The pilgrims of India,' wrote Tucci, 'who worship water more than any others, and who have made bathing one of the fundamental rituals of their complex liturgy, break the frozen surface of the lake, undress and immerse themselves in the frozen vortices. It is a miracle that they survive, accustomed as they are to living in very different climates. But anyone familiar with the Orient knows what power the spirit has over the body and how faith can often prevail over the laws of the flesh.' [11]

Beyond the lake the path dips down into a mass of rocks, slabs of stone and sheets of ice and snow. A Bon pilgrim, who was climbing the hill, performing the kora anticlockwise in accordance with the canon of his faith, pointed out the way to the eastern valley which leads to Zutrulpuk Monastery.

A light rain, mixed with snow, had begun to fall from the sky.

At the bottom of the valley the ground was waterlogged; the snow from the peaks gathered here in a criss-cross of small streams among which it was not easy to find the path.

Gochótar and his caravan were by now far away.

Remaining behind, with no one else in sight, we did not realize we had deviated from the main path and were now heading towards the Lham Chu, the river which flows along the eastern valley of Kailash. When we realized our mistake, it was too late. We did not even consider turning back: it was evening and the clouds behind us were dark and heavy with rain. Perhaps this was the storm Gochótar had referred to. We could do nothing but wait. What at the beginning of the valley was little more than a stream had turned into a raging torrent. The water displayed remarkable force and the boulders at the bottom were sliding, ready to start rolling as soon as their centre of gravity changed. We reached Zutrulpuk soaked to the skin.

That night the storm took us by surprise. Under the weight of the snow our light tent gave way. Everything was drenched, but we had no way of drying ourselves – it was too cold and we were too tired to care.

At dawn a thin layer of snow covered the plain of Zutrulpuk.

Destroyed during the Cultural Revolution, and now a modest construction of mud and rock, the monastery of the Cave of the Miracle is still an object of great veneration in Tibet.

Here Milarepa, one of the mystics most dear to the Tibetans, spent many long years in meditation, wrapped only in a light cotton

garment, and keeping himself warm by means of *tummo*, the yogic practice of generating heat spontaneously.

In this same place, according to the legend, Milarepa endured and conquered the temptation of magic, as a result of which he took command of the holy region from the Bon, which also marked the start of peaceful coexistence between the two different religions.

At that time, Kailash/Tisé was under the absolute control of the Bonpo. One of the most famous members of their community was the magician known as Naro Bonchung.

Meeting with Milarepa and his Buddhist disciples on the bank of Lake Manasarovar, Naro Bonchung told them that the sacred mountain belonged to the Bonpo, but that he would allow them to remain there and meditate if they were prepared to renounce their faith. Milarepa refused, in turn claiming ownership of the mountain which a prophecy of Buddha said would belong to the Buddhists.

Naro Bonchung then proposed a contest of magicians, the winner of which would gain possession of Mount Kailash.

At once Naro stood astride Lake Manasarovar; but Milarepa had already covered the whole lake with his body and then lifted him up, balancing him on the point of his finger. The Bonpo rushed towards Kailash and began to walk round it in an anticlockwise direction, in accordance with Bon practice, while Milarepa and his disciples did the same, but in the traditional clockwise direction of the Buddhists. When their paths crossed, the two contenders engaged in combat on top of a rock from which Milarepa cast the Bon magician down, in a clockwise direction, opposite to the direction in which he wished to go.

Shaking with rage, but determined not to surrender, Naro suggested other tests. These included tests of strength, but there was not a rock that the Bonpo selected which Milarepa was not able to lift and send hurtling into the distance. Then there were tests of speed, but Milarepa, an expert in *loung-gompchen*, was able to achieve a supernatural lightness and speed which meant he was always the winner. This was followed by the construction of shelters for the night, but Milarepa used the power of thought to render the rocks intended for the roof so heavy that the Bonpo were unable to lift them.

Exhausted and humiliated, but still not beaten, Naro proposed a final test: the one who first reached the top of Kailash at the dawn of a day with a full moon would gain possession of the mountain.

On the agreed day, as dawn approached, Milarepa's disciples saw Naro harnessing the sky to his magic drum which he directed at the summit of Kailash. Anxiously they turned to their Master; but the latter continued in meditation until, at the last moment, using the power of thought, he stopped the Bonpo, rendering him incapable of going any further. And as the first rays of sunlight struck it, Milarepa appeared on the icy summit of Kailash in all his splendour, while the Bonpo, alarmed at the apparition, tumbled to his ruin down the mountain slopes, causing the gods considerable mirth.

Soundly beaten, Naro Bonchung asked Milarepa, who agreed, that his followers be allowed to continue walking round the mountain in an anticlockwise direction and that the Bon be given a new place of worship. Milarepa then picked up a fistful of snow from the summit of Kailash and hurled it to the peak of a nearby mountain which, since then, has been known as the mountain of the Bon.

A ray of sunlight pierced the clouds and illuminated the Zhong Chu valley. Along the path could be seen the dark silhouettes of pilgrims making their way down the valley.

The holy mountain had disappeared from sight behind them.

They had struggled, bent over, and they had prostrated themselves on the path of what Ekai Kawaguchi and Lama Govinda after him had referred to as a great natural Mandala.

In their ascent to Drolma Lá they had passed the gates of death and had faced the judgement of Yama, the Lord of Death. As they descended they were reborn and the waters of the Gauri Kund had blessed their exhausted bodies. Now, released, they marched forwards, as if possessed by some inner strength.

Perhaps it was the liberation that comes from finding oneself, as Tucci wrote, 'in an earthly projection of heaven,' or the conviction that 'having ascended so high, they had ventured into regions which, as if by enchantment, are separate from the realm of human existence.'

Where rivers gush from the mouths of animals.

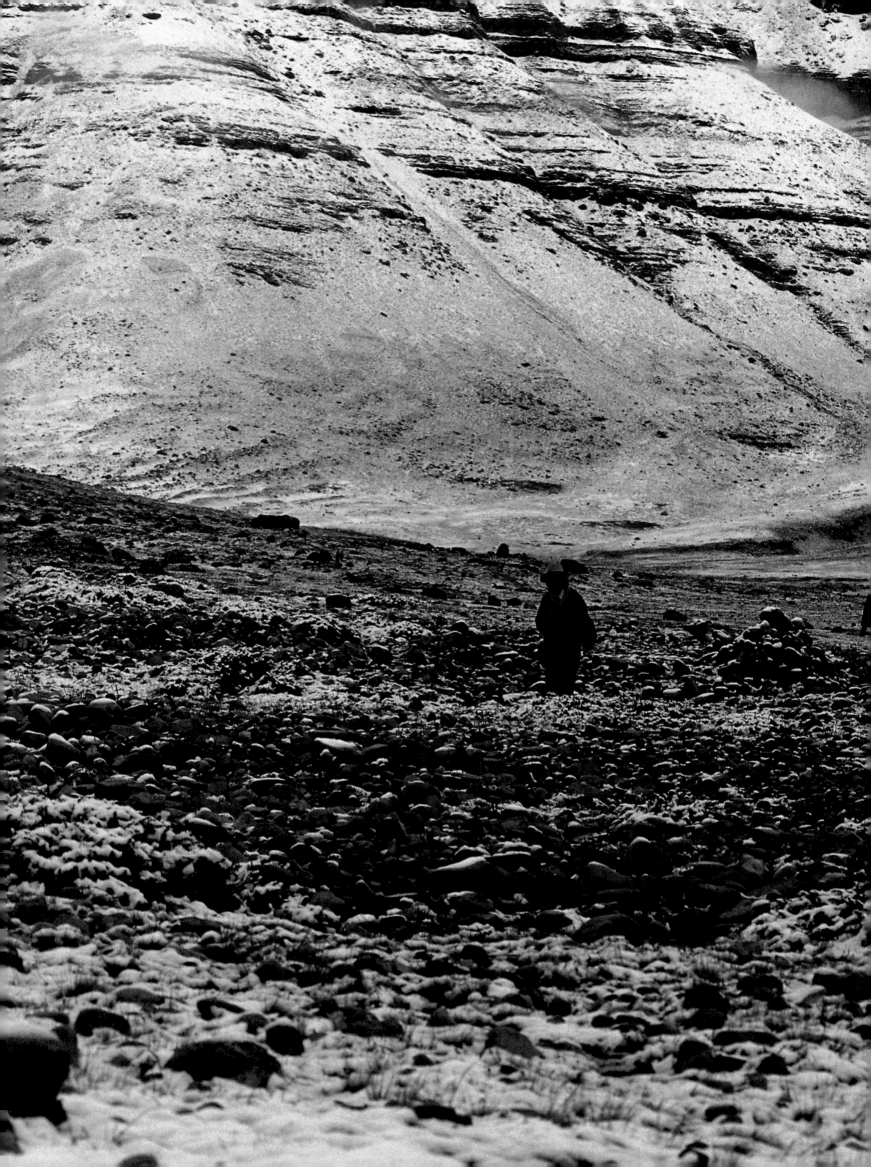

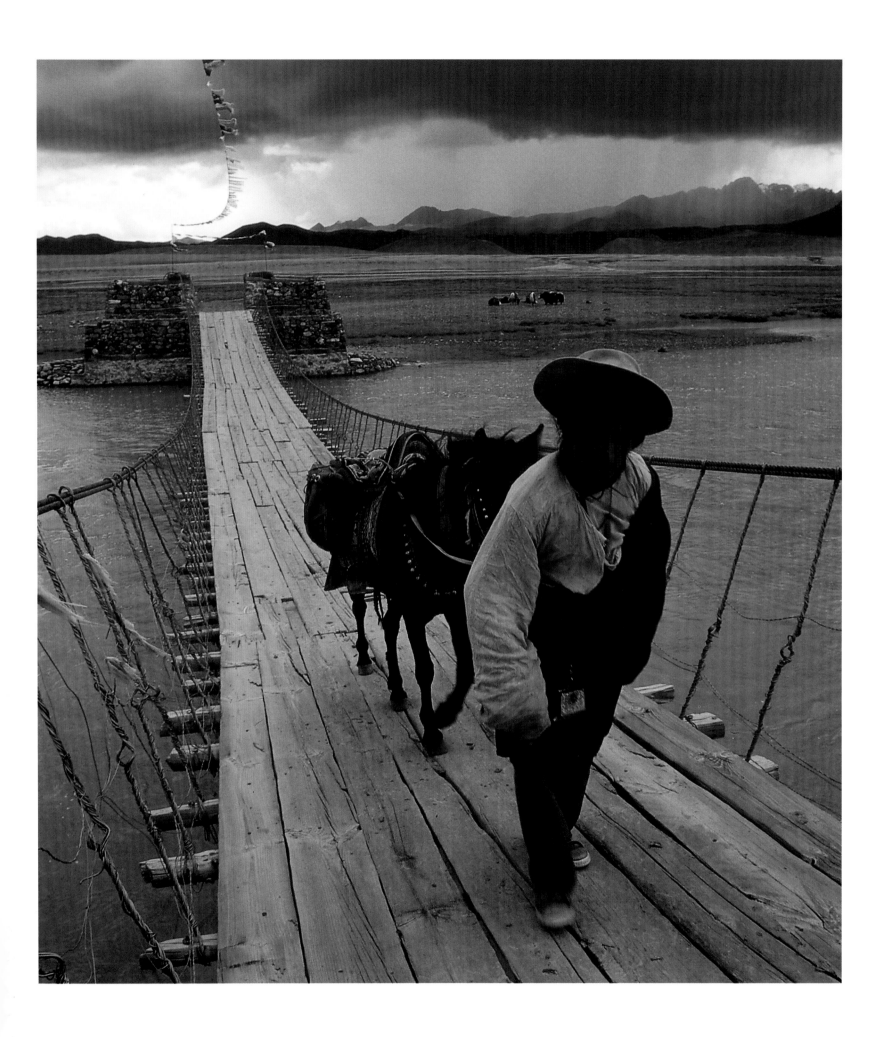

CHILDHOOD

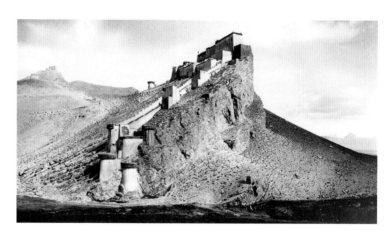

Khamba Dzong
(photograph: John Claude White, 1904; Royal Geographical Society)

YARLUNG TSANGPO

CENTRAL TIBET, at the end of the 20th century. A blue truck from Xichane, travelling east, stops for a break. A human cargo of Khampas, merchants and pilgrims, returning from Mount Kailash, pours out onto the bank of the Tsangpo. Leaning against the tyres of the truck a man, enveloped in a sleeveless sheepskin jacket, turns his prayer wheel. Another walks alongside the river, at each step sliding another grain along his string of his prayer beads, reciting the mantra of Chenrezig, the Buddha of Compassion: 'Om Mani Padme Hum.'

Central Tibet, at the end of the 19th century. A caravan of yaks from Laddakh, bound for Lhasa, travels along the path beside the Tsangpo. One man is walking, immersed in prayer. Every hundred paces he tells his beads and murmurs a mantra from the unknown verses. This man is Nain Singh Rawat, the legendary Pundit, the first of that ilk. Not a pilgrim, but a secret agent working for the Survey of India; a Bothia by birth, from the Johar Valley, trained in the art of secret topographical research in forbidden territories.

At the school set up for this purpose by the Survey of India, the Pundits were introduced to secret research techniques. These had more to do with geographical reconnaissance than with espionage in the strict sense. During their two-year training, aspiring Pundits were taught to use a compass and sextant; to recognize the constellations and use them to provide geographical co-ordinates; and to deduce altitude from the temperature of boiling water.

The school was based on the idea of T.C. Montgomerie, a British engineer in the Bengal Army, that natives from the mountains would arouse less suspicion and could penetrate the forbidden Tibet more easily than the English.

Sent on secret missions into territories where their lives were at risk at every step, the Pundits became experts in the techniques of disguise – as merchants, pilgrims, etc. – and were adept at inventing spurious but plausible-sounding stories that stood up to their inquisitors' most probing questions. They learned to translate into verse the technical data they discovered, and they recited this continually like a mantra so as to memorize it.

The laboratories of the Survey of India – worthy predecessors of Q's laboratory, dreamt up by Ian Fleming for English spies in the James Bond mould – produced clever instruments that were supplied to the Pundits: boxes and baskets with false bottoms for concealing a compass and a sextant; prayer wheels with a lid that could be opened for the insertion of minute sheets of top-secret notes; strings of beads that could be used to measure distances, with the ritual 108 beads reduced to a more convenient 100.

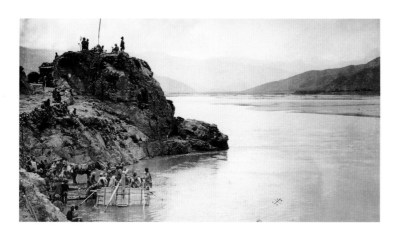

The crossing of the Brahmaputra by Younghusband's expedition
(photograph: Capt. Rawling, 1904; Royal Geographical Society)

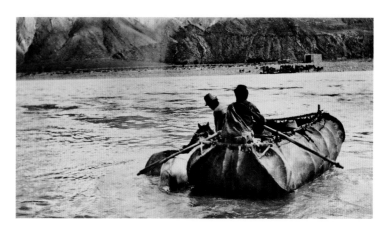

A coracle crosses the Tsangpo
(photograph: Lt. Col. J. L. R. Weir, 1931; Royal Geographical Society)

As nameless entities acting as secret agents, identified only by initials and working for a pittance, the Pundits undertook risky ventures beyond the curtain of the Himalayas on Her Majesty's Service.

It was the time of that great silent conflict, known to history as the Great Game – a conflict that at the end of the 19th century witnessed the bid for supremacy between the secret services of the two great imperialist powers, Russia and Great Britain, in their attempt to control the unexplored regions north of the Himalayas.

It was in the context of this conflict between British India and the Tsarist Empire that Rudyard Kipling, in his novel *Kim*, placed the figure of the Pundit, whom he described as a spy in the Great Game and personified as Hurrer Chunder Mookerjee, the spy modelled on the mythical Chandra Das, whom Kim helps in his mission to find the great secret river.

At that time the Survey of India had two primary objectives: to determine the exact location of Lhasa and to trace the course of the Brahmaputra, along whose valley the Jesuit Ippolito Desideri, as the first Westerner, had travelled as far as the road to Lhasa. The valley that guided the caravans of merchants from Ladakh and from the Ngari region was fabled to be rich in gold deposits.

Travelling incognito, disguised as a pious Buddhist, Nain Singh, in the wake of a caravan bound for Lhasa from Ladakh, followed a long stretch of the Great River. Here he witnessed the death of three nomads traders who drowned in the waters of the Tsangpo as they tried to cross it in a fragile yak-skin boat. The precious findings of Nain Singh filled many gaps in the map of Tibet with regard to the valley of the Tsangpo, and he was the first to measure its extent.

After him other Pundits, some well known, others more obscure, negotiated the banks of the Great River in order to discover where its waters had their origin; according to legend, in the region of Kongpo the source disappeared into a hole in the ground.

Along the valley of the Brahmaputra these invaluable pilgrims made their way on Her Majesty's Service in the second half of the 19th century. Travelling at a regular pace, regardless of the terrain, as they had been taught at the Survey of India School, they measured distances: at every hundred paces, as if praying, they slid one bead along the string.

No one would have suspected that the pious fellow traveller who attached himself to the caravan was surreptitiously dipping a thermometer into the pot of boiling water used to make tea; or that he was secreting, in his specially designed prayer wheel, tiny slips of paper containing details of the heights of passes, the co-ordinates of a village or descriptions of the meanderings of the Great River, written in verse form and in hieroglyphics that could only be read by those trained in this work.

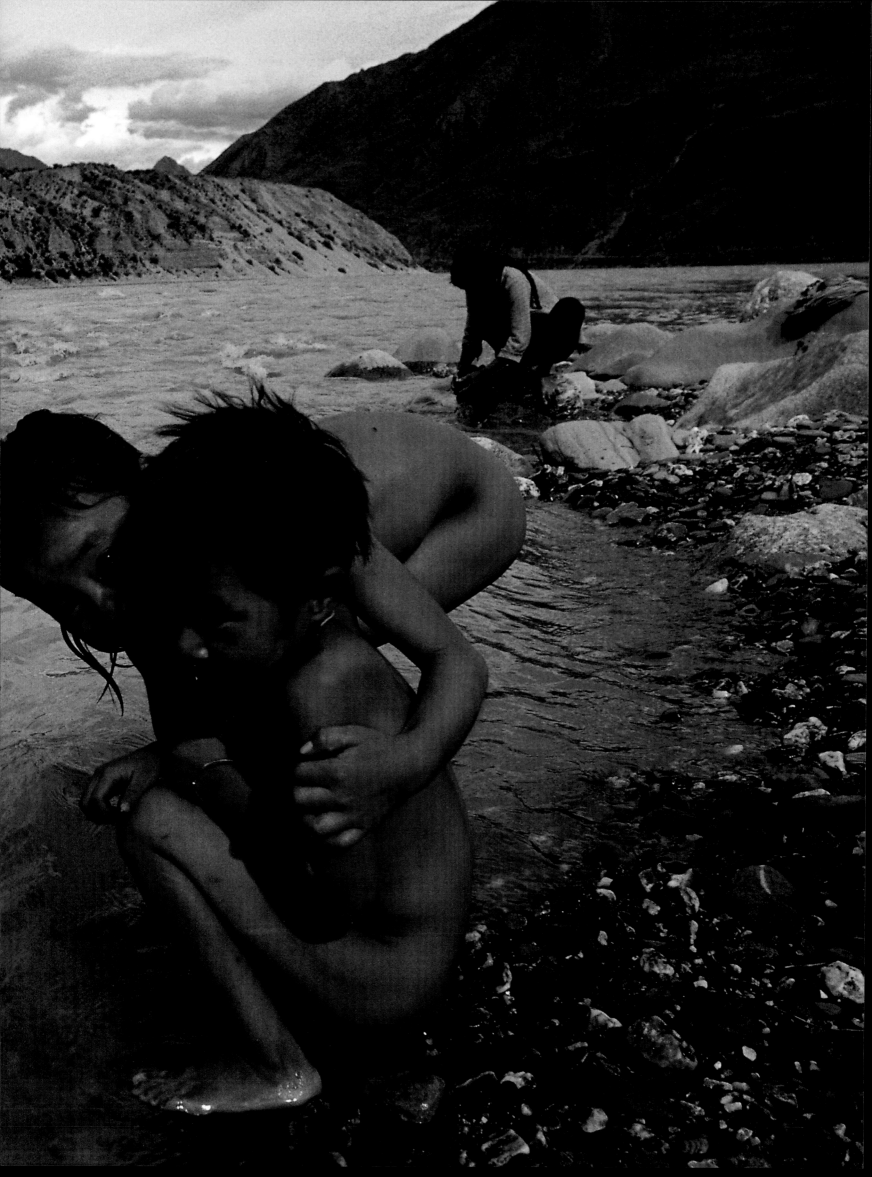

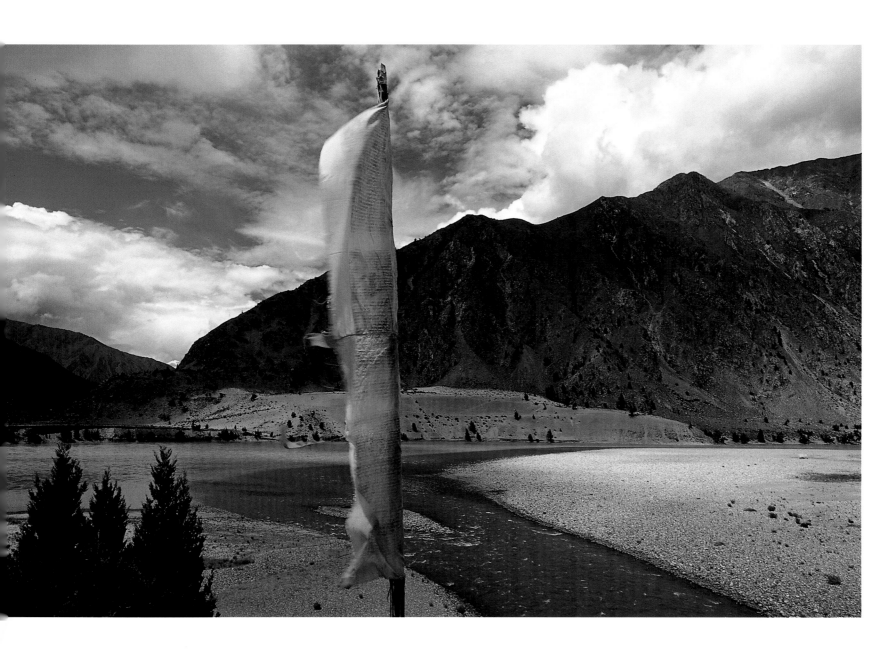

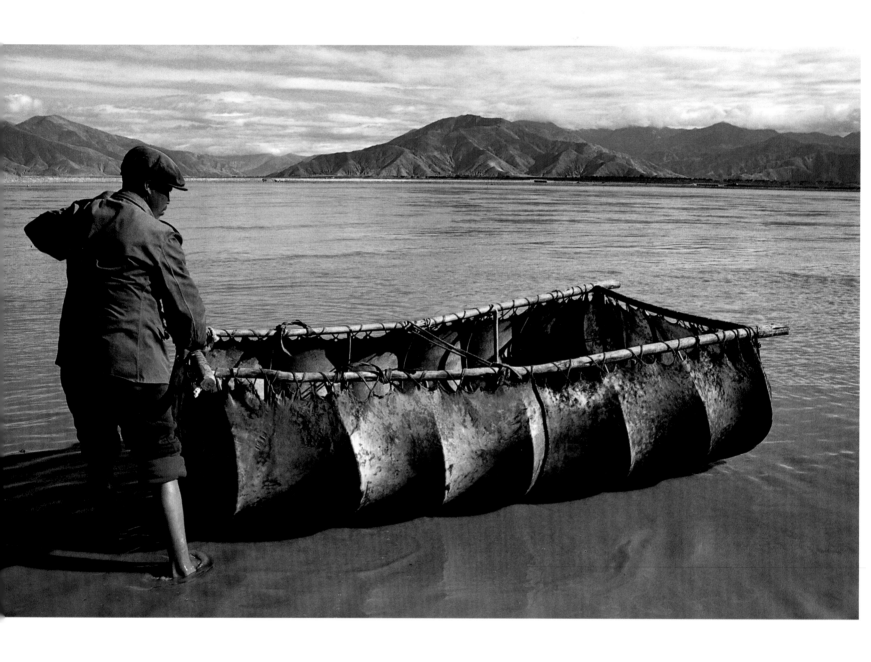

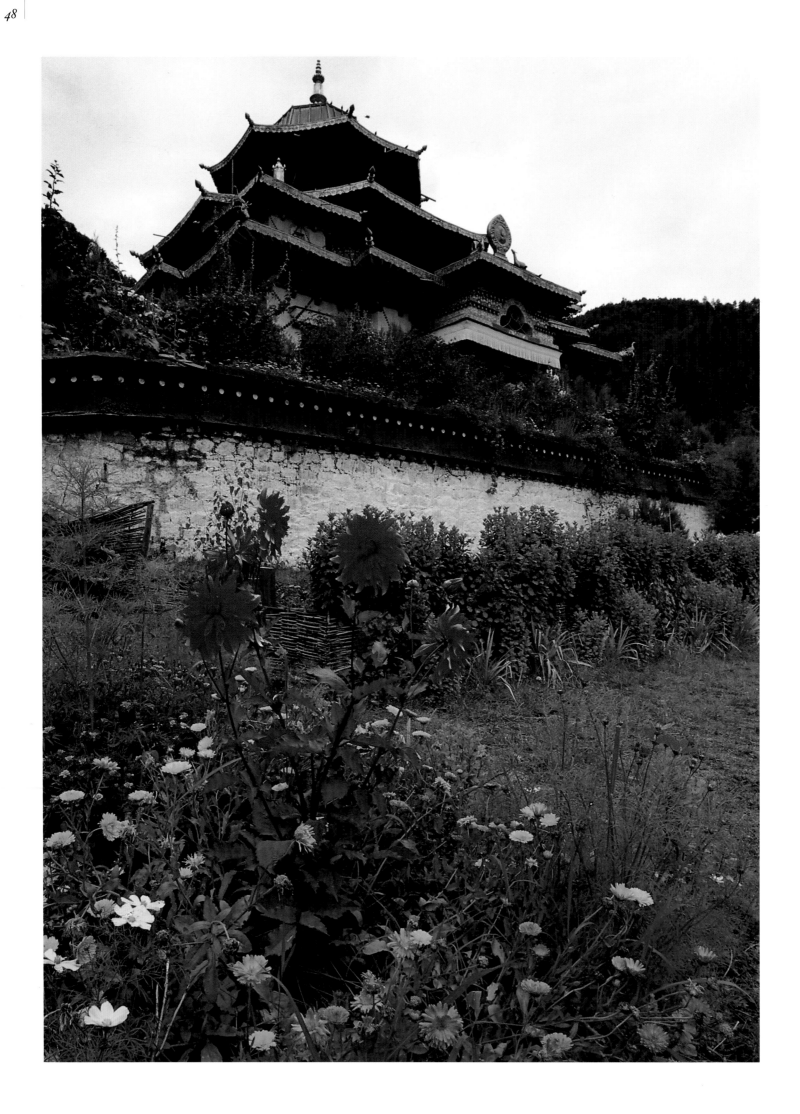

Tsang. The summer of 1995. The Tsangpo awaited us at Latsé, in the region known as Tsang. The current was fast. The surface was dangerously whipped up into whirlpools and eddies. The high water level caused by the summer monsoon made it uncertain whether we would be able to cross the river. On the right bank they had already erected the concrete pillars for the bridge that now spans the river. Crossing was effected by a barge secured to two steel cables spanning the river from bank to bank. Because of the higher water there was the risk that the current would snap the cables and sweep the ferry away in its flow. So the ferry lay at anchor for several days, waiting for the water level to fall. The Great River had barred our way.

Tsang. Summer, 1904. At Chaksam, on the way to the Forbidden City, Colonel Francis Younghusband's expedition encountered a more formidable obstacle than the Tibetan army: the Tsangpo. The river is wide and deep. At its narrowest point it measures around two hundred metres. The British expedition, a group of men and animals numbering several thousand, had only four Berthon boats, brought from India.

At Chaksam the soldiers requisitioned two wooden ferries that had been forgotten by the Tibetans and a number of coracles, light yak-skin vessels. It was decided that would cross over. Major Bretherton, responsible for the logistics of the expedition, gave instructions to tie two of the Berthon boats together to form a raft, and this set off with the first contingent. The whirlpools took hold of the vessel and overcame it. Major Bretherton and two Gurkha soldiers lost their lives beneath the rolling billows of the Tsangpo.

'It was as if the genie of the river,' wrote Edmund Candler, war correspondent for the *Daily Mail*, after the mission, 'offended by our intrusion, had claimed its toll by taking the life of the most valuable person on the expedition.'[1]

Bretherton's organizational skills had enabled Younghusband to cross the Himalayan chain with an army of over four thousand men – including soldiers and civilians – with an impressive supply of equipment, provisions, weapons, munitions, beasts of burden and horses.

The mission had set out with the apparent non-military aim of negotiating with the Tibetan government a commercial agreement to establish permanent diplomatic relations between the two countries.

However, the real and undeclared purpose of the mission entrusted to Younghusband by the Viceroy of India, Lord Curzon, was to

counter the Russian threat facing the governing forces in British India at the end of the 19th century.

At that time there were rumours about Russian military missions in Tibet; there were murmurings about a treaty of alliance between the Dalai Lama and Russia, and it was suspected that the Buryat monk, Dorjiev, the thirteenth Dalai Lama's mentor, was nothing less than the Tsar's secret agent.

For Curzon and Younghusband it was no easy matter obtaining authorization from England for an armed expedition into Tibet, at a time when that nation had no wish to disturb the territorial stability already achieved. They therefore had to resort to such superficial pretexts, fed back to the central government as: evening the score with regard to the humiliation the Tibetans had caused the British Empire when it captured and imprisoned two of its citizens – who in fact were two Sikkim natives belonging to the secret service; or imposing the recognition of boundaries on Tibetans accused of having carried out a raid, using yaks, on the mountains of Nepal. So the expedition set off.

The impressive military contingent that followed ostensibly had the function of providing an escort.

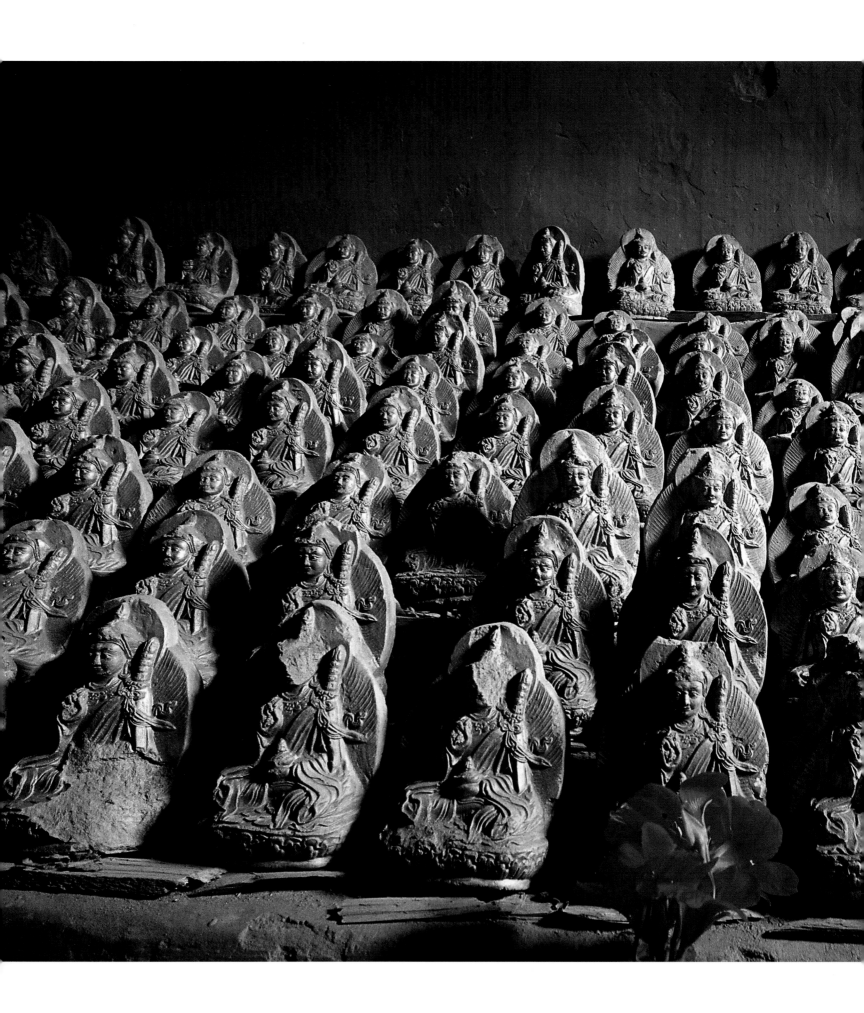

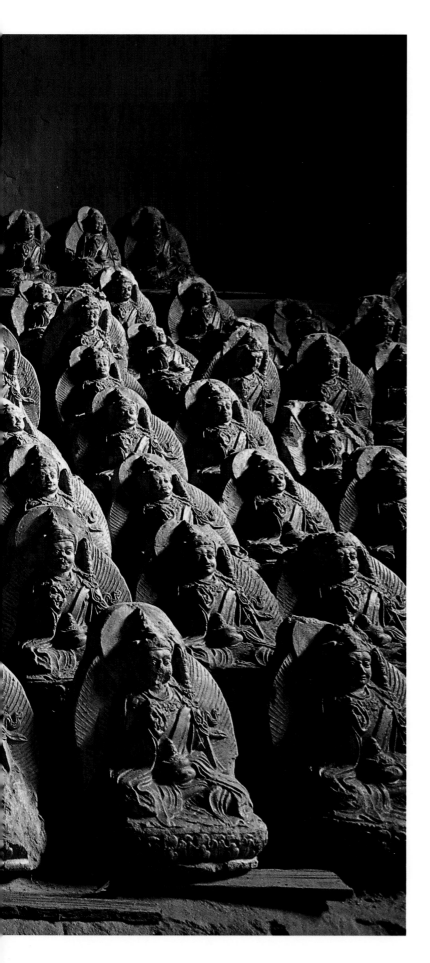

But the arguments did not convince the Tibetans, who had become even more diffident towards foreigners as a result of the invasions of the Gurkhas from Nepal in 1791 and of the Sikhs in the mid 19th century.

According to Candler, Tibet was at the time ruled 'in the form of a feudal system', in which 'the monks were the lords and the peasants the serfs, and the hostility against foreigners had its roots in the monks' fear of losing power.' [2]

'The lamas' wrote Candler, 'used spiritual terrorism to maintain their influence and to retain temporal power for themselves' and, fearing that the arrival of the English would bring about changes in their closed world, they thought that in this way they might protect their religion.

There was a prophecy, they said: it had been predicted that 'Tibet would be invaded and conquered by the *phyi-ling*, or the Europeans; followers of the true doctrine would reach Shambala, the northern paradise, and Buddhism would become extinct.' [3] For this reason foreigners were prohibited from entering Tibet.

On a number of occasions the Tibetans, using delaying tactics, refused to deal with Younghusband. They refused to enter into any negotiations with him unless the English first withdrew from the borders of Tibet.

At Guru the mission was confronted by a Tibetan army deployed in safe ranks behind a wall.

Once again the parties met: carpets were rolled out, cushions provided, tea was offered, but all to no effect. General MacDonald, head of the companies of Sikhs and Gurkhas which led the expedition, twice asked Younghusband, who had political responsibility for the mission, for permission to attack. But he was refused. The battalions were made to advance, with bayonets fixed until they were right up against the Tibetan soldiers, but not a shot was fired; the latter, either out of fear, or because they had not been ordered to attack, did not react.

In short the Tibetans were surrounded by the English army which then crossed the enemy lines unharmed.

Then, while a courier was galloping to Curzon with a message from Younghusband to the effect that victory had been achieved

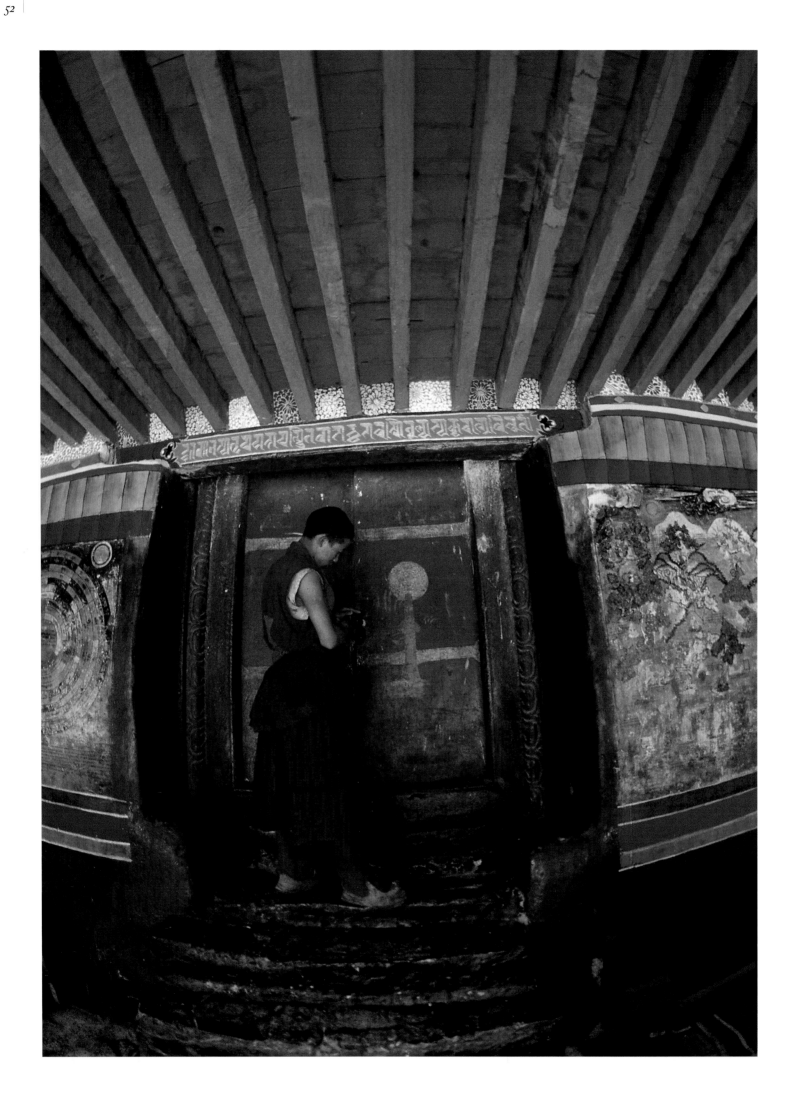

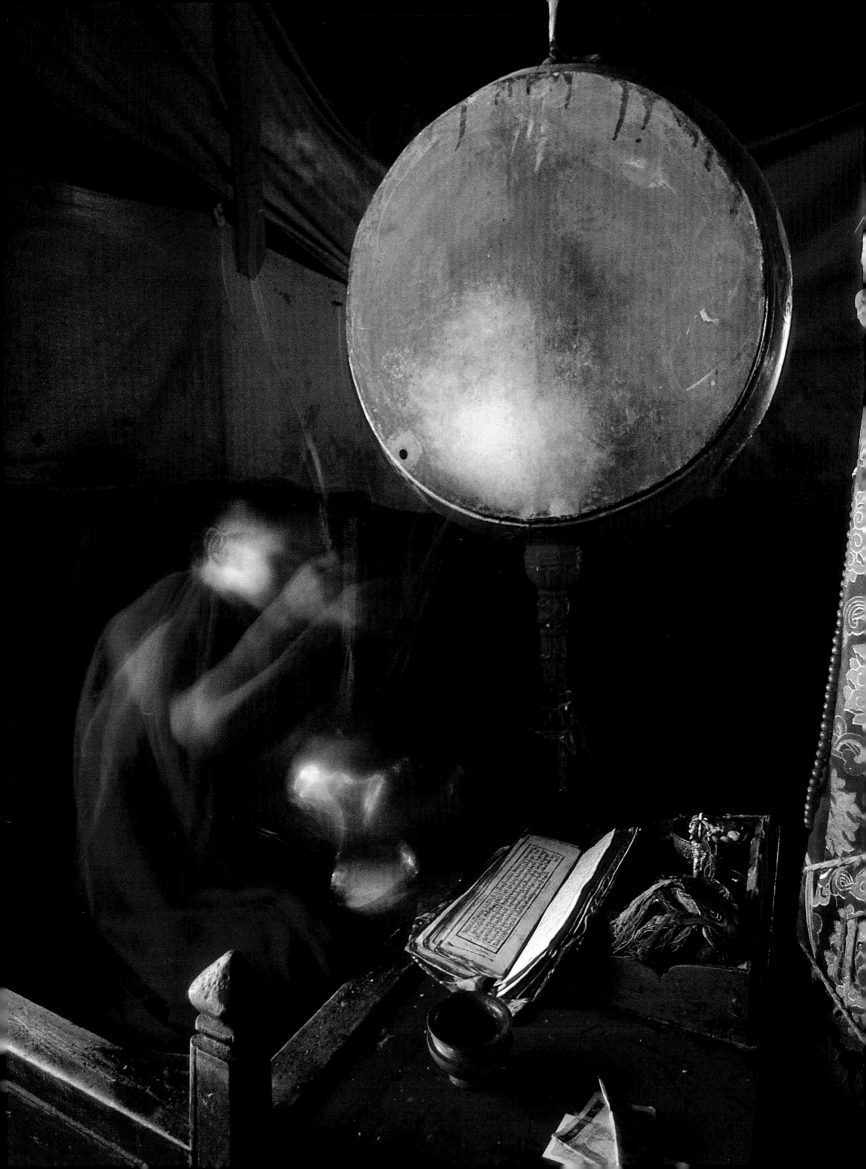

without shedding a drop of blood, something happened which turned Guru into the scene of a massacre.

After surrounding them, MacDonald gave the order to disarm the Tibetans. But the latter refused to hand over their family swords, since these were passed down from father to son, or to hand over the old muskets which they needed for hunting as well as defence. According to Patrick French, in his discussion of Younghusband, it was probably this attempt to separate the Tibetans from their family weapons that lit the fuse for the ensuing carnage.[4]

According to Candler, the *Daily Mail* correspondent who had his hand severed by a sword, the first shot came from the musket of the Tibetan General, Lading, as he galloped in among the soldiers who were endeavouring to disarm the Tibetans, and hit the Sikh who had taken hold of his horse's bridle.

According to the evidence of Tseten Wangchuk, one of the few to survive the Guru episode, while the Tibetan soldiers at the wall awaited the outcome of the talks between the two factions, 'a shower of bullets rained down on us from the surrounding hills. We did not even have time to draw our swords. I lay on the ground beside the body of a comrade, pretending I had been killed. The sound of shooting continued for the time it would take for six successive cups of boiling tea to cool down.'[5]

It was a massacre. The soldiers continued to shoot at the Tibetans as the latter walked around in the midst of the flying bullets, 'their heads bowed, as though they had been betrayed by their own gods', wrote Candler.[6]

In the summer Younghusband entered the Forbidden City with his troops. It was the year 1904, the year of the 'wooden dragon', which the prophetic lamas had predicted would be a year of tragedy for Tibet.

The veil of mystery which had hidden Lhasa from the world for centuries had fallen. Younghusband had opened the gates of Tibet to the outside world, bringing an end to its capital's isolation.

But that mission, which took a considerable financial toll on the British Empire, and in which the Tibetans had paid a high price in terms of human life, was destined to yield little profit.

Younghusband found no trace of Russians in the Forbidden City, or any deposits of arms belonging to the Tsar's army; these were simply false rumours spread by the Russians themselves.

The thirteenth Dalai Lama, Ngawang Lobzang Thubten Gyamtso, fled to Mongolia escorted by various attendants and the Buryat monk, Dorjiev, whom the English had suspected of being a Russian spy. In Lhasa the Dalai Lama had left his seal, but not the powers that went with it, in the hands of the regent, Te Rimpoche.

In September 1904, following protracted negotiations, and in an atmosphere of great ceremony which saw the lamas in their brocade gowns and the English officials in full military uniform, in the presence of the Ambans, representing the Chinese government, a commercial treaty was signed between the English and the Tibetans. A few articles in this treaty established the introduction of a tax on trade in certain items; the right of the English to maintain a commercial office and a telegraph station within the borders of Tibet.

If in terms of geographical knowledge Younghusband's mission is credited with having enabled Captain Rawling to carry out a complete reconnaissance of the Tsangpo valley from Xigatsé to the western regions of Lake Manasarovar, from the political and commercial points of view the expedition was a failure. It marked the consolidation of Chinese power in Tibet, through recognition of its actual sovereignty over the country. In 1907, in the formal agreement signed by the English and the Russians, both powers undertook not to establish direct relations with Lhasa and to recognize Chinese sovereignty in Tibet.

In 1908, travelling from Mongolia, where he had taken refuge, the thirteenth Dalai Lama went to Beijing to ask the emperor to withdraw the Chinese troops who had invaded and taken control of Kham. Returning to Lhasa at the end of 1909, having obtained no assurances, he was forced to flee to India to escape the Chinese

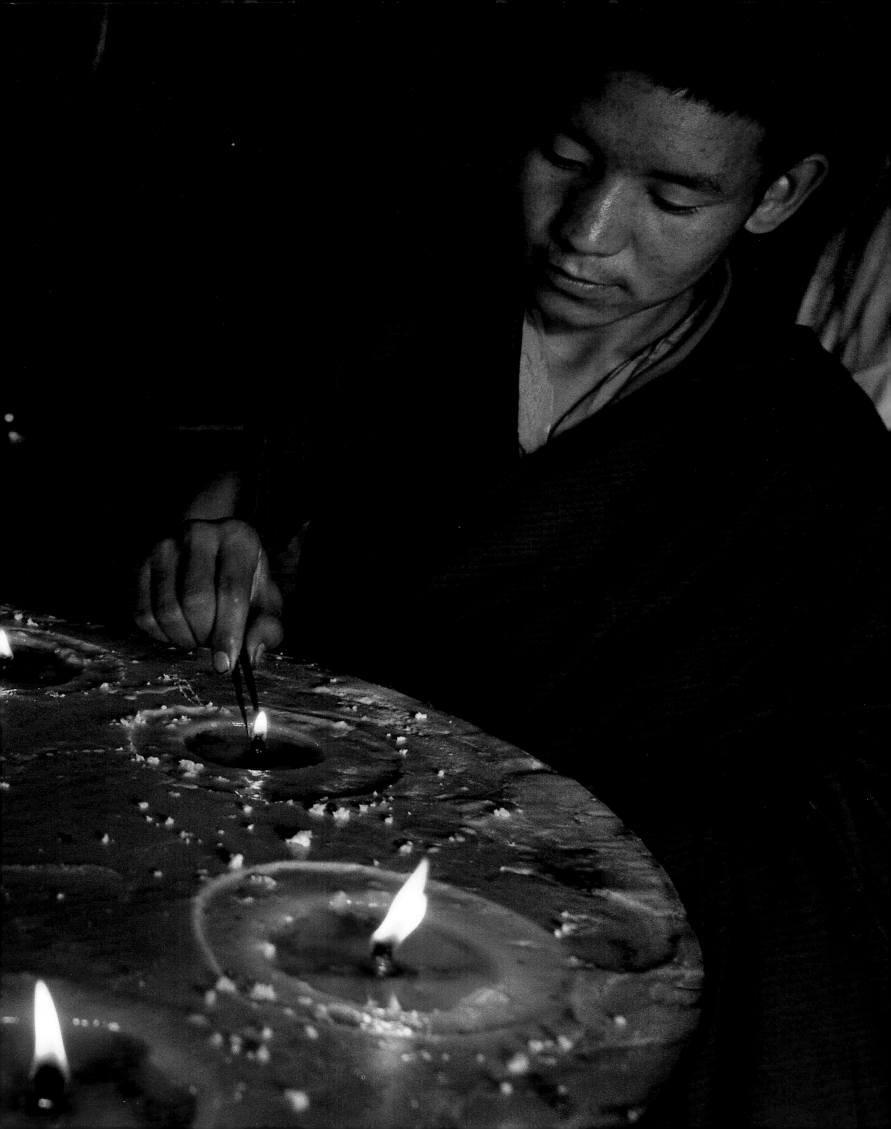

troops who had entered Lhasa, shedding blood in the holy city which at the time was crowded for the ceremonies of Monlam.

The Chinese soldiers dispatched by the Ambans in search of the fleeing ruler were stopped at Chaksam, on the banks of the Brahmaputra, by a small group of Tibetans determined to protect their god king.

In the meantime, the Manchu dynasty was crumbling in Beijing. In 1911 a Republic was proclaimed. In February 1913, the Dalai Lama, having now returned to Lhasa, where every trace of Chinese influence had been removed, issued an official decree announcing full and total independence from both imperial and republican China.

Fifty years later, following a far more bloody Chinese invasion, the Great River was witness to another escape: that of the fourteenth Dalai Lama, escorted by the Khampas on his journey to exile in India.

* * *

Tashillumpo, 1881. The last Pundit, Sarat Chandra Das, not a rough mountain dweller but a cultivated Bengali born on the coast and educated in Calcutta, reached Xigatsé accompanied by a Sikkim lama, Ugyen Gyatso, trained in the art of undercover reconnaissance at the Survey of India school for Pundits.

On their arrival 'the rays of the setting sun shone on the golden buildings and tombs of the Tashillumpo Monastery,' the residence of the Panchen Lama, the second religious authority in Tibet ever since 1682 when the fifth Dalai Lama first conferred this title – which means 'Erudite Grand Master' – on his mentor, Lobsang Choki Gyeltsen.

Having gained the confidence of the prime minister, Sarat Chandra Das, a progressive character who was eager to acquaint himself

with customs beyond the mountains, made Tashillumpo a base for exploration along the banks of the Tsangpo.

At the time there was a certain tension in Xigatsé, caused by the oppressive attitudes of the Chinese Ambans. During the annual inspection of the borders with Nepal, these officials became ever more insistent on the payment of taxes by the Tibetan population and there were uprisings and harsh acts of repression.

The description given by Chandra Das of the pomp with which the Ambans conducted themselves gives an idea of the position of supremacy enjoyed by the Chinese in Tibet at the time.

From the roof of the house belonging to his friend the prime minister, Chandra Das witnessed the parade of the Ambans on the anniversary of the Chinese emperor's ascent to the throne.

'At the head of the procession were the standard bearers and the troops on horseback; behind them came the Tibetan officials. Some people carried placards two foot square announcing the titles of the Ambans and their supreme authority over the whole of Tibet. There were around three hundred dignitaries and gentlemen from the provinces of U and Tsang in the retinue of the Ambans. The Ambans' sedans were carried by eight Chinese soldiers each and around fifty Tibetan soldiers were used to pull them along with long ropes. Throughout the procession the Tibetans occupied a subordinate position and the Chinese showed their superiority in every possible way.' [7]

Tashillumpo. Summer, 1995. The monastery gates were barred. Walking along the Xigatsé road was not permitted. A Chinese policeman urged us not to leave the guest-house. His tone was polite, but he was determined not to yield. The golden roof of the temples shone in the distance: it was the only thing visible. It is strictly forbidden to approach the lamasery.

In May of that year, His Holiness the Dalai Lama had announced the discovery of the eleventh reincarnation of the Panchen Lama in Lhari, a village in north-western Tibet – a six-year old boy called Gendun Choekyi Nyima. A few days after the announcement, the child disappeared. It is thought he was snatched from his home and taken to Beijing by the Chinese Secret Service.

The Chinese government did not recognize the authority of the Dalai Lama to designate the reincarnation of the Panchem Lama, and in December of that same year it crowned another child, Gyaltsen Norbu, as the official Panchen Lama.

In that same summer of 1995 many rumours were heard in Xigatsé. The boy recognized by the Dalai Lama had been abducted. Chadrel Rimpoche, the abbot of Tashillumpo Monastery, appointed by the Chinese as head of the committee to determine the reincarnation of the Panchen Lama, had also disappeared. The Chinese officials approached on this matter stated that, before leaving Beijing to return to Tibet in May 1994, the lama had gone down with an illness and had been taken to hospital. However, there was a rumour that he was suspected of having attempted to contact the Dalai Lama regarding the choice of the reincarnation and was put in prison. The Chinese newspapers accused him of 'tampering with religious rituals and ancient customs.'

It is thought that purges were carried out inside the monastery walls to remove the 'bad elements.' The reports indicate that, in the following year, many monks were expelled from the monastery for refusing to deny Gendun Choekyi Nyima, the child designated by the Dalai Lama, and others were imprisoned for burning photographs of Gyaltsen Norbu, the seven-year old boy appointed by the Chinese authorities.

<div align="center">⟨ ◆ ⟩</div>

Central Tibet, the 20th century. On the bank of the Tsangpo, a group of peasants waits to be ferried across the river. When the boatman brings the light yak-skin craft to the water's edge, everyone climbs aboard with various baskets, sacks of grain and even a bicycle. With a push on the oar the coracle moves away from the bank and, like a leaf, is drawn along by the current, bearing its multicoloured load.

On the opposite bank some men with a donkey await the arrival of the coracle, the only means of crossing the Tsangpo.

Central Tibet, the 14th century. At Lhadon Tscencar a coracle ferries a man across the Kyi Chu, a tributary of the Tsangpo. On reaching the other side, the man finds he has nothing with which to pay the boatman, and the latter, infuriated, strikes him several times on the head with his oar, and then hurls him into the water.

The man in question was Thangtong Gyelpo, 'the king of the desert plateau,' a Yogi born into a poor family of peasants in a central Tibetan village, and the master of the art of controlling air and fire through meditation. After being so badly treated by the boatman, the Yogi was saddened to think how many other travellers had been forced to endure similar treatment when crossing the river. Filled with compassion, he swore he would construct an iron bridge to span the river.

After amassing a hundred pieces of unrefined gold by asking for alms, he set off towards Kongpo in search of the iron-bearing rocks.

In Kongpo it very quickly became known that this respected Master was travelling around the region asking for alms, and many people joined forces with him. Assisted by local smiths, Thangtong Gyelpo and his disciples excavated the rocks that would provide the necessary iron. For eighteen days they beat thousands of rods, each day producing a chain some twenty metres in length. The inhabitants of Kongpo gave him two hundred and forty yaks to carry the iron to central Tibet. Reaching the river Kyi Chu, where the boatman had assaulted him, Thangtong Gyelpo, with the help of the people of Phudha who supplied him with hundreds of ropes to suspend the bridge, kept his promise, making the first of the fifty or more iron bridges across the rivers of Tibet that he constructed during the course of his life of 125 years.

This was the year 1430, a year the Tibetans called the year of the 'Ironbridge Yogi.'

<div align="center">⟨ ◆ ⟩</div>

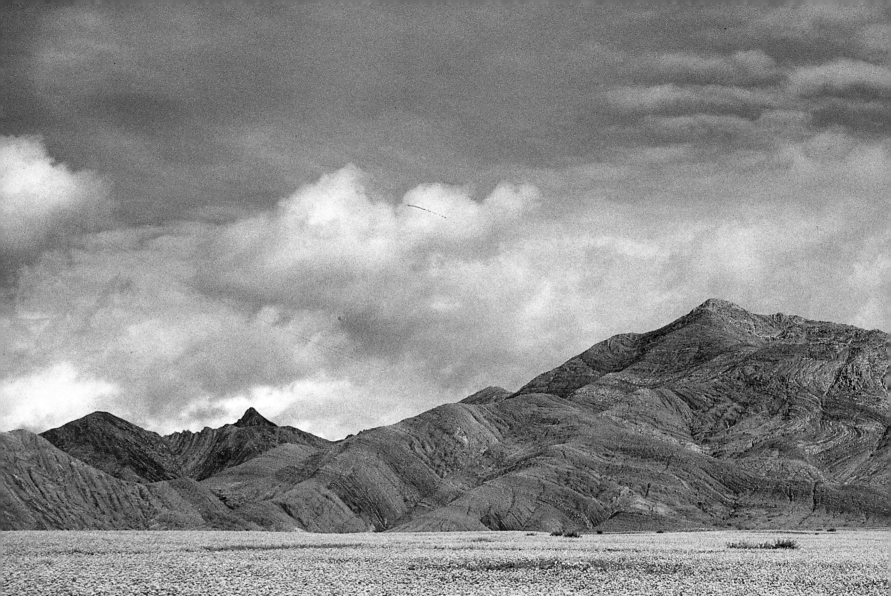

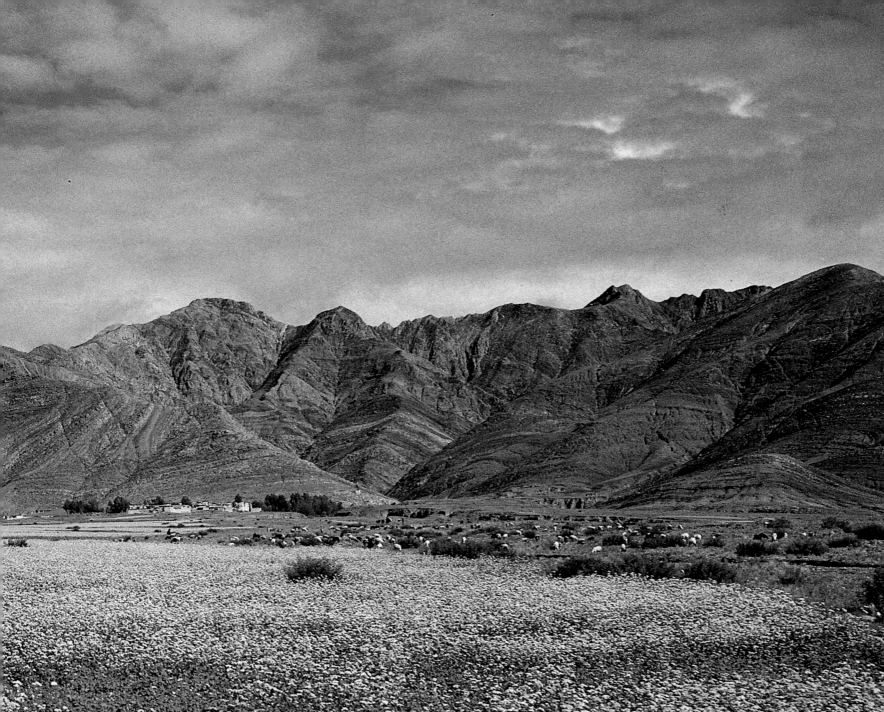

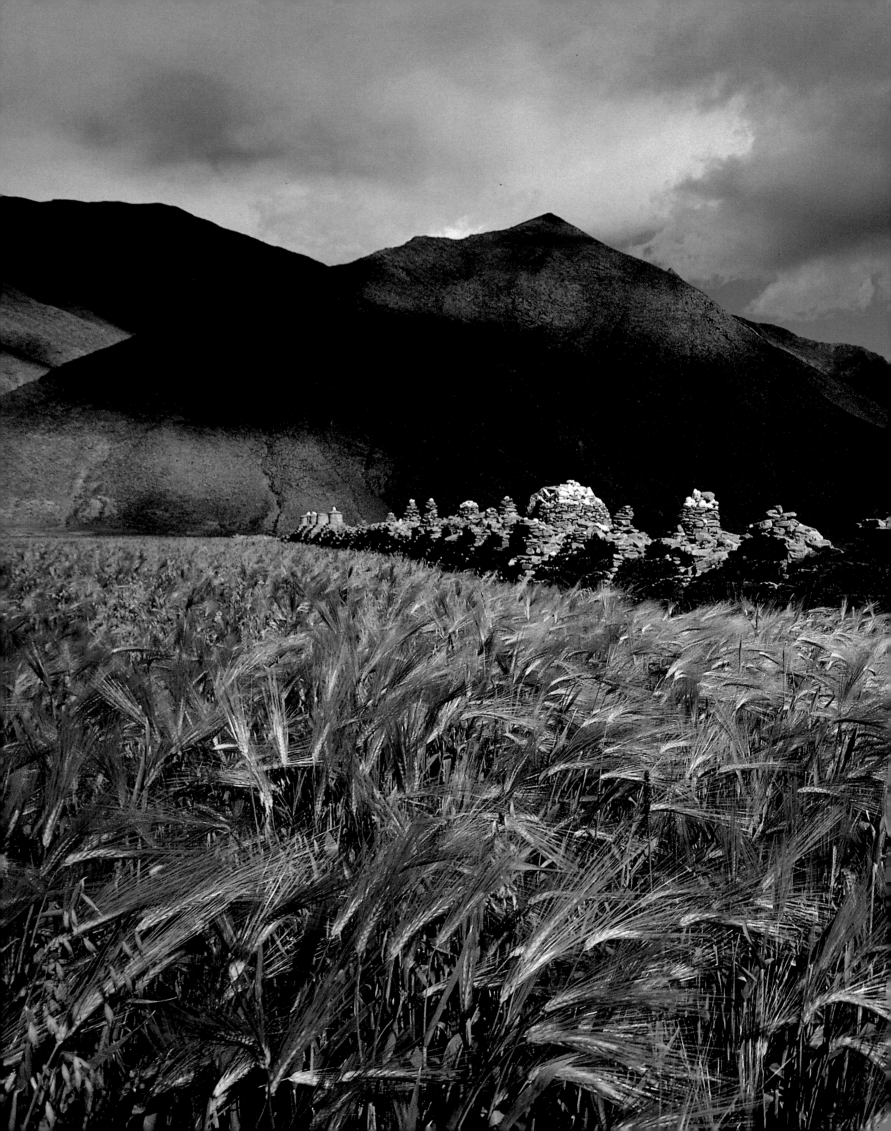

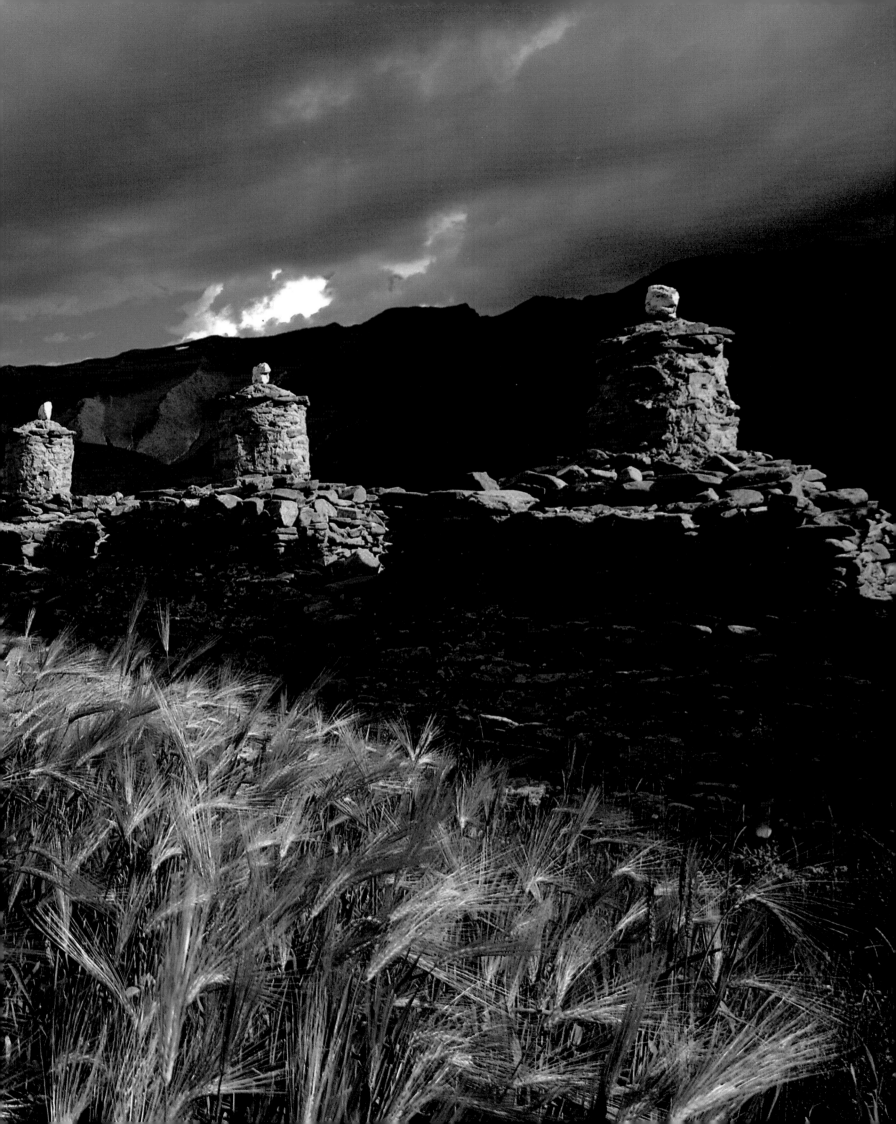

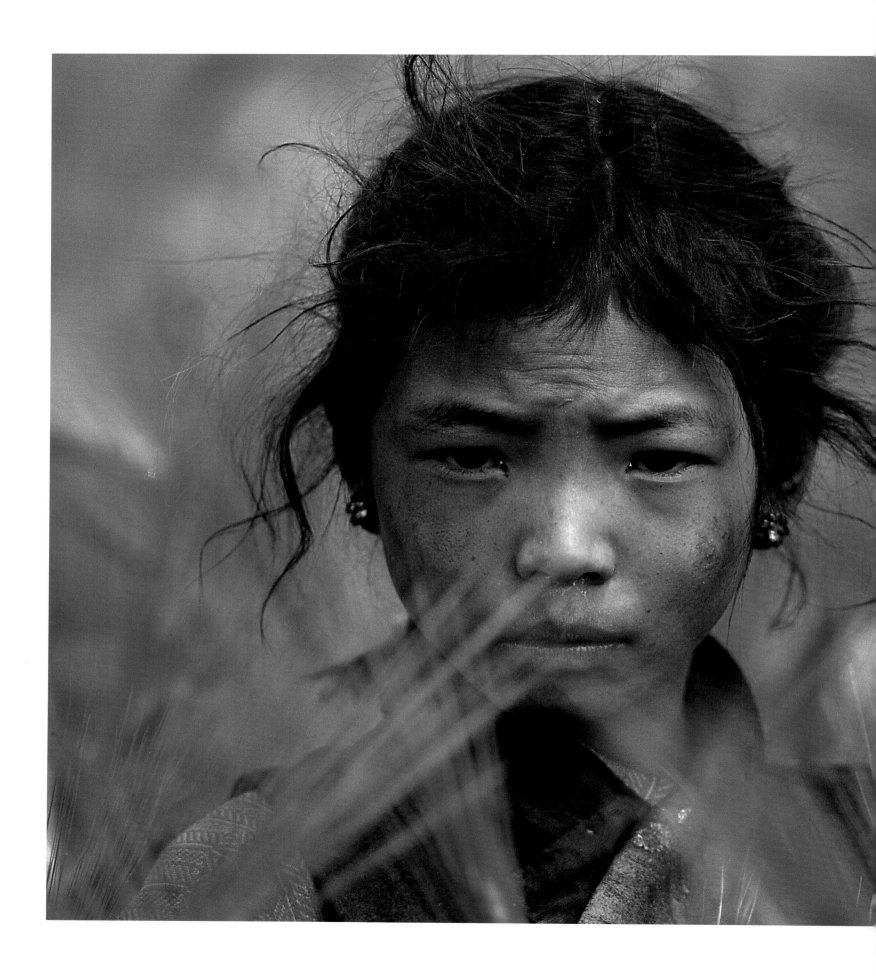

Tsetang, 1882. From the lofty roof of his house, Chandra Das looked towards 'the north of the city, Gonpo-ri, one of the favourites places of Chenrezig (Avalokiteshvara), where, according to tradition, the monkey king and the evil spirit brought up their family of monkeys, from which the Tibetan race was descended.'[8]

According to the legend contained in the *Mani Kumbum*, Tibet was originally submerged beneath the Teti Sea until Avalokiteshvara (Chenrezig to the Tibetans), the Bodhisattva of Compassion, opened up a gorge through which the great river, the Brahmaputra, could flow. From the waters emerged a country of hills and valleys, surrounded by high chains of mountains, populated by spirits.

Because there were no human beings, Avalokiteshvara and his wife, Dolma, were incarnated on the earth, he as a monkey, Trehu, and she as a demon of the rocks, Senmo. Trehu, who had taken a vow of chastity, lived in meditation. But he was tormented by the despairing cries of Senmo, who could not bear the burden of solitude and implored him to become her husband. Moved with compassion, Trehu went to the Potala to ask Avalokiteshvara's advice. The Bodhisattva told him it was time he married and had children.

From this union between the monkey and the demon six children were born, half monkey, half human – the ancestors of the tribes who now populate Tibet – to whom Avalokiteshvara assigned the forests of the South. But very soon the monkeys became men and multiplied; they suffered from the heat of summer and the cold of winter, and it was not long before there was no longer enough fruit on the trees to meet their needs. Trehu once again consulted Avalokiteshvara, who gave him six types of grain to plant in the earth: barley with the six-cornered ears, corn, sesame, mustard, rice and peas. This resulted in the first cultivated fields in the Yarlung valley.

In Tibet this is thought to have taken place in the U region near Tsetang. The name means playground, the courtyard in which the monkey and the demon of the rocks brought up their offspring.

The humans, who very quickly multiplied, spread throughout Tibet, where they lived without a king. One day, in the valley of the Yarlung, a boy appeared, the son of a noble Indian family from Magadha in Bihar. He had been born with long blue eyelashes, a full

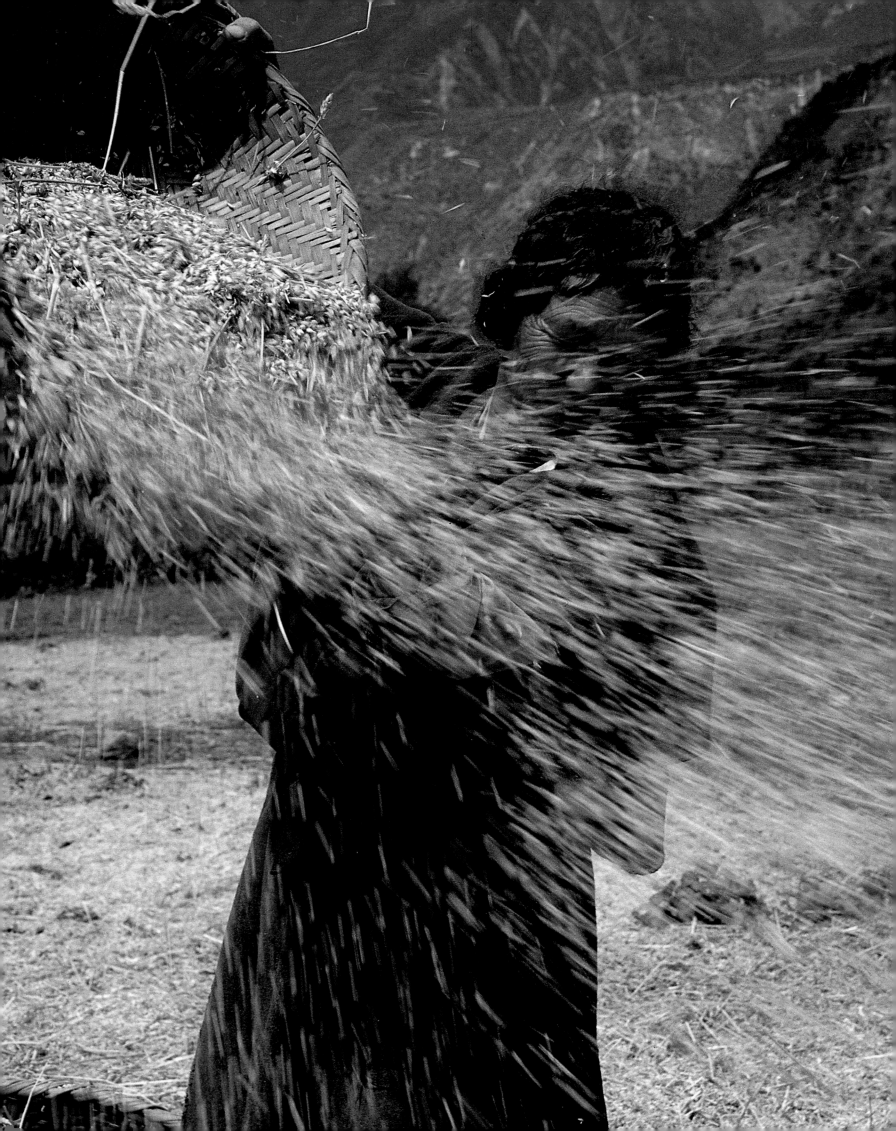

set of teeth and webbed fingers; in shame his father had hidden him in the mountains. The young man was wandering around Tibet when he met a group of Tibetan adherents of the Bon religion, who asked him where he had come from. Not understanding their language, the boy pointed to the sky.

Thinking he had descended from heaven, the Tibetans made him sit on a sedan, gave him the name Nyatri Tsanpo ('he who is carried at shoulder height on a throne') and made him their king.

Nyatri Tsanpo built the fortress of Yumbulakhang in the valley of Yarlung and was the first of those celestial kings known as the dynasty of the Seven Thrones. These were thought to have been let down to earth on a divine rope and were the means by which, on their death, they returned to their place of origin without leaving any mortal traces. This continued until the divine rope linking heaven and earth was accidentally severed by Digum, the eighth king of the Seven Thrones dynasty, after he had fallen prey to the magic used against him by one of his ministers. Thus the kings of Tibet became mortal.

The Tsangpo valley, 1996. On the threshing floor of the stone house, Tse Drolma stands in front of an enormous straw basket containing barley; she lifts a sieve and, with her arms extended, shakes it from side to side. A cloud of golden straw flies into the air and the chaff falls to the earth, leaving the heavy grain in the sieve. This is the gold of Tibet, the most precious of the six cereals that her ancestors received as a gift from the divine Monkey. The harvest has been generous and the ne, the strain which grows well at high altitudes, has produced an abundant crop.

Drolma buries her hands in the golden grain and fills a sack which she carries into the house and places beside the clay hearth. Silence reigns in the room. All that can be heard is the bubbling of water in the kettle. On the shelves along the walls are various cooking utensils,

bowls, thermos flasks and oil lamps. In a corner is an enormous copper boiler for the water and the chang.

Drolma stokes the fire and places a pan of barley grain on top. She shakes it lightly. The room is pervaded by the smell of toasted cereal. Sitting on a bench, Tsering, Drolma's father, pours a handful of *tsampa* into the tea bowl, adds a piece of yak butter, pulled with his fingers from a pat of butter wrapped in a greasy cloth and which, with a slow movement, he kneads into a rounded lump before throwing it into his mouth and chewing for a while.

From the large window overlooking the valley the Tsangpo can be seen in the distance.

Tossing a sack full of barley onto her shoulder, Drolma leaves the house and makes her way towards a stone outhouse built over a stream. Inside, the single room is occupied by an enormous grinding mechanism: two round stones, worn smooth by time. All that can be heard is the gurgling of the water, interrupted by the creaking of the mill vanes. Drolma pours the golden grain into the yak-skin funnel above the mill. She then stands beside the millstone and, from time to time, pulls lightly on the thin rope tied around the opening. The grain falls through slowly and disappears between the two stones. Two, five, ten at a time. At the edges of the stones the white *tsampa* dust begins to appear.

When we arrived in the Tsangpo valley, in mid-summer, the cultivated fields of barley and Saracen corn fields alternated with areas of red *gyapra* flowers, from seeds of which a flour was obtained, used for a sweet paste of which the Tibetans are extremely fond.

Throughout the valley the peasants were preparing to celebrate Hongkor, a ceremony whose purpose is to bless the harvest before the crops are gathered in. The men were examining the ears and the women were preparing food and filling large copper boilers with *chang*.

At dawn on the appointed day the peasants put on their best clothes, saddled their horses and, in procession, preceded by a lama specializing in Tantrist practices against hailstorms, made their way to the fields, followed by all the members of their families. These carried on their shoulders the Buddhist scriptures, the *Kangyur* and the *Tengyur*, reciting mantras and invoking the gods and spirits who rule over the fertility of the earth.

The rest of the day is spent pleasantly, and involves the consumption of large quantities of chang and dancing. The women wear coloured striped aprons and the men yellow felt hats. Everyone exchanges *khatas* as a sign of good luck.

Then, before returning to the village, each person throws a handful of *tsampa* into the air, crying 'So so La gyalo' and waits for the cloud of white dust to fall to the ground.

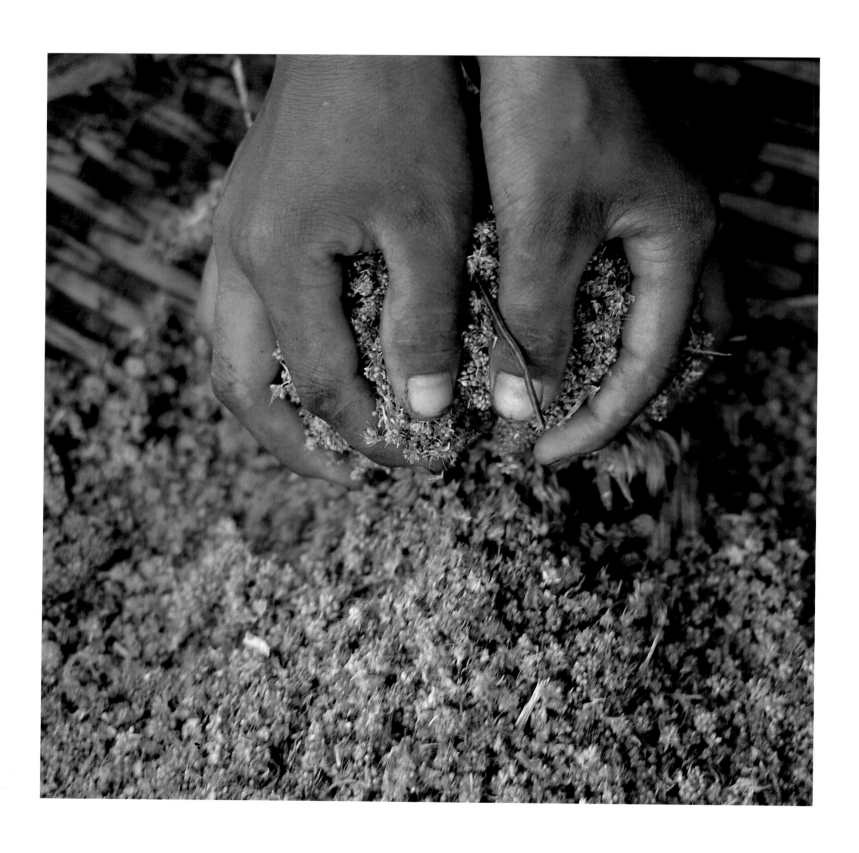

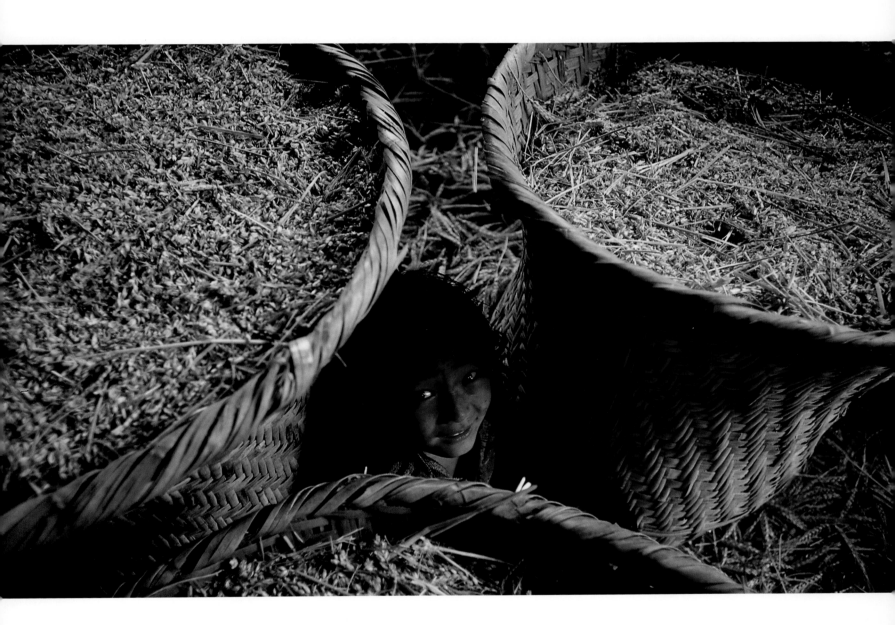

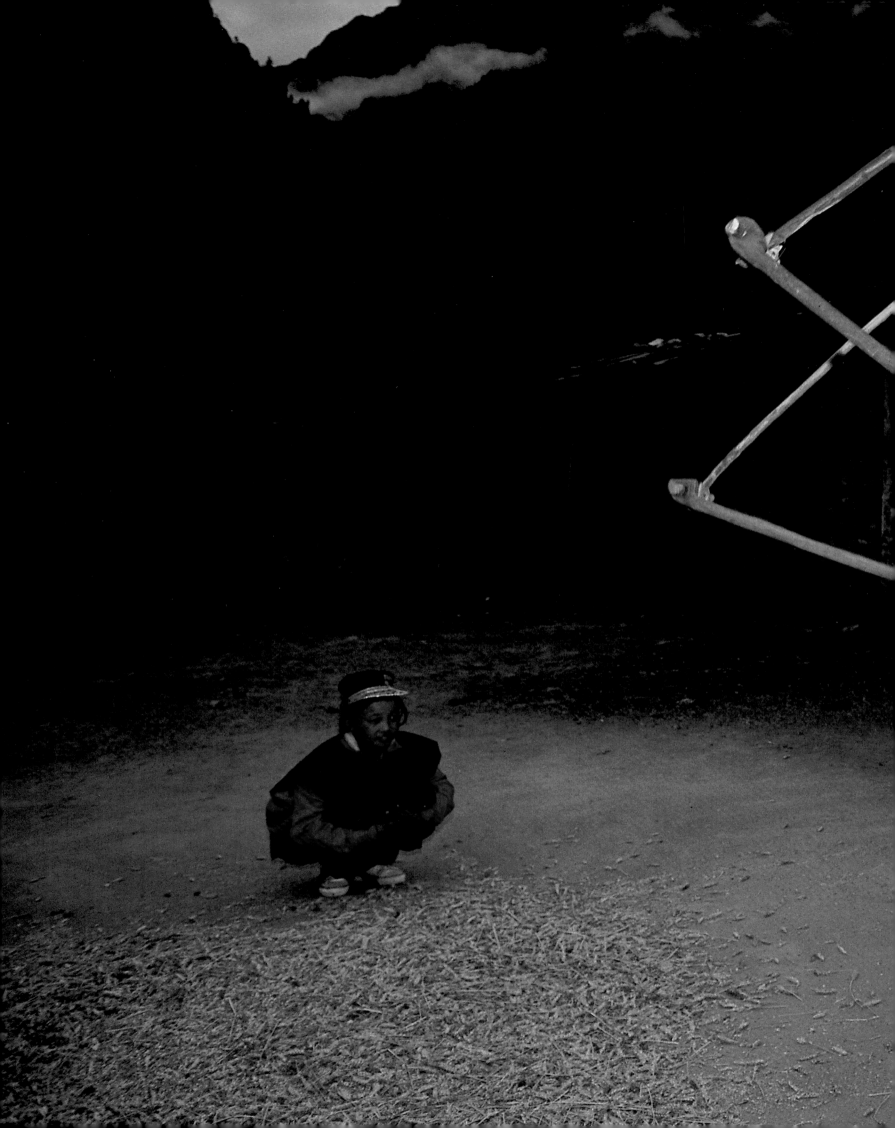

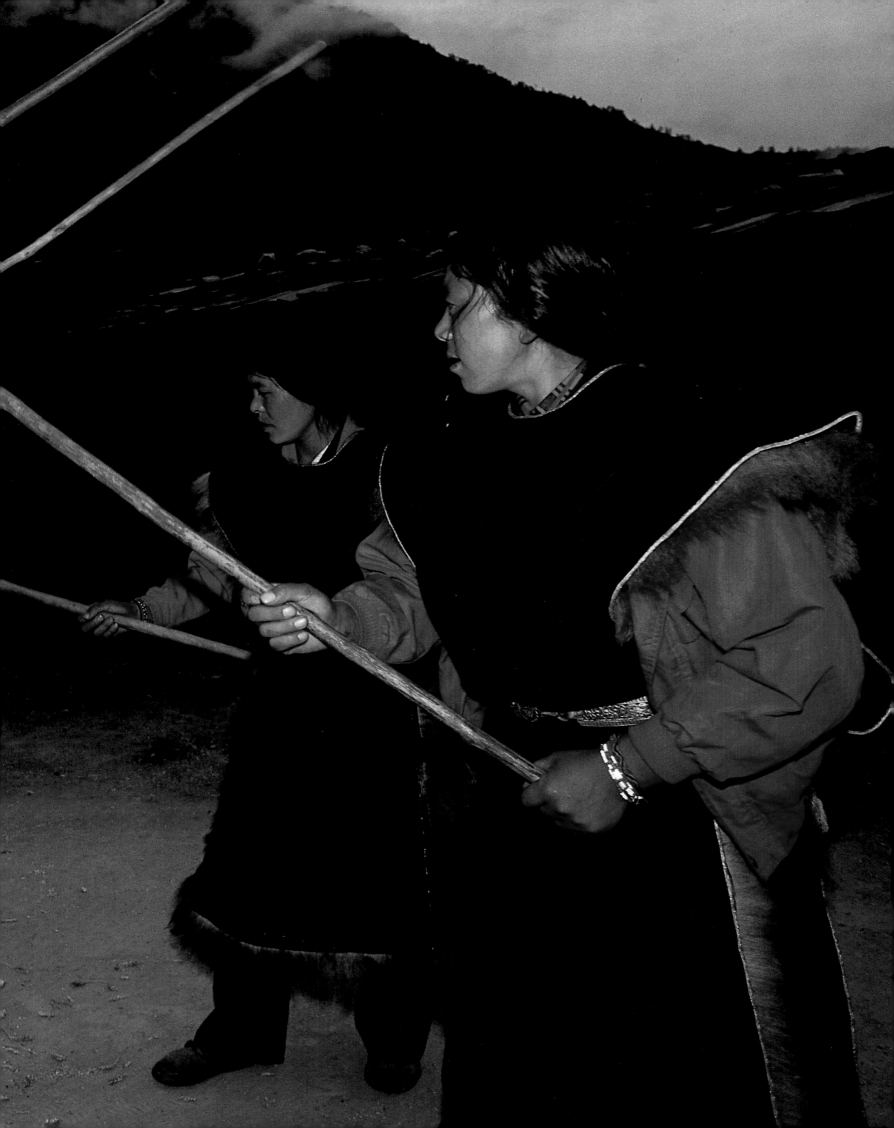

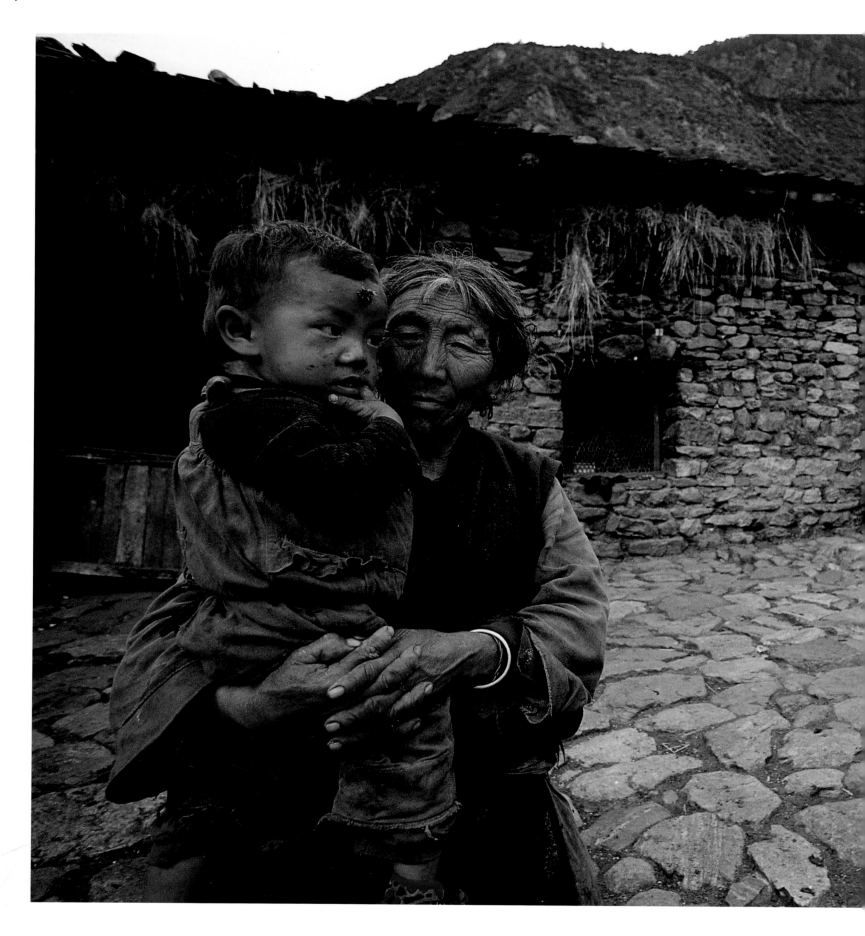

Beijing, September 1997. The European press agencies forward the news, announced in a Chinese newspaper, that a dam of even more monumental proportions than that of the Three Gorges across the Yangtse is to be built for the biggest hydroelectric station in the world. It could be built in Tibet in the next century, on a large curve in the Brahmaputra.

In the next millennium, perhaps, the waters of the Great River could flow in a new direction – towards China.

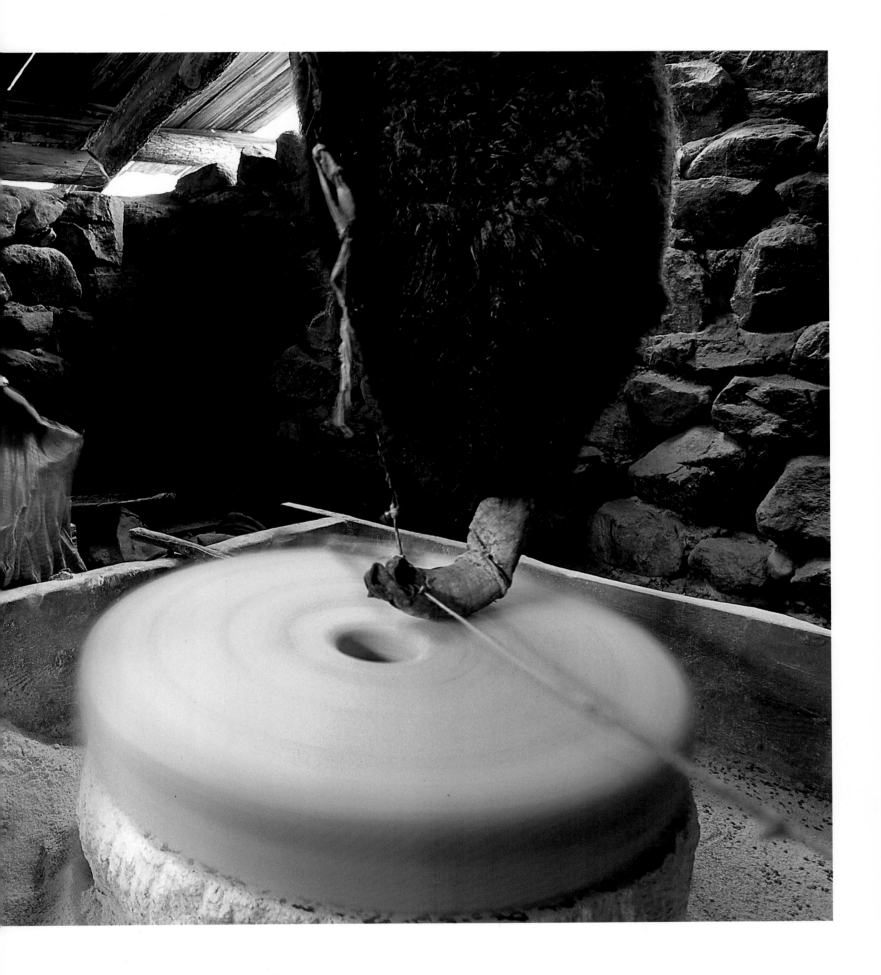

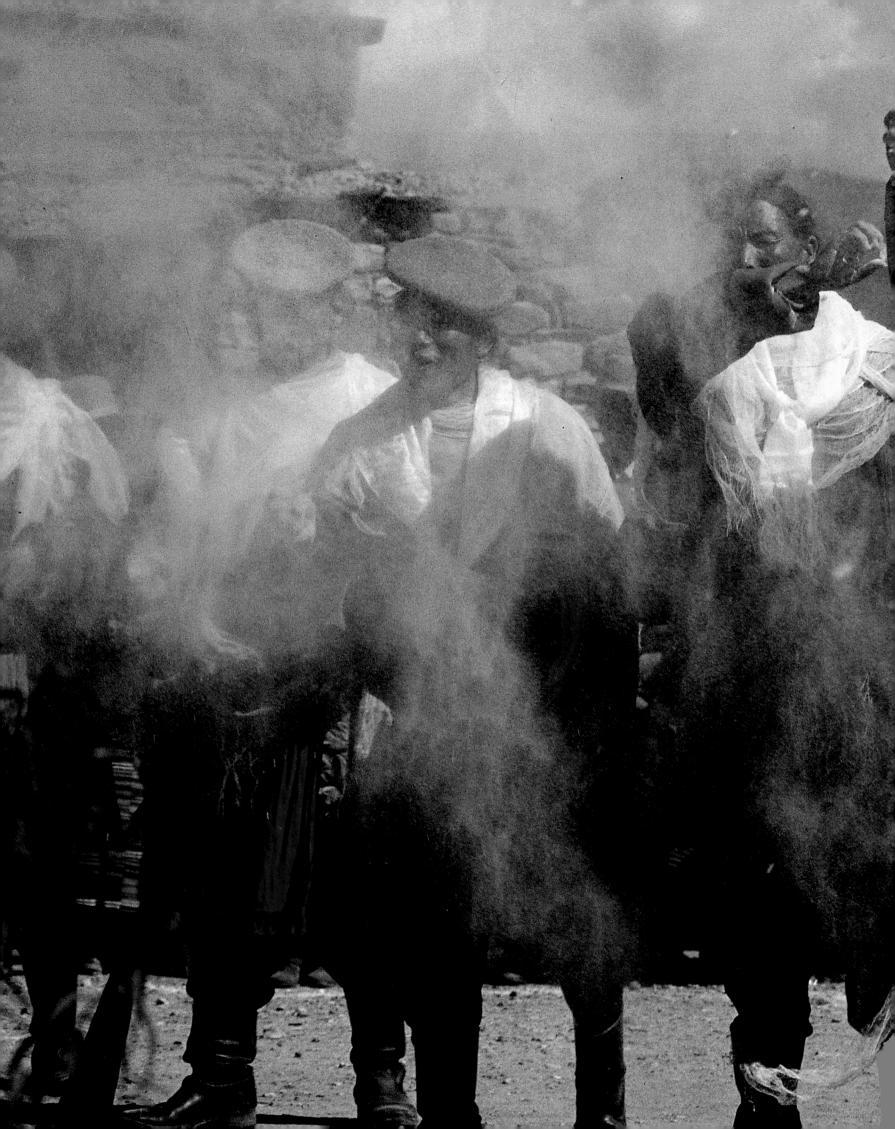

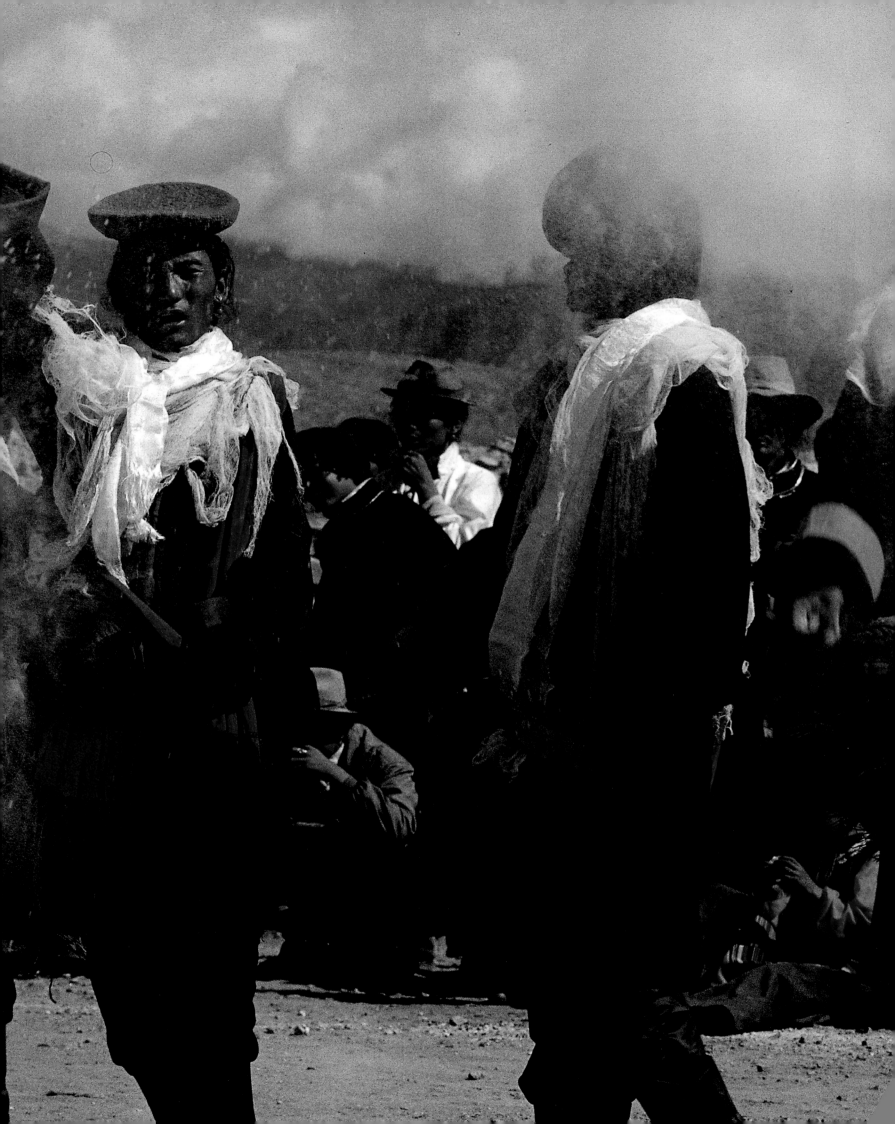

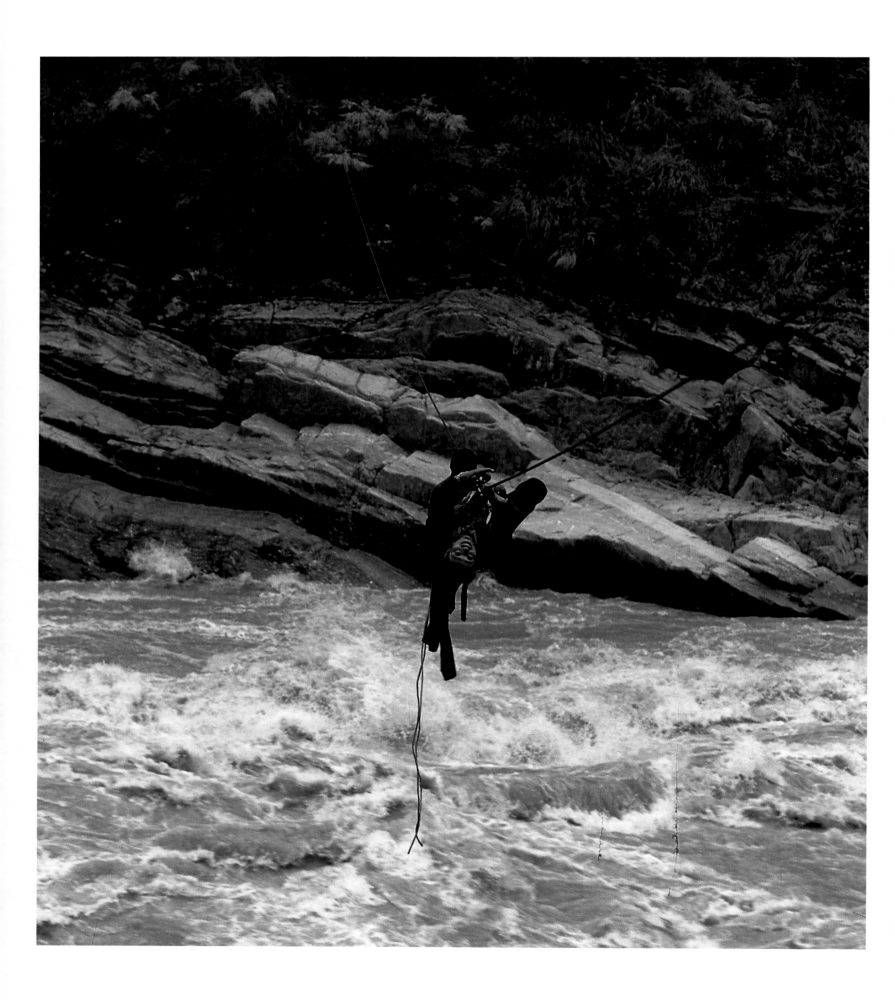

YOUTH

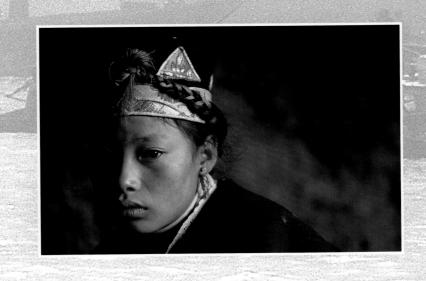

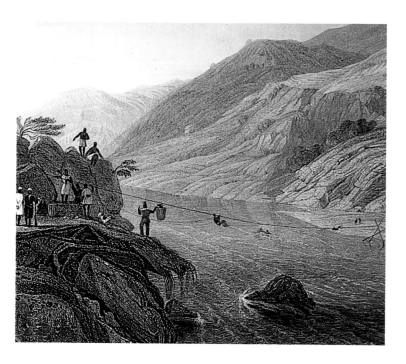

*Crossing the river by cable
(lithograph: G. F. White
Himalaya Mountains, 1838;
White Star Editions collection)*

TSANGPO

IT IS THE END of summer. Overflowing with water and made both dense and dark by the rain, the Tsangpo continues its course eastwards between sand and mountains of barren rock. Every now and then the deep blue waters of a glacier stream join it on its journey; for a short distance they maintain their separate identity, then they disappear into the brown waters of the Great River.

After Miling the current increases and it is not long before the river is transformed into a mass of turbulent water that disappears between the rocky faces of the Kongpo and Poyul gorges. A remote region of eastern Tibet, permeated with sinister legends.

The inhabitants of central Tibet used to call it a 'land of savages,' where the native population were devoted to killing and to terrible magical practices. They believed that originally the natives of the Kongpo area were demons with large horns on their heads, who lived in the forests and wore the skins of their human victims as ponchos.

Even today, in Tibetan folklore, the two long points that close the fold in women's hats and the *gushu*, a poncho made from coarse woven wool and worn by men, are believed to be vestiges of the horns that used to grow from the heads of the demons; as well as of the skin of their victims.

The women in the region had a somewhat disquieting repute. It was rumoured that some of them, experts in magic practices, gave travellers a powerful poison, extracted from flowers from the banks of the Brahmaputra.

When, on reaching Nyingtri in Kongpo we mentioned the stories of the poisoners we had read about, the reaction of Jamyang, a university student in Lhasa, was immediate: 'They do not exist.'

At the historic heart of Kongpo, Nyngtri lies close to Lingxi; until a few years ago there were only a few stone houses in this remote area of eastern Tibet. Today Lingxi is a rapidly expanding town with a Chinese identity. There is nothing sinister about this, apart from the anonymous concrete housing blocks and the enormous chandelier dominating the foyer of the hotel which is nearing completion.

Jamyang did not seem prepared even to attempt to find out about the existence of the flowers from which the poison may have been obtained. However, he did utter the words 'It's dangerous.' So he must have known something!

We needed to find someone who would be prepared to overcome any atavistic fears and reveal the secret of an ancient practice

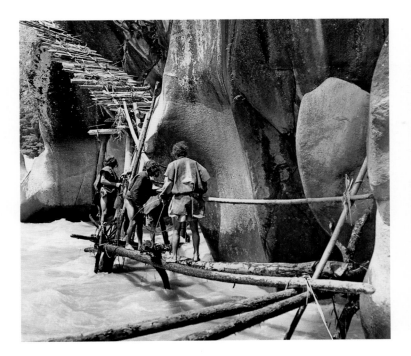

Cane bridge, 1935
(photograph: Kingdon-Ward, Royal Geographical Society)

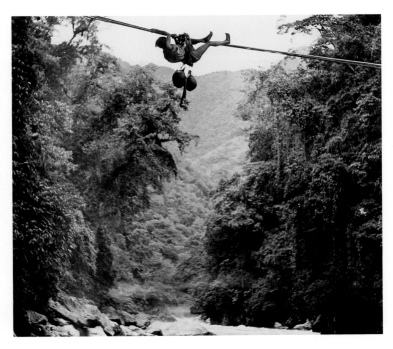

Crossing the river by cable
(photograph: Kingdon Ward, Royal Geographical Society)

which had its origins in the beliefs and rites of the followers of the Bon religion.

At one time the adherents of this religion – the majority of whom are today concentrated in eastern Tibet – were infamous for their magic practices and cruel rites including human sacrifices aimed at taking possession of the vital spirit of *g.yang*, the victim's capacity for good luck.

We began by asking the pilgrims who at full moon performed the *khora* around Bonri, the sacred mountain of the Bon at the confluence of the Tsangpo and the Giamda. We finally obtained a name, that of Nyima Tashi, an old man who had lived for some years on the mountain slopes. Perhaps he could reveal the mystery of those flowers made poisonous by the waters of the Brahmaputra and tell us how the women of Kongpo learned to extract the poison.

Finding Nyima Tashi's house was no easy task. In Tibet, a country where time and space seem limitless, directions are very approximate. An hour's walk may in fact mean a whole day; nearby may mean a few metres or over a mile. We got lost again and again. Once the path ended up in a forest, another time we came back to our starting point, yet another time we ended up on the edge of a rocky bramble-covered precipice. At last we found the narrow path, scarcely visible beneath the high ferns, the brambles and the rocks, which led us to the home of Nyima Tashi.

Like other houses in Kongpo, it was built of rock with painted wooden gratings at the windows. Above the door hung the skull of a mountain goat. A large eagle's beak projected from one of the doorposts, and beneath one of the windows the skins of a wild cat were displayed.

The inside was dark and smoke filled the room, bringing tears to the eyes. On the black walls someone had traced a scorpion and a swastika in butter, the signs of good luck for the household and of devotion to the protecting spirits.

Nyima Tashi was a man of indeterminate age, but he did not seem as old as had been described. He wore a military khaki jacket and a Chinese army beret. His wife appeared in the darkness; she crouched beside the clay hearth, wrapped in a shroud of dense smoke and wearing the same military beret as her husband.

Jamyang murmured to us not to eat, drink or touch anything. Nyima Tashi invited us to sit down. On the wooden bench lay a dead field-mouse. Nyima Tashi's wife came over and placed four steaming cups of tea with butter in front of us.

'When the world began,' Nyima recounted, 'there were two kings in Kongpo. One was wise and generous, the other as evil as a demon; he was in fact the Prince of the Demons. One day the evil king, whose name was Khyappa Laring, received word that Tonpa Shenrap, the Master of the World and the founder of Bon, a

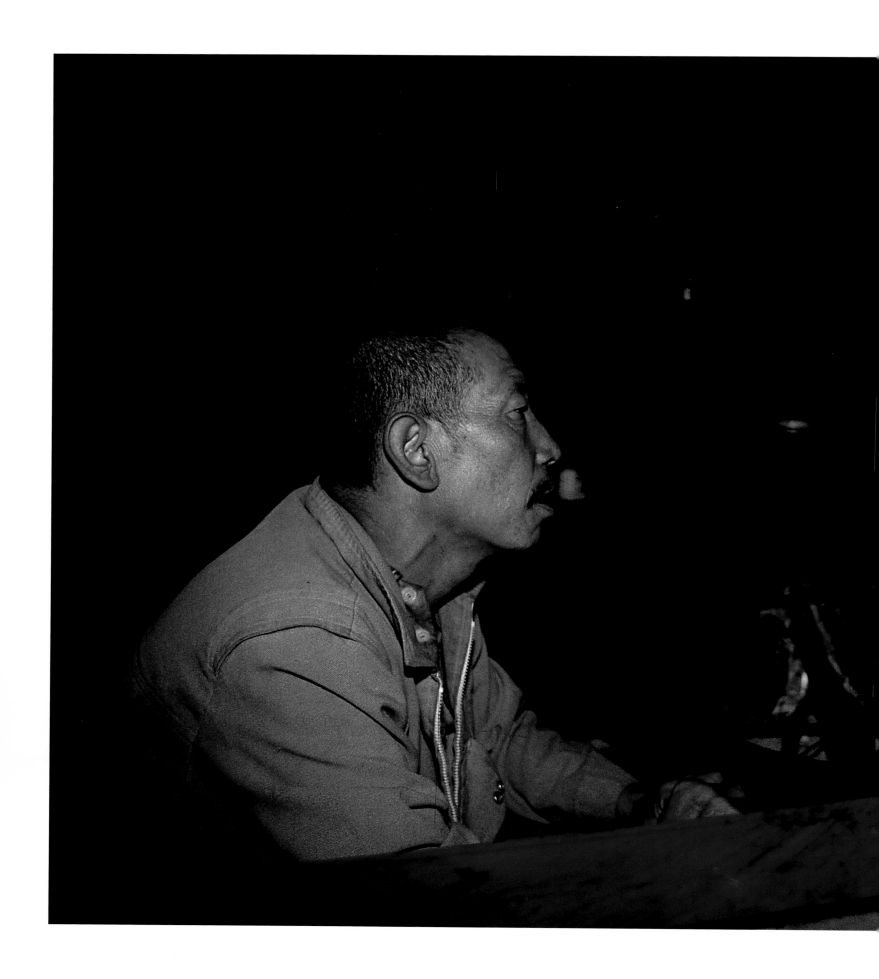

Buddha who lived in the west of the country in the region known as Wolmo Lungring, was on his way to visit Kongpo in order to spread the new religion. The Prince of the Demons then hatched a plan for stopping Tonpa Shenrap. He selected seven of his most loyal subjects and sent them into Tonpa Shenrap's kingdom with the mission of stealing the seven finest horses belonging to the Buddha and bringing them back to Kongpo. Here Khyappa Laring concealed the horses in a remote village on the mountain so that Tonpa Shenrap could not find them. That village has been known ever since as Tatoka, 'he who stays at the top with the horse'.

'Tonpa Shenrap, who was the Buddha of the Bon and from whom nothing could be hidden, set off in search of his horses.

'Fearing the Master of the World's anger, Khyappa Laring implemented his plan for preventing Tonpa Shenrap from reaching Kongpo. He first caused a large snowdrift to cover the horse tracks; then he hurled a mountain into the Tsangpo/Brahmaputra and stopped its flow. But the Buddha of the Bon knew more powerful magic: with his light he melted the snow, then placed his hand beneath the mountain, lifted it up, and placed it like a resplendent jewel on the bank of the Tsangpo.'

That mountain, Nyima Tashi informed us, is Bonri – the mountain we were now on, the place where the Bon come on pilgrimage from every corner of Tibet.

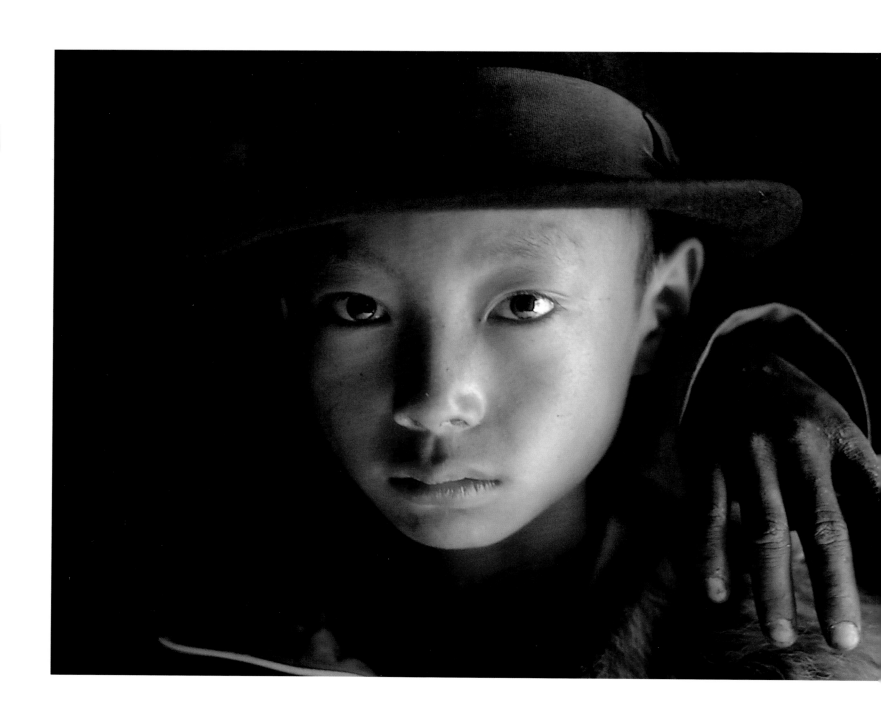

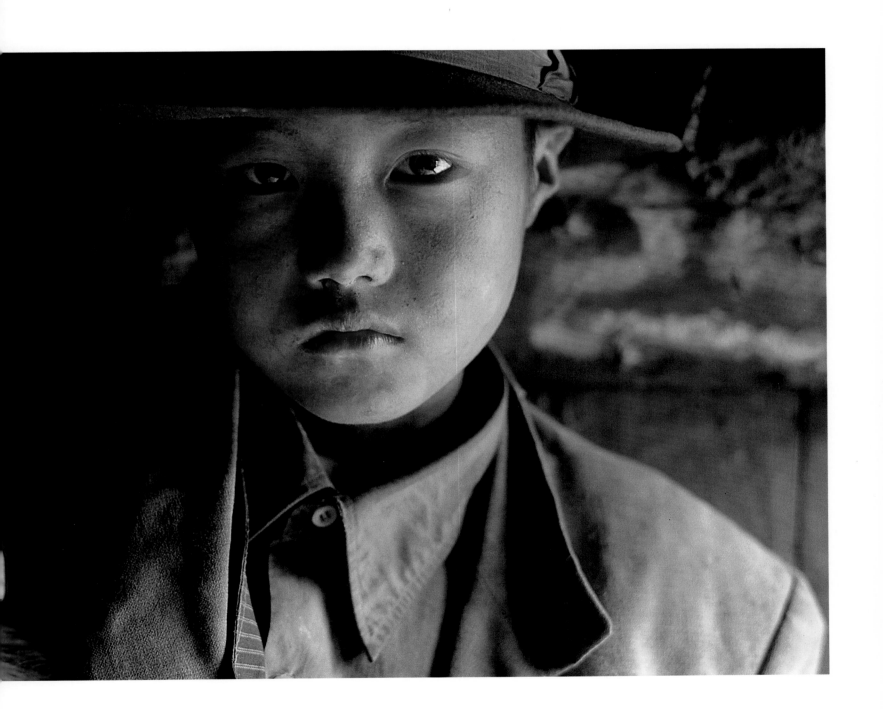

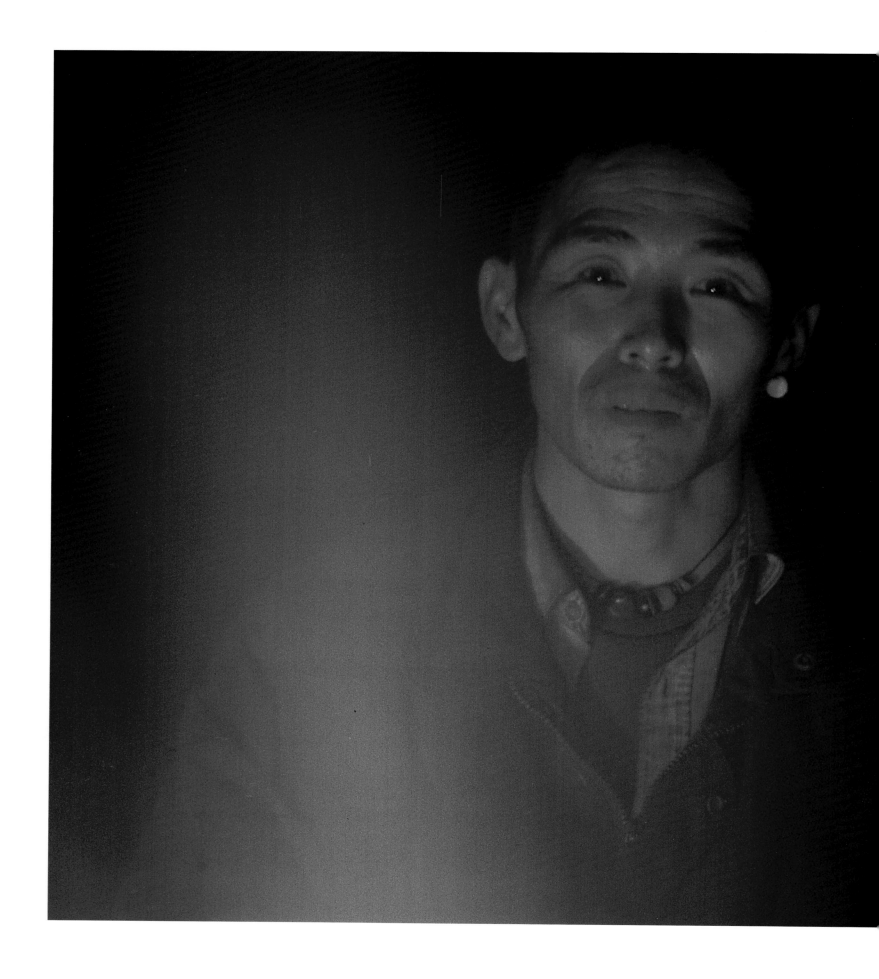

'The Demons of Kongpo then diverted the flow of the Tsangpo to submerge villages, hills and cultivated valleys. In his infinite compassion, Tonpa Shenrap transformed the lotus flowers into boats, boarded them and, together with his retinue, was borne along by current of the river. Seeing the Master of the World, resplendent with light, the Lord of the Waters swore allegiance to him, embracing his teaching, and the waters of the Tsangpo began to flow more slowly, resuming their usual course towards the east.

Infuriated by this, the Prince of the Demons caused a storm to break to kill Tonpa Shenrap with thunder, lightning and hailstones the size of pebbles, but with a single gesture the latter turned the lightning into stars and the hailstones into flowers that later spread over the surrounding mountains, while the horde of demons were cast into the Kongpo gorge.

Khyappa Laring then challenged Tonpa Shenrap to a final test: an archery contest in which the loser would submit for ever to the victor. The arrow shot from Khyappa Laring's bow travelled many thousands of miles out of sight. But Tonpa Shenrap released so fast and powerful an arrow that, after destroying the palace of the Prince of the Demons, it buried itself in the bank of the Tsangpo/Brahmaputra, creating a stream of turquoise waters. Defeated, Khyappa Laring gave himself into the hands of Tonpa Shenrap and, embracing his religion, became one of the protectors of the Bon doctrine.

Tonpa Shenrap then returned to his kingdom. Certain she-demons, loyal to Khyappa Laring and determined not to submit to the Buddha of the Bon, appeared to him as beautiful young girls and offered him a poisoned draft.

Guessing their plan, Tonpa Shenrap pretended to fall into the trap, drank the poison as if it were nectar, and then pretended to be very ill. The she-demons, convinced that the potent poison they had administered to him had produced the desired effect, were exultant and prepared to restore the Prince of the Demons to his throne.

Suddenly, however, Tonpa Shenrap resumed his normal state and cast a spell of old age on the she-demons, transforming them into decrepit old hags. In horror they prostrated themselves before Tonpa Shenrap, imploring him to pardon them. All were forgiven except two, who fled and took refuge among the peaks of Kongpo. Here they divulged to the women of the area the secrets of the poison and the art of harnessing the powers and riches of others by robbing the victims of their vital spirit.'

Nyima Tashi broke off his story and sipped another cup of tea. Our own cups were still full on the table, untouched.

The *gombi*, the cow bladders used as bellows which hung above the fire, let out a sinister dry wheeze.

'It's going to rain,' Nyima Tashi observed, glancing towards the bellows. 'They always make that noise when rain is on the way.'

Nyima Tashi's account was imprecise: the popular imagination had mixed and confused the myths of Tonpa Shenrap, Buddha of the Bon, with episodes from the life of the epic hero Gesar of Ling, conqueror of Kongpo, who is said to have civilized the demons who originally inhabited the region. However, we thought it proper to record it as we heard it from Nyima Tashi's lips.

The tea was cold by now, but no one made any move to encourage us to drink. In a country where hospitality is highly regarded, the refusal of food by a guest was considered normal.

Another episode made an impression on us. Some days later, while staying in a village at the edge of Bonri, we accepted an invitation from two old women to visit them at home. When we took our leave, Tiziana and Norbu, the Nepalese Sherpa who was our assistant, were presented with a large quantity of dry cheese; the same cheese that we had bought from mountain shepherds on many occasions before entering Kongpo.

As soon as we had left the village, Jamyang dug a hole in the ground and buried the cheese 'because not even the animals can eat it.' And he urged Tiziana and Norbu to wash their hands thoroughly in a stream.

Nyima Tashi's house was full of people. Two boys leant against the wall, drinking in every word of his story.

'Where did the poison come from?' we ventured to ask.

'From the *tsen gdu*,' replied Nyima Tashi. 'They flower in summer at high altitude, on the Kongpo mountains around Bonri from where the water of the Tsangpo can be seen, because it is from the sight of the Brahmaputra that they derive their poisonousness. Some have sky blue petals; others, the ones with the most potent poison, are vermilion.'

Every part of the *tsen gdu* is poisonous: the leaves, the stem, the petals, but above all the pistil and the base of the flower. Their poison is very slow acting.

'A month or two, even three months, may pass before the poisoned person dies,' announced Nyima Tashi. 'That is why no one known who the poisoners were'. According to the information about the she-demons in the legend, the poison is administered only to travellers or to those passing through. The people who have been poisoned die mysteriously, far away from the house in which the poison was administered. Therefore no suspicion rests on the poisoner, who is able to enjoy the vital energy and the *g.yang* of the victim.

Some time later Jamyang told us about mysterious deaths he had heard about in Lhasa: people who had come on pilgrimage to Bonri and had then died without any illness or other obvious cause of death. The sextons who, in accordance with the holy funeral rite, had the responsibility of cutting the bodies into pieces

as food for the vultures, had mentioned finding traces of poison in the flesh.

Nyima Tashi added that the poison obtained from the flowers growing in sight of the Tsangpo is odourless, colourless and tasteless. It is said that the poisoners place a small quantity beneath their finger nails and that, when offering tea to their guests, they allow it to fall into the drink simply by pressing the finger against the edge of the cup. Others say that it is administered in solid food, such as cheese, or injected into eggs by pricking a hole with a thorn that has been dipped in the poison. According to popular belief, a tiny amount on the skin or even on the clothing of the victim can be fatal.

'There are those who say,' continued Nyima Tashi, 'that the poison is prepared at full moon and the women blacken their faces with soot.'

No one knows who the poisoners are. Or perhaps someone does. There are those in the country who have become very rich. One of these stories related to events that had taken place in the village some fifteen years earlier.

'At the time there lived in Nyingtri a young man who was in love with a beautiful Kongpo girl. One evening, as he was going to his beloved's house, he heard strange sounds coming from inside. Peering through the window, he saw the girl's mother with her face half blackened with soot and half white with tsampa. Her hair was dangling down and the other half was tied up in a plait. The woman held a pan in her hand, which she was shaking vigorously, reciting mantras. There was not the slightest draught in the house, yet the *rlungta*, the prayer cloths that hang from the domestic altar, were fluttering as though in a mountain breeze.

Terrified by what he had seen, the boy ran off, but the woman realized what had happened and followed him. He ran as fast as he could, but the woman seemed to fly and quickly caught up with him. The boy begged her not to harm him, promising that he would tell no one what he had seen. The woman agreed, provided he was prepared to leave Kongpo.

The boy went far away, to India. However, he told his best friend, who lived in Kongpo, what he had witnessed that night.

So people know who this woman is, but they are afraid to reveal her identity.'

It was in search of *tsen gdu* on the mountains of Kongpo that we came across Saddhi, a tawny coloured bitch of indeterminate breed, who became our inseparable companion on the paths which were to lead us from the base of Namche Barwa along the course of the Tsangpo until the great Curve formed by the river before it crosses into India and assumes the name Brahmaputra.

We had prepared the expedition with great enthusiasm and with the scant information we had been able to gather on the area, an area which is still one of the least-known places in the world. We had planned to travel as far as the Curve and hoped to be able to follow the river bank from the base of Namche Barwa, almost 8,000 metres high, a mountain not known to Europeans before 1912.

We knew that it was not always possible to follow its course, especially in summer when the river is swollen and covers sections of the track from Gyala to Pemakochung, a small uninhabited monastery lost in the gorges of the Brahmaputra. We nevertheless decided to make the attempt.

At Pe, at the foot of Namcahe Barwa, the road stopped. We had either to continue on foot or on horseback. Little had changed since the times when Bailey, Morshead and Kingdon-Ward had travelled along these same paths in search of the mythical Tsangpo waterfall.

For many years European geographers wrestled with a number of unanswered questions. Were the Tsangpo of Tibet and the Brahmaputra of India the same river? Where was the hidden waterfall which the waters must negotiate in order to descend from an altitude of over three thousand metres to the more modest level of just over one hundred metres, the altitude of the Brahmaputra in India? Where did the waters of the Tsangpo go when they passed through the impenetrable gorges of Kongpo? According to a legend recounted by E. Candler, they disappeared into a huge hole in the

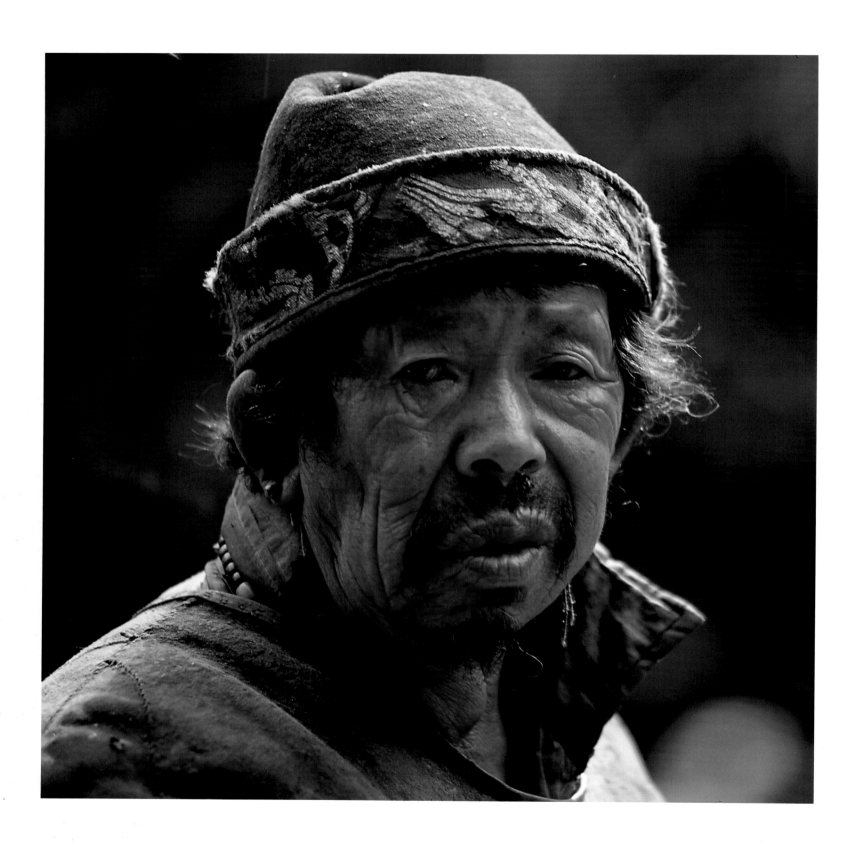

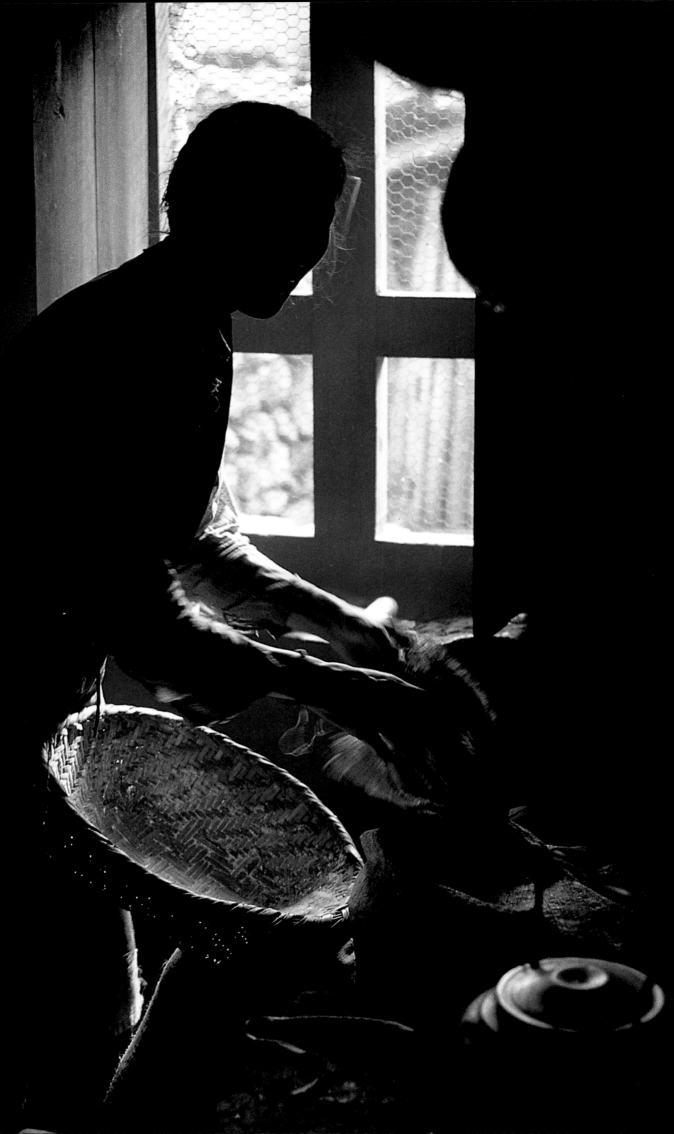

earth. Sarat Chandra Das, in his explorations along the course of the Great River, met a 'grey-haired monk who had travelled extensively in Kongpo and between the Nagas and the Mishmis'; this monk told him that 'the savage Lopas of the mountains robbed Tibetan pilgrims' and that 'the Tsangpo entered western Bhután by means of a spectacular waterfall over the edge of an enormous precipice that the locals call the 'Face of the Lion'.'

From the geographical point of view there were many possible solutions: the Yangtse, the Mekong and the Salween all descended from an area north of Burma. Then there was the Irrawaddy, as well as the Dibong and the Dihong which descended into India and flowed into the Brahmaputra. The only sure way of solving this mystery was to follow the course of the Tsangpo in Tibet and to go up the Brahmaputra in Assam. But this was also the most arduous solution.

The Great River passes through some of the most difficult terrain in the world, between outcrops of rock and mountains covered in dense rain forest. There were political obstacles: the Chinese prevented foreigners from entering a territory over which they laid claim; and the Tibetans themselves did not welcome foreigners wishing to enter their country.

Even in India the track was fraught with its own difficulties. The Himalayan slopes of that region, now known as Arunachal Pradesh, were covered with impenetrable forests populated by hostile, aggressive tribes. The Abor, the Mishmi and the Gallong – the names of some of the peoples in this area who are continually in conflict with each other – looked on expeditions in their territory as an excuse for ambushes from which they could gain some material benefits.

In the second half of the 19th century, when the Survey of India decided to send its Pundits to carry out reconnaissance in the area, a number of openings were made in the dense veil of mystery that surrounded the course of the Tsangpo.

In 1879 the research carried out by Krishna, known by the initials A.K., ruled out the possibility that the Tsangpo flowed into any of the three rivers that descended from the area north of Burma: the Yangtse, the Salween and the Mekong. However, there was considerable doubt as to whether its waters found their way into the Dihong, the Dibong or the Lohit, rivers which flowed off the Himalayas into Assam. It was only at the end of the 1870s that Captain Harman, having measured the flow rates, came to the conclusion that the waters collected by the Tsangpo along its route through Tibet must be linked up with the Dihong, the largest of the three rivers in question.

In order to confirm this, in 1878 the Survey of India, which was run by Captain Harman at that time, sent Nem Singh (code name GMN), to Tibet with the task of inspecting the course of the Tsangpo after Tsetang. Nem Singh followed the course of the Great River as far as Gyala, a small village at the foot of Gyala Pelri, in the company of his servant, Kintup, a young illiterate Sikkimese.

A year later, Kintup returned in the service of a Mongolian monk chosen by the Survey of India to continue the uncompleted reconnaissance work of his predecessor, Nem Singh.

Reaching Gyala the two were instructed to following the course of the Tsangpo to where it ran closest to the Indian border. Here, on a certain agreed date, they were to throw five hundred small lengths of wood in which they were to insert the thin metal tubes with which they had been issued, together with other instruments normally supplied to Pundits. Captain Harman and his men would wait for these sticks on the other side of the Himalayas in Assam. If they arrived, it would establish once and for all that the Tsangpo and the Brahmaputra were one and the same river.

The Mongolian monk and Kintup followed the course of the Tsangpo as far as Pemakochung. where the track came to an end. Having no alternative but to retrace their steps, they headed north. At this point, for some unexplained reason, the Mongolian monk abandoned the mission and sold the unschooled Kintup as a slave to

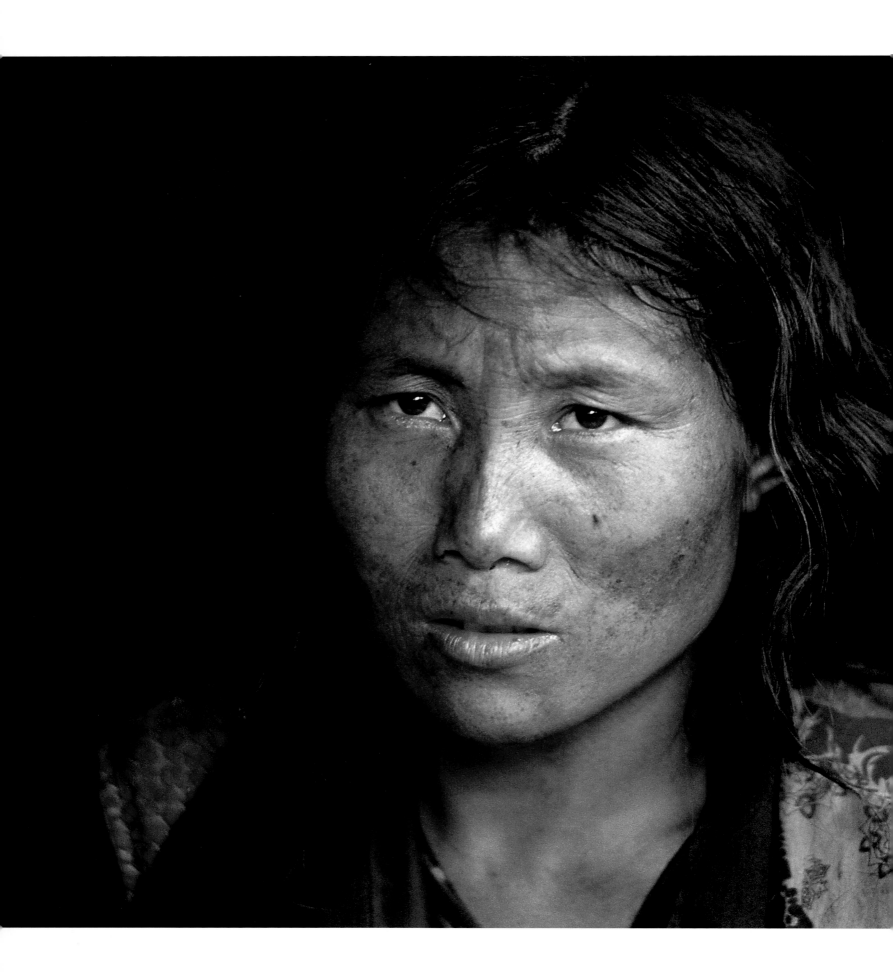

the local *dzongpon*. For seven months Kintup worked as a tailor, waiting for a chance to escape; when an opportunity arose, rather than returning to his Sikkim homeland, he decided to continue the mission that had been entrusted to him. He returned to the Tsangpo and followed its course for some distance until, reaching Marpung Monastery, the men sent out in his pursuit by the *dzongpon* caught up with him.

Kintup presented himself to the Abbot of Marpung and, throwing himself at the Abbot's feet, told him he was a poor pilgrim, tricked and sold as a slave by an ignoble travelling companion. Moved with pity, the lama bought him for fifty rupees. Though still a slave, Kintup enjoyed better conditions in the service of the lama. Eventually he gained the latter's confidence and was given permission to go on pilgrimage. Kintup made his way to a cave on the river where he prepared and hid five hundred sections of wood for throwing into the Tsangpo. A long time had passed since he had left Darjeeling with the Mongolian monk, and before launching his prepared pieces of wood onto the river, Kintup had to get a message to the Survey of India so that someone in Assam would be ready to watch for them. He then set off for Lhasa on pilgrimage and, with the blessing of his patron, headed for the holy city. Here he dictated a letter to Nem Singh informing him of his betrayal by the Mongolian monk, of his own trying experiences and of the date on which he planned to release the sticks into the river. He entrusted his message to a fellow Sikkimese, instructing him to take it to Darjeeling. Returning to the monastery, he once again served the lama until it was time to depart. When he asked for permission to go on another pilgrimage, the lama was so impressed by his faith that he gave him his freedom. Kintup then set off, as a free man, in the direction of the Tsangpo. In November of 1883 he threw his sticks into the river. He then resumed his journey to India, following the river valley, but the aggressive Abor tribes forced him to turn back. Reaching Darjeeling, after a gap of four years, he learnt that during his absence both Nem Singh and Captain Harman had died and that his message had never reached its destination. No one had been there to watch for the sticks carried along by the Tsangpo towards the sea.

The account of his journey met with a cold response from the Survey of India. The only news – which later proved untrue – to arouse any excitement was that of a 150-foot high waterfall formed by the Tsangpo, which everyone was prepared to believe for the simple reason that this is what they reasonably expected to be true.

The absence of facts was made up for by imagination, and it was believed that the gorges of southern Tibet hid a waterfall which could compete with the more famous ones of Niagara and the Zambesi. In 1906 Sir Thomas Holdrich, President of the Royal Geographical Society, in his *Tibet the Mysterious*[1], imagined a 'Tibetan branch connecting with the Assam railway and a spacious hotel for visitors and those who enjoyed the outdoor life, right opposite the waterfall.'

Many long years passed before the existence of the legendary waterfall could finally be verified.

When, after punishing expeditions against the native tribes in the early 20th century, a way through the forests of the Mishmi and the Abor was opened up, the British official, Colonel F.M. Bailey, set out in the footsteps of Younghusband's expedition with his companion Morshead in search of the mythical waterfall on the Tsangpo. He was later awarded a gold medal by the Royal Geographical Society.

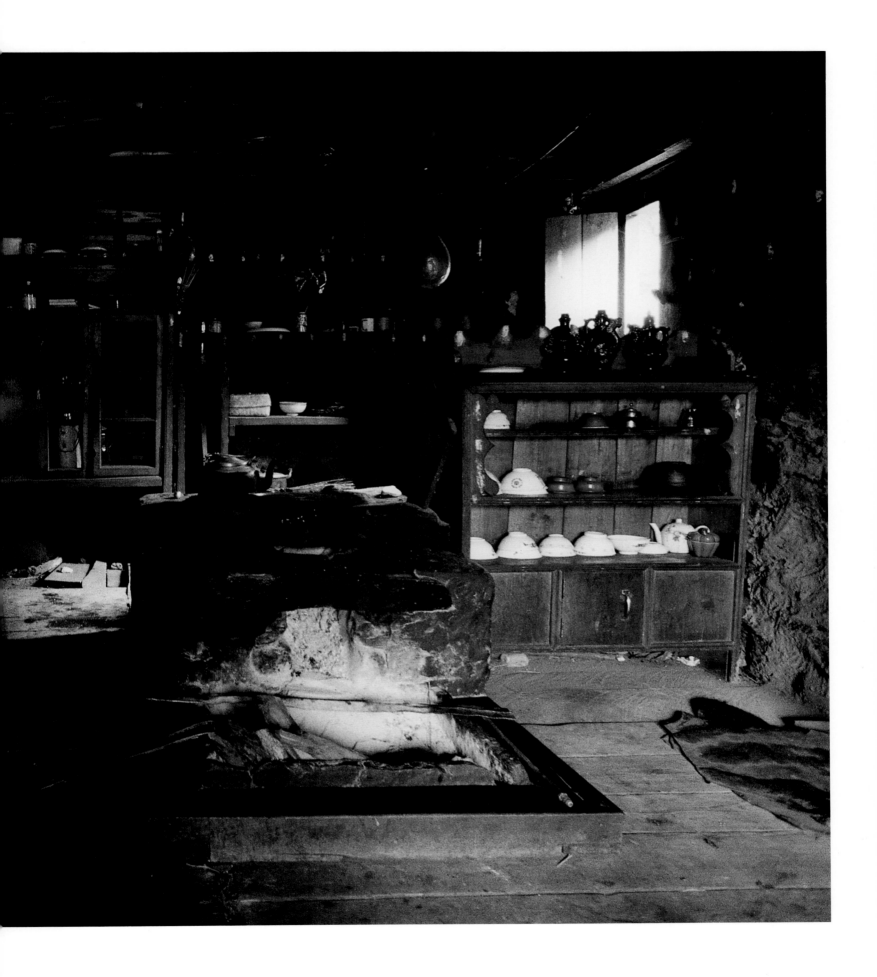

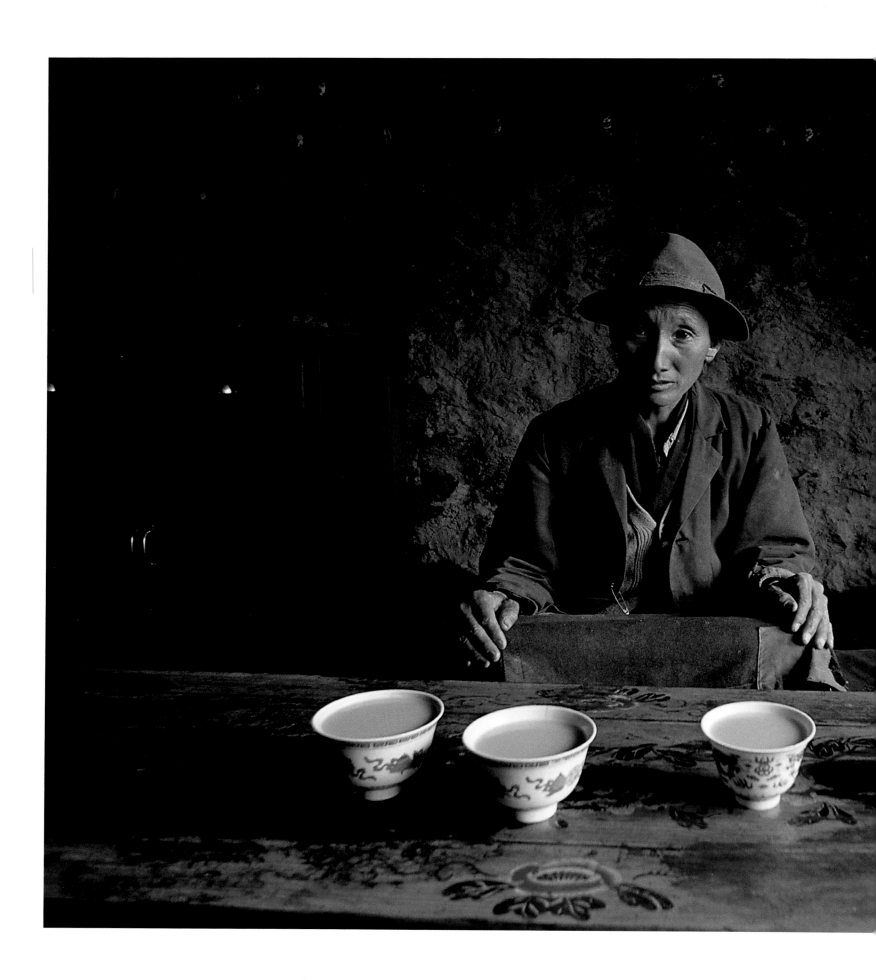

On the basis of the information contained in Kintup's report, whose accuracy they were able to verify, they followed his route to Pemakochung but found no trace of the waterfall about which so many stories existed.

While Morshead devoted all his attention to topographical surveys, Bailey collected precious specimens from the abundant flora and fauna which were unknown in the West. He was the first to observe the blue poppy, *Meconopsis betonificifolia Baileyi*, of which the famous botanist Kingdon-Ward brought back seed ten years later.

Returning from this expedition, Bailey set off in search of Kintup, with whom contact had been lost in the meantime. He found him earning his living as a tailor. At their meeting, as Bailey reported, it was discovered that Kintup, who was unable to write, had had to dictate the results of his discoveries. 'He had never said that the Tsangpo formed a high waterfall,' but had spoken about 'a 150-foot high waterfall formed by the torrent which was supposed to conceal the god Shingche,' and about another waterfall '30 feet in height near Pemakochung.' The latter, referred to by Kingdon-Ward as the rainbow waterfall and described by the English botanist as a 'beautiful sight with rainbows that come and go among the clouds of spray,' was clearly not the 'fabled waterfalls' of the Brahmaputra that had been the goal of so many explorers.'[2]

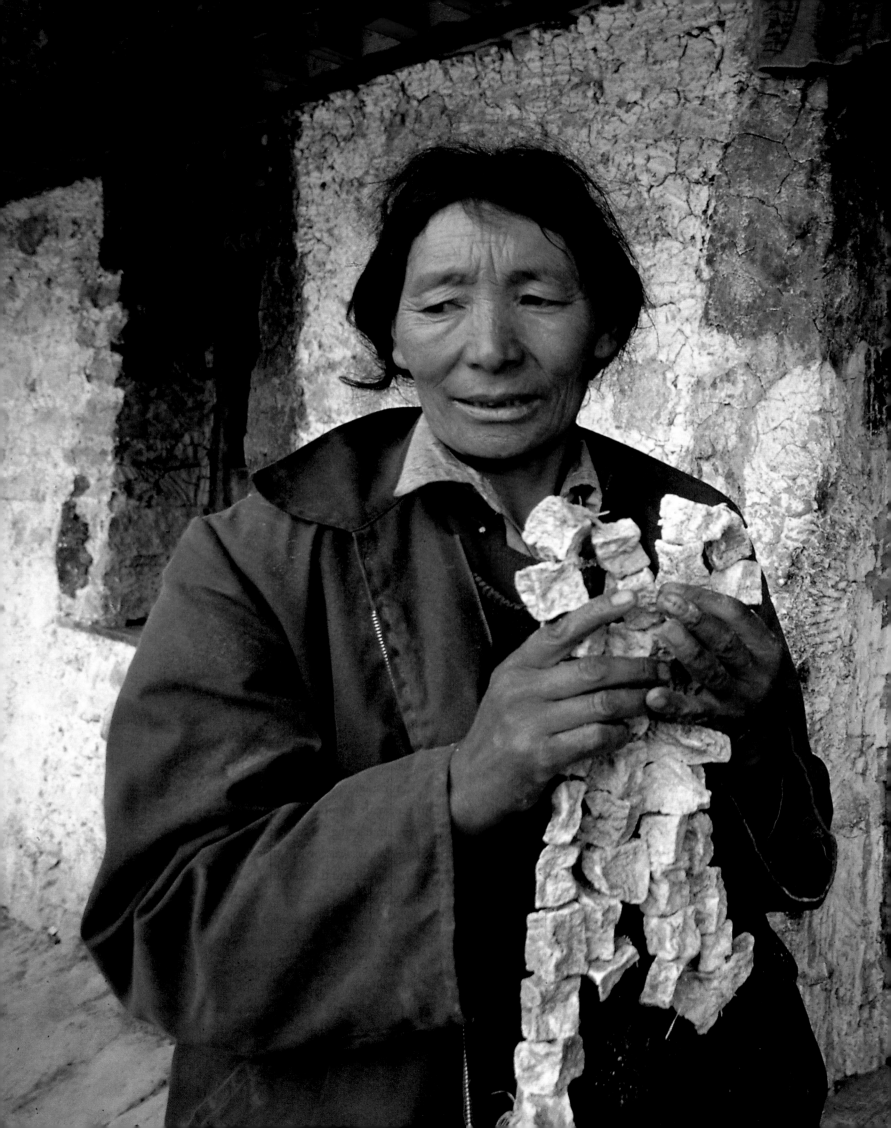

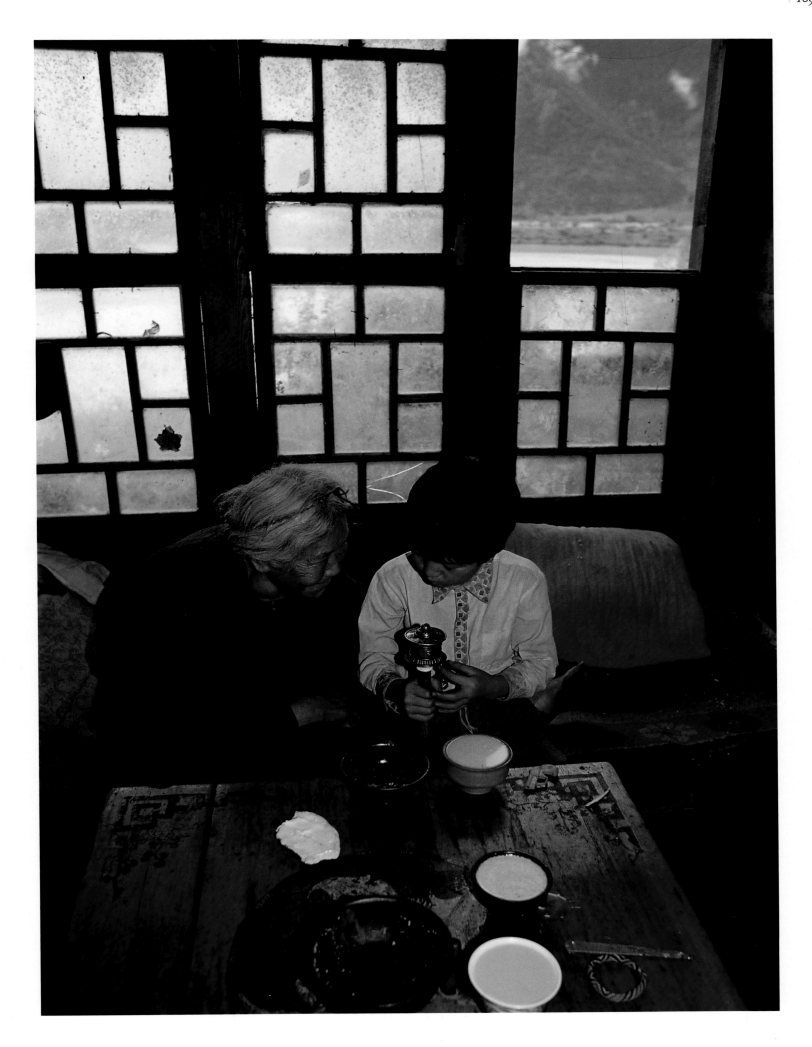

Little had changed since the first explorations and we found many of the places referred to by Kintup and Bailey. On the way to Gyala we came up against some hunters with a pack of dogs; these were of the same breed as Saddhi, bred for bear hunting. The whole of the next day we were accompanied by the cries of dogs following the scent of a bear; sometimes these would come from a distant crest, other times from somewhere in the forest. It was the only sound in the valley, apart from the voice of the river itself.

We were afraid Saddhi would desert us to follow the pack, but she only needed a handful of *tsampa* and a stroke to decide that her destiny was tied up with our own. It happened one night.

We were camped in a clearing, near a ruined house. As usual, Saddhi had chosen a sleeping place near our tent. In the middle of the night she began to growl, and then to bark furiously; in the end she was howling and we could stand it no longer. Our attempts to discourage her were in vain. Her howling cut through the silence of the night and reverberated through the gorges and out across the river, which returned her cries with disquieting echoes.

In Tibet the howling of dogs at dawn or during the night is a bad omen, presaging evil events in the days ahead. It is reported that in 1959, during the nights which preceded the massacres of the Chinese troops, the dogs of Lhasa could be heard howling constantly.

At dawn we found Saddhi lying exhausted in front of our tent. No one had managed to get any sleep and each of us stared into our cups of tea in silence. I asked Jamyang if he had any idea what had been going on in the night. Was it an animal? It could not have been wild boars, because Saddhi would normally chase them off, whereas on this occasion she had not moved away from the protection of the tents and was barking as if fearing something. A bear, perhaps.

'It was a ghost,' Jamyang announced with conviction. 'A *sundré*, or a living body from which the mind has departed; or perhaps a *shindré*, the spirit of a dead person; or it might have been a *ndré*, a good ghost, recognizable by its very narrow eyes.' According to the Tibetans, animals see these ghosts but will not approach them.

Shopi, one of the porters, began telling us that he had encountered many *sundré* and that, on one occasion, he had even seen a *ndré*. Nyima said he was making it up – only people with special powers as mediums could see a *ndré*. But Shopi replied that he had seen it hiding under the armpit of a clairvoyant who lived in his village. In turn Kelsan Nyima recounted how, one evening, when he was in a forest near Gagga, he met an old woman who beckoned to him to approach her. Convinced she was a *sundré*, he fled back to the village.

Leaving Gagga, a village on a promontory overlooking the Tsangpo, we followed the right bank of the Great River along a path dominated by the massive Namche Barwa. We crossed the cultivated fields around Tripe, a cluster of stone houses beside a stream whose waters cascaded down from the glacier, and wound our way along the side of the mountain overhanging the Tsangpo.

The path climbed and fell continually: one minute it ascended the rocky crags, the next it plunged back down to the river bed. After this it would return to the higher outcrops of rock and then make its way through an oak forest broken up by the occasional clearing. At times the path skirted the rock face and we were forced to relieve the ponies of their burdens so that they could negotiate its demanding contours carrying no additional weight: one slip could be fatal on those precipitous slopes that fell towards the Tsangpo.

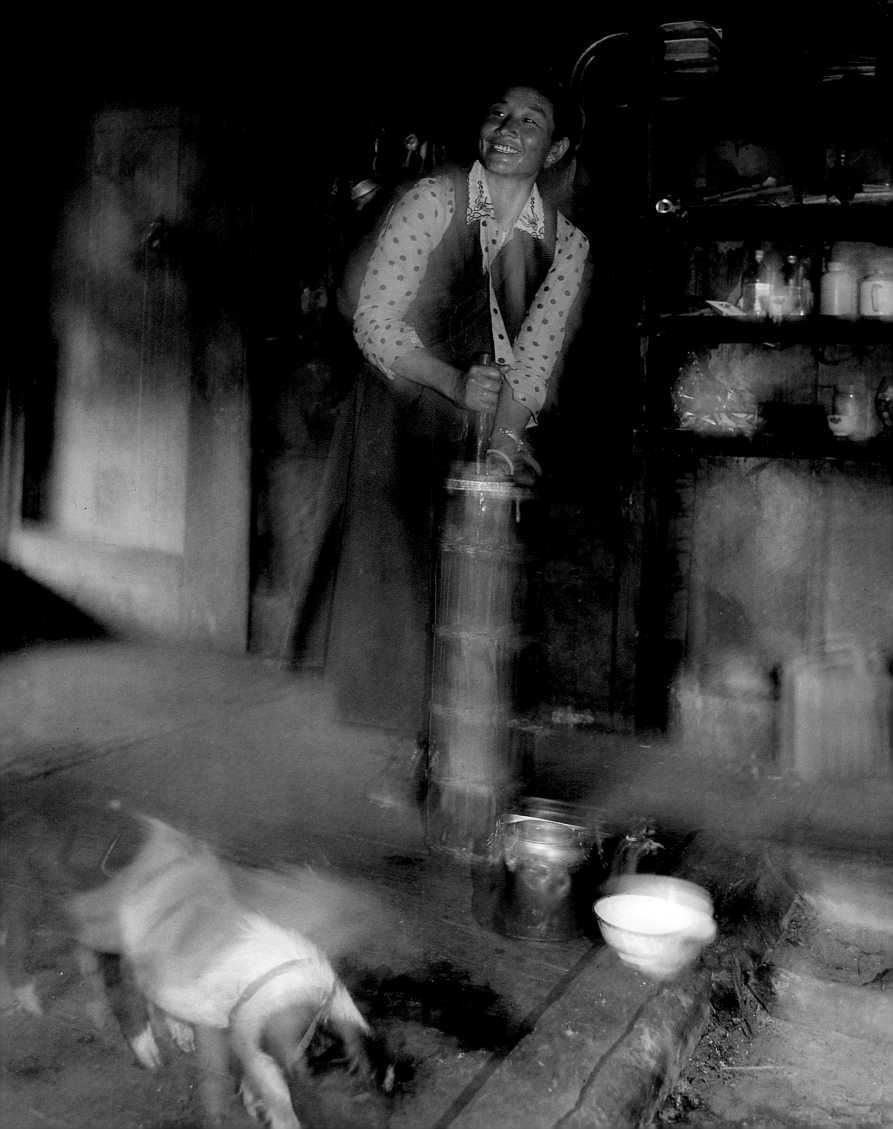

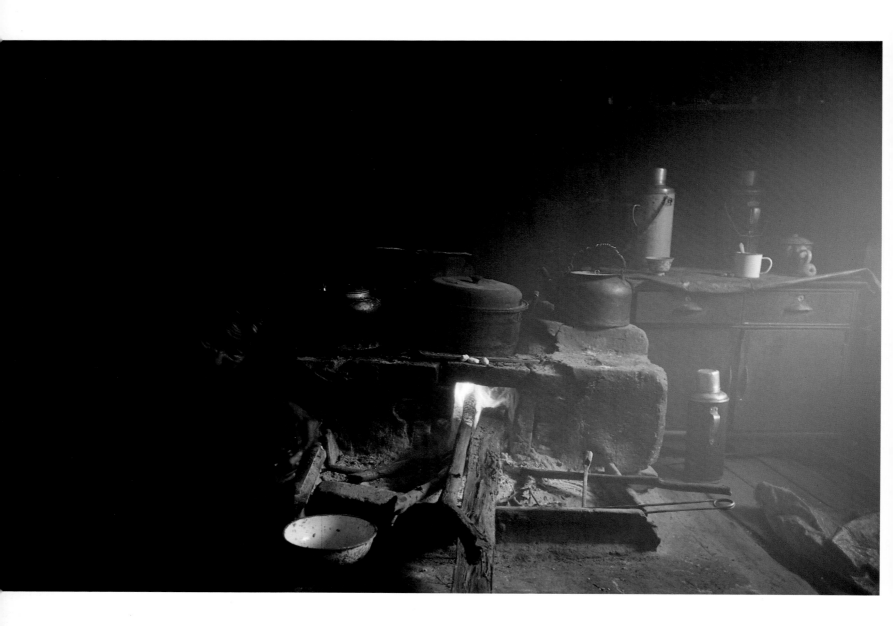

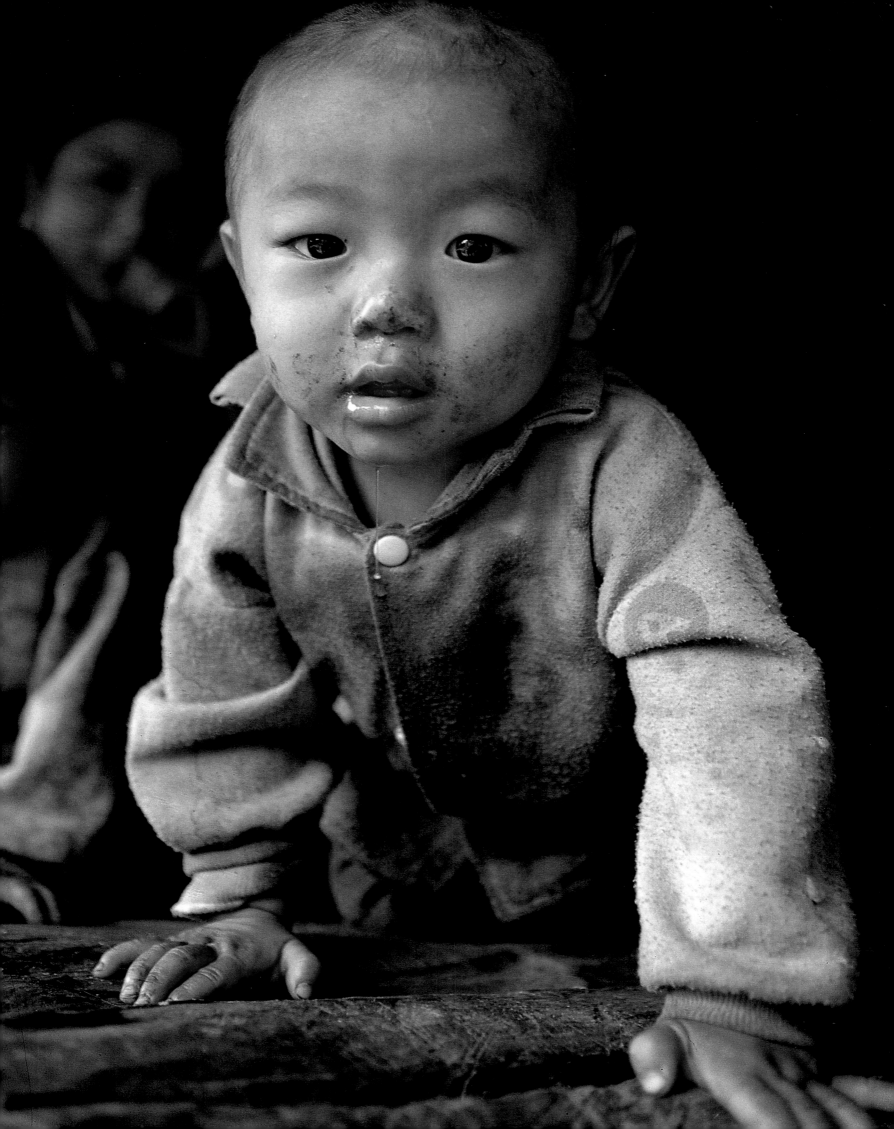

It is not strange that in a country like Tibet, where nature is so hostile, certain beliefs about the supernatural are so ingrained in the national psyche, even in young people such as Jamyang, who are in contact with a lifestyle, in either the Western or the Chinese mould, which television beams into their homes.

According to Kelsan Nyima, the clearing in which we had camped for the night was swarming with ghosts. There had once been a large village on the spot, with over one hundred houses. The people were rich. The forest gave them all the food they needed to live on – fruit, roots and game in abundance; bears, monkeys, oxen and wild boar.

One day a poor, malnourished lama visited the village. He knocked at all the doors, but no one was prepared to give him food, money or shelter for the night. The boys of the village then started to tease him and chased him, pushing him against the rocks. Enraged, the lama, who belonged to the Black Bonpo sect, skilled in the art of black magic, took refuge in the dark of the forest. He went into a state of meditation and called up a storm to shake the earth. A large landslide detached itself from the mountain and engulfed the village, sweeping it and its inhabitants into the turbulent waters of the Tsangpo.

All that was left was the clearing, and it was to this site that the ghosts of the lost village would come at night in search of their homes.

The Tibetans believe that when a person is very attached to something he is forced to abandon – his house, for instance – after death, he becomes a ghost and continues to haunt the spot on which he was separated from the object to which he was so attached. These are the so-called *mimayin*, the spirits of those who die with unsatisfied desires.

That day we walked through the dense forest until in the evening we came to Gyala, the village Kintup and his Mongolian lama had reached, thereby opening up the way to discovery of the Curve of the Tsangpo.

Unfortunately the news was not good: the river was too full and it would be impossible to reach the Curve via Pemakochung. Even an attempt to reach it from the left bank failed.

We crossed the river on a precarious wooden barge. Its motor could scarcely hold up against the strong current.

'A year ago,' the young boatman told us, wrapped in his brown woollen *gushu*, 'the river took control of a boat with twelve people on board. That left only twenty of us in the village.' We were reminded of Bailey's account of a woman who, at that same point, was carried off on a ferry, and was last seen entering the rapids before the Rainbow Falls.'[3]

The path was overgrown. In one of the gorges we saw the waterfall behind whose waters is hidden the god of Shigche Chogye, referred to by Kintup. As when Bailey was here, there was too much water and we were unable to make out the image sculpted in the rock.

Shortly after this, our path was blocked by a wall of rock. There was nothing for it but to retrace our steps to Pe and try again from the north, following the route of the Po Tsangpo to the point where it joined the Tsangpo, in the hope of reaching the Curve from there.

On a parched afternoon in late August we reached Pailong, which consisted of two rows of wooden huts either side of the road to Chamdo. We needed porters for our provisions and equipment, since it would be unthinkable to obtain supplies on the way and the path along the course of the river was too narrow and dangerous for beasts of burden.

As soon as we had crossed the suspended bridge at Pailong, we entered a world in which Nature had absolute control.

The river, to quote Kingdon-Ward, 'flowing like a damned soul between the hot hell of the heart of the Himalayas and the cold hell of the windswept peaks that overlook the gorges, became more and more turbulent, and at the same time the landscape became harsher and the rumbling of the water more threatening.'[4]

As we proceeded, the walls of the valley closed in above us. The only traces of human existence were the swinging bridges over the waters as they descended into India. Wooden bridges suspended in the void, through the chipped slats of which were glimpses of the furious river; primitive bridges, a testimony to the ingenuity of man in overcoming an impossible river. Some were nothing more than a steel cable thrown across from one bank of the Tsangpo to the

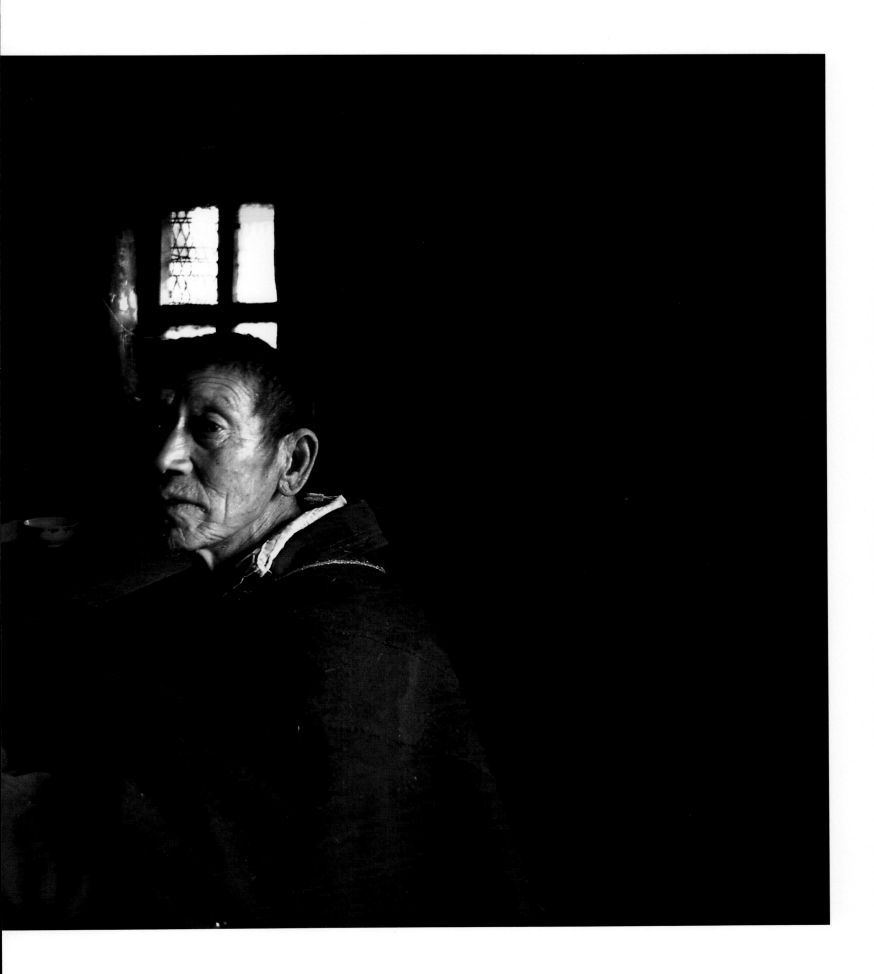

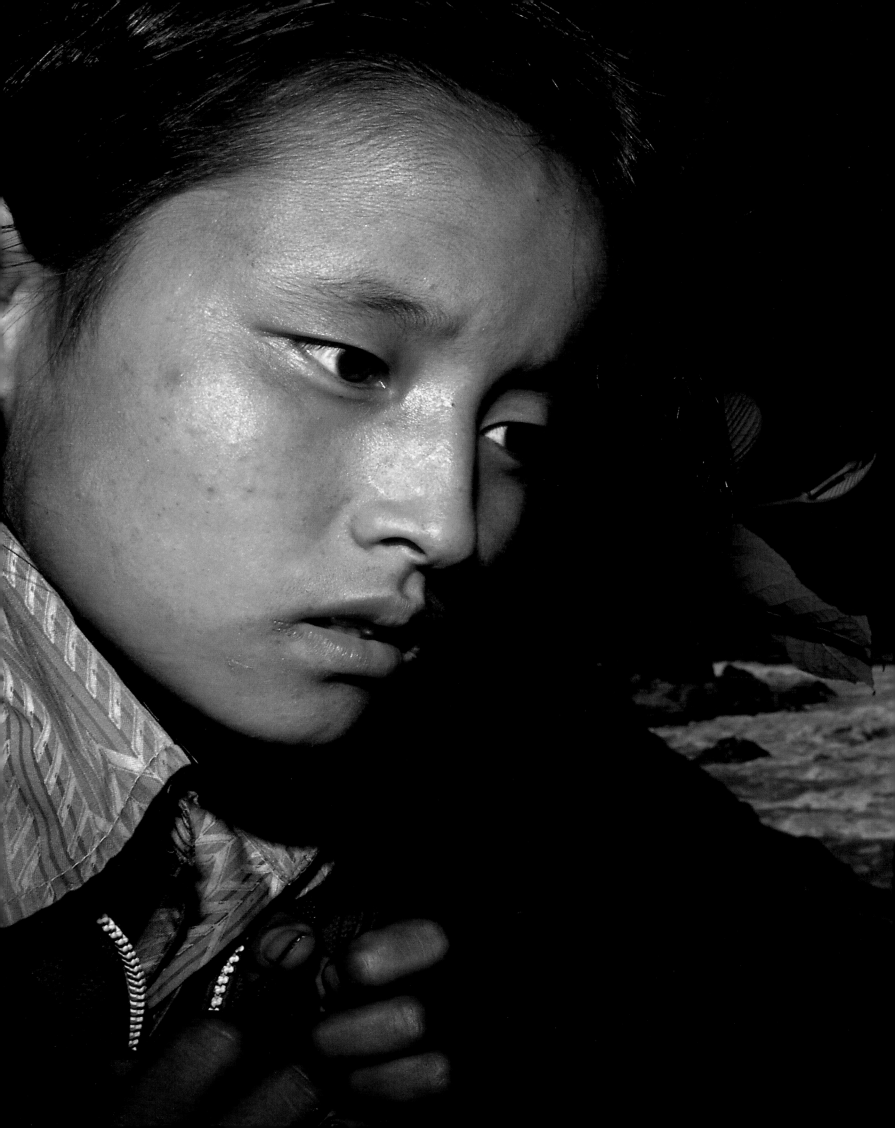

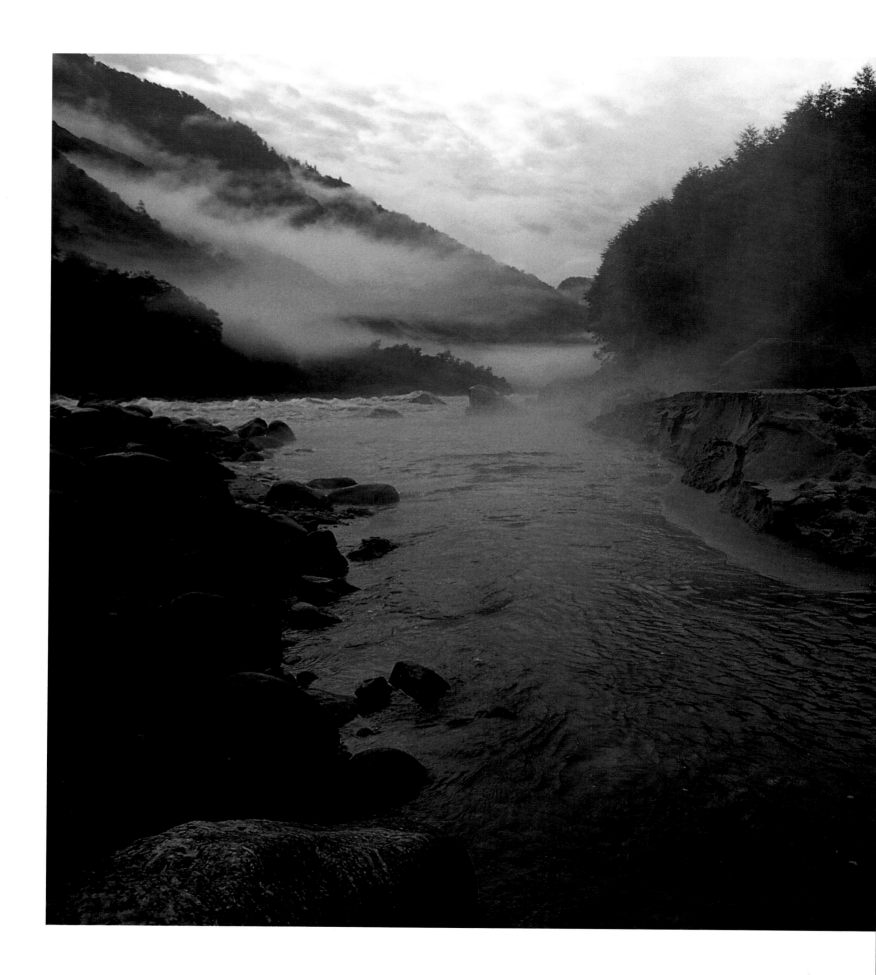

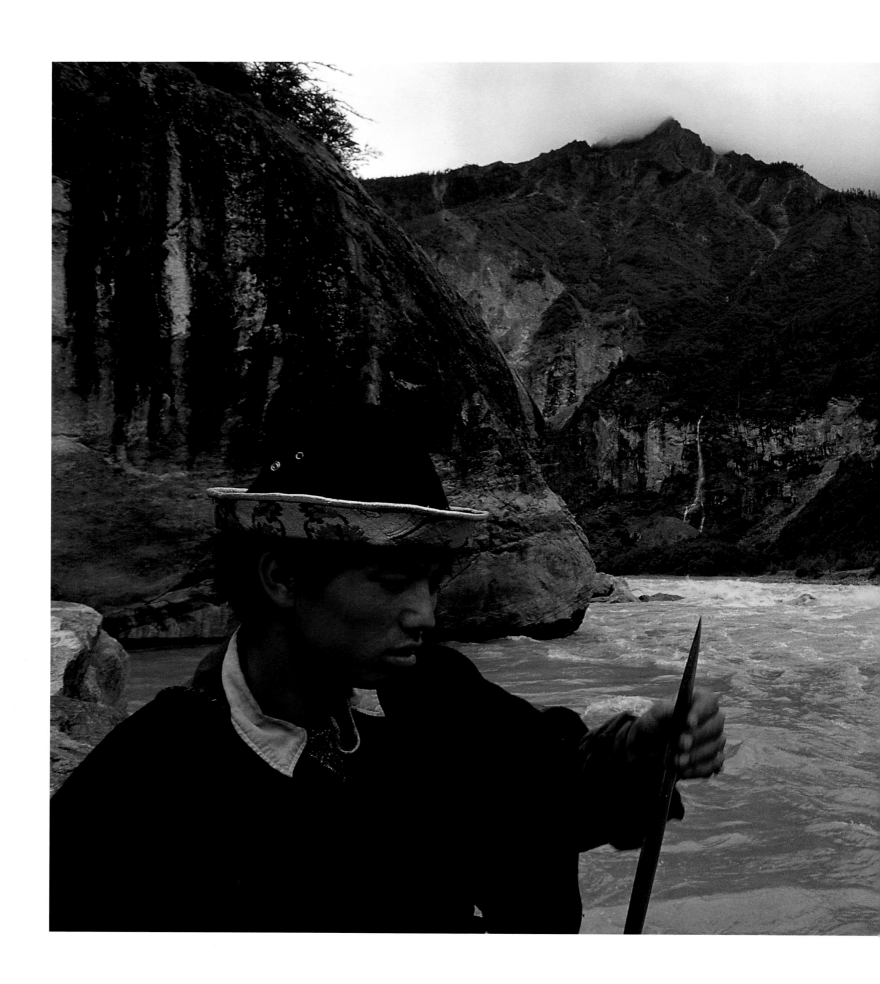

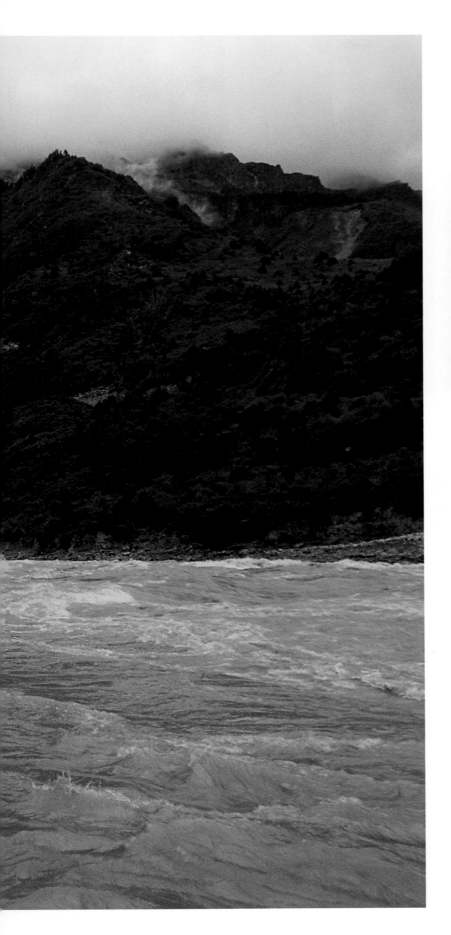

other, and the natives crossed these by means of a pulley and a rope which they tied around their waists. Kingdon-Ward too was impressed by how dangerous it was to cross by means of these bridges: it requires extraordinary skill and control of body and mind. The danger comes from the river.

'When you are half way along the cable,' says Pema Tsetar, a Memba who lives at the point where the Po Tsangpo meets the Tsangpo, 'you have to muster all your strength to climb back up towards the other bank, exerting every muscle in your arms and legs. The sound of the water is deafening and the whirlpools beneath you can make your head spin. It is at this point that you may be overcome with nausea and you may become immobilized, unable to go forwards or backwards, a prisoner of the river until, overcome with tiredness, you fall into the waters which draw you to certain death.'

The path leading up to the Curve is cut out of the side of the mountain, high above the raging torrent. From time to time a land-slide has obliterated any trace of the path, gouging deep wounds in the rock face and producing cones of detritus which fall away down into the river flowing over one hundred metres below. More than once we were forced to tie ourselves together with a rope.

Often the path disappeared beneath vegetation. Pema Tsetar cut a way through this with his knife as though it were some heavy-duty

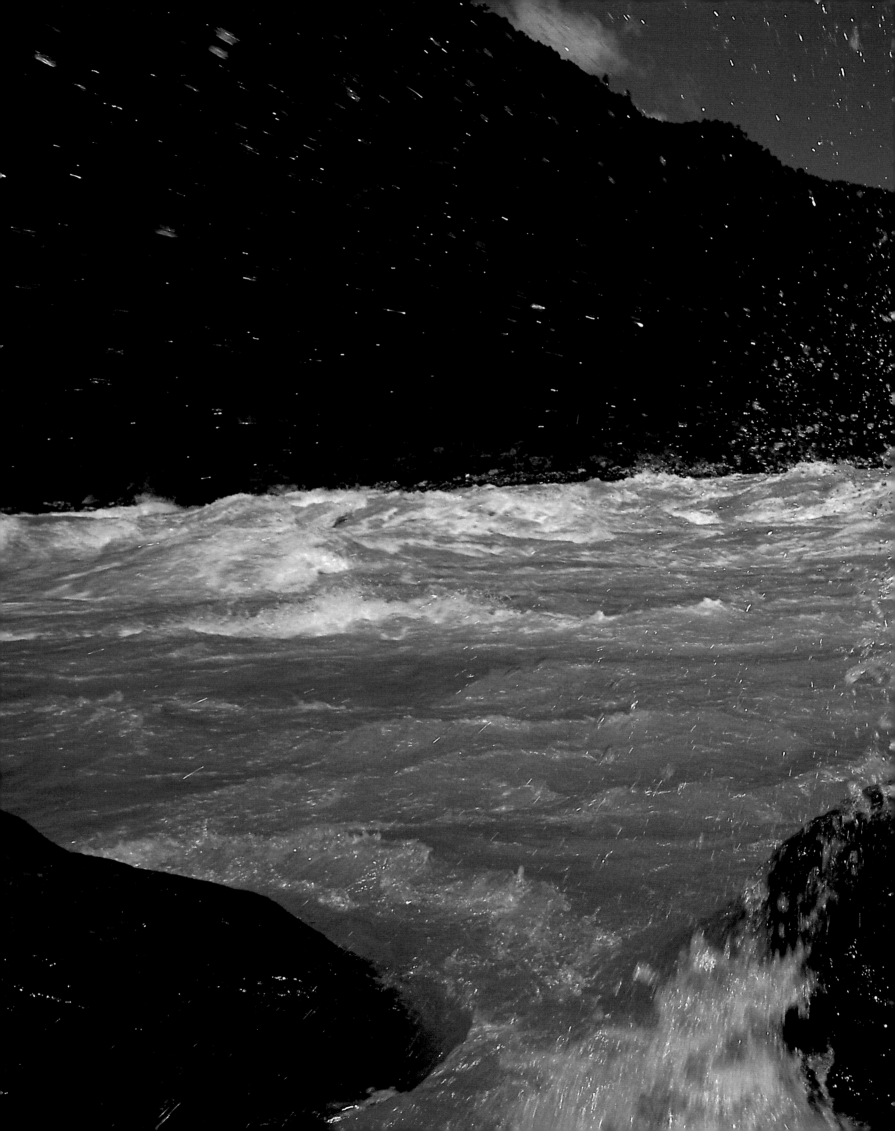

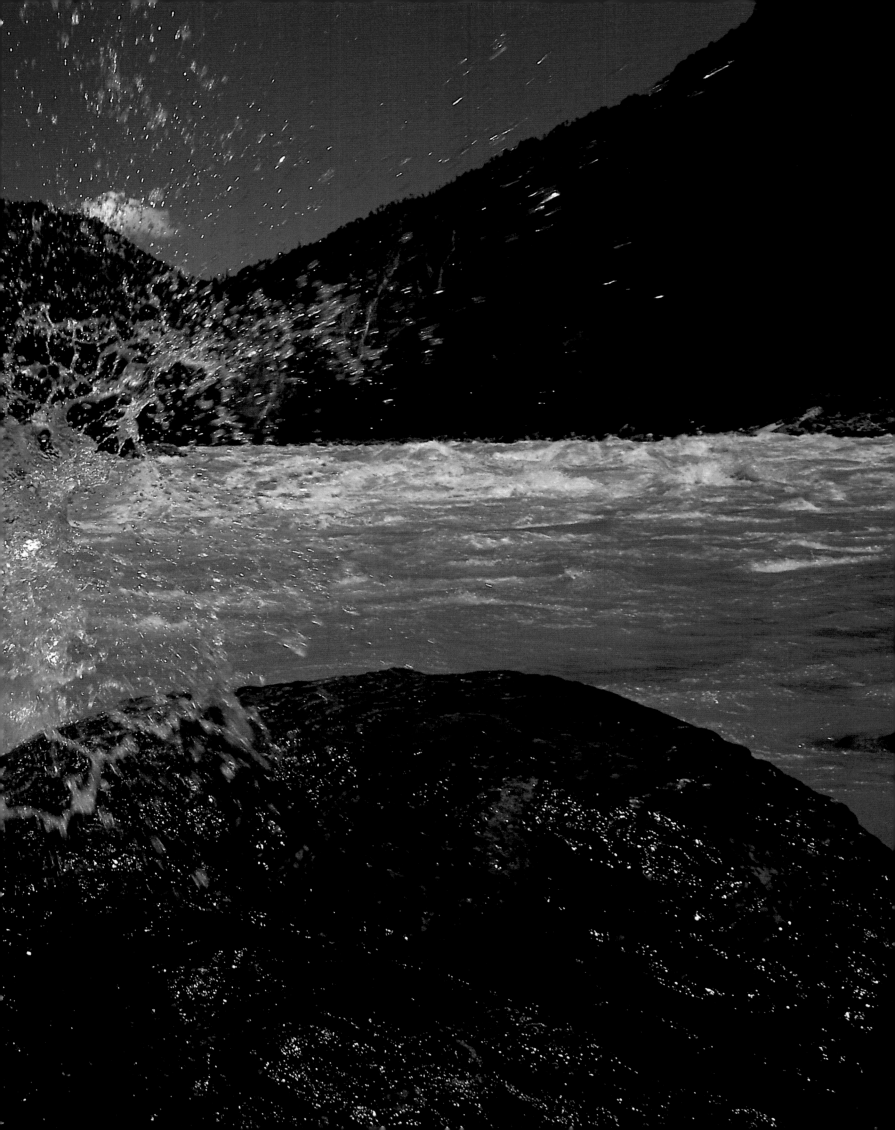

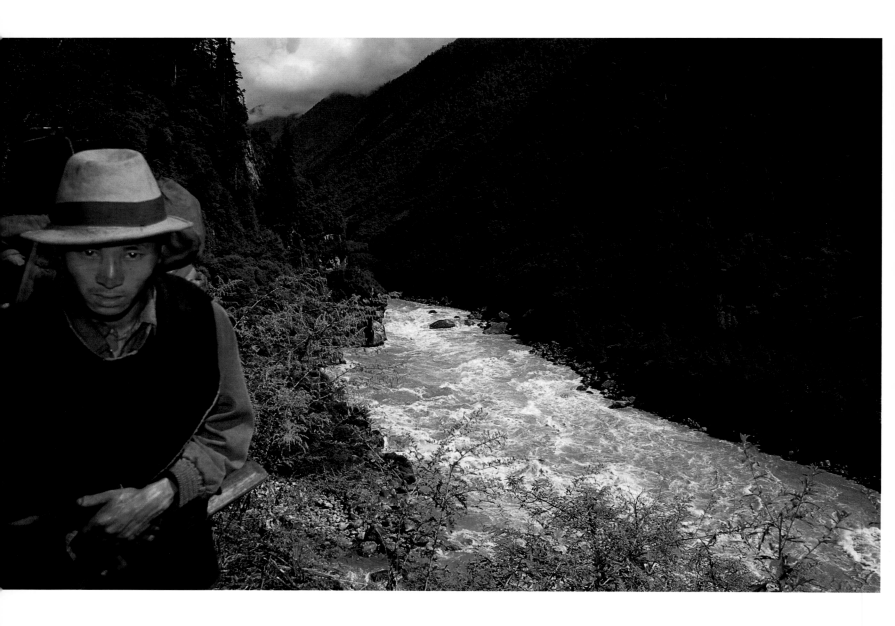

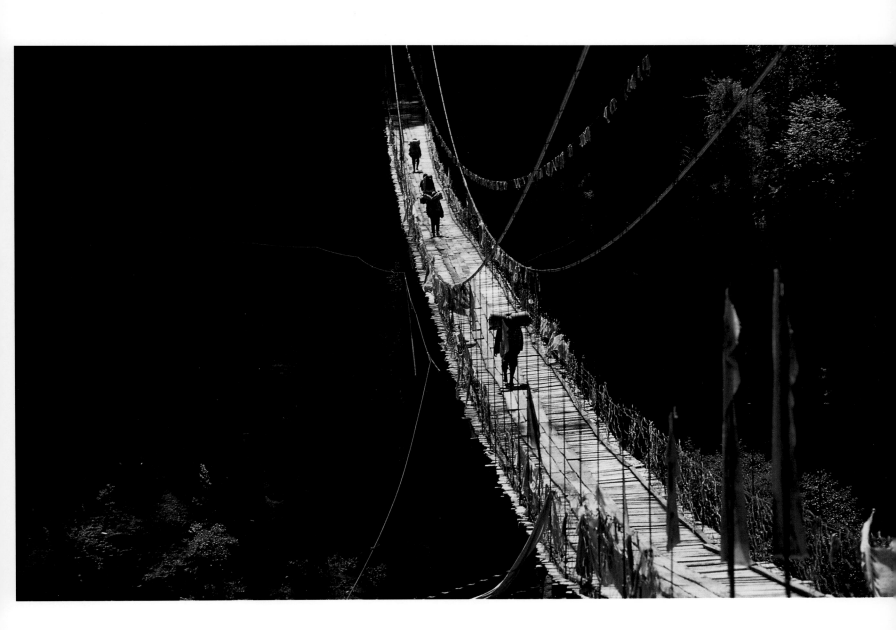

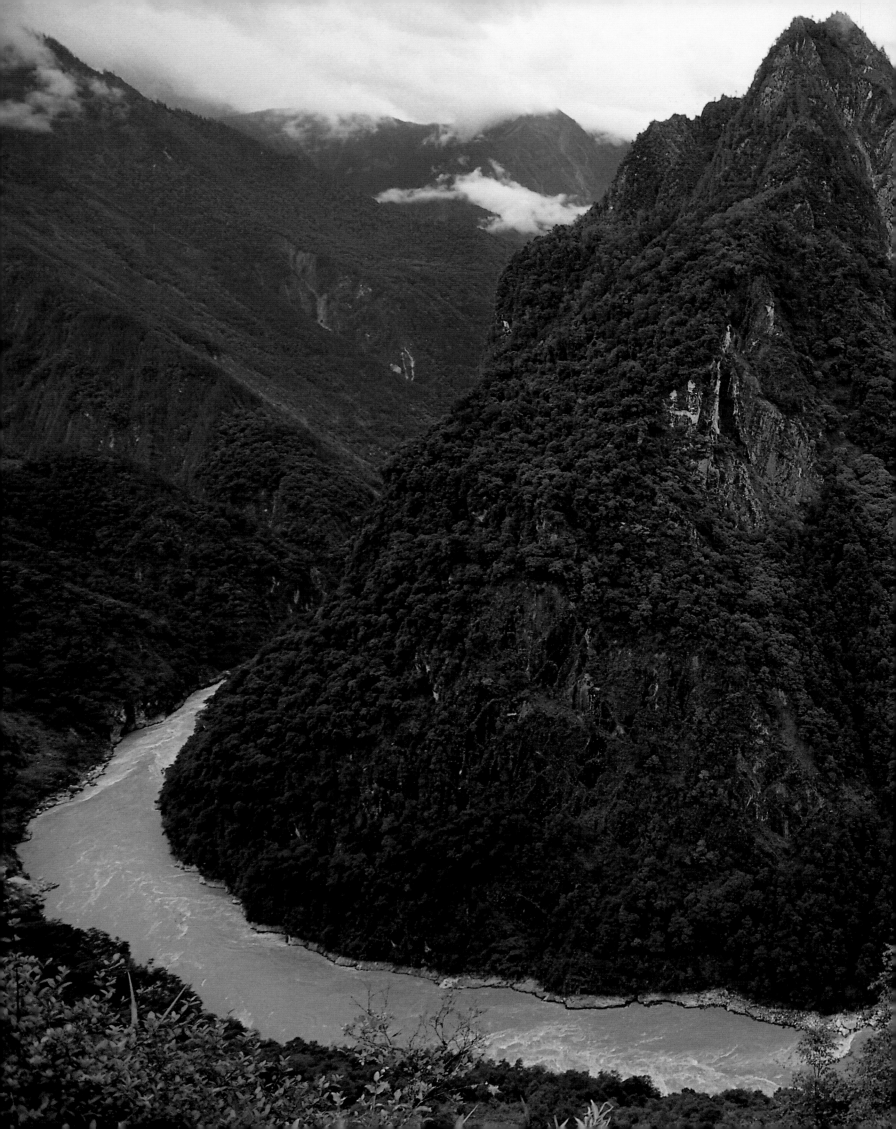

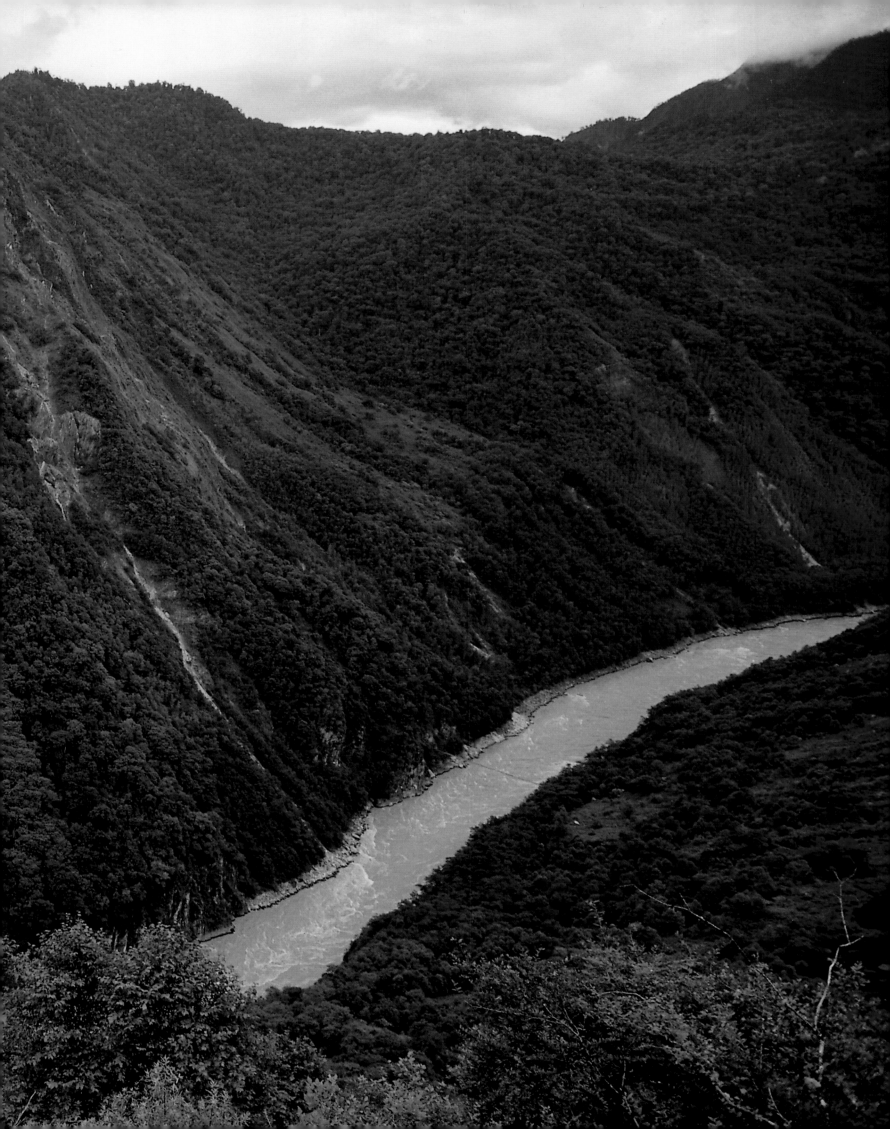

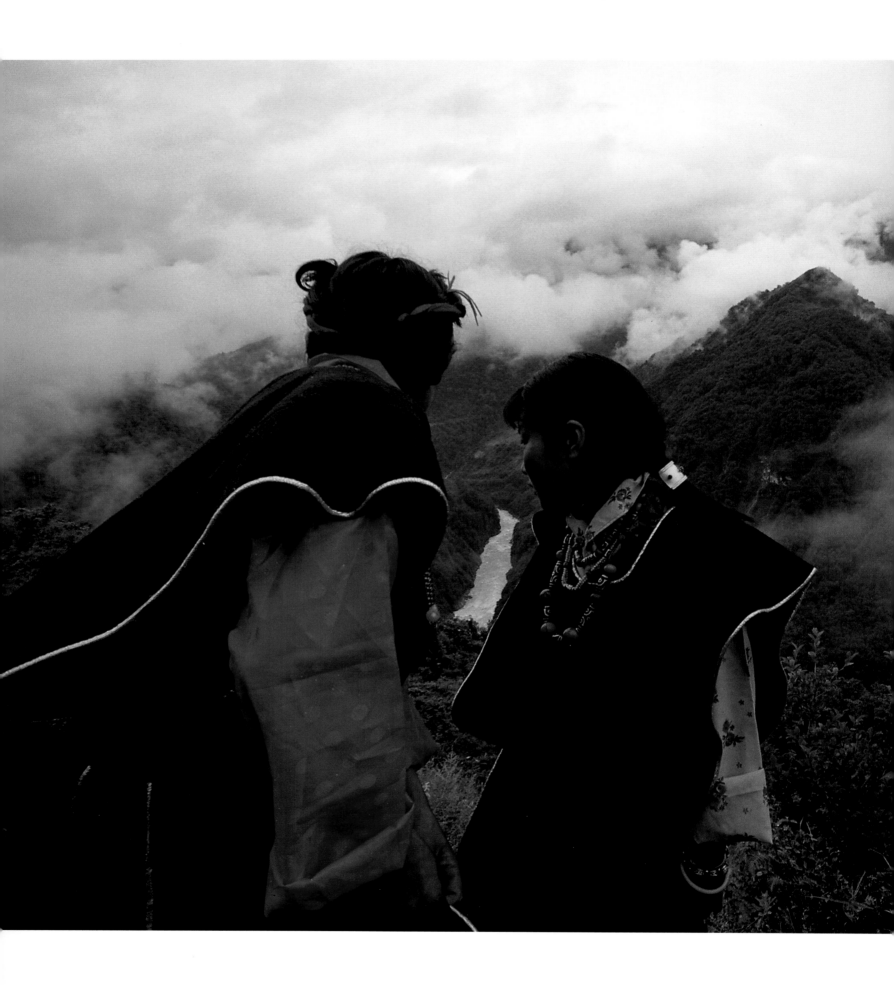

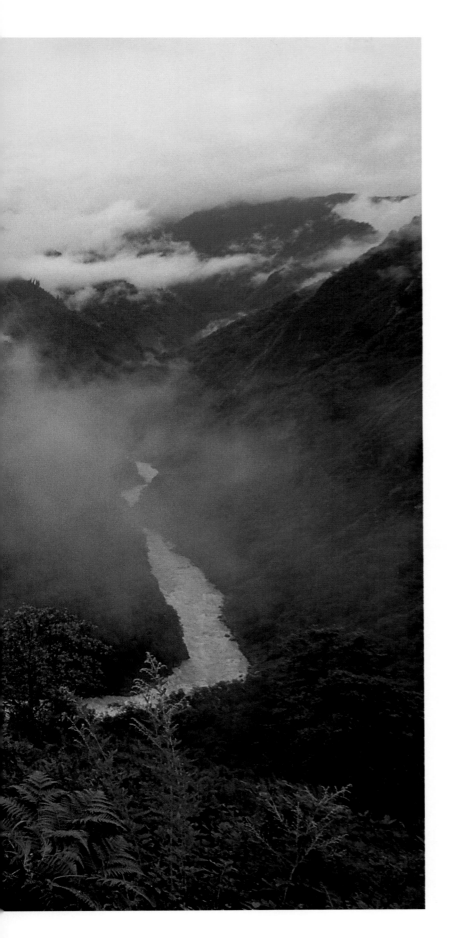

machete. In these gorges the mountains are covered with a dense blanket of rain forest. It is hard going through lianas and an undergrowth of ferns and other species of plant of every imaginable size which conceal snakes and from which thousands of insatiable leeches hang, eager to ambush any passing prey. One evening I counted over twenty of these nasty, uninvited guests on Gianni. But that was nothing compared with the hundred and fifty which Bailey had removed from his own body!

One evening we set up camp near a suspended bridge at the base of a gorge. On the mountain-sides the trees all leaned in the same direction as though buffeted by an incessant wind. According to local folklore, the vegetation here, which had been pushed over by the passage of demons fleeing from Tonpa Shenrap, had never managed to straighten out again.

Pema Tsetar sat at the middle of the bridge, his prayer beads in his hand. We could not see his face, but could imagine his lips moving almost imperceptibly as he repeated his mantras. I called out his name. He did not reply. Convinced he had not heard me because of the noise of the river, I approached him, calling him again. Still no response. 'You must call his name three times, then he will reply,' said Tako, a young woman who had joined up with us on the way back to her village in the mountains. 'Only when your name is called three times should you respond, because then you can be certain it is a human being calling you. Twice indicates it is a god. But if your name is called only once, you must never reply, because it is a ghost. That is why it is best to wait until your name is called three times before turning round.'

At Datchou, a village consisting of just five houses, jutting out on a spur of the mountain-side, near the confluence between the Po Tsangpo and the Tsangpo, we were met with a sight unusual in Tibet: an infinite stretch of mountains covered with jungle, spreading down from two icy peaks described in mythology as the breasts of the goddess Dorje Phagmo, wife of Demchog: these are Namche Barwa and Gyala Pelri. Their peaks, over 7,500 metres in height, were less than twenty kilometres away. Some 5,000 metres below, the Tsangpo, flowing with incredible force, had opened up a way for itself between the mountains on its way to India.

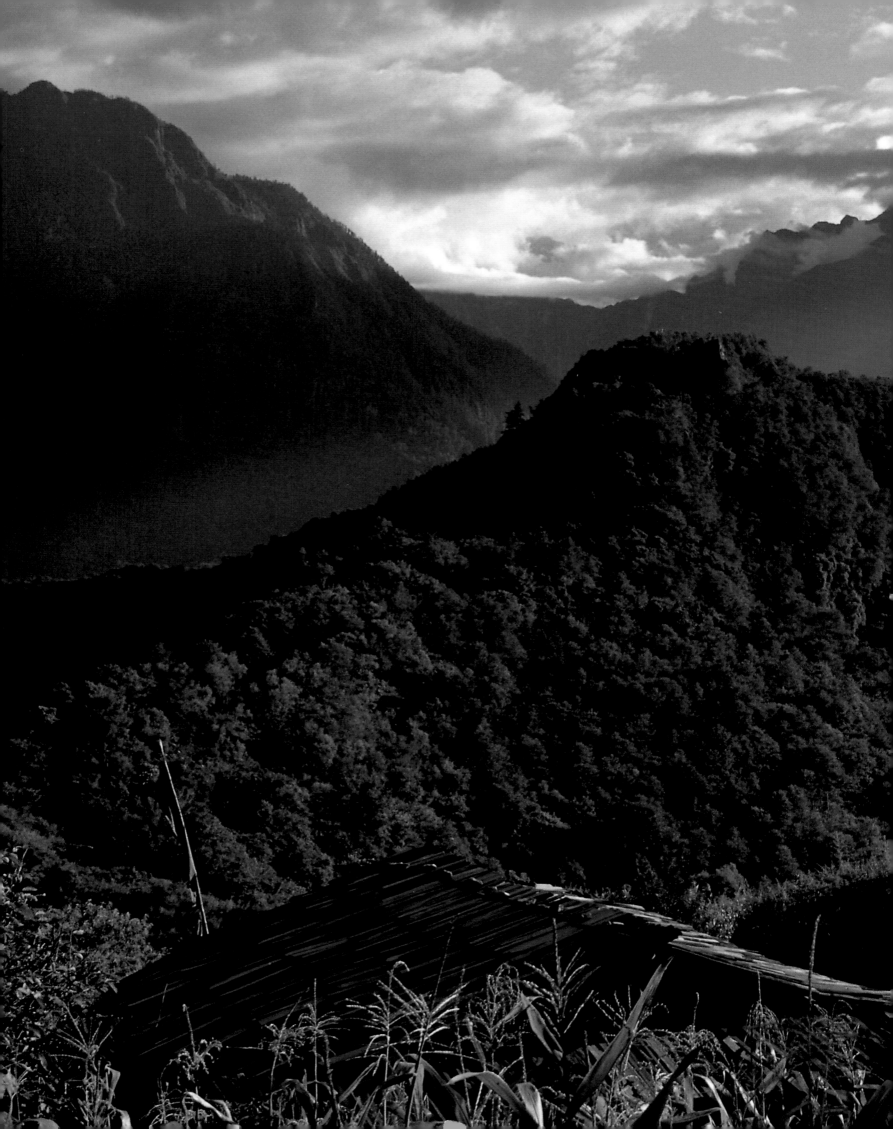

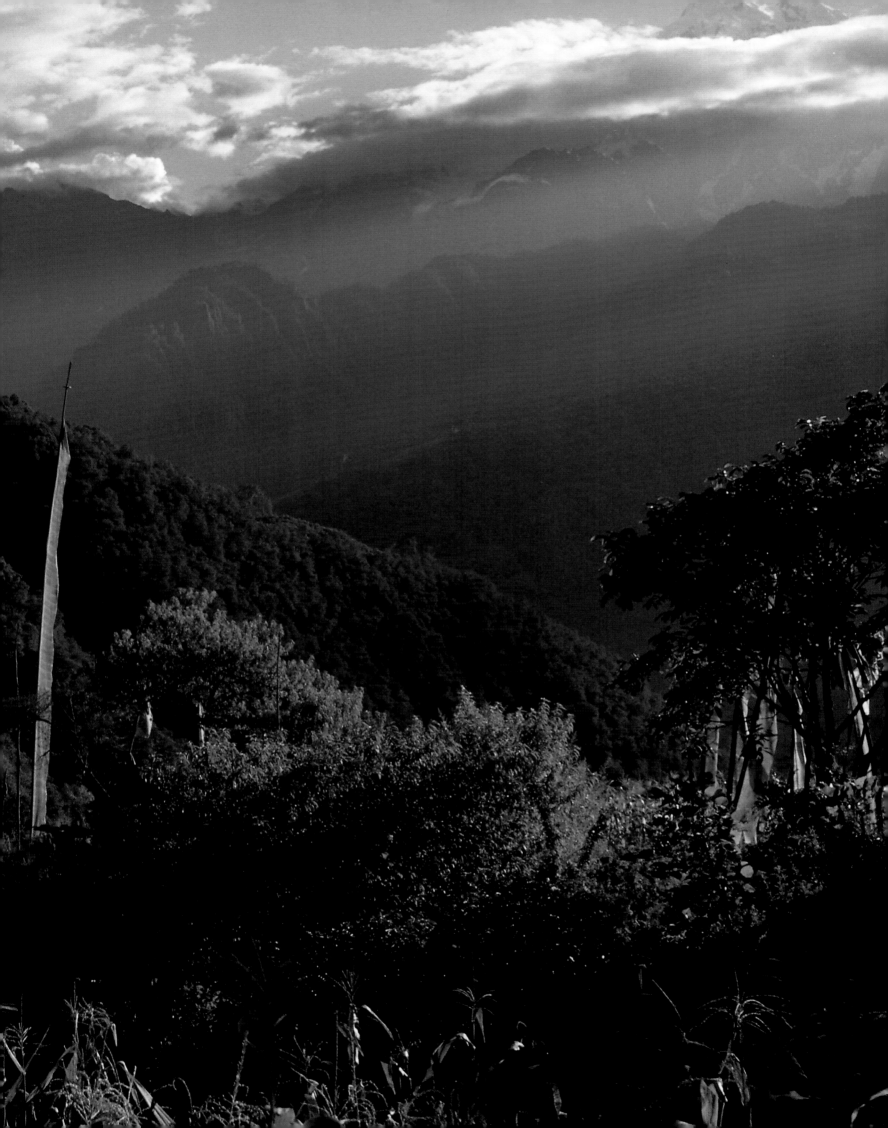

134

The head of the village, Sonam Nyima, is a Khampa, a man of sturdy build with a broad smile. It is not unusual to come across Khampas in these mountains. Many found refuge here when they fled from their native eastern Tibet to escape from the invading Chinese during the Sino-Tibetan conflict of 1905. They fled to what was, for them, the Promised Land, Nepemako.

They knew only, as Bacot wrote, 'that they needed to head west, towards sultry India, for one moon, or for a moon and a half, and would have to cross many rivers. So they set off on their journey.'[5]

Nepemako is situated in the great loop which the Tsangpo traces before it leaves Tibet and becomes the Brahmaputra. To reach it you have to wait until the trees hang down and form a bridge over the river. It is an earthly paradise, invisible to human eyes, where are built the palaces of many gods, a place where 'work and death do not exist because one need only collect the fruit produced naturally by the earth,' and where 'according to the scriptures, one can enjoy immortality until better times return.' Nepemako is shaped like the goddess Phagmo herself: she reclines, holding Kongpo in her right hand and Poyul in her left. Gyala Pelri is her head.

At nightfall the stars appear one by one, until the whole sky is resplendent with their light. Sonam Nyima pointed out the constellations: the Northern Belt (the Milky Way), Minduk (the Plaeiades), the Seven Brothers of the North (Ursa Major).

After so many nights spent in deep valleys, we were struck by the number of stars that pierced the darkness.

We began to count them, for fun: one star, two stars, three stars.

Sonam Nyima interrupted us: 'If you count them just as stars,' he said, 'they in turn will count us as corpses: one corpse, two corpses, three corpses. You must count them as goddesses: one goddess, two goddesses, three goddesses. Only then will they count us as human beings: one man, two men, three men.' Without another word, Sonam stood up. For a moment his impressive bulk obscured part of the sky; then he disappeared into the night.

From the depths of the valley beneath we could hear the voice of the river as it continued its journey towards India.

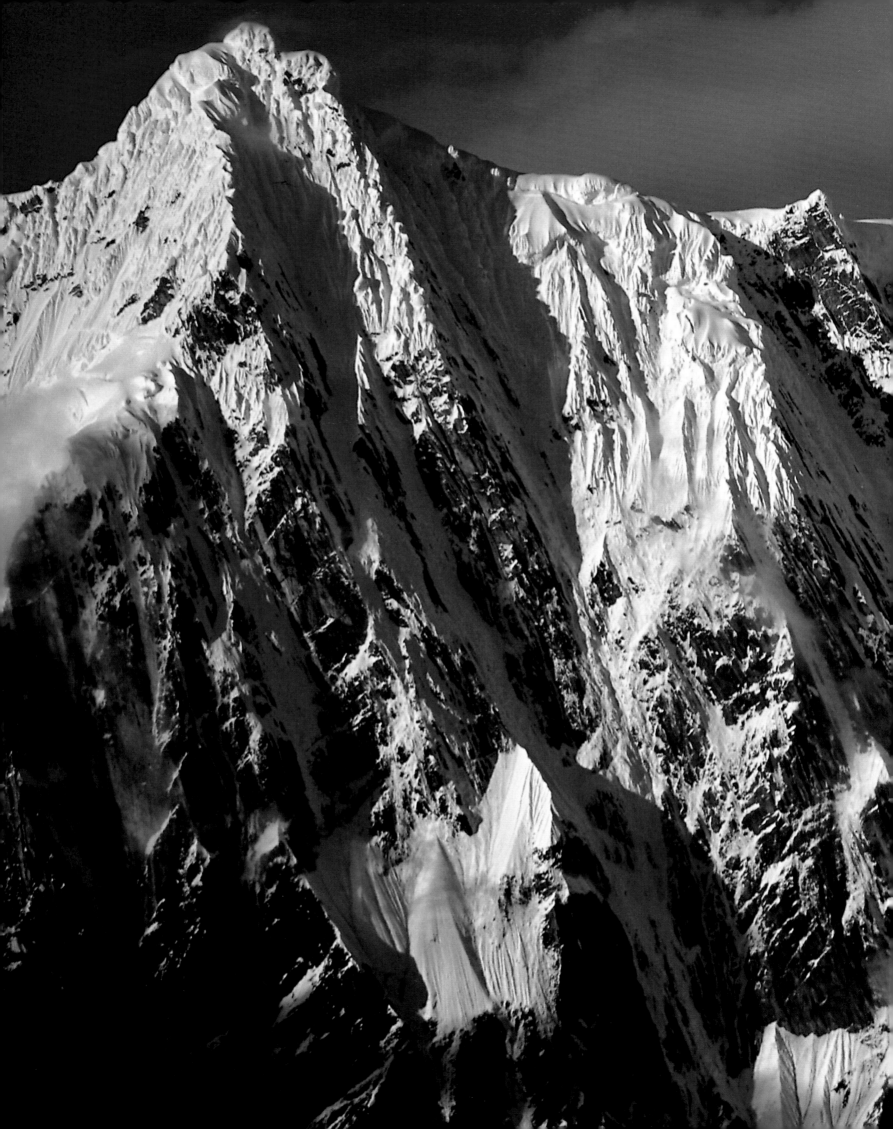

MATURITY

Group of Abor
(lithograph: from Descriptive Ethnology of Bengal, *E. Tulte Dalton,*
1872, John Randall Collection, London)

BRAHMAPUTRA

BRAHMAPUTRA: 'The son of Brahma.' In the *Kalika Puranas* it is recounted how in ancient times, on the banks of lake Manasarovar, Rishi Santonu and his wife, Amogha, lived a life of devotion to Brahma, the Supreme Being who inhabited the waters of the holy lake. Pleased with such devotion, and entranced by Amogha's beauty, one day, when Santonu was on pilgrimage, Brahma appeared to her and offered to give her a son. Frightened by this sudden apparition of the four-headed deity, whom she mistook for a demon, Amogha closed the door of their hut. When Santonu returned, Amogha told him what had happened. Rebuking his wife for spurning the god's blessing, Santonu went to the spot where he had appeared. A thick fluid shone on the threshold: it was Brahmabija, Brahma's seed. Santonu ordered his wife to drink it. Amogha obeyed and after some time gave birth to a son in the form of water, Lohit, whose waters gathered together in a lake in the Himalayas. Santonu the Wise blessed the Son of Brahma and assured him that one of his descendants would eventually come to release him from the pool in which he was a prisoner.

Many years later this spot was visited by Parasuram, the son of Rishi Jamadagni, guilty of having chopped off the head of his mother, Renuka, with an axe.

Seeing Citraratha, the king of the heavenly musicians, on the banks of the lake, as he experienced blissful pleasures with the divine *apsaras*, Renuka had tried to re-enact the same erotic games with her husband. The mere thought of this was enough to seal her fate. Jamadagni, in meditation, saw what had happened and ordered his older children to kill their mother. But they refused. Only the fifth son, Parasuram, agreed to carry out his father's orders, provided that Renuka could be reborn, pure and resplendent. And so it came to pass.

But the assassin's axe remained attached to his hand. To free himself of it Parasuram visited all the holy places, but still the axe would not leave his hand. Until finally, on the advice of Brahma, he came to the lake where Lohit was prisoner. Parasuram bathed in the waters; by magic the axe came away from his hand and the blood which had covered his hands was removed, staining the water red. Since then the people of Assam have referred to the Brahmaputra by the mythical name Lohitya, the 'Red River.'

Impressed by this miracle, Parasuram decided that water so holy must be made accessible to all mankind so that, by bathing in it, they could be released from their sins. With a blow from his axe, he

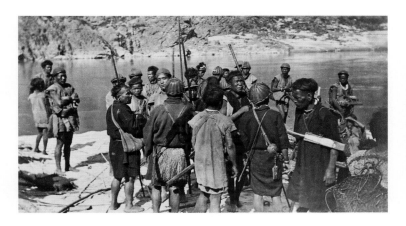

Group of Abor; Madu Gam
(photograph: A. Bentinck, 1911, Royal Geographical Society)

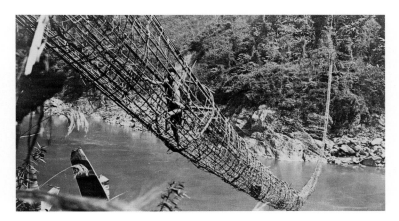

Crossing a suspension bridge
(photograph: A. Bentinck, 1911/12, Royal Geographical Society)

opened a channel from the lake and the Lohit-Brahmaputra flowed freely towards the inhabited plains.

The place, known as Parasuramkund, is the mythological source of the Brahmaputra in India.

The *kund* of Parasuram is hidden in a remote area of Arunachal Pradesh, in the heart of the forest inhabited by the Mishmi tribe.

We arrived there early one cold evening in January.

Thousands of pilgrims from every part of Assam were waiting to ascend the hill that leads up to the *kund* so that they could bathe in it on the day of Makar Shankranti.

The police were controlling access to the path which was not open until midnight. We set up our tents among the freezing pilgrims who were sitting around improvised fires. Bimal Chandra of North Lakimpur wanted to bathe in the pool to purify himself and obtain remission from his sins; Jaganath had come to keep a vow. A young couple hoped to obtain grace for the birth of a son. A tall, stocky young man was hoping for a good harvest.

The night was lit up by the oil lamps of the stalls that had been set up for the *mela*. The stands were weighed down with images of Parasuram (Rama with the Axe, the sixth incarnation of Vishnu), of Shiva and of Parvati in meditation on Kailash; of malas, strings of 108 prayer beads made from *rudraksh* nuts ('the eyes of Shiva') or from the stems of the *tulsi*, a plant which has medicinal properties.

Parasuramkund is a *tirtha*, the Sanskrit word for 'ford over a river.' One of those places which Hindus consider sanctified by miraculous events or by the presence of some deity, and to bathe in such a place means 'crossing the ocean of existence' and achieving liberation. The cult of the *tirthas* is very ancient, going back to pre-Vedic times in India, and the first reference is found in the *Mahabharata*, the Hindu epic dating back to between the 4th century BC and the 4th century AD.

The ancient scriptures contained a type of manual for pilgrims. It explained the story of the holy place, the miracles that had happened there, the way in which the pilgrimage must be carried out and the merits one could hope to gain from it. The pilgrim was required to undergo strenuous preparation and certain practices, such as fasting or shaving the head; the reason for the latter was that his sins would fall away as the hair fell from a person's head. Mountains, lakes and, above all, rivers are the preferred locations of many *tirthas*.

Srhi Hari Charan Das, a Baba of imposing stature, was custodian of the secrets of Parasuram's *kund*. He was entrusted with the task of ensuring that *sadhus* and pilgrims received the food provided by the wealthy families from the towns of Dibrugarh and Tinsukia, important centres for tea cultivation in Assam. His long grey hair cascaded down onto his shoulders. He wore a white tunic,

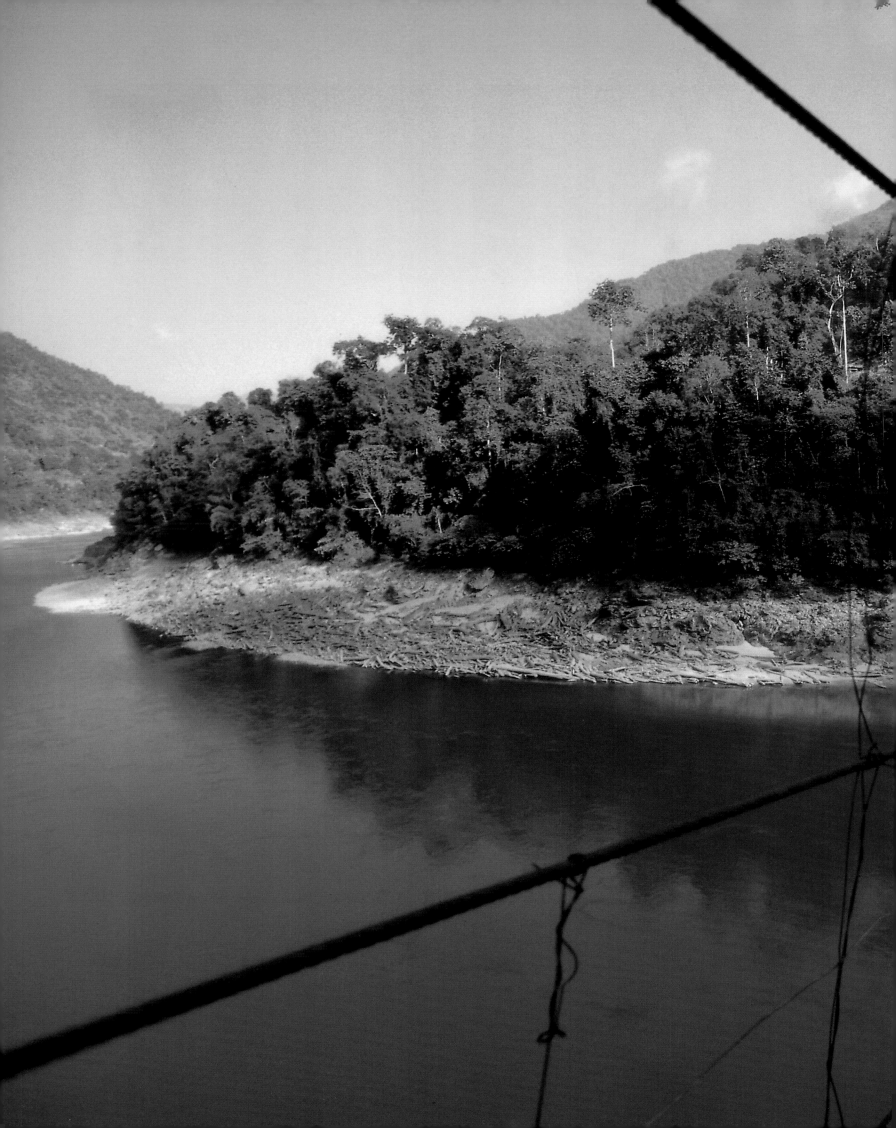

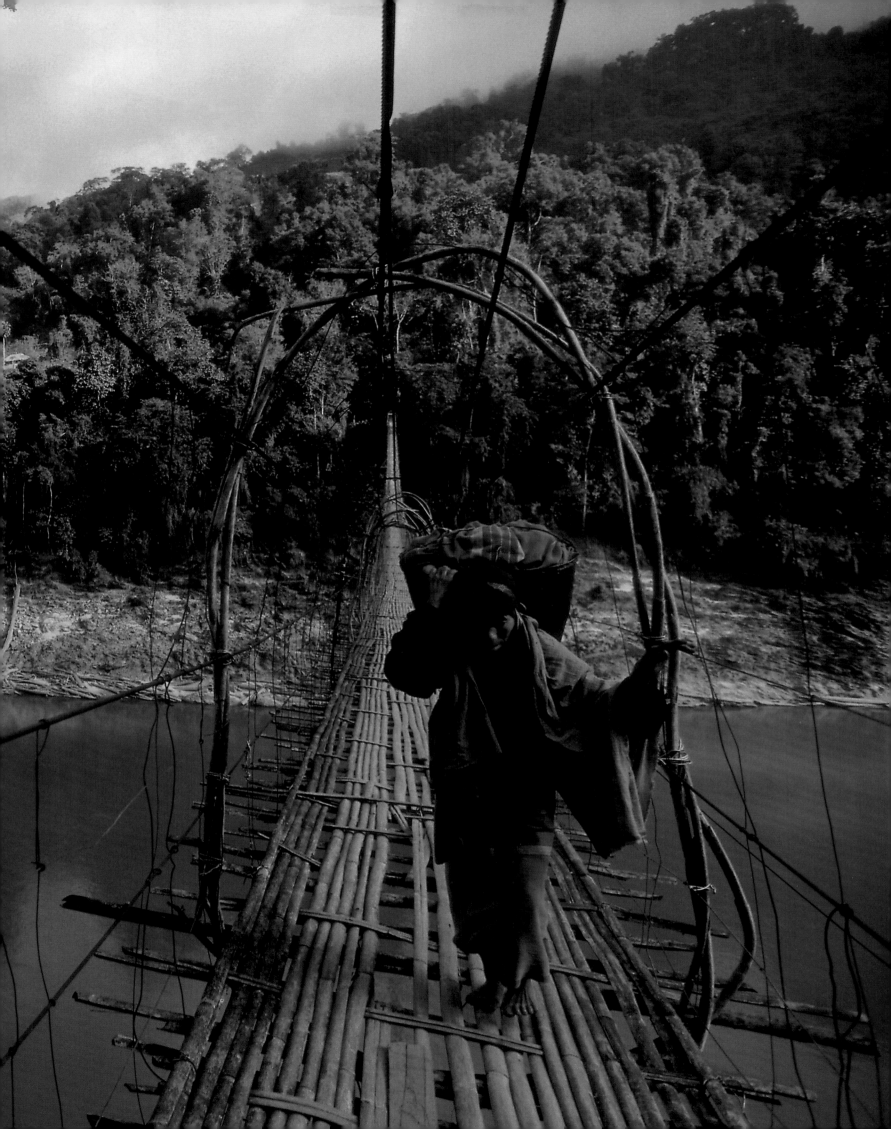

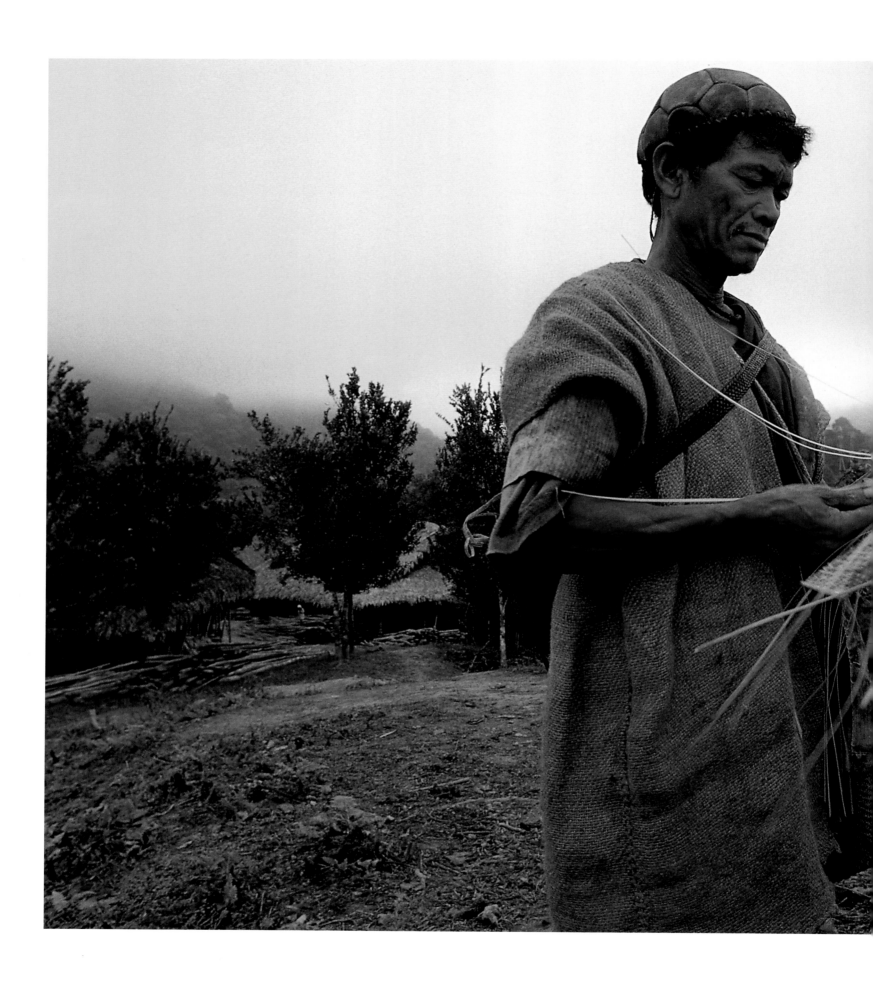

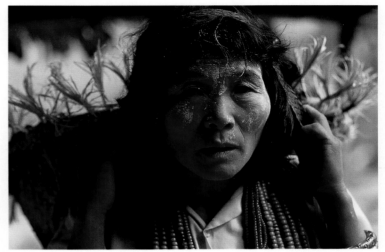

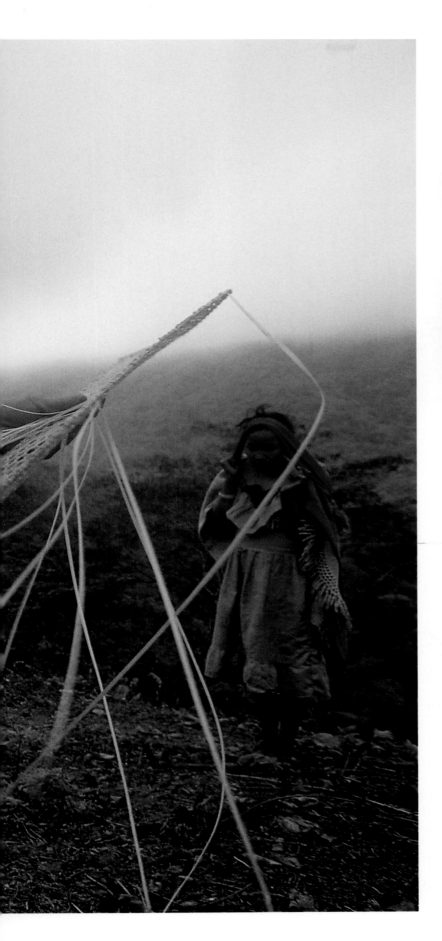

the colour of the Vaishnas, and in his hand he held Parasuram's axe. On his forehead was the *tilaka* of the Vaishnas: two upright symbols, traced in ashes, which run down the bridge of the nose.

'It is the throne of Lord Vishnu, the Preserver,' said the Baba. 'It was the same deity who permitted the *sadhus* to use the nose as a seat.'

In the shade of some large trees, on a raised section alongside the path leading to the *kund*, the *sadhus* meditated in front of a small fire, the *dihuni*. One of them, his body covered in ashes and wearing a wreath of orange blossom, poured a small quantity of water onto his hands from a brass *kamandal*, whose shape was reminiscent of the ancient *brahma-patra*, the 'vessel of Brahma,' a container which often appears in the iconography of Shiva.

'We are like running water,' he said. 'That is how a Hindu saying describes us, as we make our pilgrimage in search of *moksha*, the release from earthly ties.' After a long pause, he added: 'Our task is to guide people on the paths of the spirit and of faith. We are the witnesses of faith. We comfort the afflicted, provide care for the sick, and help for the poor and homeless. We live on the alms and generosity of the people.'

We looked around for Srhi Hari Charan Das. The Baba had gone into a state of meditation under the branches of a sprawling tree; Parasuram's axe was still in his hand.

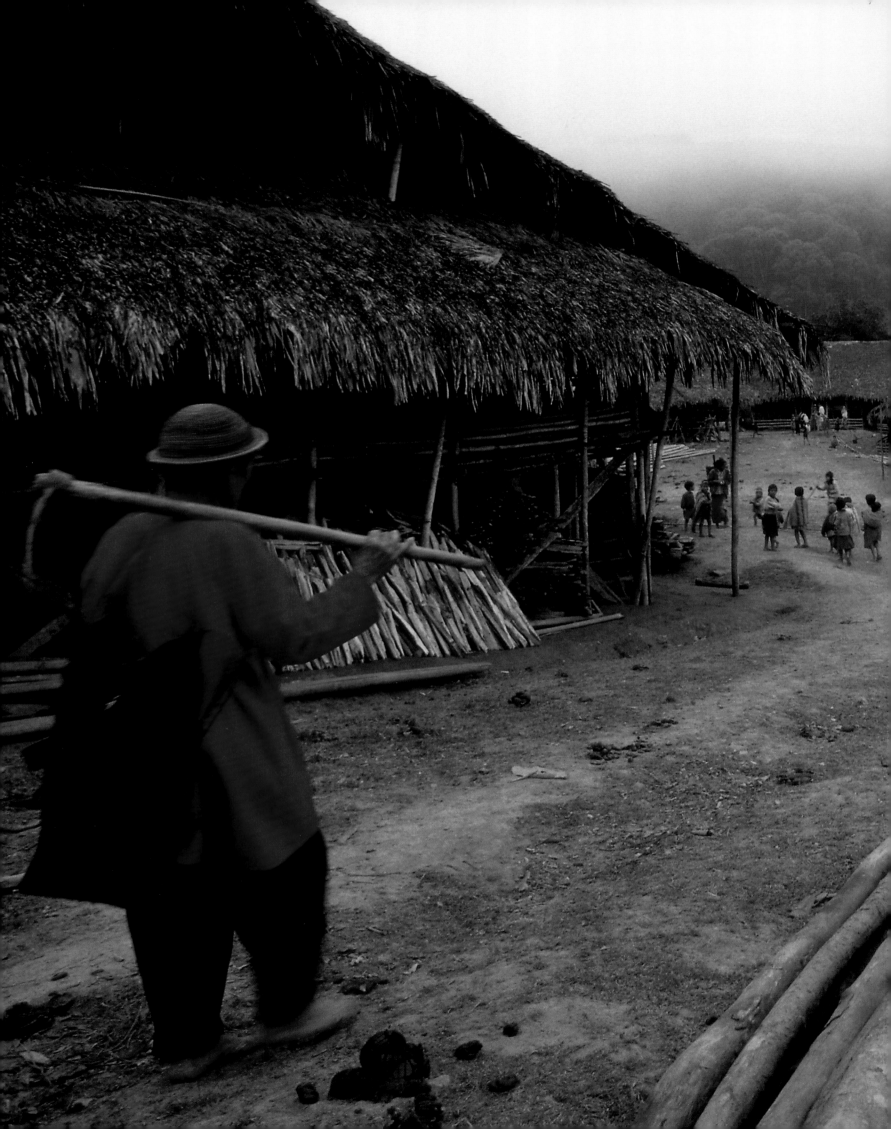

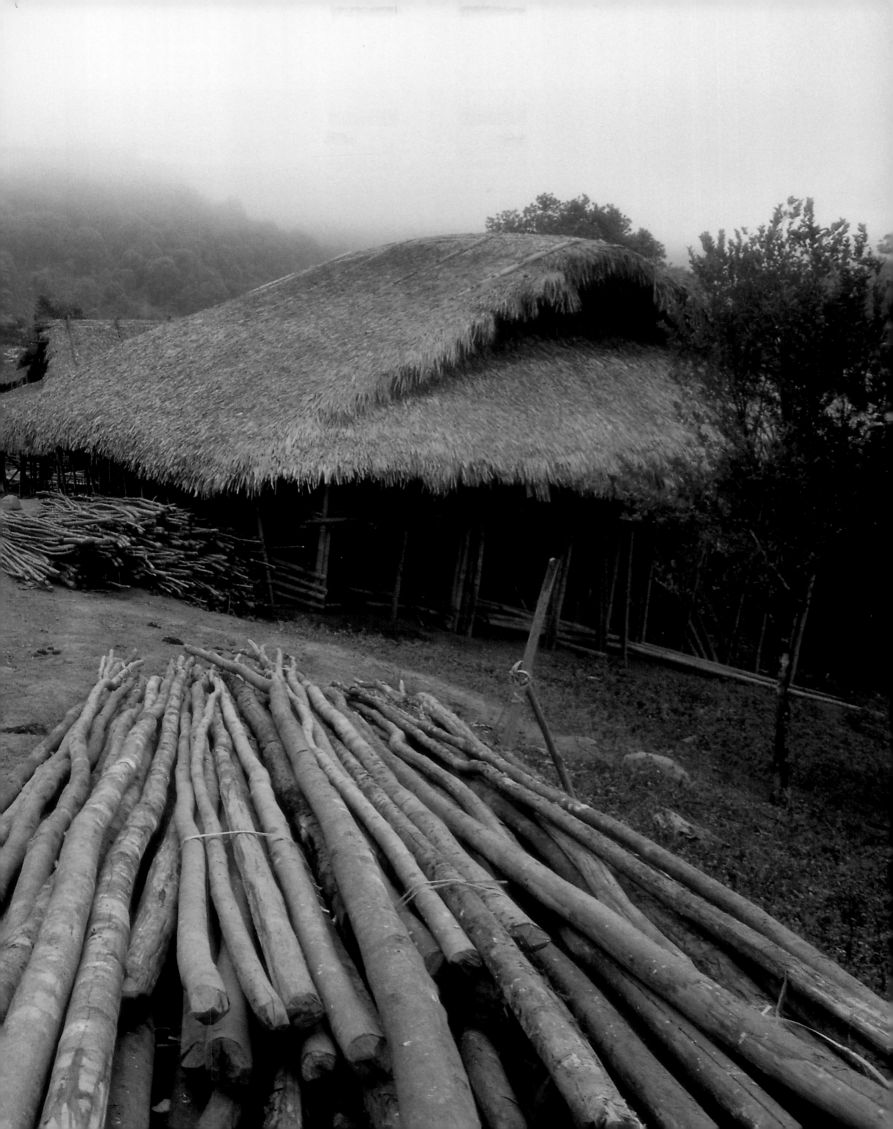

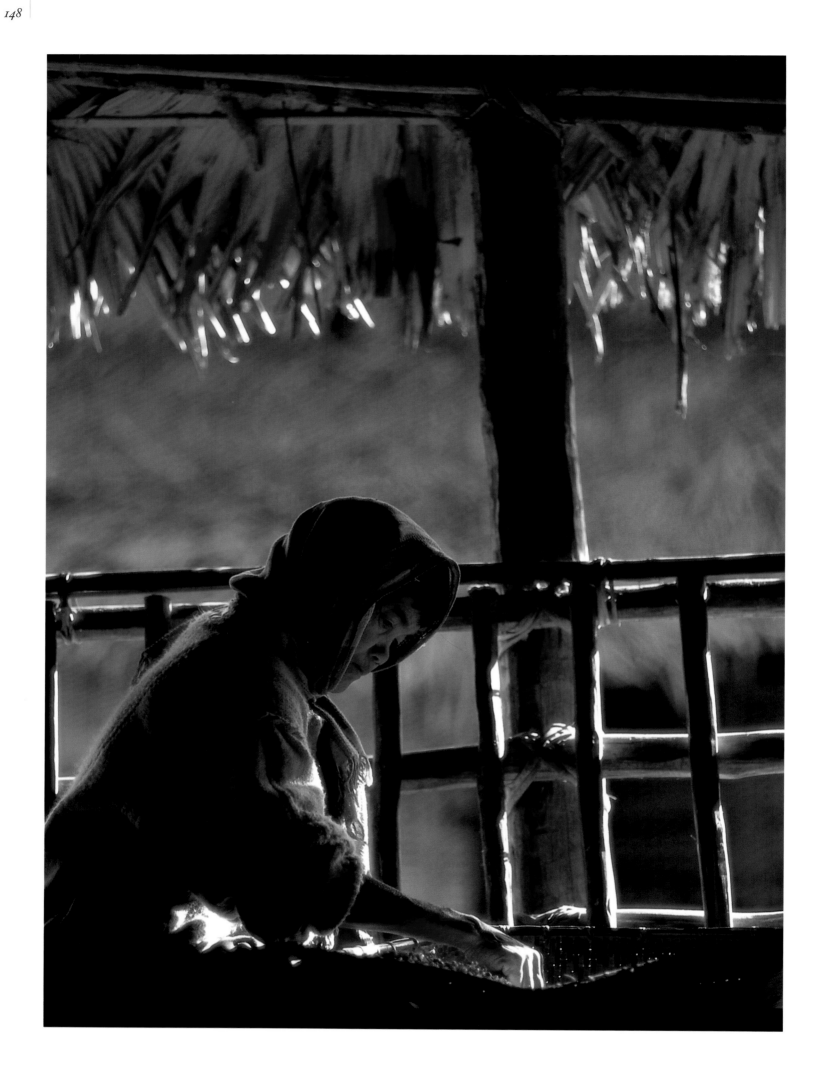

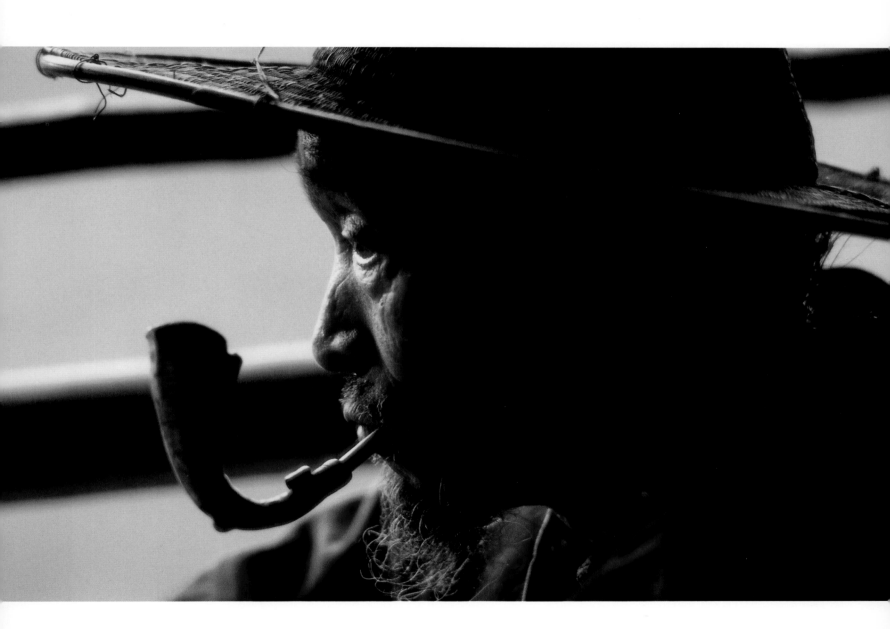

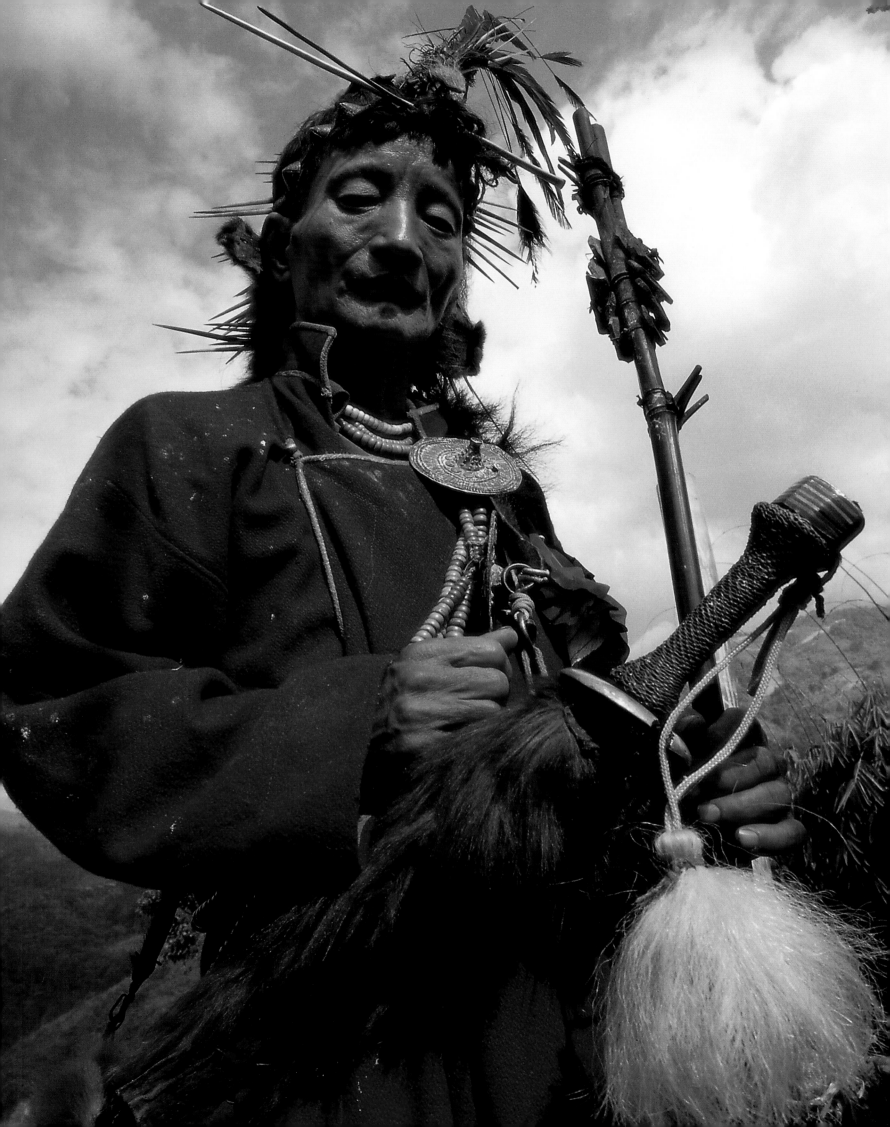

Midnight came. The police opened the gate at the foot of the hill. The thousands of pilgrims pushed their way onto the path winding its way up over a ridge and then down into the gorge; at the bottom was the holy kund.

Immobile, either side of the path, the sadhus waited for gifts from the pilgrims.

An enormous human river climbed up towards the ridge on the hillside. Row upon row of the faithful pilgrims were added to the ranks of those who had already gained access to the path. Until the crowd, pressed between two walls of forest, could no longer move either forwards or backwards. Only a few fortunate people were able to make it to the kund and bathe in the river on that special day of Makar Shankranti. Most of those present were unable even to catch a glimpse of the deep blue water and were forced to return.

An elderly couple sat waiting for the bus that would take them back to Bombay. They sat there beside one another in silence, disappointed not to have achieved a successful *tirtha*. They had saved for a long time, left their home and endured the expense and hardships of a two thousand mile journey in order to come to this remote area among the forests of Arunachal Pradesh. This is a recently created state where Indian citizens were not even allowed access to the spot until very recently.

Classified among the restricted areas of India, it is an area which has seldom been free from unrest, either because of the border conflicts with China, which refused to recognize the MacMahon line after 1959, or because of the guerrilla warfare on the opium smuggling routes from Burma, not to mention the nationalist aspirations of the various ethnic groups that populate the region.

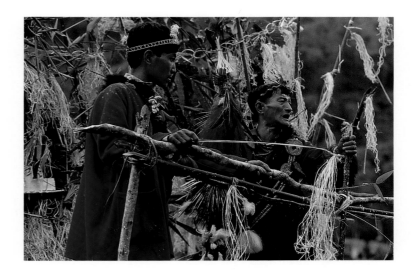

Exploration of the course of the Brahmaputra in India did not start until the beginning of the 19th century, following the conflict between Britain and Burma in 1824 that had given the English access to Assam.

In previous generations, the British India of the East India Company had ignored that extreme eastern border because it was of no obvious interest, apart from a few wild tea plantations reported to Colonel Latter by the local tribes. It was a region of impenetrable jungle with an unhealthy climate and was populated by savage tribes.

A Muslim historian, Talsih, who travelled with Emperor Aurangzeb during his invasion of Assam in the 17th century, described the region as 'a wild, fearful country, full of danger, whose high roads are as alarming as the path that leads to the world of the dead.' It was only their interest in protecting the eastern borders from the expansionist ambitions of the Burmese who, after the Assam massacres in Assam, were now threatening Cachar and eastern Bengal, that forced the English into a war in which fever and dysentery took more lives than guns.

In 1825, a modest contingent under the command of Captain Philip Burlton, made its way up the Brahmaputra with the aim of going as far as was possible. Using a local boat, Burlton made it as far as where the waters of the river divided into three different directions: to the east was the Lohit; to the north were the Dihong (or the Siang) and the Dibong.

At Sadiya, a border village between the plains of Assam and the forests of the Himalayan foothills, inhabited by savage animist tribes, Burlton learned from the Hindus that the true source of the Brahmaputra was to be found in Brahmakund on the Lohit, where the mythical Parasuram had opened a way through the mountain with his axe. However, the investigations into the size of the three rivers carried out by Burlton indicated that the probable continuation of the Tsangpo, which flowed through Tibet, was not the Lohit but the Dihong, the river which came from the north and was larger than the other.

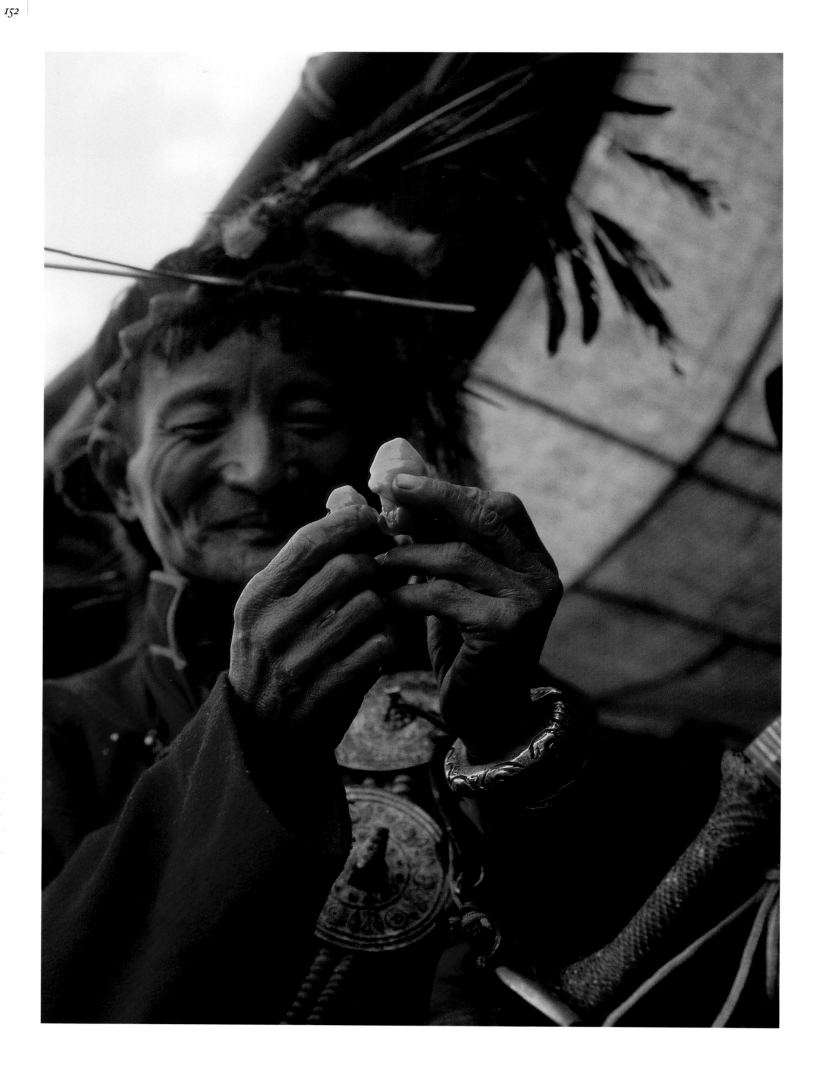

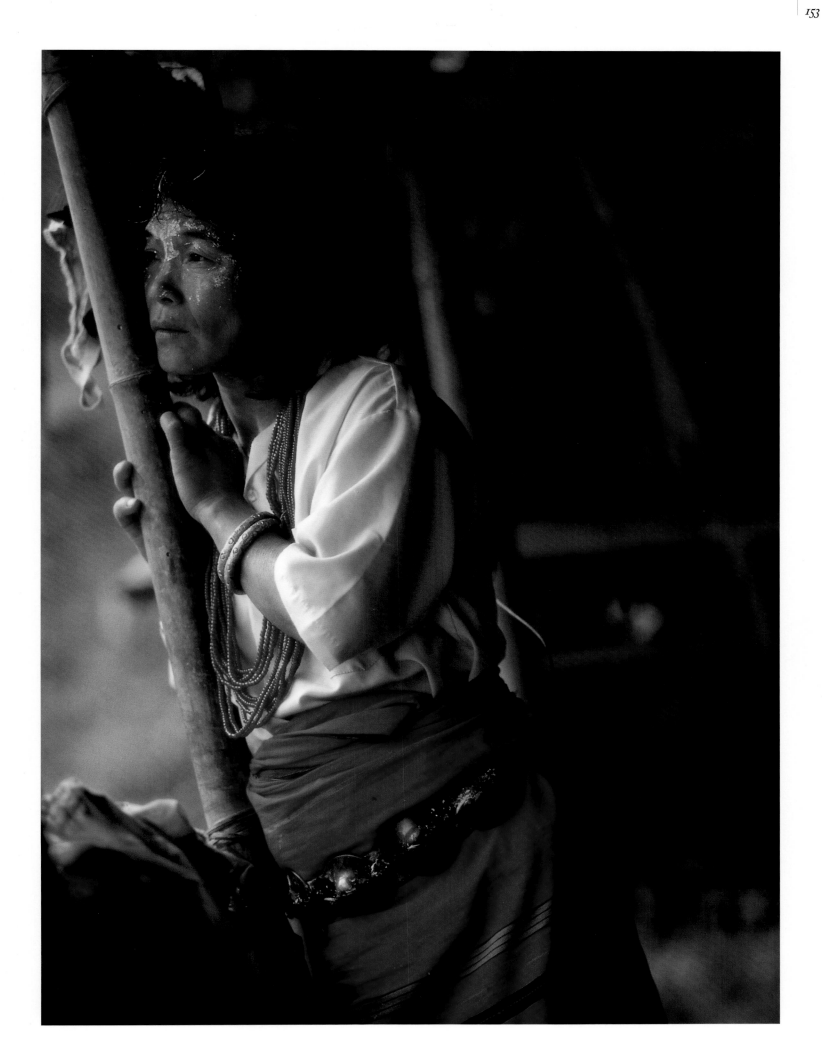

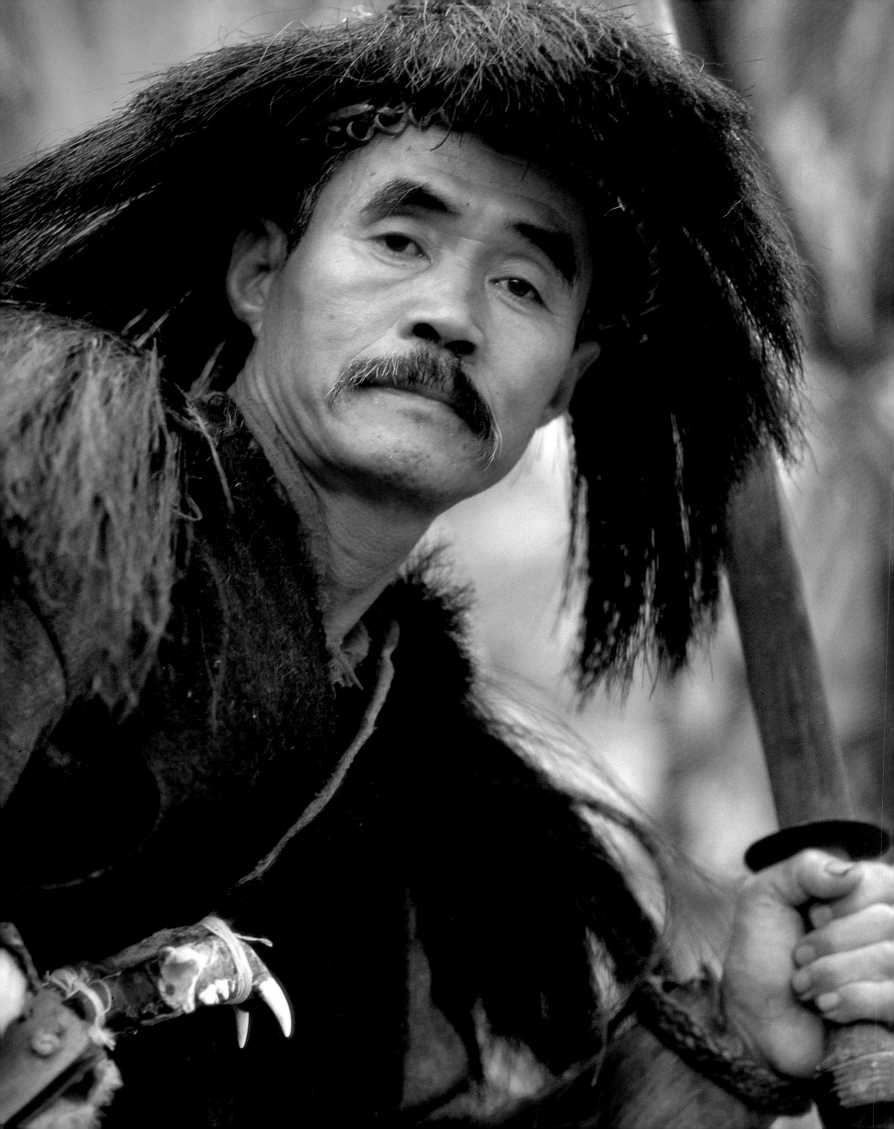

At the time the course of the Brahmaputra was still the subject of debate among European geographers. Its connection with the Tsangpo had yet to be demonstrated and there were those who thought that its waters actually flowed into the Irrawaddy.

Sadiya soon became the starting point for a number of expeditions (including those of Burlton and Wilcox) aimed at solving once and for all the mystery of the sources of the 'Burrumpooter' and to determine whether it was connected with the Tsangpo in Tibet. This, of course, made it necessary to follow the Dihong upstream, not at all an easy task.

It involved cutting a way through the hostile jungle in which giant ferns, bamboo plants, thorn bushes, lianas and nettles created a formidable barrier.

But the greatest challenge was the aggressive behaviour of the Abor and Mishmi tribes who inhabited the regions bordering on Tibet.

According to Edward T. Dalton in his *Descriptive Ethnology of Bengal* (1872), Captain James Bedford, who in 1826 had tried to locate the source of the Dihong as part of the process of solving the mystery of the Brahmaputra's sources, was stopped in his tracks by ranks of Chalikata Mishmi, who came down to the water's edge from the villages in such numbers and appeared to be so hostile that Bedford judged it wise to beat a retreat.

For a considerable period the Abor were the absolute rulers of the mountains on the Assamese border.

They were given their name, which means 'barbarians,' by the Hindus of the plains, and were even feared by the neighbouring tribes of Mishmi and Miri whose villages were often the targets of Abor raids carried out to take women and children as slaves.

Today the Abor are referred to as Adi, 'people of the mountains.' Under this name, they are numbered among the scheduled tribes, the tribes officially recognized by the Indian government.

The scheduled tribes are the result of a policy protecting tribal territories, an initiative of Prime Minister Nehru that has been continued by various governments of post-colonial India in their attempt to preserve the cultural diversity of the various ethnic groups; at times this has meant closing off whole areas, referred to as restricted areas, denying access to foreigners and even to other Indians.

At Along we met Yomgi Eshi, a Gallong Adi, and his wife, a Hindu from Guwahati, the capital of Assam. They offered us hospitality and we spent some time talking about our respective homelands and the future of the Adi. 'We are trying to assimilate progress within the context of our traditions,' said Yomgi. He left his native village to settle in Along, the regional capital of the Siang district. Yomgi and his wife live at the edges of the town in a bamboo house, made in accordance with the traditions of tribal architecture.

On the large veranda, sheltered by a roof made from palm leaves, Yomgi's wife sat at a bamboo loom. From inside the sound of a television set could be heard. Sitting cross-legged on a reed mat, we could see a slanting beam of light shining through one of the cracks in the wall. From a large chest of drawers leaning against the wall Yomgi took out a photograph album of his wedding to Guwahati. Smiling faces of the couple in a garden full of bougainvillaea; red saris; cars and rickshaws decorated with garlands of flowers, and Yomgi standing beside an old man with his hair cropped in the style of the Adi.

Yomgi then took an enormous wooden ladle from the wall and dipped it into a large bowl beside the hearth. He poured the contents into the cups that he had placed before us. It was a liquid with a slightly intoxicating, bitter-sweet smell. 'This is *apong*,' he said, 'the rice alcohol brewed by the Adi.'

He offered to drive us to his native village.

The huts, long constructions built on poles and designed to house whole families, were perched at the top of a hill among fields of millet which the Adi had reclaimed from the forest by cutting down the vegetation and scorching the earth.

At the centre of the village, on a bamboo platform, three men in red cloaks and bamboo head-dress were seated in a circle. Dense smoke came from their pipes.

'Those are the Gambura,' said Yomgi, looking in their direction. 'They alone have the privilege of wearing red clothing.'

At one time the council of elders exercised absolute power over the village: they decided on matters to do with war; the time to go hunting; and they pronounced judgements and imposed penalties. Today they simply have the role of representing the community and have a place among the authorities at official occasions.

The hut belonging to Yomgi's family was built overhanging the valley through which the Dihong flowed.

Two girls, returning from the forest, climbed the steep path singing. They removed the heavy panniers, full of bamboo twigs,

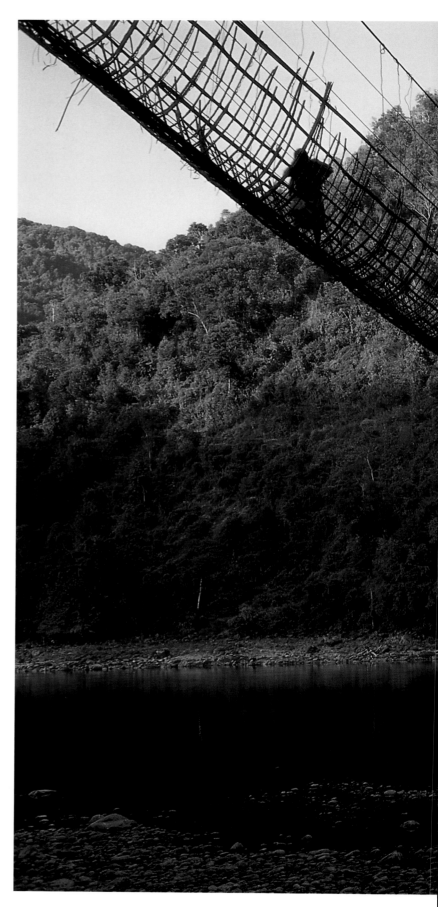

from their shoulders, joined us on the veranda and sat down in a corner. They cast a glance in our direction. They chattered and laughed. One of them wore a white shirt with puff sleeves. 'A charity dress,' Yomgi informed us. 'These are clothes in the western style imported via Calcutta or more distant ports.'

The air was fresh. From inside came an acrid smell. Near the hearth Yomgi's mother, assisted by the women of the family, was filtering *apong*. The liquid ran along an enormous banana leaf, used as a funnel, and ended up in a large metal basin.

At the door to the hut stood the *nyibo*, or the shaman. He had a disquieting look on a face with high, projecting cheek bones. He wore a red tunic and a bamboo head-dress festooned with various fetishes: wild boar tusks, tufts of goat hair, palm fibres, porcupine needles, the feathers and beak of some large Indian bird.

He seemed to have been lifted from the pages of Dalton's ethnological treatise over a century ago.

It certainly seemed to be the case that the *nyibo* was treated with respect. He was offered food and all the *apong* he was able to drink. The *nyibo* is always in contact with the supernatural worlds and knows how to dispel evil spirits.

The spirits rule over the villages and over the surrounding forest as key figures in all the important events of life among the Adi people. The *nyibo* is able to stand up to them. He prepares amulets,

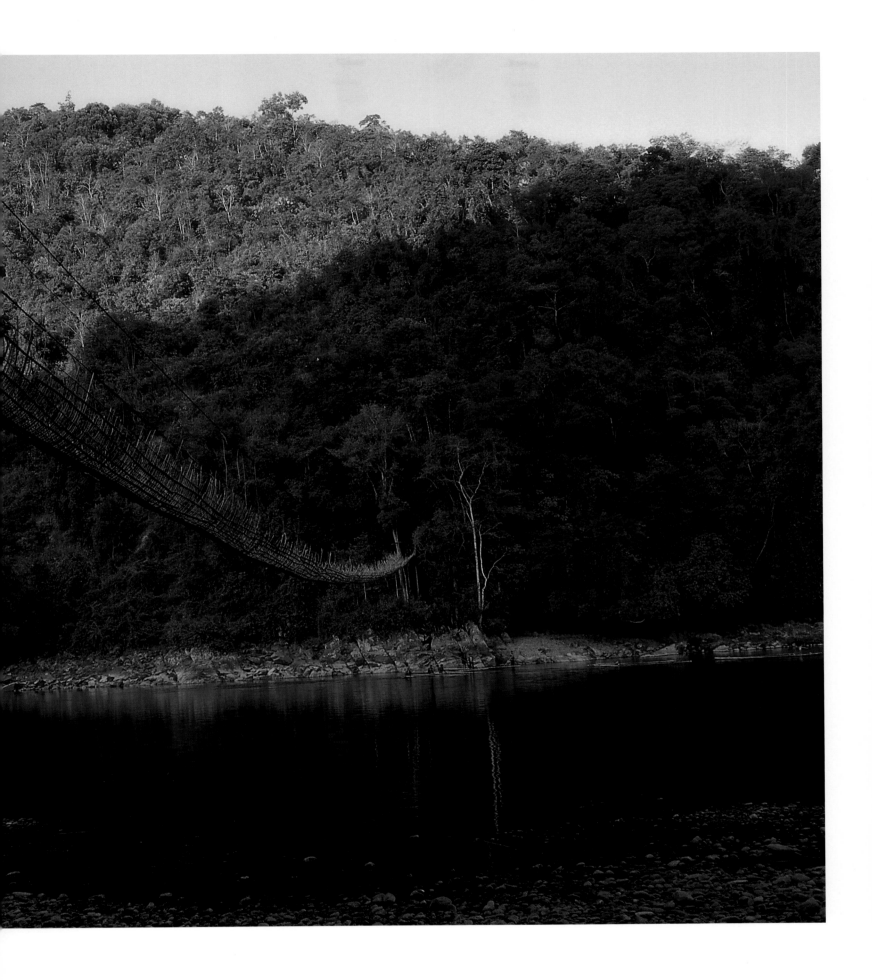

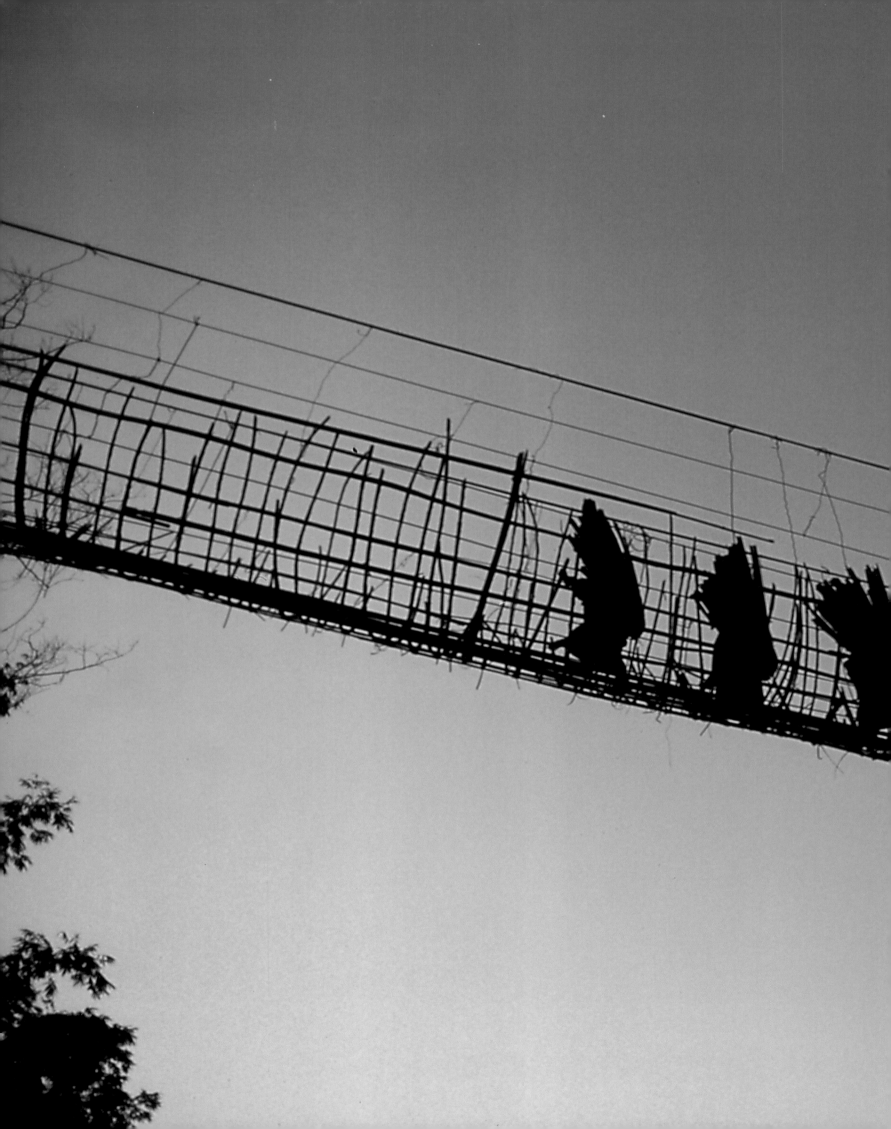

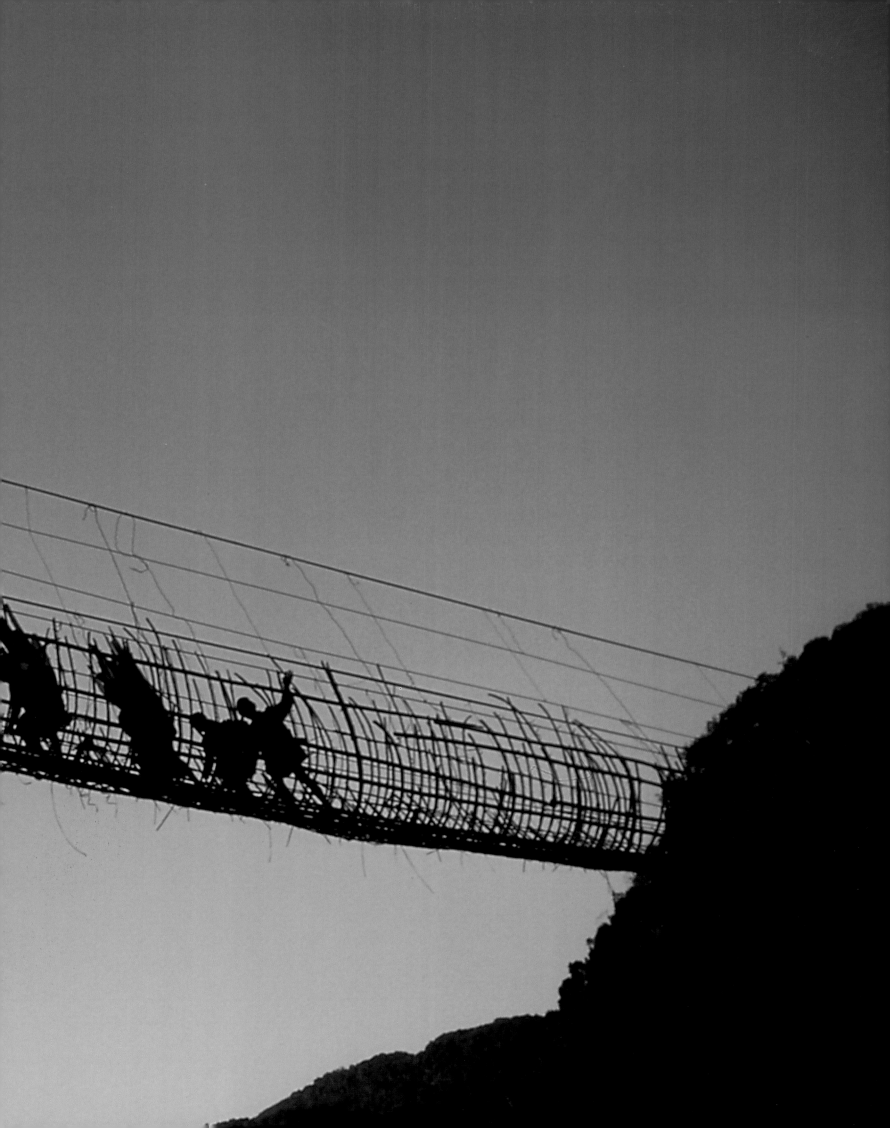

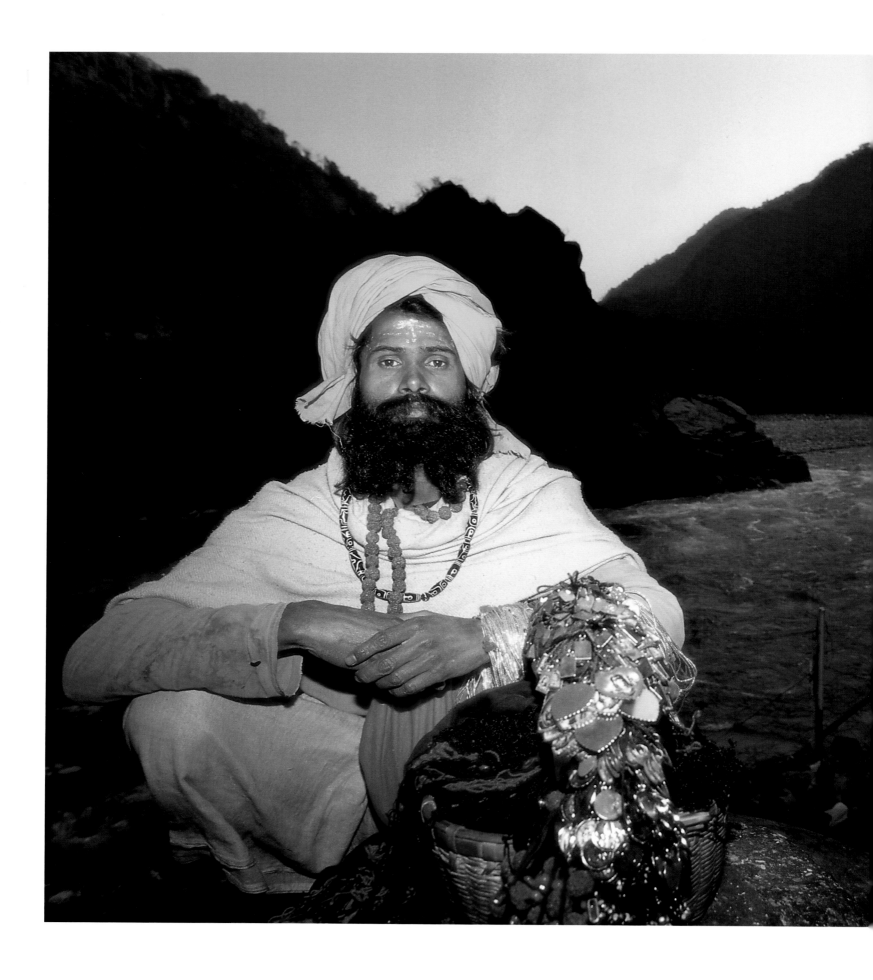

consults oracles

and reads entrails. Being animists, the Adi believe the river to be a god and fear the water spirits, whom they refer to as *nippong*. Isolated in an impenetrable jungle where nature has the upper hand, at the mercy of natural catastrophes such as floods and earthquakes, and having no defences against disease and illness, the natives have learned to attribute every event to the spirits who inhabit the rivers, the rocks, the trees and the mountains.

Their deities are the Earth-mother, the Sun-moon, or the 'Eye of the World,' from whose vigilant gaze nothing can escape.

Originally they were hunters and gatherers; everything they needed to live on was obtained from the forest. It provided them with bamboo for their huts, tools and weapons; fibres for weaving clothing and other protective items; roots, tubers and wild fruit for food and medicine; monkeys, wild goats and sometimes a tiger, whose flesh, considered an aphrodisiac, was reserved exclusively for the men.

Yomgi refilled the *nyibo's* cup with *apong*. The small crowd that had gathered on the veranda was silent. Leaning against the veranda wall a child held a puppy tight in his arms.

The *nyibo* looked into the distance, beyond the valley. Acrid smoke billowed from his pipe.

A woman arrived carrying a large leaf on which was a dark pig's liver. The *nyibo* examined it for some time and then made a sweeping gesture with his hands; he spoke a few words to the woman. Then he stood up and, as suddenly as he had appeared, was gone.

'The *nyibo* is able to discover the explanation to events in pigs' livers,' said Yomgi.

This was a preparation for the ceremony of the *mopin*, an ancient rite bound up with crop cycles.

The next morning, shortly after dawn, visitors began to arrive. The hut was full of people. Women arrived from nearby villages, bearing large panniers of rice flour. The *apong* was ready in large containers. The bowls began to be filled.

The young women gathered in the houses. They attached combs and other bamboo decorations to their hair. Around their waists some of them wore belts from which hung various metal bells.

'*Boyop*,' said one of the women. 'They come from Tibet, across the mountains.'

A woman poured a semi-liquid paste of rice flour and water into bamboo cylinders which she handed to a small group of boys in jeans and baseball caps with the peaks pointing backwards.

Formerly used as a means of exorcising evil spirits, this paste – which is daubed and spattered on anything and everything – is now an excuse for unrestrained fun from which no one and nothing escapes. Not even cameras!

Many, many people had found their way to the village. Adi, Hindus, Gamburas, government officials, visitors. The *mithung*, the semi-wild oxen, were tied to the platform posts at the centre of the village, patiently waiting for their fate to run its course. Groups of young women danced to the instructions of an older woman. Everywhere the flour and water mix rained down on the proceedings.

Then the *nyibo* appeared on the platform and everyone fell silent. The eyes of those present anxiously followed the shaman's hand which drew mysterious figures in the air. First he waved a bird feather or a bamboo leaf in the air; then he produced the entrails of a chicken. He invoked the spirits of the forest in a voice which was first gentle and confiding, then guttural and harsh. His movements were as ancient as the village itself.

He placed his hand on the *dao*, the sacrificial sword. Slowly he lifted it and held it above his head, pointing to the heavens. This was the signal for the slaughter. The men quickly tied ropes to the horns of the mithungs and turned them onto their backs, immobilizing them. The sacrifice was carried out. The *nyibo* watched from above. His gaze did not falter. It was a disquieting face. He was still with the spirits.

The animals were slaughtered with surprising speed, and the meat was distributed throughout the village.

The boys had resumed their sport with the flour and water. A loudspeaker broadcast the official speeches. The women were dancing again.

We looked back to the platform. The *nyibo* had disappeared. We came across him towards evening. He was with the Gambura.

We approached. The fetishes no longer adorned his bamboo head-dress, but he was still wearing the paper sticker which someone had affixed to his chest, with the word 'priest' written on it. He invited us to join him. Gianni and I exchanged glances. The uneasy feeling we had experienced in his presence on the previous encounters was now gone. No longer was there anything disquieting about his face. We were now approaching the year 2000. Our eyes met those of the *nyibo*. There was a flicker of understanding in his face. He smiled. He knew what we had been thinking.

Tadari Tamut, an Adi from the Minyong, climbed onto a red Yamaha and turned off along a different track ending at the forest. He was swathed in a native gown, over which he had thrown a worn-out jacket. His hair was cropped in the traditional style. Dalton wrote that this hairstyle was achieved by holding a wooden bar against the head and cutting all around with the blade of a knife. When it was impossible to go any further, Tadari dismounted and strode out through the undergrowth between the rocks and bamboo plants.

He was making his way to the river, a small tributary of the Dihong, where he had set his bamboo traps. 'These are the best traps for fishing,' he said.

However, as we proceeded, Tadari seemed more and more pre-occupied and his pace quickened. It was as if he wanted to hide his tracks. We walked for the best part of the morning, following in his footsteps up and down the hills. When we finally reached the river, Tadari was sitting beside a small fire which he had kindled in a hut hidden beneath the dense trees. He was clearly uneasy at our presence. Though he had agreed to our accompanying him, he had hoped we would be unable to follow his route along the obscure mountain paths and so fail to reach the river.

'If a stranger sees where I have placed my traps,' he said, 'the fish will not enter them. Then we will catch nothing.' Reluctantly,

Tadari went into the water; he lifted some stones and removed the traps. They were empty, apart from two tiny silver fish. The expression on his face was full of recrimination. We said he could have our food and this seemed to console him a little.

On the way back we crossed a suspension bridge, a masterpiece of primitive engineering. An elaborate tubular structure in bamboo cable extended across the river, suspended from either bank at a height of over thirty metres above the water. We later saw a replica across the Dihong-Brahmaputra, covering a distance of over two hundred metres.

The Adi have been building these bridges from time immemorial.

According to ancient Chinese witnesses from the 4th century AD, monks who crossed the jungles of the north-eastern Himalayas were very impressed by the suspension bridges built by the Adi.

All around there was nothing but forest and the limited horizon of the valley. Ideal territory for ambushes.

Time has removed all traces of aggression from the Adi. Yet the first explorers of the course of the Dihong described them as dangerous, hostile tribes against whom the English conducted a number of punitive expeditions at the end of the 19th century and the beginning of the 20th.

Towards the end of the 19th century – when Kintup was following the course of the Tsangpo in Tibet – on the Indian side Jack Needham, the Political Officer in Sadiya, was following the Dihong upstream. He was the first to negotiate the forest fortress paths of the Abor. Around fifteen years later his successor, Noel Williamson, made a second attempt, leading a peaceful expedition with a tea plantation doctor, Dr Gregorson, bearing various medical provisions. A tragic fate awaited them.

According to the reconstruction of events by Angus Hamilton[1] and Captain F.M. Bailey[2], the massacre to which Williamson and Gregorson fell victim 'was due to a series of misunderstandings.'

The day before setting out from the Abor village of Rothung, heading northwards up the Dihong, Williamson's expedition was robbed. As he left the camp Williamson told the Gambura that, on

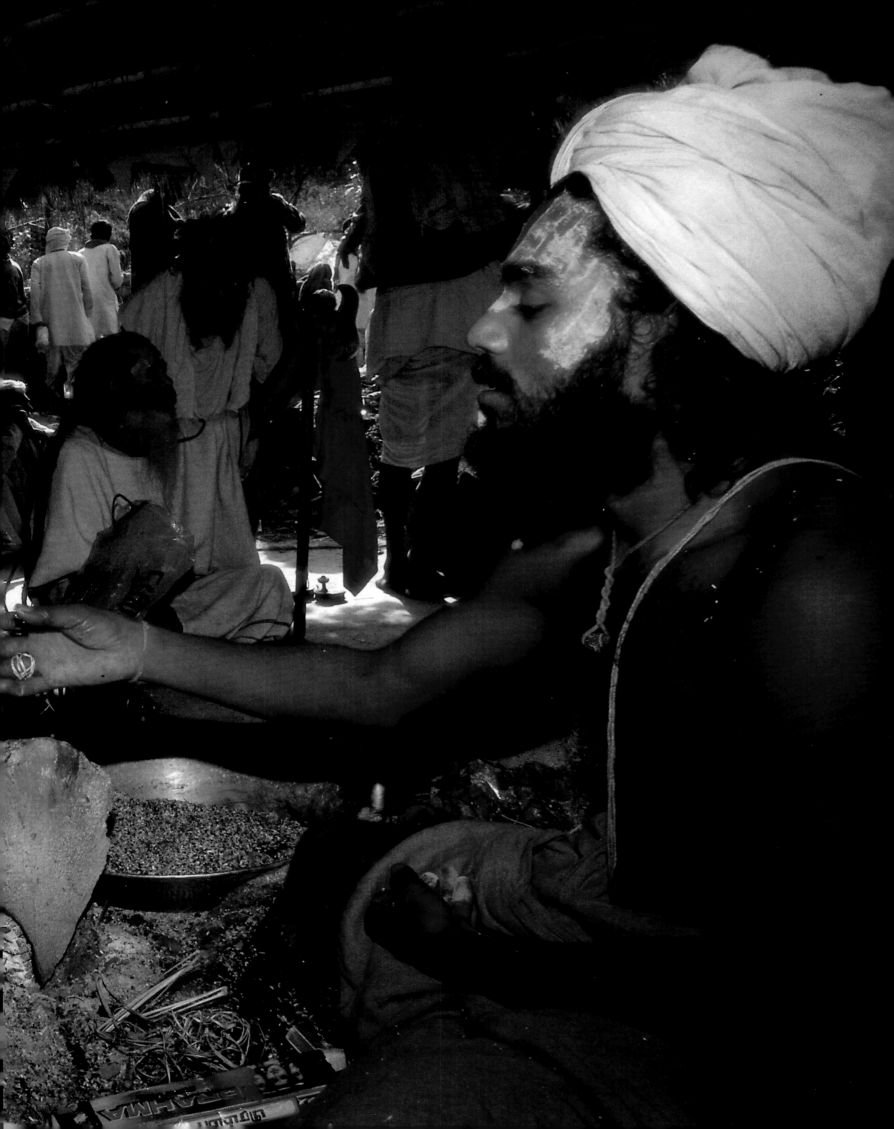

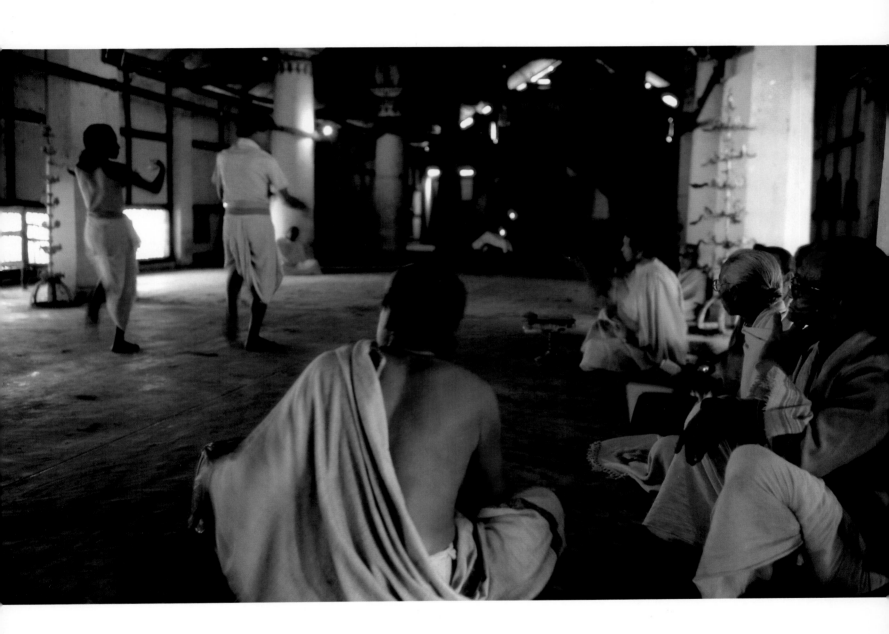

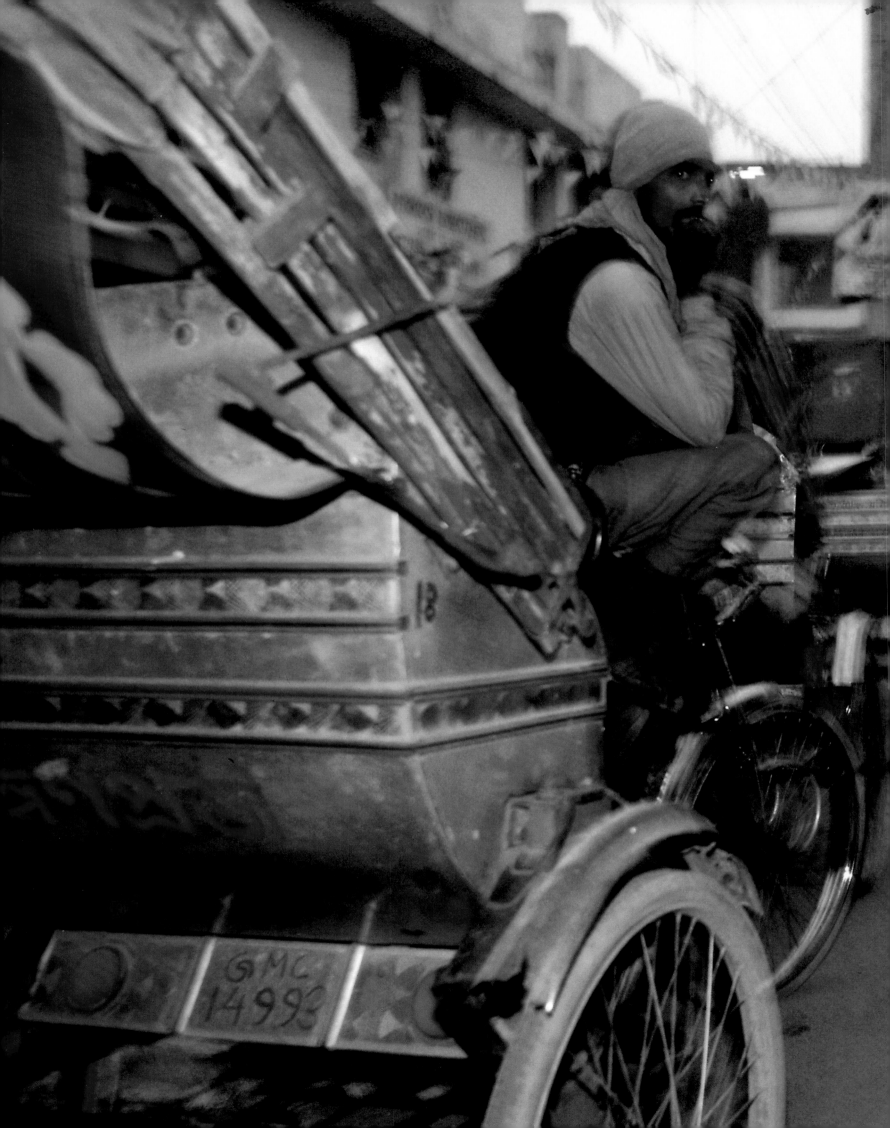

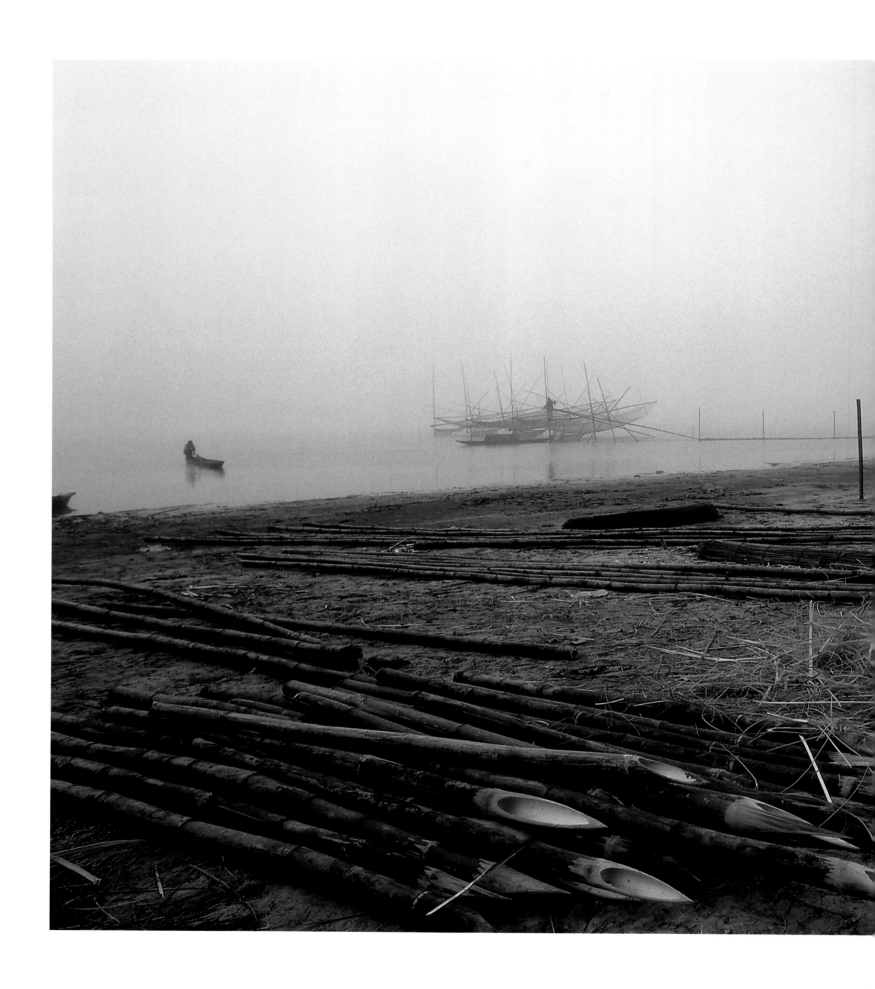

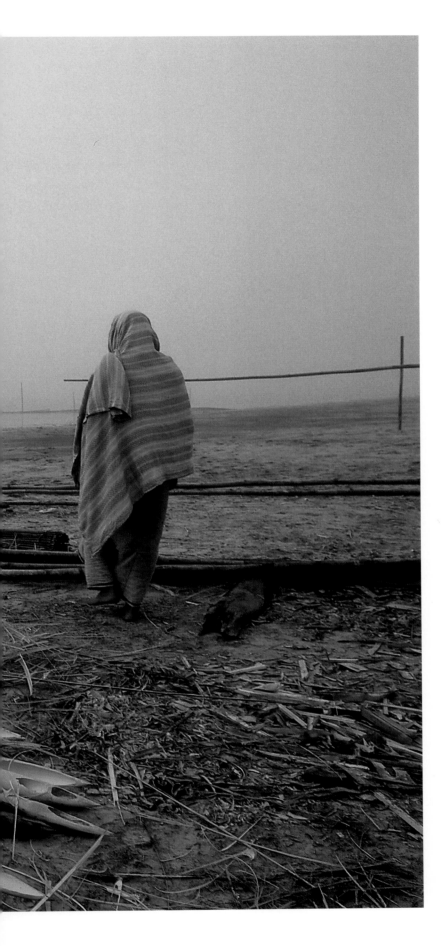

his return, he would seek redress for what had been lost. Some days later, the expedition was brought to a standstill by an epidemic which struck down many of the porters. It was decided to carry the three most serious cases to Pasighat, while Gregorson tended to the others. With just a few men, Williamson continued northwards along the right-hand bank of the Dihong.

On the return journey the three sick men, accompanied by a Miri, stopped at Rothung. According to Bailey, the Miri had with him three letters in black-edged envelopes relating to the death of King Edward VII and bearing a wax seal. Williamson had entrusted him with these for delivery in Pasighat.

'In order to make himself look important,' the Miri waved the envelopes under the noses of the Abor, explaining that 'white symbolized the white man; and the black border represented the Indian military police.' When the Abor asked whether the red markings stood for anger, the Miri answered in the affirmative. Believing that the English were about to vent their anger on them because of the expedition provisions lost in the robbery, the Gambura pronounced a death penalty. Williamson and the whole expedition were killed by the Abor on the banks of the Brahmaputra.

The British response came quickly. In 1911, under the command of Major General Hamilton Bower, known as Buddha Bower, a formidable army of Gurkha soldiers and porters from the scalp-hunting Naga tribes marched on the Abor hills.

This was the most significant punitive expedition the English had ever organized against the 'barbarians' in the mountains on the border with Tibet. For months the Brahmaputra was ploughed by steamers loaded with arms and soldiers from Calcutta.

Hearing rumours that the English were approaching their territory, the Abor used all the ambush techniques of which they were masters. Heaps of rocks, ready to rain down on the soldiers, were amassed on the hill tops. The suspension bridges were cut, the villages, already inaccessible by the nature of the terrain, were fortified and fences were erected. For days and days men and women prepared *panjees*, bamboo points made as hard as steel in hot ashes, and planted them along the access routes to the villages, ready to penetrate a soldier's boot or the foot of an unshod porter. They also

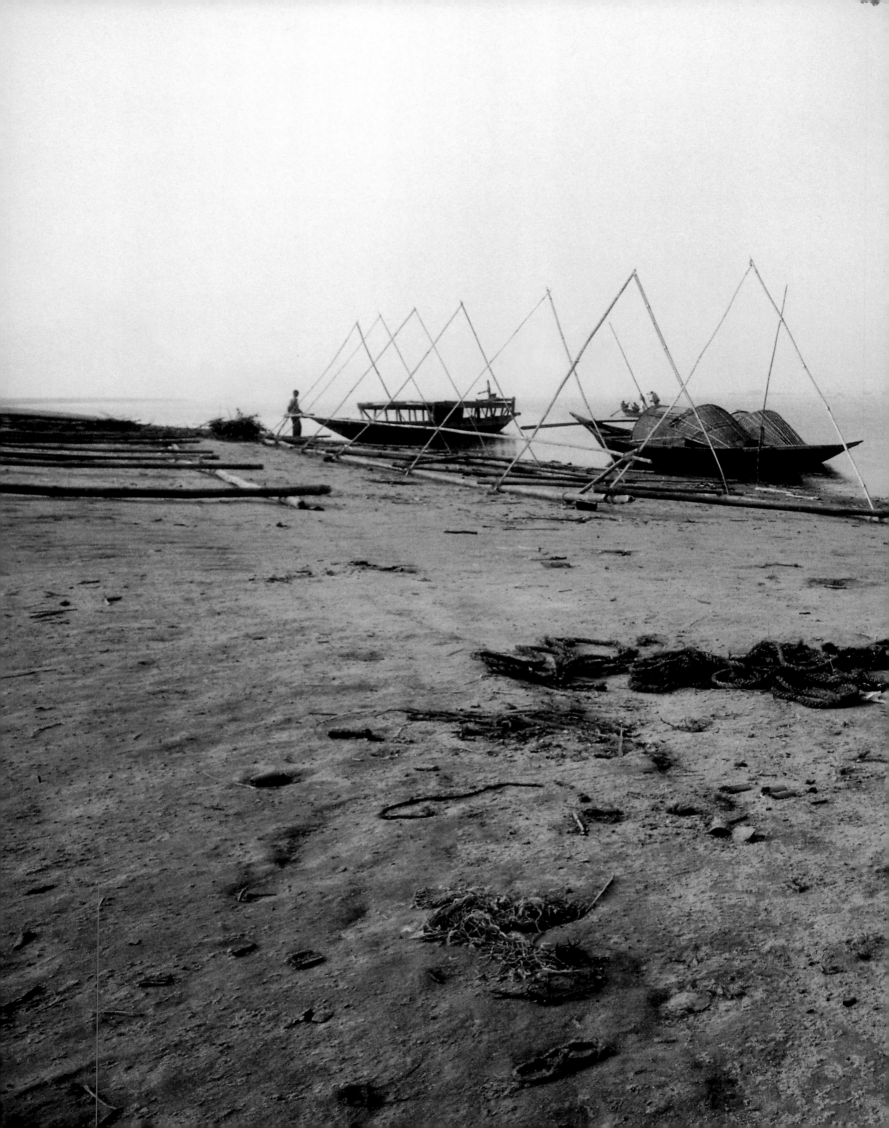

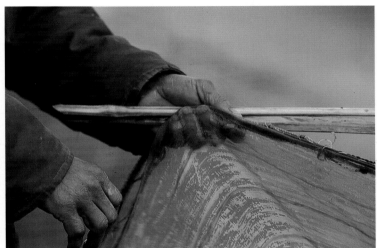

prepared poison for the poisoned arrows they would shower down on the enemy.

But a shower of poisoned arrows was of little effect against Bower's army. The soldiers slowly took control of the forest, flattening trees, throwing up bridges, and opening up a way through the jungle which, until then, had been the Abor's fortress.

General Bower's successful campaign, and the peace agreement which ensued, opened the way to Tibet and the Great River Tsangpo for Bailey and his colleagues from the Survey of India.

In Tezpur, the 'City of Blood,' the site of a mythical battle between deities in their attempt to win the hand of the most beautiful princess, Usha, and today a modern city on the north bank, the Brahmaputra is crossed by the Kalea Bhomora, one of only two bridges in Assam, bearing the name of a general of the Ahom people – a Shan tribe in the north of Burma which conquered Assam in the 13th century – and opened officially in 1987 by Prime Minister Rajiv Gandhi.

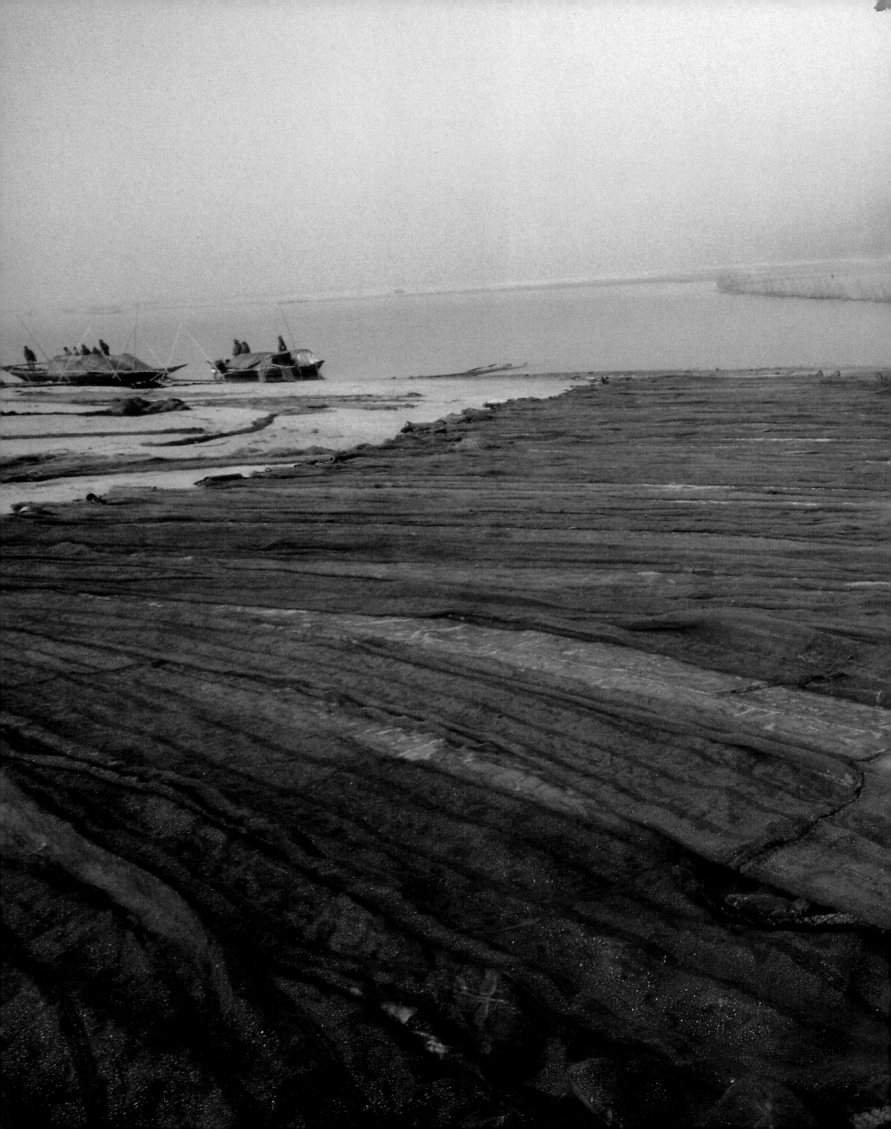

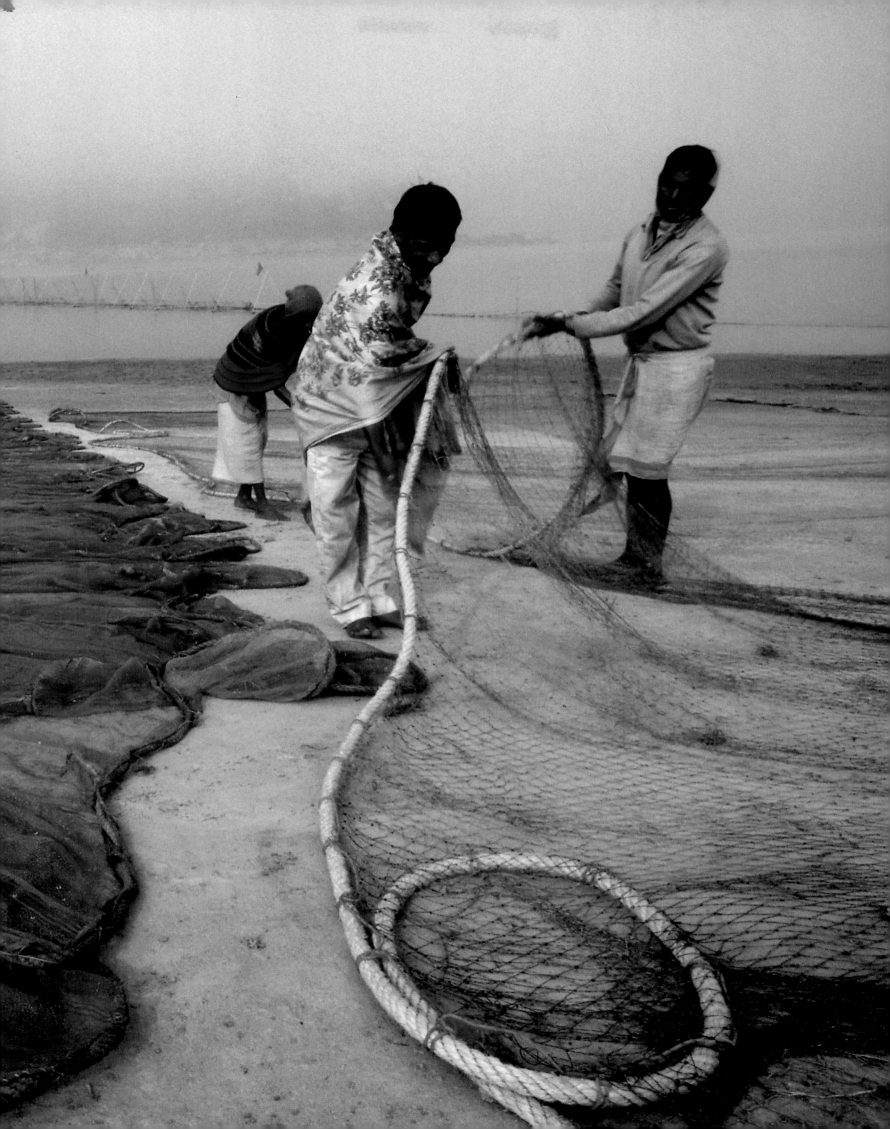

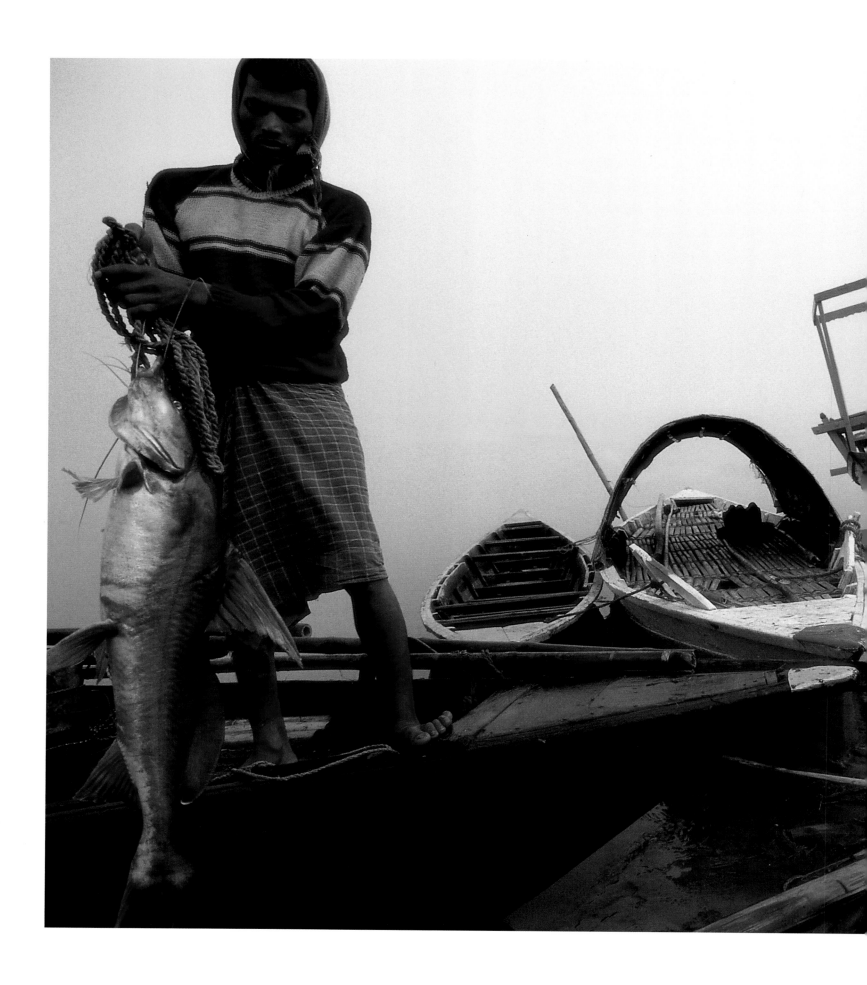

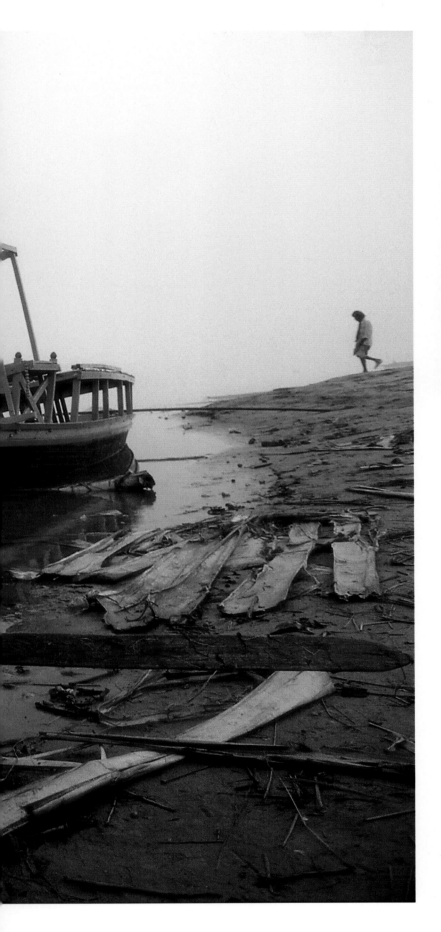

The river was wide and peaceful as we sailed towards the island of Majuli on whose banks Ram Chandra, one of the mythical kings of Assam, offered his splendid queen to the Brahmaputra.

In Assamese folklore, Majuli was born from the left breast of the goddess Kali that had fallen from the hands of Shiva and was hovering in the heavens after he had collected the scraps of body of his adored companion which had been broken into a thousand pieces by the iron disk hurled at her by Vishnu to stop her, consumed as he was with anger and ready to destroy the earth and the whole of humanity.

According to the myth recounted by the *Kalika Purana*, in despair Shiva carried the body of his wife, Sati, who had taken her own life because of the shame of an offence which her father had committed against her husband. To save the world from destruction by Shiva, Krishna shattered Sati's body with his sacred Sudarsan Chakra. As the breast of Sati gave life to the island of Majuli, so her vagina created the hills of Nilachala, where the Tantrist temple of Kamakhya stands in Guwahati, the ancient Prajjyotishpura, the 'city of the astrologers,' of which we read in the *Mahabharata*. Today the city is undergoing extensive industrial and commercial development.

For centuries the followers of Tantrism have met in the temple of Kamakhya.

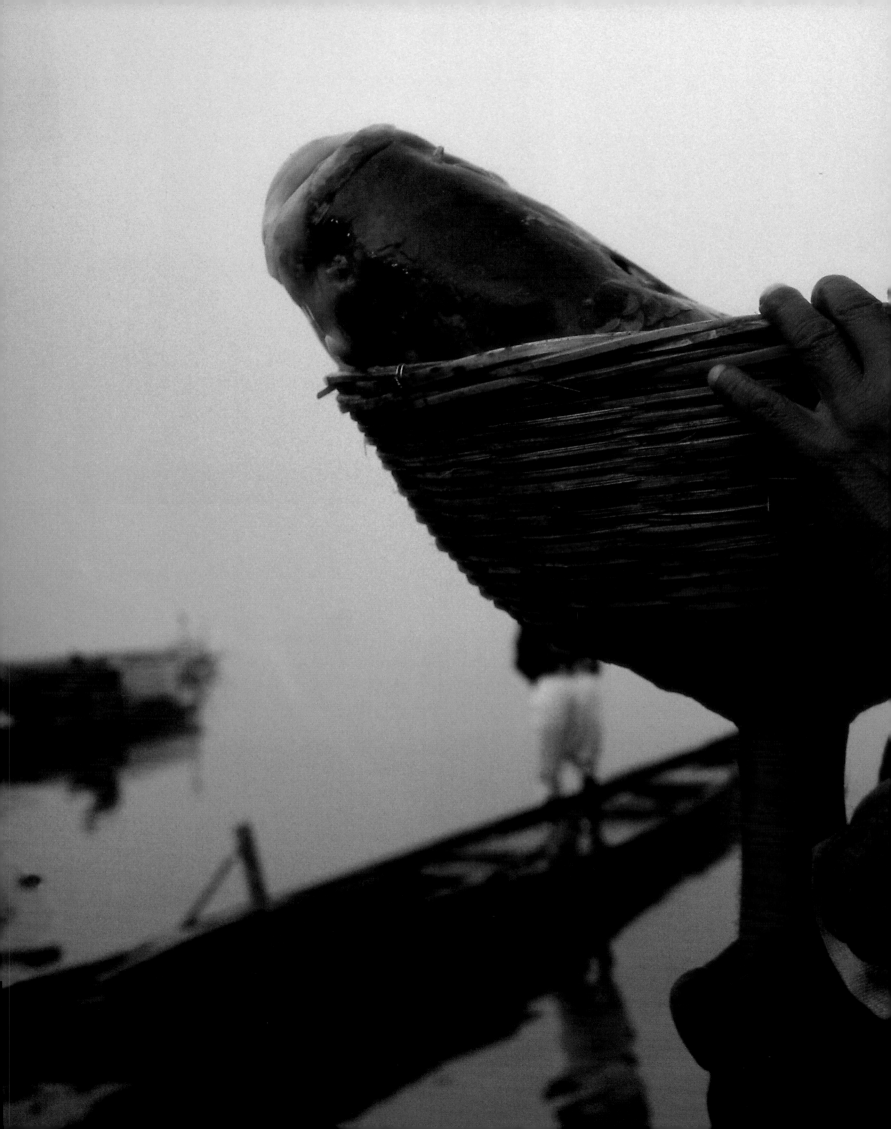

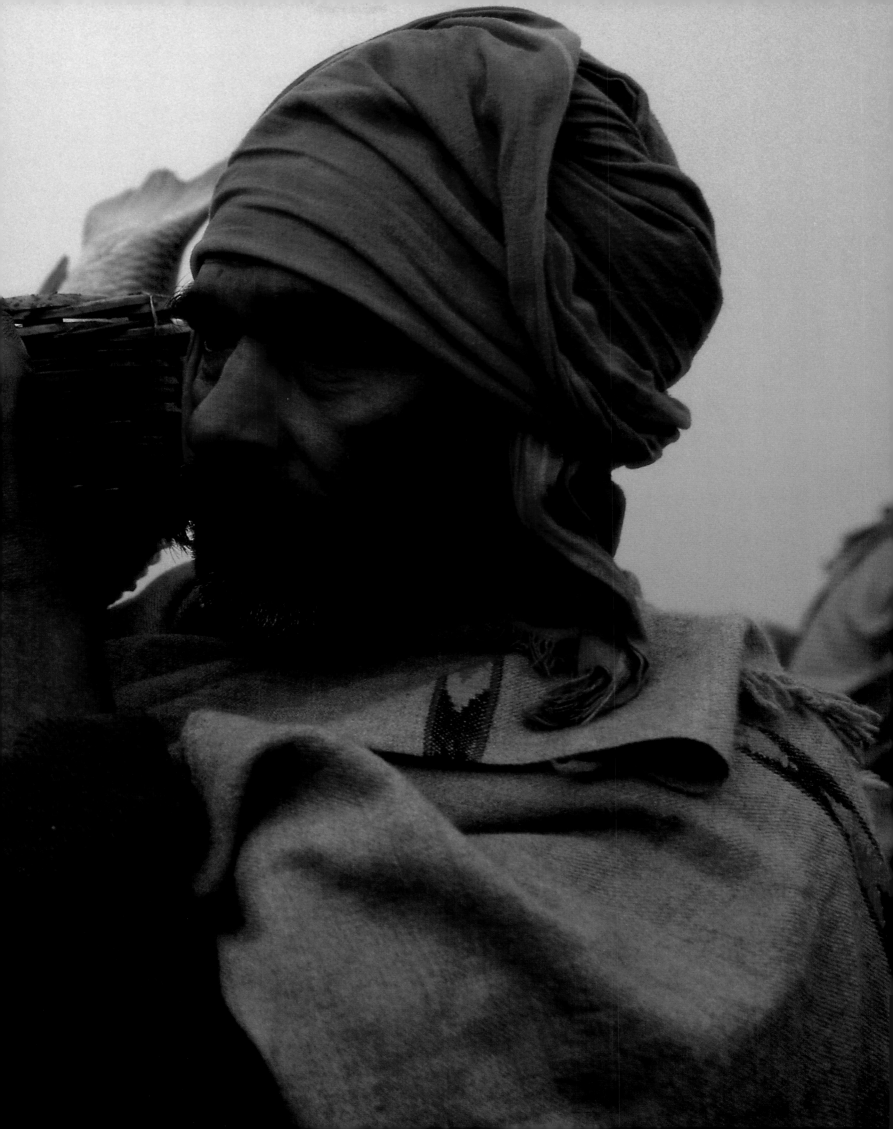

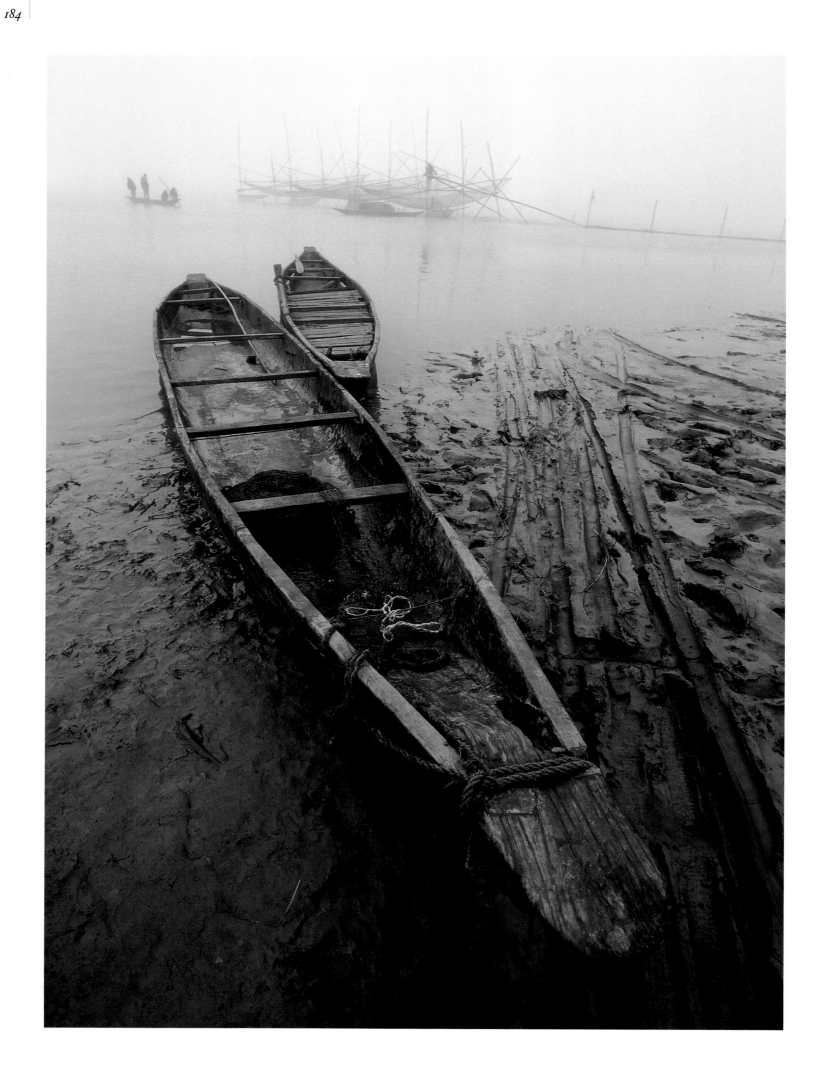

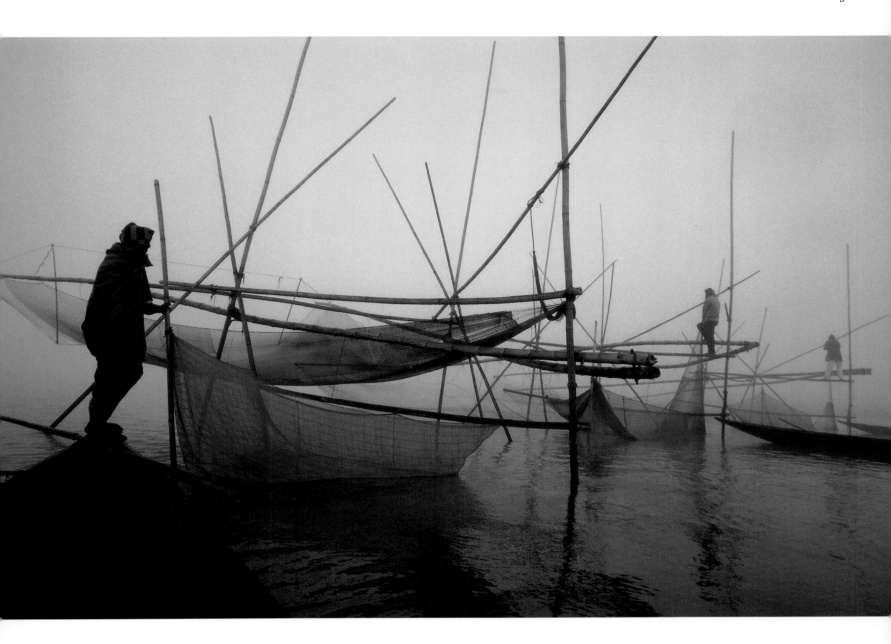

Jean-Baptiste Chevalier, a French consular official in Bengal in the second half of the 18th century, left an account of the sacrificial rites offered every year by the king of Assam, in the temple in Guwahati, to the Kamakhya goddess Shakti, represented by the Tantrist symbol for the female sex.

He spoke about vestal virgins in the temple, the most beautiful girls in the kingdom who, 'having the most beautiful bodies, the purest complexions and the most attractive colouring that nature had ever produced in any country in the universe, initiate the novice in the mysteries of love. It is here, in this intoxicating and enchanting atmosphere, that the souls of bodies joined in tender union melt into blissful oblivion.'[3]

Through the mist we could hear the sirens of the steamers. The mists slowly rose from the river banks, revealing the rice fields and the hills of Assam, carpeted with tea plantations.

The banks of the Brahmaputra, where in 1823 Robert Bruce first discovered wild tea plants, are one of the wettest regions in the world. From March to September the monsoon rains deluge Assam to such an extent that, as Elwin wrote, the rain here forgets the Indian monsoon pattern of a dry season followed by a wet season.

On this natural mountain range around one third of the tea of India is cultivated.

'Between July and September thousands of pickers work on the two thousand plantations of Assam.' Yashwardhan Singh Rautela is the head of a plantation of eight hundred and fifty hectares, employing over one thousand labourers and staff. 'The leaves are mostly harvested by the women: only gentle female fingers guarantee a good yield without spoiling the quality of the leaves. With a rapid movement, their hands remove the youngest leaves and throw them into the basket which each picker carries on her back.'

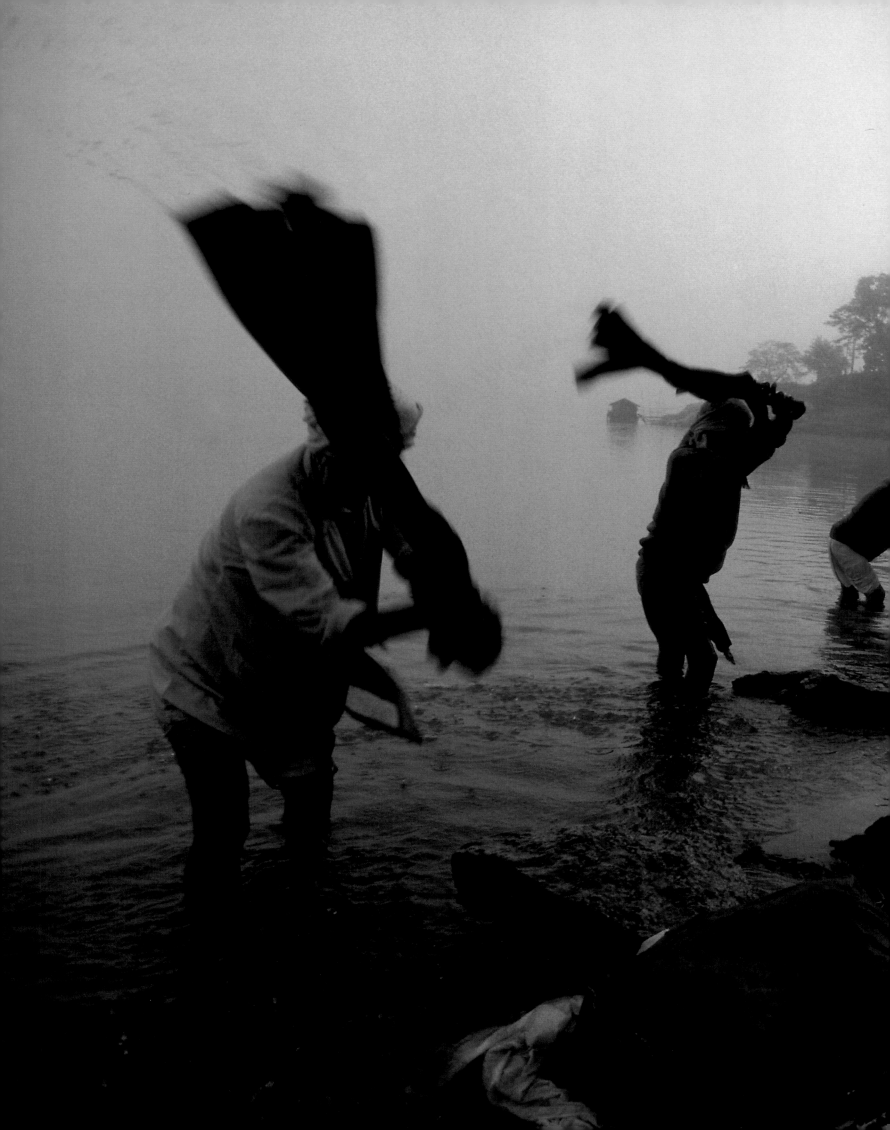

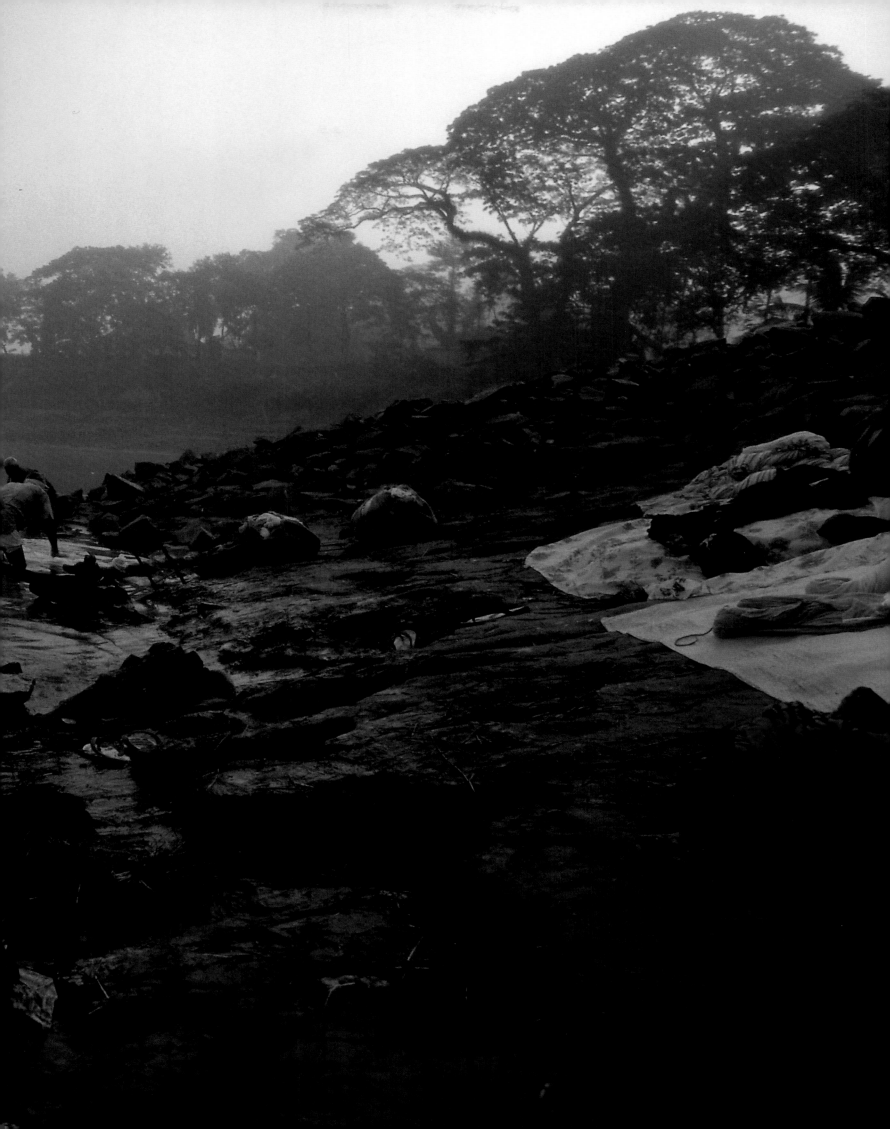

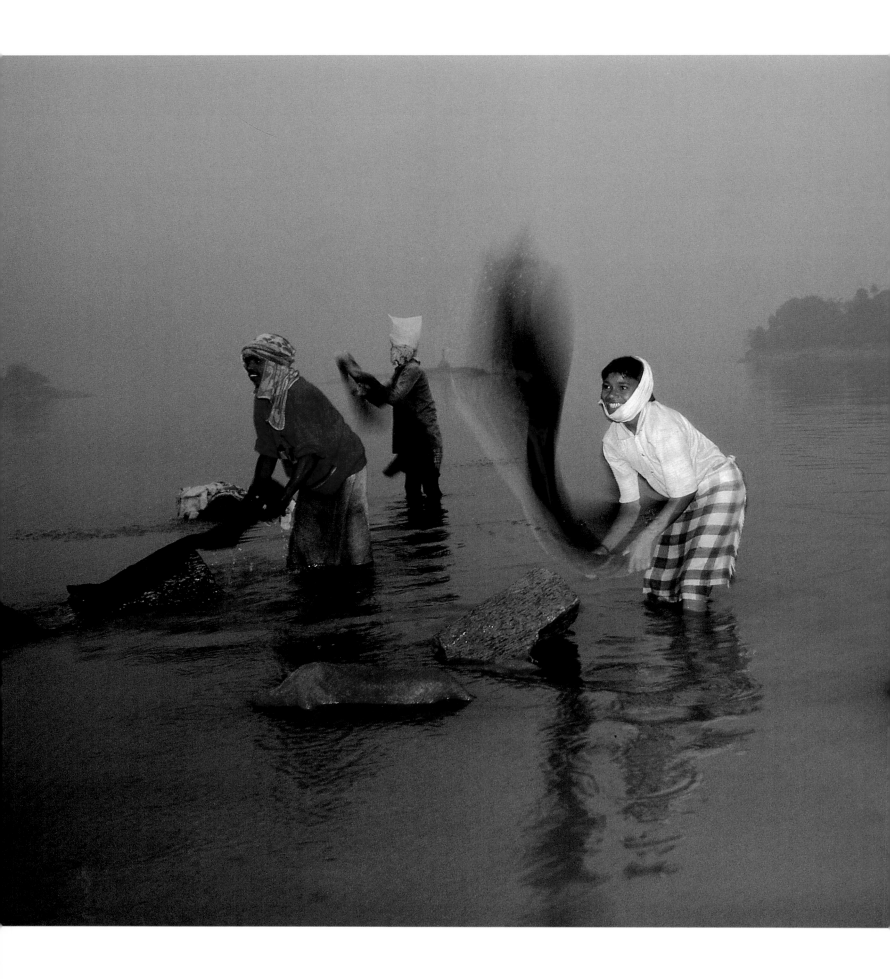

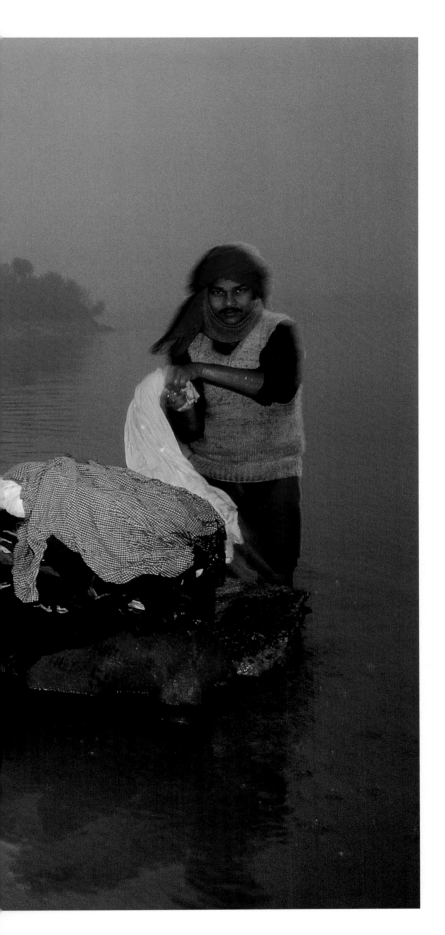

Rautela and his wife, Nimmi, gave us a very cordial welcome. Their house, surrounded by a park in the English style and a garden full of flowers, is a white house of the colonial type, at the heart of the plantations. An enormous bed of neatly arranged shrubs, none more than one-and-a-half metres in height, sheltered by tall trees against which, according to Rautela, it is not uncommon to see elephants rubbing their sides.

On the veranda Nimmi poured black tea with a strong aroma and a slightly bitter taste – one of the best unprocessed teas in the world – into porcelain cups.

'Today the plantation is independent and takes its responsibility to its workers seriously. There is a school for their children, a dispensary and a medical post. The working conditions are very different from those endured by plantation workers in the last century. At that time they were at the mercy of unscrupulous farmers and agents who recruited them in Bengal and along the banks of the Brahmaputra, with the promise of light work and good wages.'

Many perished on the journey, before reaching their destination; others were overcome by a shortage of food, by malaria fever and by crippling work enforced by lashes from a whip. People spoke of the 'bitter tea of Assam.'

The tea route was established by the English of the East India Company in the early 19th century. In 1815 Colonel Latter mentioned that the Shingpo of Assam cultivated a type of wild tea which they ate with garlic or used in the preparation of a drink. In 1823 the East India Company received a report from the Scot, Robert Bruce. He wrote about the discovery of some wild tea plants in the jungles of Assam and about having obtained the consent of the Shingpo to take some samples. But the Anglo-Burmese war broke out and the project was completed by his brother Charles Alexander, who was given the task – by the Tea Committee, established in 1834 by the Governor of India, Lord Bentick – of creating in Assam the first native tea plantation.

With the help of the Shingpo, over a period of four years Charles Bruce cleared the jungle and collected and planted tea on the banks of the Great River.

In 1838, the steamer Calcutta ploughed the waters of the Brahmaputra with the first cargo of tea produced by the British Empire, bound for London: twelve cases which, in January 1839, the East India Company auctioned on premises in Mincing Lane, the headquarters of the legendary Tea Exchange, which also served as an exchange for other colonial foodstuffs, and which was recently closed down.

Bruce had finally made the British dream a reality. The Empire had its tea.

In the 1860s masses of would-be planters were attracted to Assam by the recruiting campaign commissioned by the English Government. Believing the promise that they would make an easy fortune, many set off for Calcutta, caught up in 'tea mania.' The real journey was only just beginning, in fact: for a month they had to sail up the Brahmaputra until they were in Assam; this was followed by days on elephant back crossing the jungle until they reached the assigned territory. A section of jungle, infested with wild animals, that first had to be cleared.

Living in miserable barracks, highly susceptible to dysentery and malaria fever, those who had been enticed by the promised adventures of tea cultivation faced isolation and loneliness.

Only towards the end of the 19th century did conditions start to improve. A railway line was opened. Families from England started to join the farmers. The barracks soon took on the appearance of wealthy dwellings.

The tea colony had been born on the banks of the Brahmaputra.

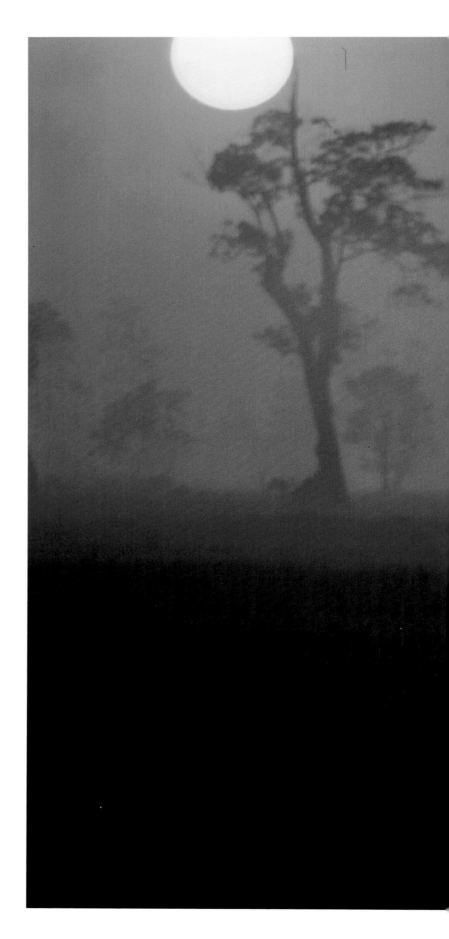

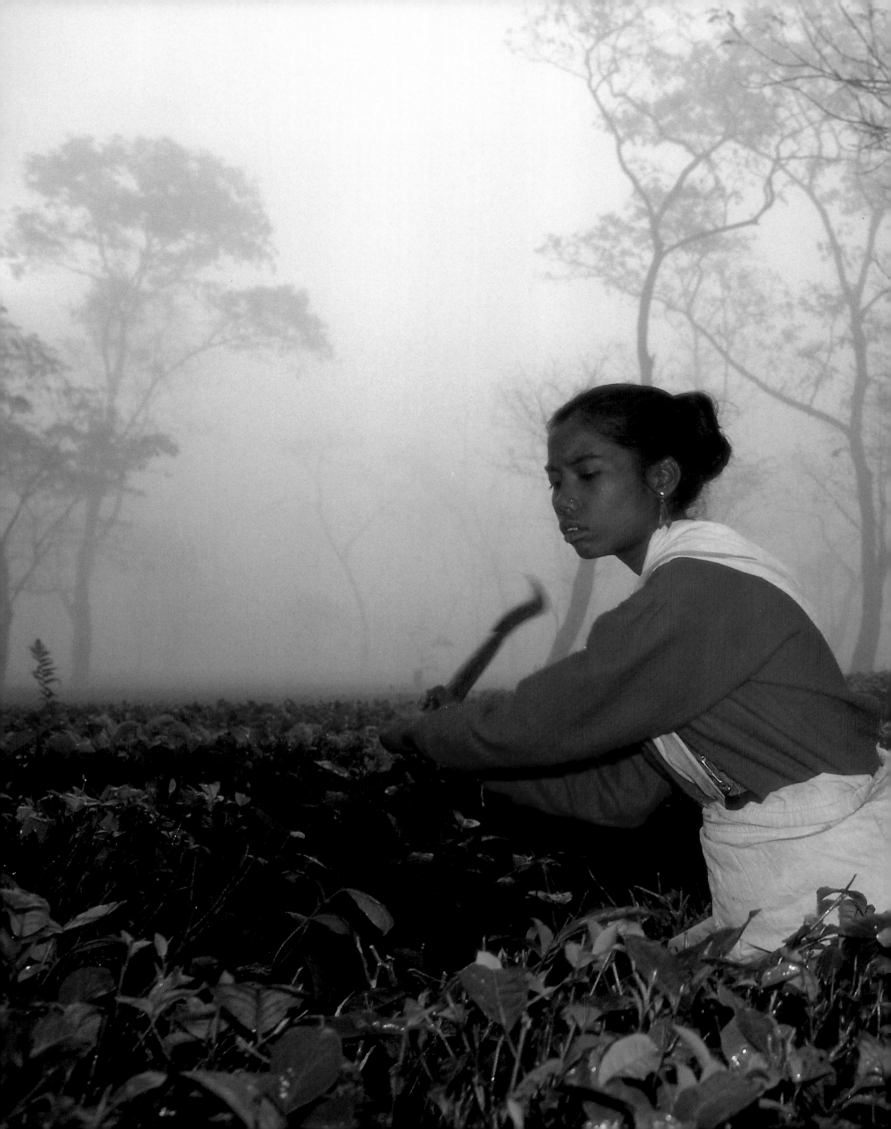

OLD AGE

Sir Charles d'Oyly, Antiquity of Dacca, *lithographs by John Landseer, from drawings by d'Oyly, 1814–27, John Randall Collection, London.*

JAMUNA

OLD BRAHMAPUTRA, 10 o'clock. The boat sails down a small stream. Land and water seem to merge. A short distance from the bank the village women wash their clothes. Standing in the water, they chatter and laugh. Their coloured cotton saris float around their bodies in the water. They move in perfect rhythm with this river, a river they have daily contact with, an intimacy going back over a thousand years.

On the clayey soil to our right the peasants plough the rice fields between mango trees and coconut palms.

Every now and then the canal widens into a pool where the fishermen plant their bamboo poles. These are 'fishing islands.' Attracted by the shade cast by these slender canes that stand erect from the river bed, the fish take refuge beside them in great numbers, and when the nets are spread around the circle of poles, they are inevitably trapped.

On the water's surface strips of grass and of hyacinths bob up and down. Dragonflies flit around above the immobile surface of the Old Brahmaputra.

Until 1787 this was the main course of the Brahmaputra. In that year, following the flooding of one of its tributaries, the Tista, the

Great River was disturbed and changed its course, opening up a new way to the south.

Abandoned to a rural solitude, many of the crowded centres that had populated its banks became ghost towns and villages, deserted and sleepy.

The Brahmaputra is one of the most unstable rivers of Bangladesh. 'The river has a will of its own,' Saddar told us. 'It does what it wants. It sees nothing. It feels nothing. It cannot be tamed. It does not care about those who live on its approaches.'

Saddar is a *majhi*, the owner and captain of a boat. He is intimately acquainted with the course of the river; its ins and outs, its sandbanks, its eddies and its dangerous currents.

'The Brahmaputra never runs along the same course for two consecutive years. It is the source of life for our people,' he continues, 'but it also produces fear.'

The fear that, when it rains, it will break its banks, sweeping everything in its wake and seeking a new bed where in the past was a village or a rice field.

Saddar has the dark skin characteristic of Bengalis; his arms are muscle-bound. He moves from one side of the *malar*, the large dark wooden boat whose hull is shaped like a flat spoon. He scrutinizes the colour of the water to determine its depth and any hidden dangers. Every now and then he issues an order to the crew who

Sir Charles d'Oyly, Antiquity of Dacca, *ibid.*

Sir Charles d'Oyly, Antiquity of Dacca, *ibid.*

have switched off the engine and are using long bamboo poles to stop the boat running aground on a sandbank.

It is no easy task navigating this canal in a heavy boat. A course has to be threaded between sandbanks and the fertile mud of the river banks.

'In the dry season it is increasingly more difficult to negotiate the watercourses each year,' says Saddar. 'Canals that boats could tackle without any problem in the past suddenly have insufficient water even for small flat-bottomed vessels.'

The current carries a large amount of sediment with it, fragments of fertile earth that only yesterday the river snatched from the Himalayas or from the rice fields of Assam; tomorrow this will form an island somewhere in the delta or on the river bed.

Every watercourse crossing Bangladesh builds up mud deposits. It then shifts and creates a new bed. It collects and deposits earth elsewhere. In an endless cycle that has been going on for centuries, the earth gives way to water and the water reconstructs the land.

Man has moved in to exercise dominion over the river and to bend it to his own needs. Countless canals and irrigation ditches have been dug in India and Bangladesh; on the Ganges a dam has been built to divert water from the eastern and western plains of Bengal; at its outlet clay banks have been built up to withstand the tidal waves that can occur during cyclones.

The sediment that the river had always carried out to sea is now beginning to find a resting place in the river beds, making them more difficult to navigate.

The Old Brahmaputra has become an unimportant canal.

The Great River that under the name Tsangpo crossed the high plateau of Tibet from west to east, passing through the gorges of the Himalayas and re-emerging in the plains of Assam as the Brahmaputra, eventually reaches the ocean across the alluvial plain of Bangladesh, bearing the name Jamuna.

At Goalkund the waters of the Son of Brahma and the 'father of all rivers' intermingle with those of Ganga, the 'mother of all rivers,' heavy laden with the ashes of thousands of bodies that have been cremated along its banks. Merging in an embrace celebrated in the ancient songs of the Bauls, story-telling gypsies of Bengal, in rhymes full of erotic ambiguities, Padma (the Ganges) and Jamuna (the Brahmaputra) make their way together out into the sea.

This immense mass of water, subsequently joined by a third river, the Meghna, then divides into countless canals teeming with the life of Bangladesh. A bundle of arteries opening out like the petals of a flower, in the Padma, the Lotus Flower (this is the meaning of the word Padma), whose petals spread outwards towards the ocean, forming the largest delta in the world.

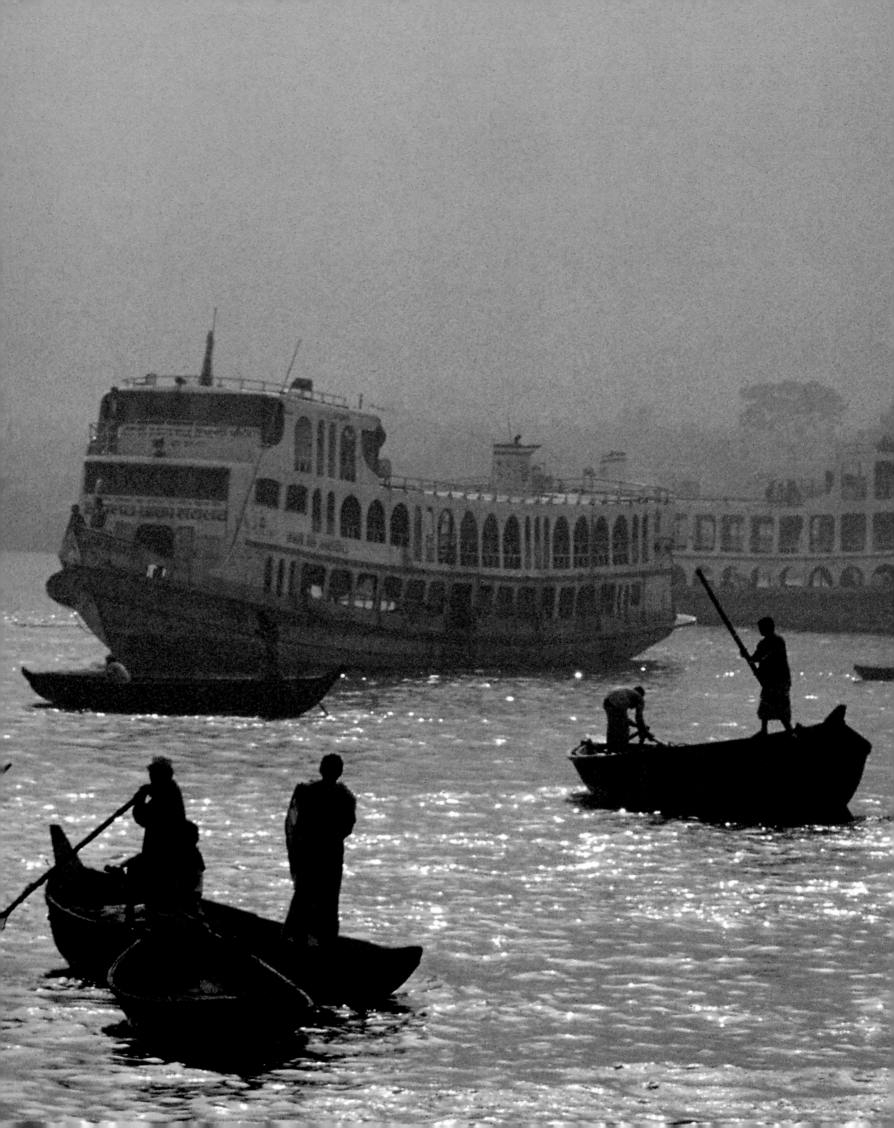

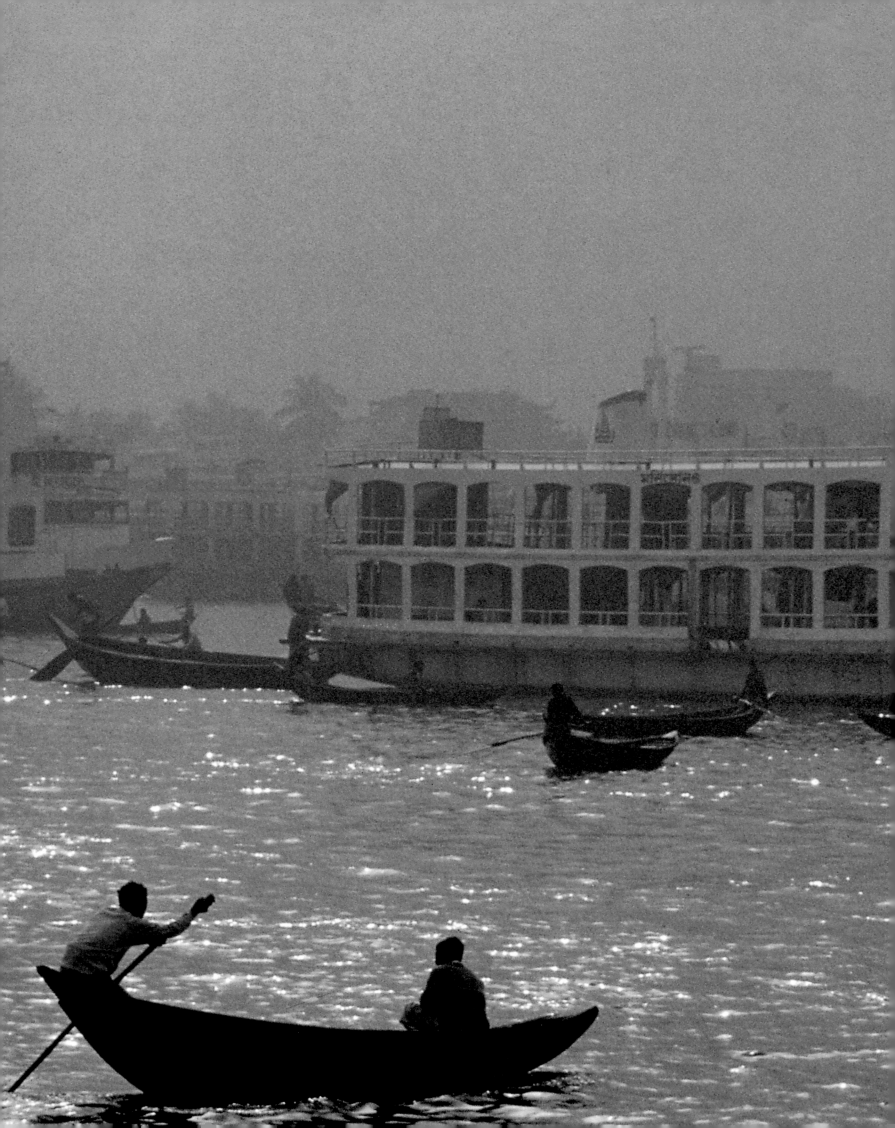

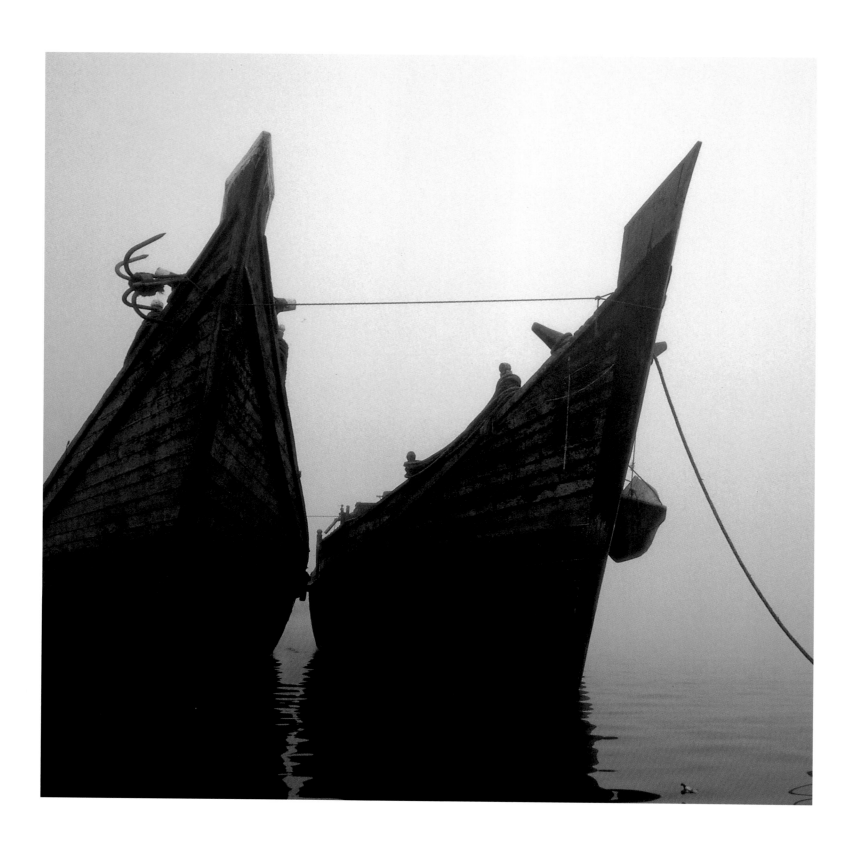

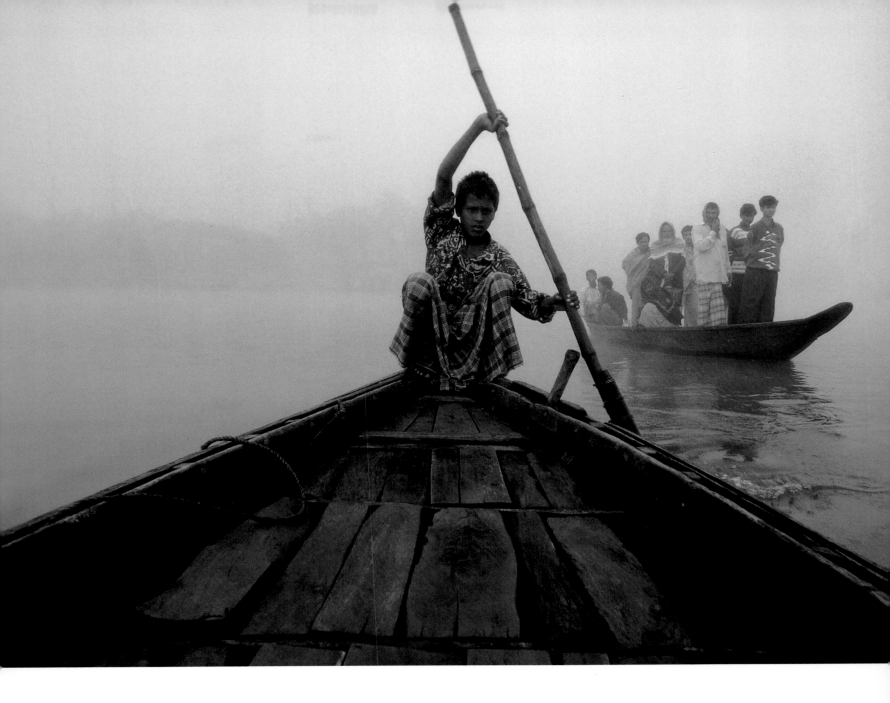

A series of waterways that in ancient times enabled navigators to penetrate what in antiquity was known as Golden Bengal, and which the Moghuls referred to as the 'paradise of the nations.'

It was by sea that the Chinese arrived in this region where, a thousand years ago the Arabs also settled in what is now known as Chittagong. And it was here, towards the middle of the 14th century, during a voyage lasting over twenty-nine years, that the famous explorer, Ibn Battuta, a native of Tangiers, set foot ashore. The Afghans came from Asia. The sea also brought Portuguese, Dutch and French, as well as the Greeks and Armenians, the pioneers of the jute trade. And finally the English of the East India Company who very soon became the controlling force for trade throughout Bengal.

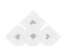

Chandpur, 6.30 in the evening. We arrived in Chandpur, on the river Meghna, when it was already dark. The moon was reflected in the still water. The port was on the point of falling asleep. On the boats anchored around our own boat the fishermen were preparing for the night. They were cooking their *dhal* on their small clay fires and the air was heavy with the tempting smell of the *sringala*, the vegetable rolls that are a typical dish of Bangladesh.

'No one likes sailing by night,' Saddar informed us. 'Pirates lie in wait along the banks. Ready to attack and steal cargo, money and even the boat itself.' He told us about encounters with these thieves of the river and about how, as a boy, when he sailed with his father,

the boats would travel in convoy for mutual protection. Born on the river, Saddar learned the secrets of navigation from his father. He belongs to a family of *majhi*, an hereditary caste of master boatmen among whom the secrets of the boatman's trade have been passed down through the generations. Fathers take their children with them while they are still young. By watching the adults, these children learn how to row with long oars, hoist the voluminous cotton sales, hold the tiller and anchor their craft at the river's edge with long ropes.

'A good *majhi* is attentive to the river's discourse. He knows where the slack water builds up at high tide; he listens to the wind and takes advantage of the changing currents, avoiding those that could be dangerous.'

Among people who live on the rivers, the *majhi* enjoy special status, as do the *sareng*, the master pilots who steer the boats through waters the crew are unfamiliar with.

The next morning, the voice of the *muezzin*, broadcast from a loudspeaker, broke the silence of dawn. A dense mist engulfed the port of Chandpur. Nothing could be seen. From time to time, a voice or the snapping of a branch betrayed the human presence. Through the encircling mist appeared the dark hulls of two *goloi*, the high wooden prows of the boats used in Bangladesh. They look like ghosts emerging from a past in which sailors from the Far East or the Middle East crossed one another's paths on this country's rivers.

The mist lifted and we could make out a long row of boats lying at anchor in the port. Beside our *malar* the gypsies' dinghies were moored, floating homes covered with reed matting as a roof. Crouching at the stern a rather beautiful young woman was washing clothes in the water, while a small child trotted around her, nibbling at a piece of *chapati*. Inside this floating home, a dwelling of

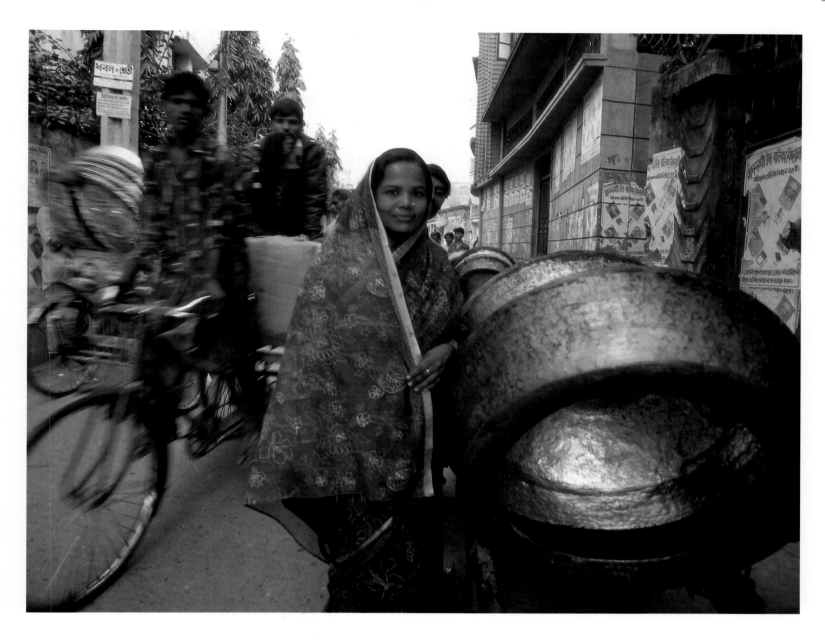

just a few square metres, everything was neatly arranged: very few household goods, the blankets used to sleep on at night and a chest containing the few items of clothing the family possessed, onto which someone had pasted an image of Krishna.

Nomads of the river, at one time astute dealers in medicinal herbs and pink pearls surrendered by oysters from the river bed, the gypsies are now gradually disappearing.

On board a flat-bottomed piragua, we paddled around and watched as the port woke.

A boatman was pushing out a straw dinghy. On the wooden platform at the end of his craft, seated behind a mound of vegetables, a man was tying up bundles of carrots and lettuces to sell in the market. Two small boys cast a net into the dark waters in the hope of catching a fish. On the jetty, his arms extended beneath his green checked *longhi*, we could see Saddar, talking animatedly with

a group of *dalal* who acted as middlemen for the goods to be sold. People of the river like Saddar depend on these dealers. The *dalal* have contact with the landowners, the farmers and the merchants, and it is they who take care of the transport contracts. Today it may be a consignment of straw; tomorrow a consignment of jute, bricks, tiles or earthenware vases.

The river was alive with activity. The boatmen announced their services. A crowd of people in brightly coloured clothing stood on the jetties, waiting for the ferries to depart. The noise of motors filled the air. The boats then left the port of Chandpur, launching out into the vast open expanse of water where the Jamuna and the Padma, now forming a single river, are joined by the Meghna.

At this point, where the river is so wide that, if you sail down the middle, neither bank is visible, Bangladesh seems to be a land of water.

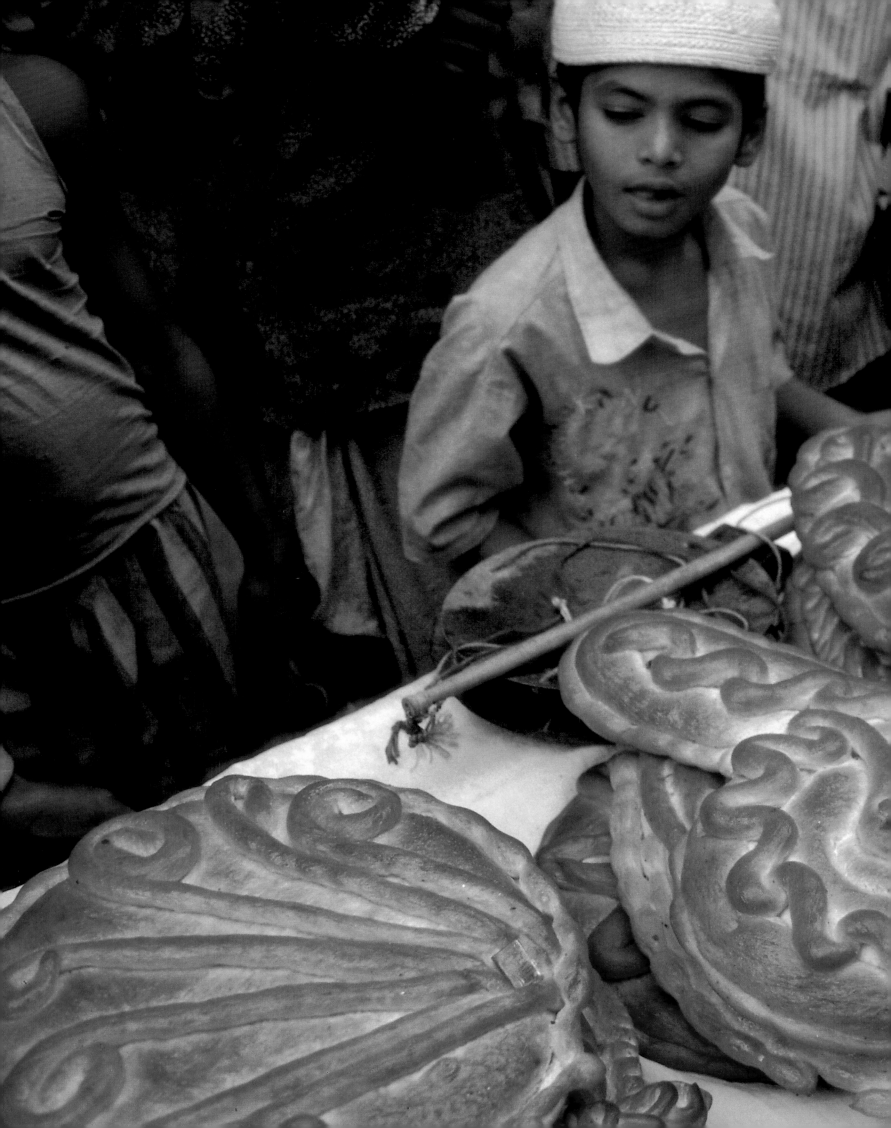

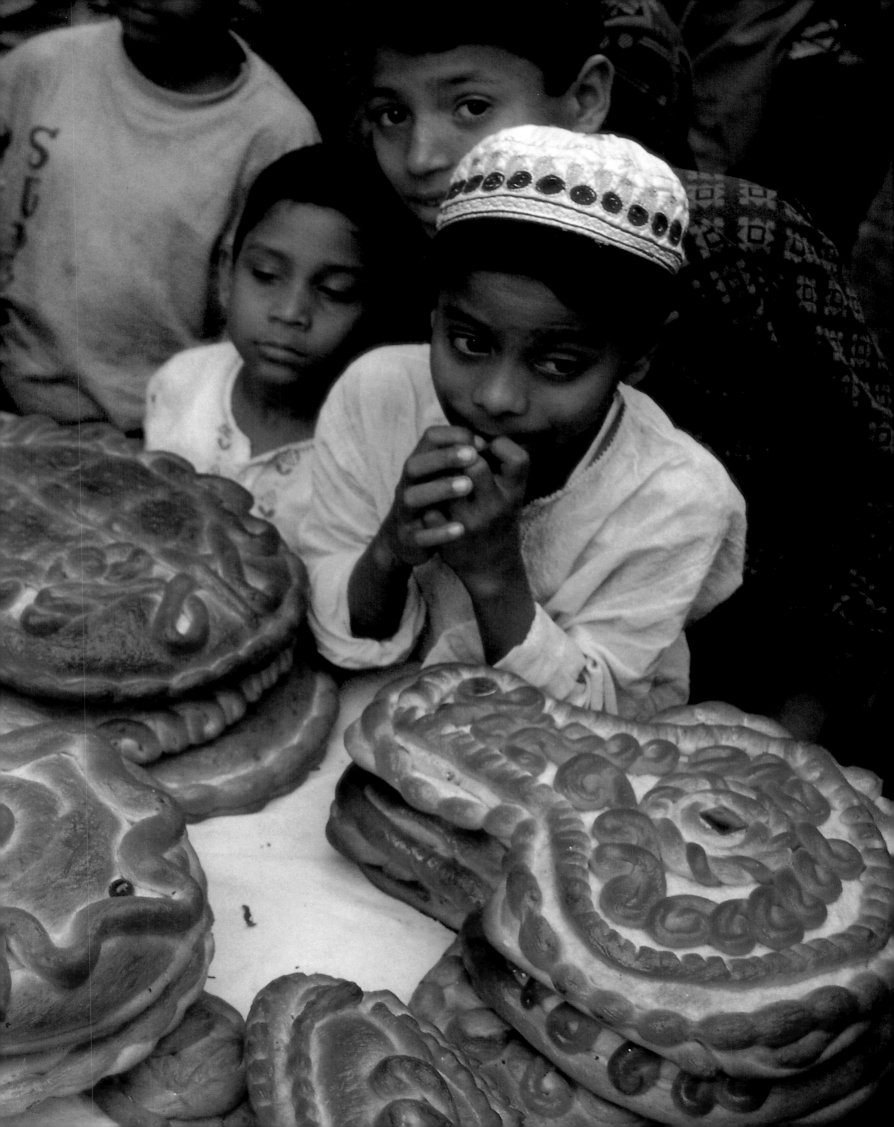

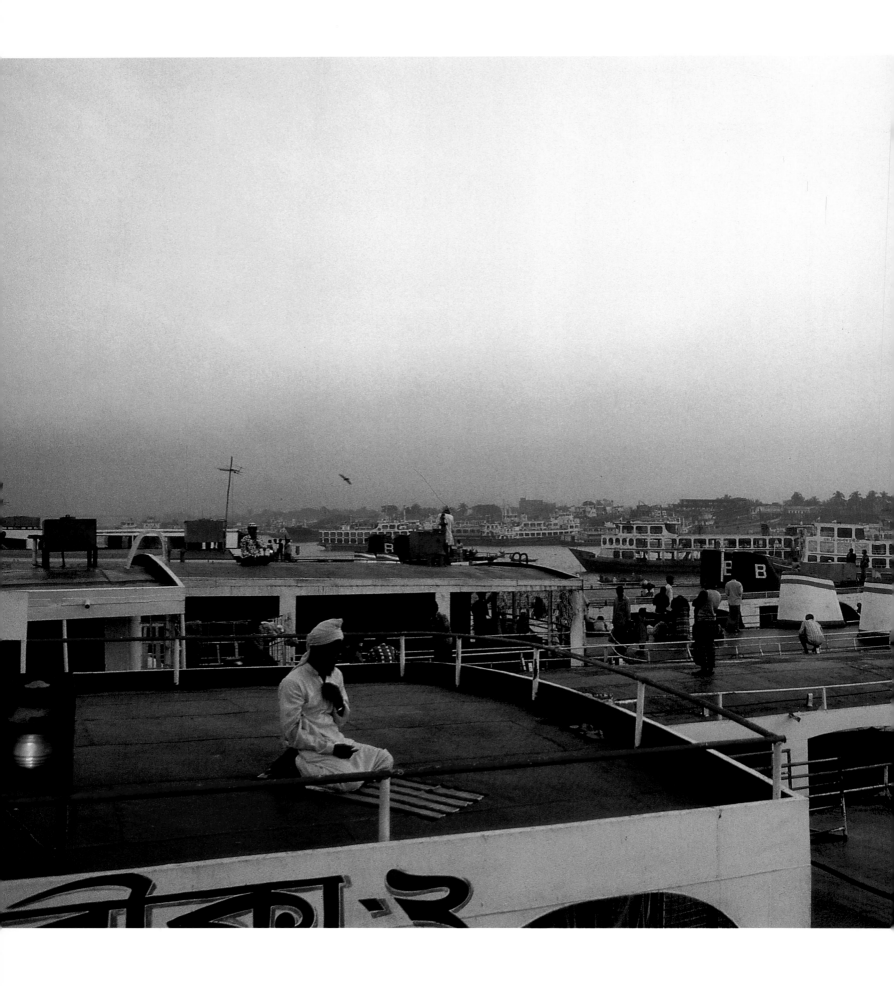

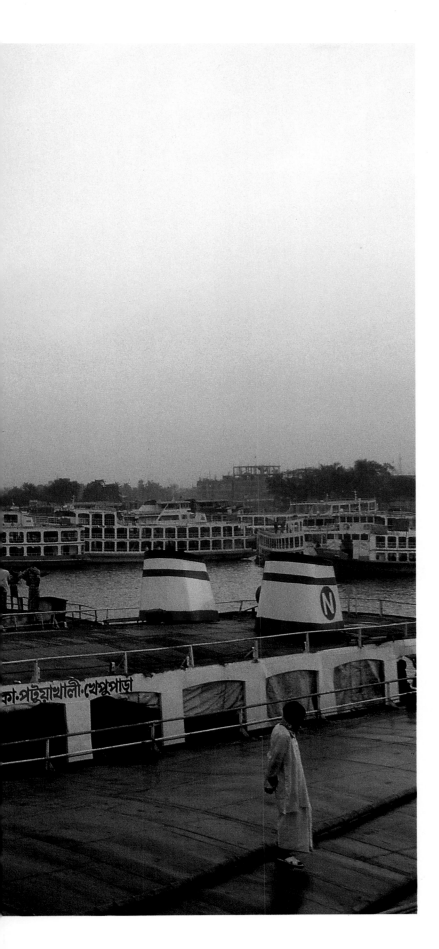

Not a land on the water, but water on land. One-third of the State's whole territory is water in the dry season, but when the rains come, almost seventy per cent of the country is submerged. The water comes from the rivers, the sea, the sky and the snow that the summer sun melts from the Himalayan peaks.

From June to September the rain falls unremittingly. The clouds are dark. This part of the earth's surface, one of the lowest areas on the planet, gives off a strong-smelling humidity. The smell invades the ruined temples, the mosques and the countless palaces. The river swamps the fields, and the villages, built on embankments look like islands lost in the middle of a vast expanse of opaque water. This is the Bangala, the ancient country of the 'people who live on the hills.'

Buriganga, 4 o'clock in the afternoon. A dinghy carrying a large cargo of jute approaches on our left. The golden fibre almost sinks the vessel as it bobs up and down beneath its large unfurled sails. Saddar stops the Chinese motor and greets the crew with a shout. He inquires about the harvest. The crew complains that, just like the price of jute itself, the money they earn transporting goods has been cut. They blame it on synthetic fibres that have resulted in reduced demand.

From time immemorial, the peasants of eastern Bengal have grown jute, and even today it is one of Bangladesh's main resources. Ever since the first Dutch voyagers started using it to wrap the coffee they sent from their colonies in South-East Asia, merchants from all over the world have been coming to Bangladesh to import the golden fibre that can be used to make sacks for transporting tobacco or cereals. The jute market was so buoyant that the peasants referred to it as the golden harvest.

On the horizon appeared an enormous raft over three hundred metres long, on which could be seen the silhouettes of men pulling on a rope. It looked like a floating island made from thousands of neatly piled bundles of bamboo of equal length. It was preceded by a piragua from which two boys were dropping an anchor, tied to a stout rope. At the other end of the cable, on the raft, their bodies bent over with the effort, the men were engaged in a tug-of-war with the river. The floating cargo glided slowly on the surface, covering several metres. 'That's the bamboo on its way down from the mountain forests near Syleth,' said Saddar, slowly approaching the boat.

As soon as we set foot on it, swarms of mosquitoes flew up from the bundles of bamboo.

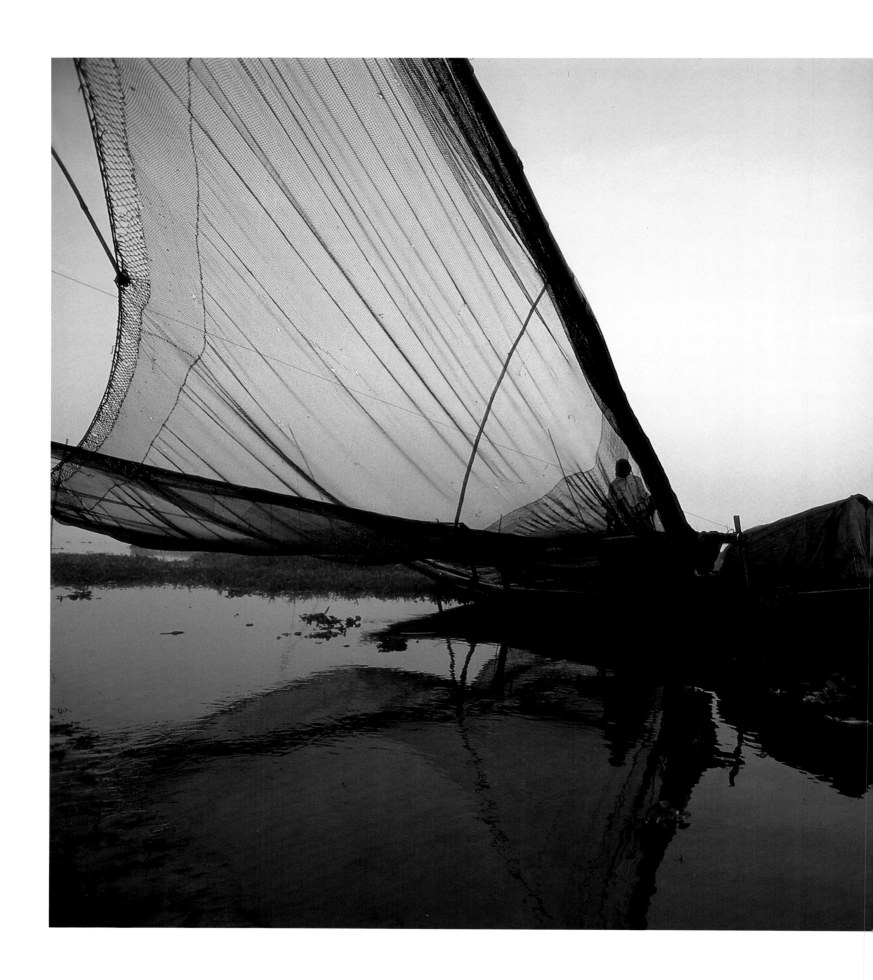

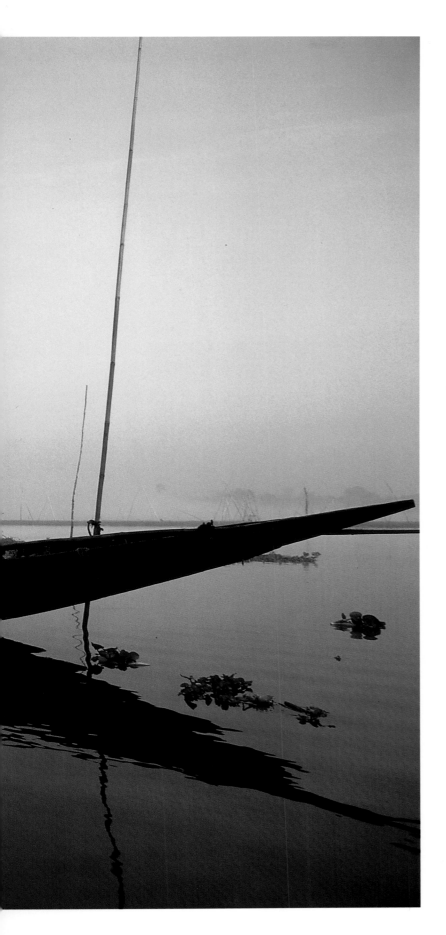

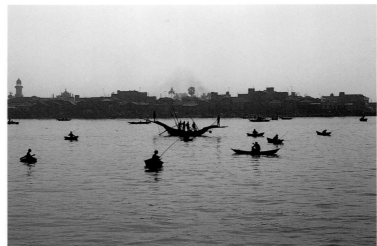

We were introduced to Mohammed, the oldest member of the crew. He was a tiny man, but incredibly strong. He had often come down from Dacca with the bamboo. He knew the river and the city traders, which made him a highly respected person.

Isolated on the river for over a month, Mohammed and his companions live as nomads, camping on their bamboo cargo, the only shelter being two huts made from reeds. Mohammed lit a cigarette. Rice was being cooked for all the crew on a large clay hearth.

The raft created a strange echo effect. Mohammed smiled: 'Did you hear it? That's the voice of the river that travels with us throughout the journey. It speaks to us through the bamboo. It's a soothing sound when the river is calm, but threatening when you're in the middle of the current.'

It was almost sunset. On the horizon the sun appeared beneath the massive bridge built across the Meghna by the Japanese. Seizing the rope, Mohammed and his men pull their craft onto the Buriganga, the canal linking the Meghna to the Brahmaputra. A solitary dolphin from the Ganges shows itself above the surface of the water and, for a while, follows in the wake of the bamboo cargo. A chant rises from the raft: 'Pull, pull; Allah is with us; pull, pull, we'll make it.' Once again the men and the bamboo follow the course of the river.

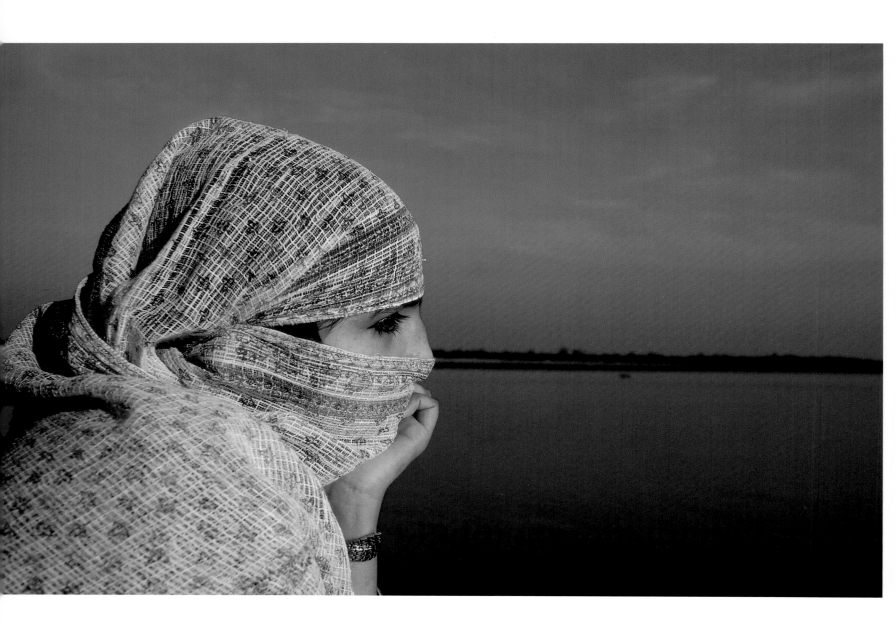

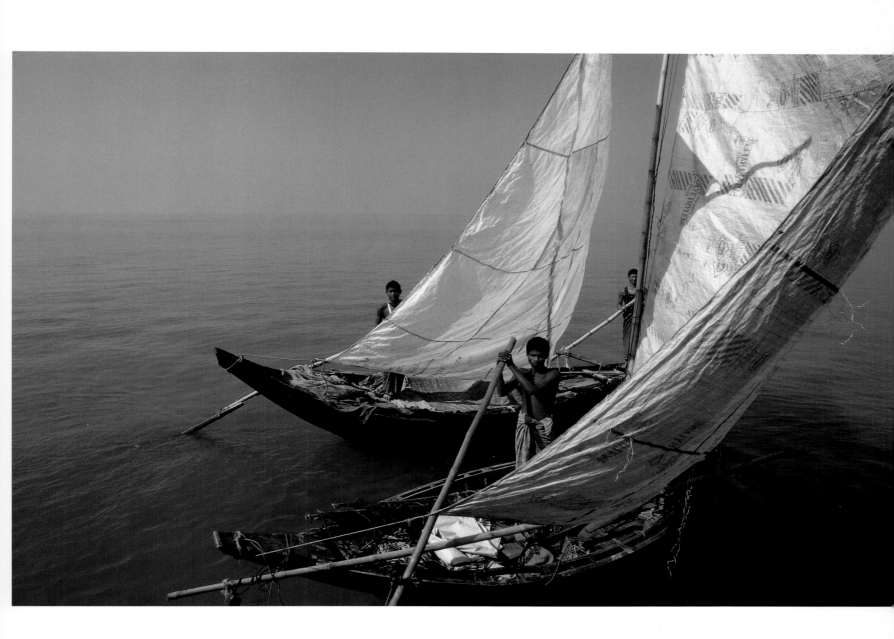

Dacca City, 5 o'clock in the afternoon. Sitting on the red plastic-coated seat of a rickshaw, on which a somewhat naïve tiger has been drawn, we make our way along the road to the old city.

We are swallowed up in the Dacca traffic. It is not long before we find ourselves stuck in a traffic jam of wheels, handlebars, pedals, legs and elbows. Men and rickshaws are caught up in a hopeless tangle from which escape seems an impossibility. With one foot on the ground and the other poised on the pedal, the rider of the vehicle beside us turns in our direction, opens his arms in a gesture of powerlessness and smiles: 'Traffic jam,' he murmurs in English.

All around us lies Dacca, the city of over two hundred thousand rickshaws. One is crammed full of children on their way home from school; another is carrying a businessman in a starched shirt, with his imitation leather overnight bag; beneath an awning two women, their faces covered by light saris, are engaged in conversation. Alongside us another rickshaw, overflowing with coloured paper flowers, looks like an improbable bouquet on two wheels.

Rickshaws are the key players in the city traffic. They invade the whole of the network of streets, the crossroads and the unprotected pavements. We struggled to find a way through the old part of the city. A compact labyrinth of bazaars, crumbling buildings, narrow streets running down towards the river that is itself teeming with boats of all kinds.

This is the heart of Dacca, a capital of over six million inhabitants, in search of an identity in a modern world and following in the wake of the economic progress taking place in India.

Dacca is an ancient city, but to a significant extent it owes its importance to the massive geographic changes that occurred in the course of the Ganges during the 16th century. The sacred river, which until then had flowed wholly through India, changed its primary course towards the east, forming what we now know as the Padma, and opening up a way to the sea across the Brahmaputra and the Meghna.

As a result Dacca became an important centre along this new waterway, an artery for trade between the Bay of Bengal and the plains of India.

In Bengal's history the shifting course of the rivers over many centuries has meant the rise and fall of many towns and cities. This was the case with the ancient cities of Mahastan and Gaud.

Supposedly visited by the Buddha, the two cities were important Buddhist centres when, in the 4th century BC, according to Ptolemy, the Gangaridi – or inhabitants of the Ganges delta – stopped the advance of Alexander the Great. As part of the Maghada Empire, Mahastan enjoyed its greatest glory during the reign of Emperor Ashoka, one of the most popular figures in Indian history. His conversion to Buddhism in 262 BC marked the spreading of Buddhist teaching throughout his realm.

After the fall of Ashoka's empire, first during the reign of Gupta (in the 4th century AD) and later in the reign of the Palas (between the 7th and 12th centuries), Buddhism experienced a golden age in eastern Bengal. Large monasteries sprang up along the river, inhabited by thousands of monks, referred to in the ancient texts of Chinese voyagers. Fa Xian, who in the 5th century AD visited Mahastan, was impressed by the grandeur of the Buddhist monasteries. In the 8th century AD, Pahapur, not far from Mahastan, was considered one of the most important Buddhist centres south of the Himalayas and had great influence in China, Tibet and the whole Buddhist world.

On their way east, boats plied the rivers and the great delta, laden with cotton fabrics and the highly valued silk made in Mahastan and Malda, near Gaud.

At the end of the 11th century AD, the Pala dynasty was superseded by that of the Senas, a dynasty that had its origins in southern India and imposed Hinduism on Bengal, making prosperous Gaud the capital of the new kingdom. This is the city Ptolemy referred to as the 'city of the kings' and Marco Polo mentioned in his writings as the 'golden city of Bengal.'

In 1199, having taken Gaud by deceit and with a handful of soldiers, Baktiar – originally a commander from Turkestan – acquired Bengal from the Sultanate of Delhi, a centre of Muslim power that

dominated a large part of northern India at the time. In the middle of the millennium of Islamic dominance, which knew its greatest glory during the period of the Mongol emperors, the Land of the Rivers, present-day Bangladesh, developed an abundant agriculture and became a world centre for cotton and silk spinning.

Trade routes prospered by land and by sea. Goods travelled by the Grand Trunk Road, the two thousand miles which linked Bangladesh and Afghanistan across the Ganges plain.

The routes from the Bay of Bengal, which the ruling Muslims protected from attack by pirates, were a meeting place for sailing ships laden with tea from China, spices from the Moluccas, and rice, jute and silk from the Indian subcontinent. Over a hundred boats a year sailed down the delta waterways from north to south bound for the open sea and the spice routes to Java, Burma, China, the Arab world and the Mediterranean.

As the capital and main commercial centre of the Mongol Empire in Bengal, Dacca saw the importation of exotic goods from Persia, Central Asia, Afghanistan and Turkey.

It was not long before the small white tokens that served as the primordial currency in the country's ancient tribal kingdoms gave way to pieces of silver and local currency.

Dacca Port, 7 o'clock in the evening. We have left Saddar's malar for a big-orange coloured boat, a 1928 steamer bound for Sunderbans. The river is a restless place: countless boats ferry the inhabitants of the city from one bank to the other. Dense and oily, the water produces deep golden reflections in the light of the setting sun. Along the banks, where the ferries are anchored, a small boy carries a tray of peanuts and drinks as he attempts to find a way through the crowd, proclaiming his wares at the top of his voice. He disappears behind a tide of men, women, baskets overflowing with mangoes, coconuts, watermelons, bundles of jute, flour and rice. The river is a confusion of busy oars, voices and shouts. From the

mosques the voice of the *muezzin* calls the faithful to prayer. On the roofs of the ferries lying at anchor in the port, men in cotton *longhis* prostrate themselves facing towards Mecca. The cries to Allah resound across the river.

Like a scream, the steamer's siren disturbs the evening, announcing its departure. The steamer leaves behind it the lights of Dacca and is engulfed in the darkness of the Great River.

Sunderbans, 6 o'clock in the morning. Dawn is approaching. A dense forest emerges from the mist. Mangroves, *gema* and *sunder,* the trees with purple-coloured wood from which Sunderbans takes its name. This is all that remains of the extensive forest that once covered the Ganges plains, the land through which a way had to be cut first by the Aryans, and after them by the various land and sea invaders. An impenetrable forest extending across the brackish water, ending in a narrow raised section, above thousands of channels that at one time provided ideal hiding places for the Magh pirate boats. Over the centuries the vegetation has adapted to the regular tidal movements and protects the land from the fury of the summer typhoons.

Seated on the prow of the piragua, Diran Vishas examines the bank and points out some large footprints in the mud: 'The tiger came along here in the night,' he announces.

He belongs to a dynasty of fishermen who for generations have hunted with otters. Every year he spends many months living the life of a nomad, moving from one brackish water channel to the next.

Like everyone else in Sunderbans, Diran and his children must live with the atavistic fear of the man-eating Bengal tigers.

It was only a few years ago that tigers in Bengal were in danger of extinction; now they are so numerous as to pose a constant threat to the fishermen and inhabitants of the Delta who have to venture into the forests of Sunderbans.

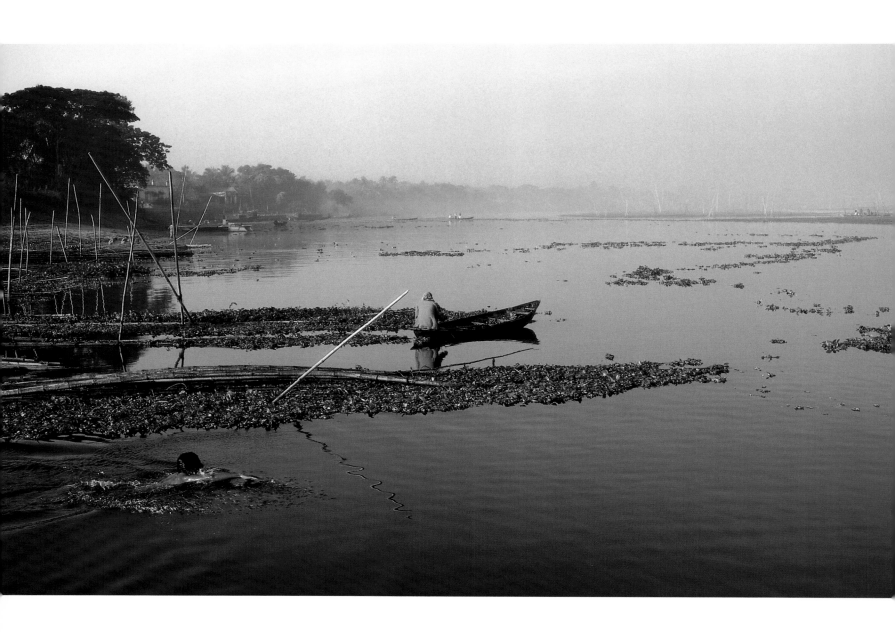

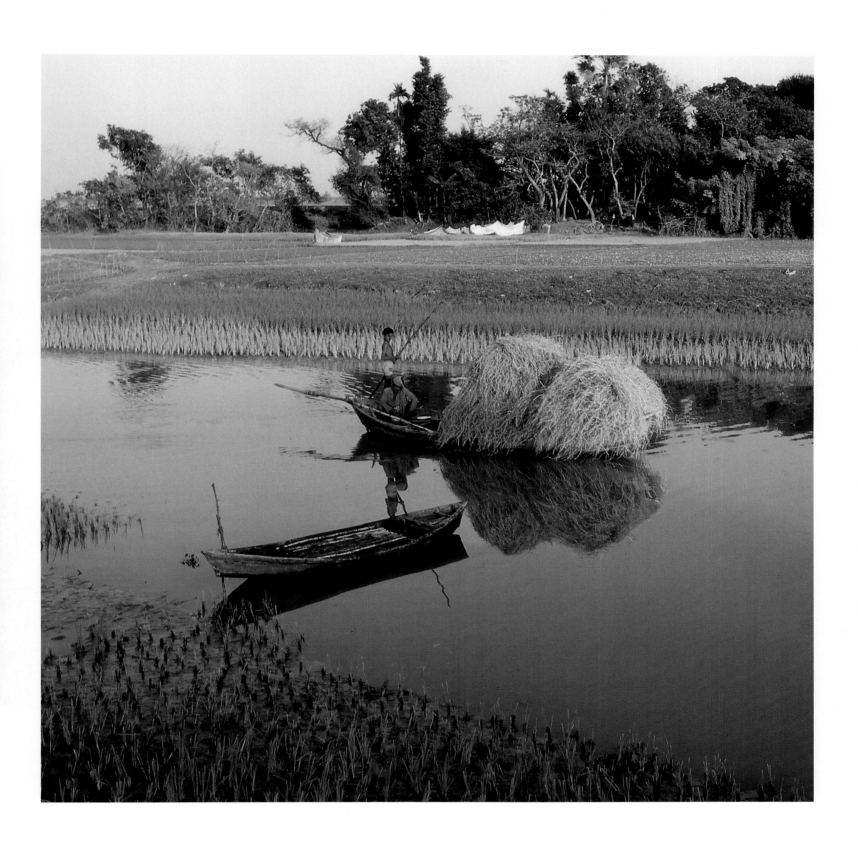

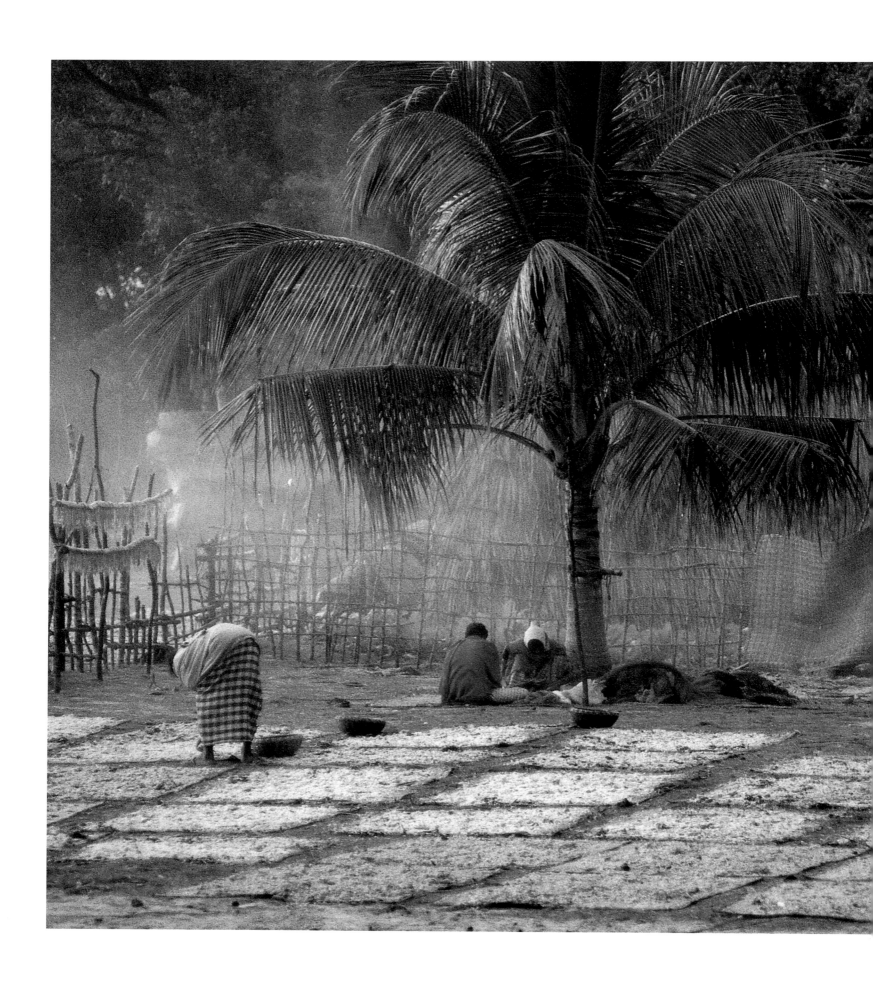

'The tiger is a very intelligent animal. It is an incredible swimmer. It marks you out. Follows you in silence. Bounds forward and attacks. From the land, from the river, from the protected trees above the water channels. It pounces on you from behind. Every year it exacts its tribute in the form of human victims,' we were informed by Shodanondo, one of Diran's sons. 'There is not a village in which the women have not lost a husband, a son or a brother.'

Now that the species is protected, the tiger seems to have regained its aggressive streak. Recent reports speak of over three hundred victims a year. Shodanondo told us of fishermen whom tigers had taken by surprise in the water channels and forcibly pulled them from their boats into the water; and of *maual* that had been attacked and killed as they were gathering the honey that the enormous bees of the region deposit in large hives in the jungle.

Slowly we made our way up the narrow channel between two spurs of dense mangroves and sunderi. Shodanondo and Kogen, Diran's brother, threaded two bamboo poles four metres in length into the sides of the net. The raucous cry of the otter was heard from a large box on the prow of our vessel.

Diran no longer remembers how this strange alliance between otters and the Sunderbands fishermen began. He learned it from

his father; his father from his grandfather, and so on back through the generations.

The origins are certainly ancient. For centuries the fishermen of Orissa and Sind have bred the *Lutra perspicillata*, known as the smooth Indian otter, which they use to guide the fish into the net.

The Muhanas of Sind would use them as a decoy to catch the river dolphins: two or three trained otters were let into the water and fed with fish and crayfish. Excited by this rich meal, they created a stir in the water, letting out their characteristic cries that resemble a barking dog. Attracted by this great excitement in the water, the river dolphins would end up ensnaring themselves in the nets that the fishermen had set to catch them.

It is believed that this was the natural fishing technique of these mustelids, namely to get the people of Sunderbans to breed them and use them for fishing. Otters of the same family often fish in groups. They swim along, in semicircular formation, at a certain distance from one another and drive the fish ahead of them. One otter then detaches itself from the group; dives and reappears with a fish in its mouth, but without losing its place in the advancing formation. They take turns doing this until the squadron has satisfied its hunger.

The tide was falling. Diran took a pair of adult otters from the bamboo box. They had glossy coats; their streamlined bodies stretched towards the edge of the piragua, anxious to reach the water. Diran clicked his tongue.

'We don't catch the *udni*,' as Diran calls the otters. 'Each family breeds its own. To introduce new blood into the breed we cross them with those of other fishermen we know. But we always keep a male so that we do not lose the genealogical line that runs back to the original stock.' The otters of the Sunderbans have a sort of unwritten pedigree, though it is well known to the fishermen of the Delta themselves.

The box on the prow still contained a young female otter that had recently produced six cubs. Diran picked up a cub with a silver coat. It scarcely filled his hands. With its eyes still shut, it stretched out its tiny webbed paws.

'My otters,' he informed us, 'are direct descendants of those bred by my grandfather who was famous among the people of Sunderbans for the extraordinary characteristics of his otters. When I got married, I made myself a piragua and my father gave me a pair of otters. I'll do the same for my own children.'

Roton and Shodanondo attached the pair of otters to the boat with a long thin rope. From the two ends of the piragua the male and the female watched the movements of the humans attentively. Kogen and Diran dropped the large square net into the water.

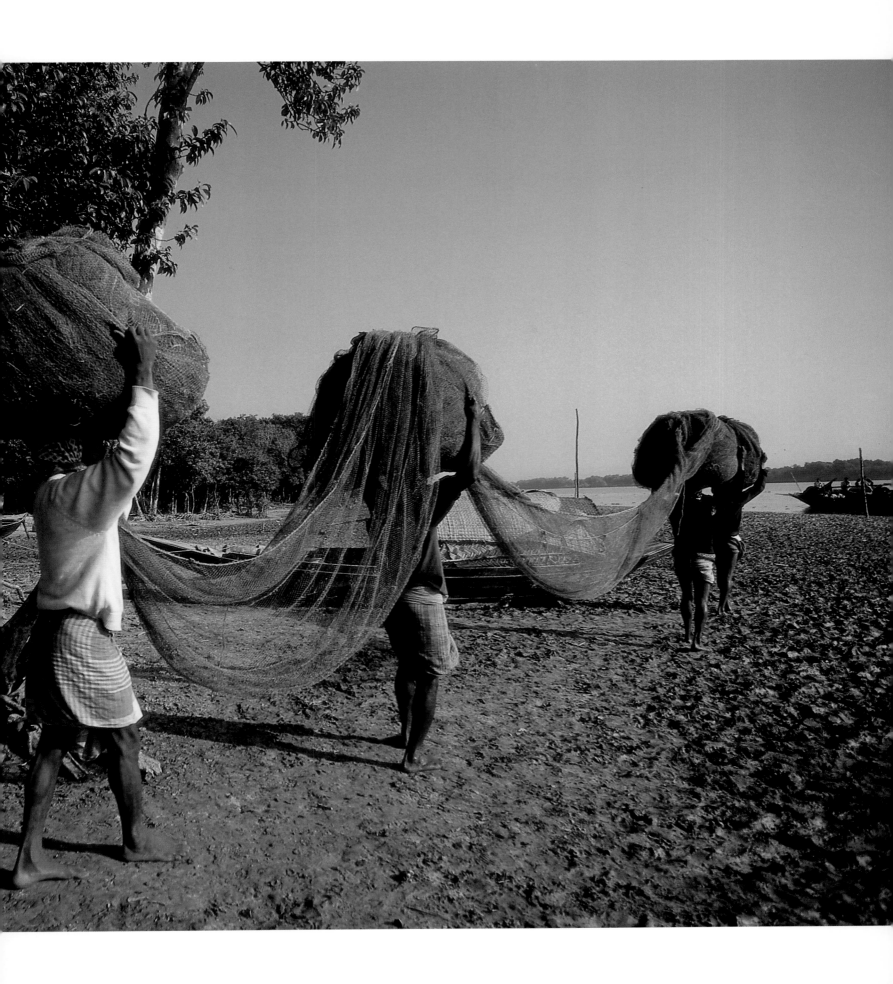

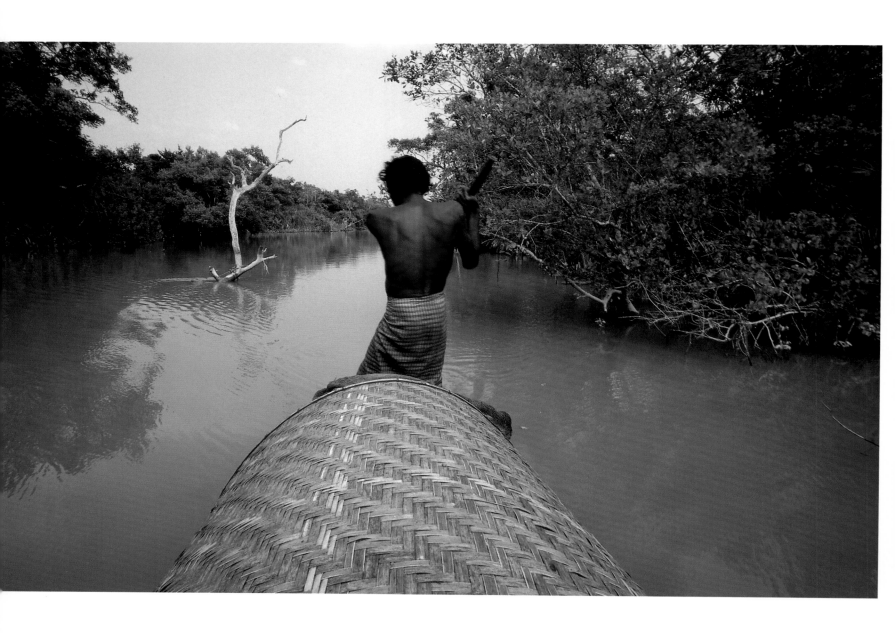

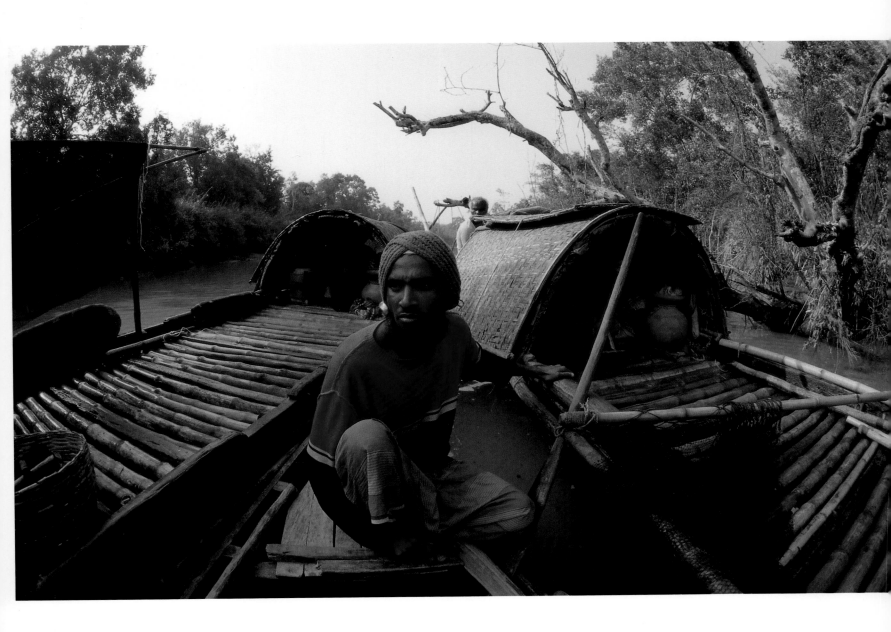

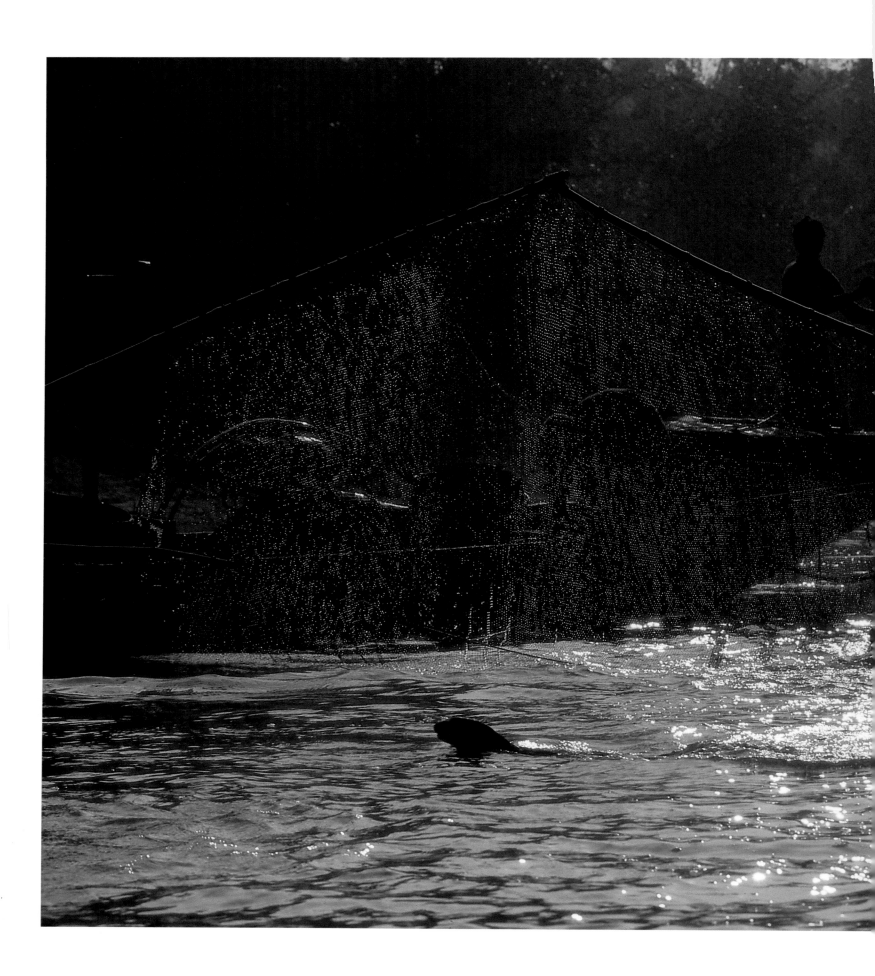

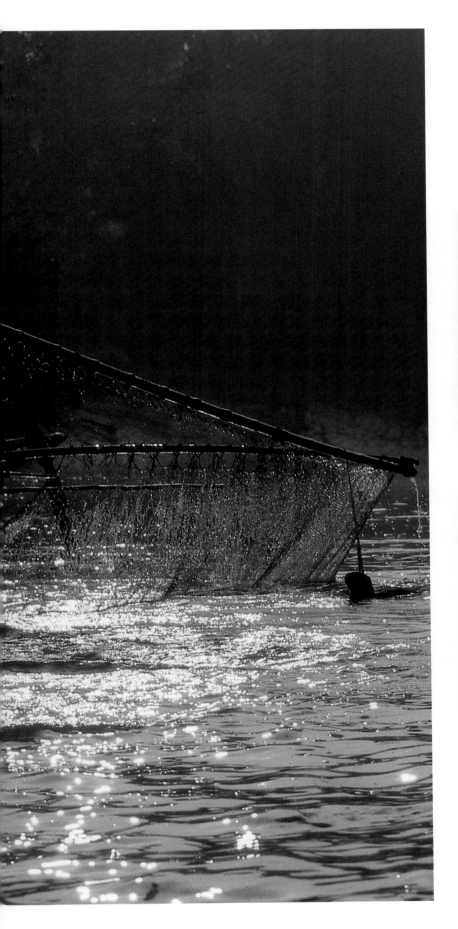

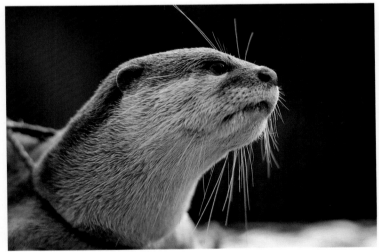

Immediately the otters dived beneath the surface and steered the fish into the net. Their tapered bodies seemed to be designed for the precise purpose of fishing and capturing their prey: the thick, glossy coat is protection against the cold. The almost cylindrical body enables them to move and turn effortlessly, causing minimum friction with the water; and the flat head, hardly visible when they swim to the surface, is perfect for going undetected. When not hunting, the otter swims slowly, using just its front paws; but as soon as speed is required, its whole body comes into action: vigorous shoves from the rear paws and sinuous movements of the body and tail propel the creature through the water. It follows close in the track of an escaping fish, copying every movement with ease. It is built for underwater swimming: small ears and a nose which acts as a valve to prevent water getting in; its rigid whiskers, always straight, act as sensors, making up for its limited vision. That is why the otter is able to move effortlessly, even through the cloudy waters of the Sunderbans channels. With its sensitive paws it is able to flush hidden prey from the mud. Even the otter's teeth, with their sharp points, seem designed to take and keep hold of its slippery prey.

Between one tide and the next Diran anchors his boat in a bend in the channel, in the shade of a large *sunder*.

Roton and Shodanondo remove the catch from the trap. They divide it up according to size. Roton places the biggest fish, still alive, in a bamboo cage that hangs over the edge of the boat, in contact with the water. Shodanondo sits at the prow. His legs wide apart, he holds a curved knife, and with one hand removes a fish from a rush basket. He cuts into it with the finely sharpened blade. Then he opens up the body and rubs it with salt. His hands are covered with a mixture of blood and salt. Roton carefully takes the prepared fish from his brother and places it in a large earthenware container. This is the food supply for the rainy season that they will take home to the family after their long expedition to the Sunderbans area.

Sitting around a clay brazier on the deck of bamboo poles, we ate the fish that Roton fried for us with a liberal sprinkling of paprika.

Shaded from the sun, Diran Vishas lit a water pipe. The spiralling blue smoke engulfed his face. The pipe was passed from hand to hand. The acrid smell of local tobacco filled our lungs. At the prow, Kogen was mending a net with a bamboo needle. The water in the channel was motionless. The otters in the box at the prow were dozing.

◆ ◆ ◆

Padma, 8 o'clock in the evening. For two days we have been moored at the inlet to a channel of water that skirts one of the thousand islands in the Delta. Kachikhali, 'the point of the tiger,' is not a village, but a flat strip of sand covered with jungle; at it edges are the fishermen's huts. They are temporary dwellings, intended to last no more than a season, soon to be swept aside by the typhoons.

The beach is a carpet of reed mats on which shrimps and small molluscs are drying in the sun. The smell of fish filled the air. Gulls and sea eagles circled over the beach, ready to pounce on the rich banquet.

Abdul Jalil arrived at the end of October. He comes here every year to fish. His day at sea begins before dawn. At sunset, he returns to Kachikhali, his boat heavy with shrimps that he tips by the basketload onto the beach. His seven-year-old son, Hussein, patiently spreads out the shelled crustaceans on the mats and separates them so that they can dry well.

Every week, a ship sails to Kachikhali; it picks up its cargo and heads west where the dried shrimps and molluscs are processed for canned cat and dog food.

Between the Delta's islands the river and sea, the land and the water lose their individual identities. The brackish water of the Bay of Bengal mixes with the fresh water brought down from the Himalayas by the Brahmaputra. The sea fish come into contact

with the river fish. The various species intermingle. Like the ebb and flow of the tides and the river currents, the invasions that have taken place over the centuries have made Bangladesh a melting pot for peoples and cultures. The aboriginal Dravidian stock interbred with ethnic groups from the Himalayas and Burma; the Aryans gave way to the Muslims who came and settled here soon after the Moghuls. Alongside the Muslims, who account for four-fifths of the population, Hindus, Buddhists and various animist tribes are also scattered across Bangladesh.

As soon as darkness descends around twenty dinghies moor around our boat, anchored in the middle of the channel at the point of the tiger. News that we have an armed guard on board has spread quickly. Attracted by the reassuring presence of a gun, the fishermen bring their dinghies to rest in what they regard as a safe port for the night, in case the tiger should be on the prowl.

The dark red water of the channel was illuminated by the oil lights. The flickering flames revealed the outline of the fishermen wrapped in their cotton blankets.

A leaf bobbed up and down on the dark, opaque surface, waiting for the tide to turn and carry it out into the ocean. The water of the Great River was scarcely moving. In Tibet it was able to turn the prayer mills. It washed away the sins of the Hindu pilgrims. And it carried echoes of the imploring cries to Allah.

Now, however, it seemed to linger in the roots of the mangroves and on the soft mud of the banks. It rested among the petals of the Great Lotus, before covering the last stretch of its almost three thousand kilometre journey.

There was a light rippling of the surface. The tide takes possession of the Great River and carries it into the arms of the ocean.

North of the Himalayas, a small drop of water issues from the Mouth of the Horse and begins its journey to the sea.

NOTES

Chapter 1

1. Swami Pranavananda, *Exploration of Tibet*, Calcutta, 1950, p. 10.
2. Giuseppe Tucci, *The Religions of Tibet*, London, 1980.
3. Swami Pranavananda, op. cit. pp. 10–12.
4, 5, 6, 7. A. H. Savage Landor, *In the Forbidden Land*, London, 1898, Vols. I and II.
8, 9, 10. Sven Hedin, *Transhimalaya*, 1913, vol. I-III, quoted in C. Allen, *A Mountain in Tibet*, 1982, pp. 205–206.
11. Giuseppe Tucci, *Sadhus et brigands du Kailash*, 1989, p. 165.

Chapter 2

1. Edmund Candler, *The Unveiling of Lhasa*, p. 239.
2. ibid., p. 246.
3. ibid., p. 245.
4. Patrick French, *Younghusband*, p. 223.
5. Tsepon W. D. Shakabpa, *Tibet, A Political History*, p. 213.
6. Candler, op. cit., p. 110.
7. Sarat Chandra Das, *Journey to Lhasa and Central Tibet*, pp. 60-61.
8. ibid., p. 229.

Chapter 3

1. Thomas Holdrich, *Tibet the Mysterious*, London, 1906, p. 219.
2. Frank Kingdon-Ward, in *Himalayan Enchantment: An Anthology*, by John Whitehead, London, 1990, p. 68.
3. F. M. Bailey, *No Passport to Tibet*, 1957, p. 150.
4. Kingdon-Ward, op. cit., p. 69.
5. J. Bacot, *Le Tibet révolté*, 1912, p. 163.

Chapter 4

1. A. Hamilton, *In Abor jungles of North East India*, Delhi, 1983, p. 43.
2. F. M. Bailey, *No Passport to Tibet*, Londres, 1957, p. 27.
3. Jean-Baptiste Chevalier, 1757, in *Les Indes florissantes, Anthologie des voyageurs français*, Paris, 1991, p. 658.

GLOSSARY

apsara	nymph or celestial dancer
chang	fermented Tibetan drink made from barley
chuba	a sort of greatcoat, a traditional Tibetan garment
dhal	dish of lentils usually accompanying rice throughout the Indian world
drong	wild yak
dzongpön	formerly a high official in Tibet, having the rank of governor
gandharva	local gods
gushu	type of chasuble (robe), generally black, commonly worn in Kongpo
g.yang	principle of personal fortune
jambu	mythical tree, connected with the earth
khata	long white silk scarf, sign of good luck or happiness
kora	ritual walk around a sacred monument or site
kund	sacred lake, pool for ablutions near a sanctuary
kyang	the wild donkey of Tibet
lung-gompchen	ascetic who is an expert in the practice of yogic speed
mala	rosary
mantra	sacred word, incantation of power
mela	large religious grouping
moksha	liberation, release from the birth cycle
Mönlam	religious ceremony of the great prayer
nyibo	shaman, aboriginal priest
penpö	Tibetan functionary, administrator
phyi-ling	foreigner, especially a Westerner
rishi	ascetic seer, endowed with yogic powers
rlung-ta	'wind horse,' the legendary messenger who distributes prayers over the world
shakti	female power, energy without which there is no life
shapje	sacred imprint
tirtha	sacred place, goal of pilgrimage
toummo	the yogic practice of generating internal heat
tsampa	barley flour, the base of Tibetan food
tsen-gdù	poisonous flower

BIBLIOGRAPHY

Allen, Charles, *A Mountain in Tibet*, London, 1983

Bacot, Jacques, *Le Tibet révolté*, Paris, 1912

Bailey, F. M., *No Passport to Tibet*, London, 1957

Battuta, Ibn, *Voyages*, vol I, II, III, Paris, 1982

Cameron, Jan, *Mountains of the Gods*, Delhi, 1984

Candler, Edmund, *The Unveiling of Lhasa*, New Delhi, 1981

Chandra Das, Sarat, *Journey to Lhasa and Central Tibet*, London, 1907

Chowdhury, J. N., *Arunachal Panorama*, Shillong, 1982

Das, Jogesh, *Folklore of Assam*, Delhi, 1972

Dalton, Edward Tuite, *Descriptive Ethnology of Bengal*, Calcutta, 1872

Deleury, Guy, *Les Indes florissantes*, Paris, 1991

Desmond, Ray, *The European Discovery of the Indian Flora*, London, 1992

Farrelly, David, *The Book of Bamboo*, London, 1996

French, Patrick, *Younghusband*, London, 1995

Govinda, L. A., *The Way of the White Clouds*, Paris, 1969

Hamilton, A., *In Abor Jungles of North East India*, Delhi, 1984

Hedin, Sven, *Transhimalaya*, vol. I-III, Leipzig 1913

Holdrich, Sir Thomas, *Tibet the Mysterious*, London, 1906

Hopkirk, Peter, *Trespassers on the Roof of the World*, London, 1982

Johnson-Moran, *Kailash; on Pilgrimage to the Sacred Mountain of Tibet*, London, 1989

Kingdon-Ward, Frank, *Himalayan Enchantment*, London, 1990

Kingdon-Ward, Frank, *The Land of the Blue Poppy*, Taipei, 1971

Kvaerne, Per, *The Bon Religion of Tibet*, London, 1995

Levenson, Claude B., *Kailash, Joyau des Neiges*, Genève, 1995

MacGregor, John, *Tibet, A Cronicle of Exploration*, London, 1970

Mackenzie, Donald, *India, Myths and Legends*, London, 1987

Mahabharata

Mollat-Desanges, *Les Routes millénaires*, Paris, 1988

Nair, P. T., *Tribes of Arunachal Pradesh*, Assam, 1985

Novak, James, *Bangladesh, Reflections on the Water*, Dacca, 1993

Pranavananda, Swami, *Exploration in Tibet*, Calcutta, 1950

Ramble, Charles, *The Creation of the Bon Mountain of Kongpo*, Delhi, 1995

Ramayana, Genoa, 1988

Savage-Landor, A. H., *In the Forbidden Land*, London, 1898

Shakabpa, W. D. Tsepon, *Tibet, A Political History*, New York, 1984

Sister Nivedeta-Coomaraswamy, A., *Myths of the Hindus and Buddhists*, London, 1926

Snelling, John, *The Sacred Mountain*, London, 1990

Stein, Rolf, *La Civilisation tibétaine*, Paris, 1962

Sources Orientales, les Pèlerinages, Paris, 1960

Tagore, Rabindranath, *Fogli Strappati*, Parma, 1988

Thoubten Jigmé Norbû and Turnbull Colin, *Le Tibet*, Paris, 1969

Tucci, Giuseppe, *Sadhus et Brigands du Kailash*, Paris, 1989

Wilkins, W. J., *Hindu Mythology*, Calcutta, 1989

CAPTIONS

ACKNOWLEDGEMENTS

During our travels along the Brahmaputra, we had to cope with many difficulties. Obstacles created by nature in some instances, but more often by man himself. We would therefore like to express our thanks to all those who helped us by showing a sincere interest and a serious, professional attitude.

Our editor, Matthias Huber who had confidence in our project; Renato Moro and Focus Himalaya Travel for their support in the expedition to the Curve; Raj Sarogi for his help with the Indian authorities; John Randall of London, who kindly permitted us to reproduce the lithograph of Dacca and other documents from old books in his collection; Dr Andrew Tatham and Joanna Scadden of the Royal Geographical Society; Rod Hamilton of the India Office, British Library; Thamserku Trekking; Shahjahan Ali and Rezaul Karim for their help in Bangladesh; Mottiur Rahaman; Shashank Gupta of Ruck Sack; Arup Kumar Barua of Rhino Travels; Jatanlal and Kanak Bucha, who yet again showed us friendship; Nimmi and Yashwardhan Singh Rautela and P. Dutta for their hospitality on the tea plantations; Yomgi Eshi for introducing us to the Adi; Dr N. K. Saikia; Sri Haran Charan Das; Lama Chodurk Gyatso; Kodak and Europhoto; TTP of Tardivello; Prof. Chodrup Tsering for his research on Tibetan mythology; our Tibetan friends who accompanied us to the Curve; Jamyang, Sonam Nyima, Kelsan Nyima, Pema Tsetar, Rinchin Drolma, Tako, Tashi Dundup, Tchupen, Menla, Tson Drolma. Nymia Tashi in Kongpo; Gochotar; Saddar, Abdul Jalil. And last, but not least, Norbu Sherpa, our incomparable assistant.

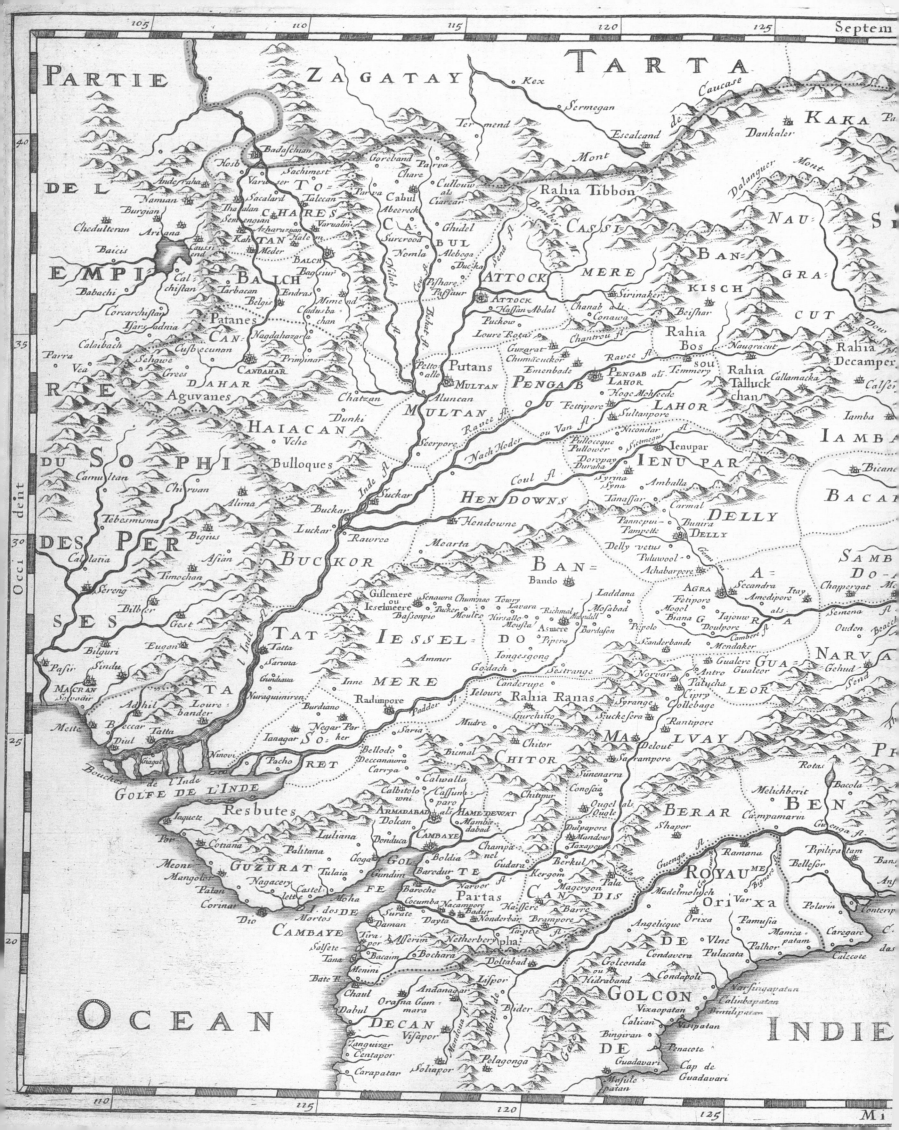

PARTIE ZAGATAY TARTA

DE L

EMPI

RIE

DU SO PHI

DES PER

SES

Occident

Kex

Sermegan

Termend

Escaleand

Mont de Caucase

Dankaler

KAKA

Badaschian

Hosb

Sachimest

Andestalia

Namuan

Burgian

Chedulteran Ariana

Baicis

Babachi

Corcarchistan

Isar, adnia

Parra

Vea

Calaibach

Varuater To=

Sacalard

Thadalan CHARES

Semengian

Asharuruan

Kah=

TAN Meder

BALCH

Bagsiur

Tarbacan

Belgis

Endras

BALCH

Patanes

CAN=

Cusb ecunan

Nagdahazara

Primwar

Goreband

Parva Chare

Tarva

Cabul

Abeereck

Ghidel

CA=

Surcrood

BUL

Nomla

Nilab

Aleboga

Ducka

Cullouw

als

Ciarcar

Rahia Tibbon

NAU

Bamber fl

CASSI=

BAN=

MERE

KISCH

Sirinaker

ATTOCK Attock

Hassan Abdal

Chanab als

Conawa

Beishar

Puchou

Loure Rotas

Chantrou fl

Rahia

Bos

Naugracut

GRA=

CUT

Rahia

Decamper

Calsee

Candahar

Chatzan

Sehawe Grees

DAHAR

Aguvanes

HAIACAN

Vche

Dunki

Petto

alle Putans

Multan

MULTAN

Guzarat

Chumäcuckor

Emenbade

Aluncan

Ravee fl

Hoge Mehsede

PENGA B

ou

Fettipore

PENGAB als

LAHOR

sou

Temmery

Rahia

Talluck

chan

LAHOR

Iamba

IAMBA

Bigius

Camultan

Chirvan

Alima

Tebesmisma

Calolatia

Sereng

Bilber

Gest

Bulloques

Seerpore

Ravee fl

Nach Heder

ou Van fl

Sultanpore

Niconda

Pulloceque

Pullower

Doropay

Duraha

Sicmegus

IENU PAR

Coul fl

Syrna

Syna

Amballa

Tanassar

Carmal

Ienupar

BACA

DELLY

Inde fl

Buckar

Buckar

Luckar Rawree

HEN DOWNS

Hendowne

Mearta

Pannepu=

Pampeli

Bunira DELLY

Delly vetus

Tuluwool

Achabarpore

SAMB

DO=

Timochan

Asian

Eugan

Bilguri

Sindu

Pasir

Macran

Solvadir

Adshil

Mette

Beccar Tatta

Diul

Giagat

Ninovi

Tatta

Saruna

Gundaua

Nuraquimiren

TA

Loure

bander

Boucher

de l'Inde

GOLFE DE L'INDE

TAT

IESSEL= DO

Gislemere ou

Iselmeere Senawra Chumnao Towry

Bassonpio Tucker Moulte

Lavara

Hirsatte

Mousta

Asmere Pipera

Ammer

Inne MERE

Godach

Tongesgong

Ieloure

Canderupe

Rahia Ranas

Richmal

Mandall

Bardason

Laddana

Mosabad

Pepolo

Scanderbande

Cambert fl

Mendaker

Gualere

Antro Gualeor

BAN=

Bando

AGRA

Mogol Biana G

Doulpore

Secandra

Fetipore

Amedipore

Tajouw fl

als

RA

Itay

Chappergat

Semena fl

Ouden

NARVA

Gehud

Me

Radinpore

Burdiano

Negar Par

Tanagar

SO=

Pacho RET

Padder fl

Saria

Bellodo

Deccanaura

Carrya

Bicmal

Mudre

Chitor

Gurchitto

Syrange

Suckesera

Norvar

Cipry

Patycha Collebage

LEOR

GUA=

Rantipore

MA=

Gualeor

Delout

Narva

Send

PRO

Resbutes

Iaquete

Por

Meont

Mangolor

Corinar

Cotiana

GUZURAT

Nagacery

lette

Palitana

Luliana

Gega

Castel

Moha

Dio

dos

Mortos

DE

CAMBAYE

Calwalla

Calbitolo

wni

Cassuma

paro

ARMADABAD

Dolcan

Donduca

CAMBAYE

Champa

nel

Boldia

Baredur TE

GOL

Gundim

Baroche

Cocumba Nacampore

Surate

Daman

Tira

por Asserim

Dayta

Netherbery

pha

Bacaim Bochara

Menini

CAMBAYE

Salsete=

Tana

FE

Partas

Gudaru

Narvor fl

Berkul

Kergom

Haisere

Badur

Nonderbar

Brampore

Chitpur

Conoscia

Ougel als

Ougle

Dulpapore

Mandow

Taxapour

CAN= DIS

Magergon

Pala

Madelmoluch

BERAR

Shapor

Melichberit

Campamarin

Guenga fl

Ramana

BEN

Bacola

Rotas

Pipilipa lam

Bellesor

Bans

ROYAU

ME

ORI Var xa

Taxa

fl

Angelique

DE

Orixa

Pamusia

Manica

patam

Palhor

Caregare

Conterip

C

das

OCEAN

Bate fl

Chaul

Dabul

DECAN

Languizar

Centapor

Carapatar

Orasna Gam

mara

Andanagar

Visapor

Mandoua fl

Soliapor

Pelagonga

Doltabad

Lispor

Bider

Morio de

Golconda

ou

Hidraband

Condavera

Condapoli

Condapoli

Vixaopatan

Calican

GOLCON

DE A

Bingiran

Guadavari

Narsingapatan

Calinbapatan

Biralipatan

Penacote

Cap de

Guadavari

Ausule

Ipatan

INDIE

Mi